CW01185525

Ulrike Ottinger

Ulrike Ottinger

Film, Art and the Ethnographic Imagination

EDITED BY
Angela McRobbie

intellect
Bristol, UK / Chicago, USA

First published in the UK in 2024 by
Intellect, The Mill, Parnall Road, Fishponds, Bristol, BS16 3JG, UK

First published in the USA in 2024 by
Intellect, The University of Chicago Press, 1427 E. 60th Street,
Chicago, IL 60637, USA

Copyright © 2024 Intellect Ltd
All rights reserved. No part of this publication may be reproduced, stored in a retrieval system, or transmitted, in any form or by any means, electronic, mechanical, photocopying, recording, or otherwise, without written permission.

A catalogue record for this book is available from the British Library.

Copy editor: MPS Limited
Cover designer: Tanya Montefusco
Cover image: Delphine Seyrig, *Freak Orlando*. Photograph by Ulrike Ottinger, Berlin, 1981. © Ulrike Ottinger.
Frontispiece image: Veruschka von Lehndorff, *Dorian Gray im Spiegel der Boulevardpresse*. Photograph by Ulrike Ottinger, Berlin, 1983. © Ulrike Ottinger.
Production manager: Sophia Munyengeterwa
Typesetter: MPS Limited

Hardback ISBN 978-1-78938-936-4
Paperback ISBN 978-1-83595-060-9
ePDF ISBN 978-1-78938-938-8
ePUB ISBN 978-1-78938-937-1

Printed and bound by CPI

To find out about all our publications, please visit our website. There you can subscribe to our e-newsletter, browse or download our current catalogue and buy any titles that are in print.

www.intellectbooks.com

This is a peer-reviewed publication.

Contents

List of Figures	ix
Acknowledgements	xi
Introduction	1
Angela McRobbie	

PART ONE: THE WIDE EXPANSE OF WORK 13

1. Ulrike Ottinger in the Mirror of Her Movies 15
 Patricia White
2. Moving Artefacts: Objects and Their Agencies in Ulrike Ottinger's Films 32
 Katharina Sykora
3. Wit and Humour – When Objects Look Back: Comical Constellations in Ottinger's Work 46
 Gertrud Koch

PART TWO: THE CITIES 55

4. Ulrike Ottinger and the Fashion Imagination in *Bildnis einer Trinkerin* (1979) 57
 Angela McRobbie
5. Ottinger's Berlin: Exotic of the Everyday 75
 Esther Leslie
6. *Prater* (2007) Cinema's Carousel 85
 Mandy Merck

PART THREE: CHINA, MONGOLIA, JAPAN, KOREA — 99

7. Rewriting the *Ethnos* through the Everyday: Ulrike Ottinger's *China. Die Künste – Der Alltag* — 101
 Cassandra Xin Guan
8. A Timely Education: *Johanna d'Arc of Mongolia* (1989) — 120
 Erica Carter and Hyojin Yoon
9. *Exil Shanghai* as Audio-Visual Archive and Cross-Cultural Collage — 142
 Tim Bergfelder
10. Hochzeiten — 161
 Laurence A. Rickels

PART FOUR: SHADOWS OF THE PAST – HOARDS AND COLLECTIONS — 171

11. 'Paris–Berlin et le monde entier': Ulrike Ottinger's Points of Departure — 173
 Dominic Paterson
12. Shadow Plays: Charting Ulrike Ottinger's Recent Navigations — 187
 Nora M. Alter
13. Anachronism and Anti-Conquest: On *Chamisso's Shadow* — 204
 Thomas Love

PART FIVE: COMMENT AND INTERVIEWS — 223

14. Ulrike Ottinger and the Strange Death of Metaphor — 225
 Adrian Rifkin
15. 'Most Young Women … Are *Bihonists*': Interview with Yeran Kim — 229
 Angela McRobbie
16. 'We Were Pioneers for Fashion Spectacles That Didn't Exist Before': Interview with Claudia Skoda — 236
 Julia Meyer-Brehm
17. 'Back Then We Often Went to the "Lipstick"': Interview with Heidi von Plato — 244
 Julia Meyer-Brehm

18. 'The Magic of Costume and Masquerade': 249
 Interview with Gisela Storch-Pesalozza
 Thomas Love
19. 'As a Viewer You Have a Lot of Freedom': 254
 Interview with Wieland Speck
 Thomas Love

Notes on Contributors 259
Index 263

Figures

1.1	Ulrike Ottinger in front of Marx Brothers (poster) in Paris, 1965, *Paris Calligrammes*, 2019. © Ulrike Ottinger.	23
1.2	Ulrike Ottinger, *Aloha*, 2016. © Ulrike Ottinger.	28
2.1	Photo staging with Uschi in Paris, 1967, *Paris Calligrammes*, 2019. © Ulrike Ottinger.	34
3.1	*BubbleGum*. © Ulrike Ottinger.	47
3.2	Charcoal drawings in preparation for *Das Verlobungsfest im Feenreiche*. © Ulrike Ottinger.	53
4.1	Tabea Blumenschein, Lutze and Nina Hagen, *Bildnis einer Trinkerin*. © Ulrike Ottinger.	71
4.2	Tabea Blumenschein, *Bildnis einer Trinkerin*. © Ulrike Ottinger.	72
5.1	Industrial Landscape Berlin, *Usinimage*. © Ulrike Ottinger.	78
6.1	Riesenrad, *Prater*. © Ulrike Ottinger.	86
6.2	Veruschka von Lehndorff, *Prater*. © Ulrike Ottinger.	88
7.1	*China. Die Künste – Der Alltag*. © Ulrike Ottinger.	112
8.1	*Johanna d'Arc of Mongolia*. © Ulrike Ottinger.	125
8.2	*Johanna d'Arc of Mongolia*. © Ulrike Ottinger.	137
9.1	*Exil Shanghai*. © Ulrike Ottinger.	151
10.1	*The Korean Wedding Chest*. © Ulrike Ottinger.	163
11.1	*Still Moving*. © Ulrike Ottinger.	181
12.1	*Chamisso's Shadow*. © Ulrike Ottinger.	200
13.1	*Chamisso's Shadow*. © Ulrike Ottinger.	212
16.1	Claudia Skoda, *Night Sessions*. © Ulrike Ottinger.	239
19.1	*Freak Orlando*. © Ulrike Ottinger.	256

Acknowledgements

First of all, many thanks go to Ulrike Ottinger. Her cooperation in this project has been generous, especially given that for the duration she has been working on several new pieces of work, as well as travelling to install shows in various parts of the world. I have absolutely appreciated her advice and her gracious and courteous input when it has been needed. I must also thank her for granting permission for the 22 images re-printed in this volume. Reinhild Feldhaus and Sarah Polligkeit at Ulrike Ottinger Film Productions have also been incredibly helpful throughout, providing the authors with so much material and information. Thanks to the Goethe Institute in London we were able to bring on board the Berlin-based writer and art historian Julia Meyer-Brehm who carried out two interviews published here. My thanks are also due to Irit Rogoff at Goldsmiths University of London, who kindly re-introduced me to Ulrike Ottinger in 2007. I had met her briefly as a post-graduate student in Berlin in the late 1970s. Various friends and colleagues in Berlin provided ideas and pointers for the interviews; they include Margit Eschenbach who was sound engineer on some of the early films by Ottinger, the artist Kerstin Drechsel, and, with sadness, I also express my gratitude to the late filmmaker Tatjana Turanskyj who was herself deeply influenced by Ulrike Ottinger. I discussed the ideas for this book with Tatjana but she did not live to see it through to fruition. My personal thanks also go to Erica Carter and Mandy Merck in London. Not only are they friends and neighbours, they have also advised, participated and helped to shape the volume. Thanks finally to the Intellect team and editorial for having faith in the ideas of this collection.

<div style="text-align: right;">
Angela McRobbie

London and Berlin, May 2023
</div>

Introduction

Angela McRobbie

The artist and filmmaker Ulrike Ottinger (born in Constance in 1942 and based in Berlin since 1972) has been making work for over 50 years. In Germany she is fully acknowledged, honoured and garlanded with awards. In France and indeed in most European countries as well as in Southeast Asia there have, over the decades, been major shows, retrospectives and extensive screenings. So prolific is the flow of work that it is hard for academic researchers nowadays to keep up with the new commissions and projects. As a quick glance through the Ottinger website (https://www.ulrikeottinger.com/en/films) shows, there is a hectic schedule of openings, shows, book publications, conferences and screenings, as well as new film productions in process. Critical engagement in the English language has come in waves, with the late 1970s and the 1980s marking a high point and comprising mostly of feminist film studies scholars, to be followed through the 1990s with a more concentrated focus by a smaller group of writers, giving way then through the 2000s to sustained interest from art historians and curators within the growing interdisciplinary field of visual culture. This brief sketch is borne out in the comprehensive bibliography of published works compiled by Katharina Sykora and published on the Ulrike Ottinger website and also in the recently published book by Sykora (2022). The website and archive will provide an invaluable point of reference throughout this volume since the artist has paid great attention to the aesthetic value of her own archival practice.

It is relevant here to comment on the origins of this collection. There was a need for a fuller academic response to the work of Ottinger in the English language. In 2009, Goldsmiths University of London (the Department of Media and Communications) collaborated with the National Film Theatre to support a retrospective of key Ottinger films for what, at the time, was called the Lesbian and Gay Film Festival. The following year some of us from Goldsmiths took part in a Goethe Institute programme of screenings. (The Goethe Institute in London has long championed the work of Ottinger.) A decade later, and during the pandemic, some more extended time on my part became available and this allowed me to embark on the work of assembling and editing this current collection. Ulrike Ottinger

herself pointed me in the direction of some key potential contributors. Others I knew to have been involved with the films and exhibitions over the years. There was a snowballing effect with some of the more senior figures suggesting the names of younger scholars to be brought on board. Ottinger's most recent film is *Paris Calligrammes* (2020) and several of the writers draw attention to this work. The artist is looking back at her time in Paris from 1962 to 1969. She does so with a breathtaking sweep of footage that is collaged and montaged together to form something like a cinematic autoethnography. The film incorporates some of the paintings, surrealist photo shoots and the engravings that she produced during these early years. And then from 1972 onwards, there is a more decisive shift to film. The articles included here do not attempt to encompass the expanse of the output, although, as it transpires, the first three contributors cast their scholarly eyes across many of the different pieces created by Ottinger.

There was another aim for this volume which was to celebrate the eightieth birthday of Ottinger (although inevitably there is a time lag between 2022, the year of her birthday and our publication date for 2024). She is a many times over award-winning artist and filmmaker whose work is unique in the postwar German canon. There is a rich and multidisciplinary interweaving of forms that include a cinema of visual anthropology often with films that are of several hours duration. These films depart from the documentary genre by interweaving techniques that include fictional elements, fables, characters and stories. The documentary form is destabilized and becomes a mere point for departure. In the earlier films, there is also an interplay with characters from fiction, such as Dorian Gray and Orlando, now made to inhabit new Ottingeresque imaginative worlds. As in their previous inceptions, these figures take flight from gender and in so doing they permit a uniquely queer cinema to emerge. In taking flight herself, and by announcing so many grand departures across the works, it seems that Ottinger is driven by a desire for travel, it is a libidinous effect. Even when it is almost local to her own country of origin, the same sense of delight in unknown geographies drives her interest. In the closing scenes of her Vienna film *Prater* (the famous park in Vienna with its historic fairground and discussed here by Mandy Merck), she shoots for the stars. In this modern-day *Riesenrad* attraction, visitors are tightly strapped into their space-capsule type seats before being hurtled outwards and upwards into the night sky, as if destined never to return. Ottinger, with her astonishing camerawork, takes her seat and joins the ride.

There is a world out there to be looked at, where the traveller will encounter other peoples and the objects which they gather around them. The challenge, in the context of the postcolonial critiques of the last decades, across the disciplines as well as throughout the art world, is marked. That expansive body of writing, where it applies to the films and art works under consideration here,

poses many questions which our contributors here face in a direct and thoughtful way. Ottinger, often invited or commissioned to make work in so many different countries, adopts the persona of the gentle but stubborn observer of things. She marries her anthropological eye with an avantgarde optic. The nature of her gaze, the relation established between her camera and an object or person, seems to occlude a proprietary relation, or any sense of a cold museum-oriented scholasticism. Ottinger's 'ethnographic imagination' figures here in the title of this volume, directing us to highly-charged debates in the fields of art theory, critical anthropology and cultural studies. But with some qualifications since, for example, Hal Foster's seminal essay 'The artist as ethnographer' addresses 'paradigms in advanced art on the left' (1995: 302). And from the start we might declare that Ottinger's is not an overtly (or even covertly) a leftist project. In the context of this book, our own imaginations are sparked by a stance that remains constant over the years, unswervingly so. Yet in adhering to an aesthetic auteur-led cinema, the work reveals itself as full of openings to specific political questions and dilemmas. And moreover from the elevated heights of what might seem like an even quaint bourgeois art positonning, richnesses are forthcoming.

Ottinger goes out into the field. But does she impute authenticity or originality to the other cultures she encounters (Foster, 1995)? What is intriguing is that there is something other than this going on. Ottinger's camera is never obtrusive, nor is it interrogatory. As a number of contributors to this volume show, the gaze is inevitably multi-mediated by, for example, institutional or geographical constraints. It is the dwelling upon the formal elements of objects and artefacts that is most striking. Ottinger is aware of her own visitor status on all her artist-expeditions. As viewers and spectators, we are also visitors to these imagined geographies. Does her being a polite and gracious guest in the house of foreign cultures in any way alter the colonial hierarchies still in place? For sure Ottinger never suggests that she is embarking on such a project. Perhaps she is nevertheless making a claim for modes of looking that permit fascination without domination.

And how are we positioned as Ottinger's guests, visitors to her shows and audiences for her films? We might be wandering around the grand-scale exhibition such as the *Floating Food* exhibition at the Haus der Kulturen der Welt in Berlin in 2013. We could also be part of the art crowds in Seoul, in Tokyo or in Odessa. Or we could be sitting watching the twelve hours of *Chamisso's Shadow* which was shot in the Bering Strait and is usually screened in three or four episodes. The question of the address in Ottinger's work is also as intriguing and as elusive as her ethnographic techniques. How is the viewer to position herself? There is always a warm invitation. The pieces themselves are invariably demanding. And though the early work has exuberant and light-hearted elements often traceable to (what was then) the gay underground, this is more muted from the 1990s onwards. At

the same time, the documentaries do not lead to sombre reportage. Yet neither are they playful. As Wieland Speck mentions in interview this leaves the viewer of the Ottinger work with 'a lot of freedom'.

Ottinger's feminist counterparts of the 1970s German cinema were largely concerned with family, motherhood, social reproduction and domestic labour. With joyful defiance, the first major cinematic journey Ottinger embarks on is one that takes her far away from this realm of the domestic; indeed the opening joke of the film *Madame X: An Absolute Ruler* (1976) is that a megaphone call is issued to women to abandon their family duties and follow the seductive world of adventure conjured by the extravagantly beautiful pirate queen. Maybe we can extend this metaphor with Ottinger issuing the invitation, over the years, as the artist whose promise is always some form of enchantment. There is a constant interest in the magical world of the fable or the fairy tale, as if she continues to leaf through her memories of the childhood classics of the 1940s and 1950s with their marvellous illustrations. This sits alongside the much more formally rigorous concerns she shows with cinema, with celluloid and its histories and traditions, and likewise with the disciplinary conventions of figurative painting and pop art in the late 1960s.

Where some might see something both naïve and problematic in Ottinger's foregrounding of her own self-enchantment with other worlds, the contributors to this volume explore this as a multifaceted positioning of the artist as auteur who is also delving into the history of past enchantments and fascinations, perhaps also into the orientalism of her forebearers. There she is, after all, (re)-enacting, in the long film titled *Chamisso's Shadow*, a famous German expedition undertaken by the botanist and writer Adelbert von Chamisso who set sail aboard the Russian ship *Rurik* in 1815. And as Thomas Love suggests in his article, the work of Ottinger could be seen in terms of what Mary-Louise Pratt calls the 'innocent anti-conquest' genre (Pratt, 1992). Yet Ottinger's work counsels against a reductionist response. She insists on the promise of a transcultural politics of mutuality, of exchange and an ethics of hospitality. She explores the possibility of intercultural mixing, and that we are all in a sense foreign to each other. Her father was an artist who, as a young man, spent time at sea working on board ships. In the course of his travels, he became familiar with African art and collected many pieces. Ottinger herself is soaked in the collector passions of figures like Walter Benjamin (who also remarked on travel as life sustaining). Her inheritances stretch from the German baroque to the Jewish (and Yiddish) traditions of popular song. Like Benjamin, she is drawn to allegory and to those modes of medieval representation that took the form of stations, which she then translates for a more contemporary cinematic idiom.

Ottinger was formed as an artist through her exposure to a multiplicity of cultural influences, from her father's collections and from the childhood fables she consumed, to surrealism and the Dada movement. She has also been drawn to the

history of classic cinema and to the work and writings of queer artists and film-makers. Was her own incipient queerness a factor which led her to envisage other worlds, other ways of living, other forms of kinship? Did she need this kind of fantasy material as a girl, in order to realize the idea of a career and a professional identity as an artist? Ottinger was born mid-way through the Second World War in the family home in Constance by the lakeside, to a Jewish mother with whom she was hidden from the Nazis in an attic thanks to the courageous role played by her paternal grandmother. Childhood memories have informed her identity as a woman and as an artist.

Part one: The wide expanse of work

The collection begins with three articles that mark the wide sweep of the Ottinger oeuvre. Patricia White brings back into the vista of feminist and queer film theory the idea of the author and the auteur and having written about Ottinger's films in the early 1980s, in this new context, she sees Ottinger taking on so many guises as dandy and conjurer, an artist who slips in and out of the many gender-fluid characters that are centre stage in her work. She is an artist with a strong interest in the history of German orientalism, with the motif of travel and with the mythologies and the 'dense node of perverse histories around the figure of the sailor' (19, this volume). The work is full of gigolos, pirates, loose women and sex workers. White acknowledges Ottinger's commitment to preserving and honouring the history of the gay underground. White also emphasizes the focus on marginalized people and bodies, from the earliest films including the erotica of *The Enchantment of the Blue Sailors* to the more recent shorts including *Still Moving* and *Aloha*. Katharina Sykora provides, in her essay, a consideration of the fluid shifting even restless movements between film and photography in Ottinger's work, and alongside this the use of objects and artefacts which play such an enduring role across the decades of her artistic production. By drawing attention to the power of objects to impose and reinforce specific cultural meanings, such that gender is a mere surface phenomenon, that is, the moustache, the extravagant eyeliner, the fedora hat, Sykora also foregrounds the contingency that underpins the process of gender ascription. She also presents an important account of the multiple framing processes that accompany so much of the Ottinger oeuvre, the 'play within a play' effect in *Dorian Gray in the Mirror of the Yellow Press* from 1984. Sykora pursues the motifs of temporality and the role of the artefact through a range of other works by Ottinger from the *Twelve Chairs* (based on an original fiction by two Russian writers Ilya Ilf and Yevgeny Petrov from the 1920s) through to the fabulist film documentaries such as *Under Snow* and *The Korean Wedding Chest*.

Gertrud Koch introduces the question of wit and humour in Ottinger's work tracing a line of connections and reflecting on the anthropology of the smile in so many of cross-cultural exchanges which figure in the films. Koch sees this as a desire to invert the colonial hierarchies. In Ottinger's interest in costumery and masquerade and in the 'baroque excess of ornamental costume', there is also humour similar to the Italian tradition of *commedia dell'arte,* with the idea of inverting, as in the carnivalesque, status and hierarchy through the 'interplay of masks'. Koch draws attention to the rites and ceremonies with the comical again surfacing through Ottinger's attraction to the grotesque 'as the uncanny side of the comical' (51, this volume). There is also Ottinger's use of 'lightness as an aesthetic category' which 'becomes a form in the musical comedies and in dance, in burlesque shows and pop' (51, this volume).

Part two: The cities

In the chapter by Angela McRobbie, the focus is on the first of the so-called Berlin trilogy, *Bildnis einer Trinkerin* (*Ticket of No Return*) of 1979. The author counters the early feminist (and somewhat moralistic) responses to the film which loudly railed against the attention given to the urban wanderings of a young woman fashionably dressed and determined to drink her way through the grey semi-derelict landscape of 1970s West Berlin. McRobbie argues that the film and its tensions mark the highly charged collaboration between the fashion designer, musician, model and actor Tabea Blumenschein, and the director Ottinger. By incorporating the signature styles of punk while also transposing onto the fashion items and costumes a fully painterly effect Blumenschein and Ottinger together make a claim to the city as a space of belonging, a city open to many types of deviance. The element of subculture disrupts a more contained aesthetic impulse bringing into vision fleeting glimpses of working-class West Berlin. McRobbie makes the case for a return to the idea of auteurship in feminist media and cultural studies scholarship, this time refracted through recognition of the idea of collaboration between director, leading actor and cast. This points to a more contemporary role for the ensemble. This chapter, with a sociological emphasis on the contribution of fashion and costume to Ottinger's oeuvre, also suggests renewed attention be paid to cultural production in both film and art practice.

The film that Esther Leslie discusses is *Usinimage*, made in 1987, and in effect the last but one of the Berlin works (*Countdown* was made a couple of years later documenting the fall of the Wall). Leslie ruminates on the image of West Berlin as envisaged by Ottinger as a space of everyday life with its shabby bars and small shops, with the bridges and the power stations and gasometers, a grey-toned

post-industrial city. Unlike other European cities of that time with their brightly lit shopping malls and tourist attractions, this remained a city of seemingly randomly sited coal mountains and slagheaps. Of course, until 1989 the city's other half was fully part of the GDR and so officially anticapitalist. Leslie picks up this theme in Ottinger, that she depicts the city not from the viewpoint of consumer culture, or of well-known landmarks but rather and in line with her earlier Berlin-based film *Freak Orlando*, from the viewpoint of a kind of subcultural underground, a space where social outsiders and marginalized people were able to gather in what were more or less undesignated or under-used zones of the city. Leslie tracks the keen interest Ottinger showed in these spaces including the bleak landscapes on the city edges. In *Freak Orlando*, there are the beautiful overgrown and always welcoming cemeteries, but also the site of the Nazi Olympics in 1936, stark and desolate, as if this must rightly be a condition for its continued existence. Leslie is aware of the most recent romancing of the city for its government-approved bohemian image. She looks back to the 1980s when it remained an urban environment where it might be possible to glimpse ideas of a 'non-fascist future'.

Mandy Merck adopts the idea of the carousel to develop her analysis of Ottinger's 2007 film about the Prater park in Vienna and its historic attractions. Dating back to 1766 and later becoming one of the world's oldest and most famous amusement parks, Merck shows the richness of the influences and histories which Ottinger brings to bear in her film, many of which refer to the birth of film itself. The novelty of film found new audiences in the Prater from 1895 onwards with various forms of the Kinetoscopes showing in what were referred to as viewing parlours. These would be sat alongside the various 'curiosities' which also included an Ashanti village with some of the inhabitants also on display for the visitors with their imperial gazes to look at. As Merck points out, the Prater fairground occupied a centre-stage position as if to advertise the advanced state of empire and industrialization in Vienna at the time. Ottinger's film *Prater* traces the idea of attractions, curiosities, especially in the form of the objects and artefacts and peoples from the colonized lands, as Merck suggests, marking Vienna as a place 'to which racialized spectacle – and racialized subjects – are imported for exhibition' (91, this volume). Key to Merck's analysis is the spectre of the racialized narratives of dangerous or primitive black masculinity as a key trope of colonial domination, cast up for popular entertainment, and providing the core ingredients for genres that were to remain in place to the present day.

Part three: China, Mongolia, Japan, Korea

In 1985 and prior to her major feature film *Johanna d'Arc of Mongolia* of 1987, Ottinger and her team travelled to China for a trip of several months which

produced among other works a 4.5 hour long documentary titled *China. Die Künste – Der Alltag* for German TV. Cassandra Xin Guan makes the case that the film be seen from a viewpoint which transcends the more polarized stances which have emerged by the writers who have either rebuked the director for her 'imperialist nostalgia' or who otherwise flag the film for interrupting the conventions which typically accompany and underpin the idea of the documentary. This latter perspective allows the film to be seen as challenging any sense of there being a 'real' Orient. Neither is sufficient, neither pays anything like enough attention to the actual existing geography, or to the prevailing political economy. Guan argues that Ottinger develops a kind of 'view within a view' so that the 'ethnographic subject' emerges as, at the very least, the object of a multi-mediated filmic practice. Commenting on the conditions the team were subjected to in the course of making this 'avant garde documentary', Guan suggests 'they became the pioneering representative of a transnational flow of material and symbolic values that would revolutionize the social relations of rural China' (111, this volume). Most important to Guan's analysis is this foregrounding of the political economy that made its presence so felt in the shaping of the cultural field that Ottinger was then able to render into a documentary form.

Erica Carter and Hyojin Yoon focus on the feature film *Johanna d'Arc of Mongolia* (1989), with Delphine Seyrig at the centre of what is a multi-genre and 'gloriously labyrinthine' piece of work which traces the history of cinema and the movies through the prism of the 'densely ornamental' railway carriage as a group of European ladies embark on a trip that takes them through Central Eastern Europe and Russia and to the steppes of Inner Mongolia and the Gobi Desert. Their trip is interrupted by a band of Mongolian female warriors, led by the beautiful Princess Xu Re Huar and the European women are taken hostage. This adventure gives rise to sequences of intercultural eroticism. Carter and Yoon understand the film in terms of its offering a philosophical rumination on the cinematic imagination and its relation to reality, as well as on the way in which a dense historical essay on multi-culture and on the 'diasporic affiliations' of geographical space can be conjured through single images, gestures, songs and decor. Key to their argument is that there is indeed a timeliness to the film, grasped not through direct socio-political themes, but through the dense aestheticism, through the sound of 'tinkling teacups' that evoke not just the epochal struggles and the ruptural history of these regions but also the new encounters emerging from changes in the landscapes and psychic geographies of *Mitteleuropa* in the momentous year of 1989.

Ottinger returned to China in 1997, this time to explore the background to the experiences of the Jewish community who had settled in Shanghai. These families had either arrived at the turn of the century or they had fled from Europe

in 1933. Describing this as a film of remembrance, Tim Bergfelder provides an analysis of *Exil Shanghai* (also 4.5 hours long) which emphasizes that the film is primarily about the experience of exile. Ottinger's technique again departs from the convention of documentary film by interspersing the interviews she carries out, with footage from modern-day China. Most of the interviewees moved to California after the war and Ottinger films them in their homes, often surrounded by mementoes and objects from their time in Shanghai. One aspect of the uniqueness of the film and its intense aesthetic effect lies, as Bergfelder argues, in the carefully selected soundtrack, much of which is drawn from Jewish and Yiddish songs, and from German and Austrian *Schlager* pop. There are also mournful songs from the Chinese singer Zhou Xuan, a star from 1930s Chinese cinema.

Laurence A. Rickels is an American scholar and psycho-analyst who has written extensively about Ottinger's art and films over many years. Here he focuses on the film *The Korean Wedding Chest*. Commissioned to make the work in 2011, the film was made in Seoul and it uses, as a kind of entrance point to an extended reflection on marriage culture in Korea, a fiction and a fable (and foundational myth). Within the film text wedding rituals and the place of the 'knot' in the Korean celebration of marriage are prominent. A scholar of Freud and the Freudian tradition, Rickels considers this idea of knots that 'are not' to reflect on the transcultural image of knotting, weaving, binding and unbinding. Weaving figures in Freud's writing (female sexuality, the dream work, Penelope and mourning) and in his life, (bringing into focus his daughter Anna at the loom in their London home and study), leads Rickels to questions of reproduction and inheritance. Rickels is drawn to Melanie Klein in this respect for whom mourning is basic to the psychic reality of desire, and what the parental figures, or couple, bequeath downwards as 'inheritance'. These themes are central to *The Wedding Chest*. Ottinger also makes a specific argument about art in everyday life, in the clothes, the fabrics, the textures, the linens and the world of decoration which, as Rickels notes, is extended in her later film set in the remote Echigo region of Japan and titled *Under Snow*.

Part four: Shadows of the past – Hoards and collections

Dominic Paterson traces Ottinger's hybrid photographic genres and object-led art pieces through the idea of their transmissibility, and through the notion of the collection, or rather the collector's passion for objects, a kind of hoarding. The transmissibility refers to the sliding process that takes place between still and moving image, where each is both secured and untethered by the other. The memorability of the images and set pieces seems to emerge from this very uncertainty

or ambivalence about where they belong. Paterson also sees the artist at work where, as a starting point, there are the story books, notebooks, drawings and other preliminary and preparatory work which are often made available for audiences to see as a practice of 'exhibition making'. However, these installation pieces are not just there to demonstrate artistry as a process, but to signal the multiplicity of forms which constitute the work as such. Paterson, who himself played a co-curatorial role in Ottinger's *Still Moving* exhibition at The Hunterian Gallery in Glasgow University, also makes the important point that these various genres avoid the 'purity and fixity' of modernism. Rather they are full of cut n' mix techniques, retrieving various forms which can then be 'enervated'. This interplay of past and present is most vivid in the idea of 'station cinema'. Paterson makes the link here with Walter Benjamin.

Nora M. Alter writes here about the twelve hour long epic travel piece of 2016 *Chamisso's Shadow*, and her essay proposes that we consider this work as very much about the porous relations that connect humans with the animal world and with nature and environment. But the film also foregrounds 'spiritual life' and the 'lure of the sea'. Alter describes the long slow whale-hunting scenes with which the film opens, shocking as they are, and powerful in the context of questions about ecology and species extinction. The framing devices from the expedition of Adelbert von Chamisso, (and prior to his travels as a botanist, the remarkable novel about the man who sells his shadow and who is then destined to explore the world lonely in his giants' boots, a marvellous children's classic), provide Ottinger with exactly the kind of narrative that can be re-purposed as she herself sets sail. In what is one of her most extraordinary productions to date, this film piece ruminates, as Alter shows, on conservation, extinction, on the ruins of communities in this area of the North West Passage or the Bering Strait and on the peoples of these regions, who are Inuit, or Russian or for that matter American. The long duration of the scenes including the interviews show Ottinger to be indeed a sensitive ethnographer. One older woman who is fishing, it transpires, was the former paediatrician for the region before retiring. Communities are being erased and as Alter shows, Ottinger creates bridges in time and in art. The Romantic German tradition stretches here to the contemporary need to transcend boundaries of human and non-human and plant life for the sake of the world. There is for sure a much longer discussion to be had about *Chamisso's Shadow* to do full justice to its project and even the practicalities of its undertaking. Hopefully for the English-speaking world this can happen in the not too distance future.

Thomas Love also considers this piece of work. As he comments 'the film seems less a document of contemporary Beringia than a reflection on the continuities and discontinuities between the contemporary and its (pre)colonial past' (205, this

volume). Love's contribution is to look at this film through Mary-Louise Pratt's notion of anticonquest, a way of narrating colonial exploration through descriptions of the natural landscape that although seemingly benign nevertheless abetted the colonial project of domination. The literature of anticonquest is characterized by an implication that the natural world acts of its own accord. This kind of lexicon runs through the works which Ottinger drew on for the film and appear to be complemented in turn with her own images of picturesque emptiness. But as Love points out, there are also important moments where it becomes clear that her work also departs from and refuses these conventions. There is no sense of narrative and there is no grand pretence of objectivity, no claim to authority. The film lays bare the terrain, as if to re-open the debate, and then opts to move to a conclusion by way of another fable, something akin to a local legend which winds its way from the imagined past to the present day. The fairy tale uses anachronism, as Love argues, to displace any idea of authenticity. And as a telling conclusion to his article, Love suggests that what appears to be an empty landscape is in fact a location teeming with its own history.

Part five: Comment and interviews

Adrian Rifkin remembers his first encounters with Ottinger's work following a student's enthusiasm. In this self-reflexive short piece, Rifkin draws attention to the processes of seeing the Ottinger works, including the various technologies of viewing, the demands of long slow takes, and what we do when we watch in a distracted manner, how significant and rewarding can such modes of reception be? Rifkin applauds the queer subjectivities in Ottinger's work, their constraint, and he asks 'Why should we know ourselves?'

Angela McRobbie interviews Yeran Kim, a Korean professor of Media and Cultural Studies. Kim looks freshly with a feminist lens at *The Wedding Chest* and provides a non-western and more sociological reply with reference to the new generation of young women refusing marriage as an act of resistance. It is as if Ottinger with all her queering gaze and close attention given to the patriarchal rituals captures simultaneously a glimmer of discontent and a sense of the changes to come.

Julia Meyer-Brehm interviews two women who have each played some role in the social and professional world of Ottinger in Berlin over the decades. Designer Claudia Skoda provides a cartography of the night-life clubs and bars, and her own fashion practice and studio work. Novelist and playwright Heidi von Plato describes the intellectual culture, the shared interest in the fables of pre-modernity and the intense sociality of the Ottinger circle.

Thomas Love interviews costume designer Gisela Storch-Pestalozza who describes her professional working life in Munich and Berlin and working with Werner Herzog before joining Ottinger including the Mongolia trip. Thomas Love also interviews the actor and film director Wieland Speck who has worked with and known Ottinger for many years. This interview marks a timely end point for the book for reasons of Speck's wide panorama and his warm observations on Ottinger's uniqueness in the art world for the duration of half a century.

REFERENCES

Foster, Hal (1995), 'The artist as ethnographer?' in G. E. Marcus and F. R. Myers (eds), *The Traffic in Culture: Refiguring Art and Anthropology*, Berkeley: University of California Press, pp. 302–09.

Pratt, Mary-Louise (1992), *Imperial Eyes: Travel Writing and Transculturation*, New York: Routledge.

Sykora, Katherina (2022), *Zwischen Welten: Ulrike Ottingers Filme im Spiegel der transatlantische Kritik*, Munich: Wallstein Verlag.

PART ONE

THE WIDE EXPANSE OF WORK

1

Ulrike Ottinger in the Mirror of Her Movies

Patricia White

This volume honours the remarkable 50-plus year career of German filmmaker, artist and photographer Ulrike Ottinger. Other notable commemorations include the German-language volume *Zwischen Welten* by Ottinger's partner, the art historian Katharina Sykora (2022), on the occasion of the filmmaker's eightieth birthday; the awarding of the Berlinale Camera in 2020; and important exhibitions at BAMPFA (Berkeley Art Museum and Pacific Film Archive), Haus der Kulturen der Welt and elsewhere. As Ottinger makes the rounds to pick up her honours, images of the filmmaker in her customary bespoke three-piece suits perform gentlemanly anachronism and spread delight. The author as dandy: Ottinger's female impersonation of figures like Oscar Wilde, George Méliès and Tristan Tzara marshals the resources of self-production against the banal everyday. The dandy signifies in Ottinger's work as both historical reference and authorial cipher. Even as the recipient of this Festschrift, Ottinger simultaneously acts as our host, a conjurer who astounds, a connoisseur who challenges.

As the awards and tributes pay deserved and delayed attention to Ottinger's person, this chapter directs our attention to Ottinger's persona. Reading the director as a text, a construction of the films themselves and their reception, as well as of interviews, images, commentary and publicity, need not defer to intention or autobiography, privilege the unity of the oeuvre or consecrate the authority of the artist. Instead, it can illuminate how discourses of gender and sexuality, generation and nation, medium and cultural value impact the figure and the power of the author. Authorship is a default discourse for approaching art cinema, and a political strategy for underrepresented groups. And since the emergence of feminist film culture in the 1970s, Ulrike Ottinger and her singular style have introduced productive discord into arguments about female authorship.

The uniqueness of Ottinger's vision is not disputed; she is a true auteur: writing, directing, designing and shooting films that spring from her distinctive imagination. However, summarizing what that vision encompasses has proved to be a challenge. She is reflexively positioned in most commentaries as a woman director who participated in the New German Cinema movement. Across the longevity of her career, she has complicated both those assignments and their intersection. She is a queer woman director whose mother was Jewish, illuminating dissident strains and projects within New German Cinema. Her abiding interest in other cultures is inscribed in histories of empire and apostasies of gender. Coverage of her films and retrospectives frequently points to Ottinger's lack of fit within traditional groupings of female, German or documentary filmmakers.

As most commentators note, Ottinger's filmography encompasses feature films of extravagant theatricality – *Madame X: An Absolute Ruler* (1978), *Ticket of No Return/Portrait of a Drinker* (1979), *Freak Orlando* (1981), *Dorian Gray in the Mirror of the Yellow Press* (1984), *Johanna d'Arc of Mongolia* (1989) – and documentaries, many shot in Asia, of extravagant length. The first of the latter category, *China-the Arts-Everyday Life* (1990), runs more than four hours. Her 2016 release, *Chamissos Schatten* (*Chamisso's Shadow*), retracing the 1815 voyage of poet and botanist Adelbert von Chamisso to the Bering Straits, runs twelve. Ottinger's fictional works have been touchstones of Anglophone and German feminist film studies – the documentaries, with their relative lack of explicit attention to gender and sexuality, not so much. Her works are consistently composed of images of often startling beauty and precision – Ottinger is her own cameraperson and exhibits her photography widely – but the two strains are often held apart, presenting a puzzle of where to place her work: in feminist film genealogies, as part of *Autorenkino*, in ethnographic traditions, in the queer avant-garde?

In her 2009 review welcoming Laurence Rickels's rich and idiosyncratic critical monograph, *Ulrike Ottinger: The Autobiography of Art Cinema*, Angela McRobbie expressed regret that Ottinger's more recent work had not otherwise been given due attention and exposure outside Germany. At that time, McRobbie objected to a 'relentless disparaging of the seriousness, tenacity and "high-mindedness" with which a filmmaker like Ottinger pursues her erudite obsessions' (2009: 260). The current volume goes far towards remedying that neglect. At best, Ottinger's relative reluctance to foreground gender and sexuality meant her more recent work was overlooked by feminist critics, and the fact that she works in German rather than English helped excuse the oversight. At worst, her gaze was dismissed as imperialist or objectifying, her German 'high-mindedness' seen as out of touch or out of date. But, as Rickels quotes Ottinger, 'In my images nothing is hidden away; if you look long enough you can read everything' (Rickels, 2008: 19).

It is no feat of interpretation to call Ottinger an orientalist. In fact, she draws upon orientalism as a field of study, one that was an important part of Germany's rise to academic prominence in the nineteenth century. In a recent reconsideration of the legacy of the discipline of orientalism, Suzanne Marchand claims that rather than simply enacting western hegemony, 'German orientalism helped to *destroy* western self-satisfaction, and to provoke a momentous change in the culture of the West: the relinquishing of Christianity and classical antiquity as universal norms' (2001: 465). Marchand speaks primarily of the turn in nineteenth-century philology from Greek and Latin to Sanskrit, but German orientalism also leaves its legacy in the figures of the collector, the ethnographer and the erudite traveller that Ottinger emulates. A recent exhibition refers to her as a 'collector of worlds' (*Paris Calligrammes*, 2019). In Brigitte Kramer's 2012 documentary *Ulrike Ottinger: Die Nomadin vom See*, the filmmaker recounts avidly reading books about expeditions and exploration as a child.[1] Of decisive significance was her introduction, through her father, to the painter Fritz Mühlenweg, who drew upon his travels to Mongolia in his popular adventure books. The learned Lady Windermere, an anthropologist who travels in a well-appointed compartment in the luxury Trans-Siberian railway, is a link between such gentlemen and Ottinger's own self-styling. Ottinger fully embraces the mythology of travel, making ethnographic and performance-based work in Mongolia (*Taiga*, 1991/2), Shanghai (*Exil Shanghai*, 1997), Korea (*Korean Wedding Chest*, 2008) and Japan (*Under Snow*, 2011), among other places, and bringing works together in her eclectic exhibitions. Ottinger does not disavow her place of imperial privilege; in her idiosyncratic way she calls forth its history, claiming as a woman a place in intellectual pursuits and attendant sartorial and sensual affinities – dandy and epicure – historically reserved for men.

Accounting for Ottinger as an auteur thus stages an encounter between seemingly incompatible modes: artifice and authenticity; performativity and ethnography; decadence and tradition. Doubtless both Ottingers, the inventive master of ceremonies and the indefatigable, nomadic observer, have a place in assessments of the artist's contributions. Astute critics have recognized this heterogeneity, with its troubles and tensions, as Ottinger's veritable creative engine, and recent retrospectives and exhibitions will spur further work in this vein (for astute deconstructions of this apparent opposition, in addition to Rickels, see King, 2007; Galt, 2011). Here I argue that Ottinger herself stages these contradictions through forms of self-inscription in her films. Among the most delightful performative flourishes are her cameo appearances in her early fictional works. Although she is often unseen and unheard in her ethnographic works, her perspective as cinematographer is arguably imprinted on every frame. We might think we've finally reached transparency in the voice-over narration of the autobiographical *Paris Calligrammes*

(2020), but, as I will argue by bringing that film into conversation with short, commissioned films that draw upon the filmmaker's personal materials, the author we get is always suited to the occasion.

The author as cameo

The author myth is given a feminist tweak right out of the gate in Ottinger's filmmaking career. Her early films were collaborations with Tabea Blumenschein: one of the first images in the title sequence of *Laokoon and Sons*, made in 1972–73 after Ottinger's return to Constance from her early stint as a painter in Paris, is a hand-drawn, decorated and labelled self-portrait of Ottinger with Blumenschein, her partner and collaborator in the 1970s. The film is in black-and-white, giving the image the quality of a drawing in a notebook rather than a film frame, subtly introducing a theme of transformation central to the film and to Ottinger's career. The two women are posed side by side – Ottinger on the left – under a crude proscenium. For those familiar with Blumenschein's flamboyantly feminine persona in later films like *Bildnis einer Trinkerin* and *Dorian Gray* – a quality that in the opening moments of this film will be called her character's 'blonde magic' – it is interesting to see that in this pairing Ottinger's is the femmier gender presentation: her hair is long and curly, while the drawing of Blumenschein features slicked-back short hair, a cigarette and elegant masculine drag. A disembodied female voice on the soundtrack that has been setting up this film's self-reflexivity – for example, speaking in the first person: 'Ich bin ein Bild' ('I am an image') over the first images – here introduces the voices that will recount the story. The English translation, 'they are women's voices', appears under the dual portrait. Feminist collectivity and occult meaning are launched with the same performative act. Ottinger remains a voice behind the film's vision, which introduces many recognizable motifs, from characters called Orlando to circus processions, while appearing as an extra in the film. Blumenschein, meantime, plays Esmeralda de Rio, whom the narration reminds us, 'is the protagonist of this story', undergoing a shape-shifting range of roles of multiple genders that complicates emerging feminist critiques of female objectification as negating female subjectivity. *Laokoon* was inspired in part by a recurring nightmare that conflated Ottinger's experiences of the brutal crackdown on the student strikes of May 1968 in Paris with hiding with her mother from the Nazis in early childhood (Rickels, 2008: 18). Yet, we are told, the film takes place in a land populated only by women (from visual evidence, this includes transwomen). The aggressors are played by women in black boots wielding clubs, a bold contrast to sanitized versions of lesbian feminist art practice in the early 1970s as gentle and affirmative. Ottinger and Blumenschein were in dialogue with

contemporary lesbian culture to be sure: in a photograph in Kramer's film, the two appear in a book-filled room, Blumenschein without make-up, holding a volume entitled *Lesbian Art and Artists*.

In another image of joint authorship, the couple appears in a photograph under a poster for their second film together, *The Enchantment of the Blue Sailors* (1975), which situates them at the overlap of feminist and queer underground film cultures of the period. Early in this 50-minute, 16 mm colour short, two handsome sailors kiss in front of a painted backdrop, the rush of waves on the soundtrack. One sailor uses binoculars to look offscreen and appears to be struck down by the sight (through a mismatched point of view sequence) of a 'Hawaiimädchen', played by a blonde Blumenschein in a tacky mess of floozy accessories. His lover (Rosa von Praunheim) next encounters Frank Ripploh in a skimpy toga, among other strange figures, before gazing through the binoculars and himself succumbing to the vision. Von Praunheim and Ripploh would soon be internationally recognized as queer German filmmakers.

Meanwhile, Blumenschein again appears in several avatars: a regal siren travelling in the desert, a doomed bird and ultimately as a sailor herself. We first see her in the sailor kit in medium shot in a fade-in from black, looking straight back at us through binoculars. Blumenschein's masculine personae are featured in numerous photographs by Ottinger as well as in short sequences in films including *Laokoon*, *Madame X* and *Ticket of No Return*. She appears as a gigolo, a pirate, a minotaur, but nowhere does she wield the conventionally male privileges of gaze, action and desire with more aplomb than in the astonishing final sequence of this film.

Lured to a bordello by two transgender sex workers, Blumenschein's sailor first negotiates, in pantomime, a price with the Madame, a transwoman posed in the shop window. Next, a shot taken from behind through the sailor's legs reveals a naked woman in a cheesy 'Hawaiian' mise-en-scène. A shape bobbing at the top of the frame is revealed in the next shot as a long silver dildo. The sailor enters the room and the two vigorously simulate multiple sex acts, while exaggerated, postsynchronized sounds of laughter distance and discomfit. *The Enchantment of the Blue Sailors* may be the long-neglected link between Barbara Hammer's mid-1970s lesbian frolics and the queer shenanigans of New German Cinema auteurs Werner Schroeter and R. W. Fassbinder (with whom Ottinger shared certain actors and crew). It certainly adds to the dense node of perverse histories around the figure of the sailor that Fassbinder exploits in his last film, the Jean Genet adaptation *Querelle* (1982). *The Blue Sailors*, like many of Ottinger's works, ends with new beginnings; the final image is another unforgettable dual portrait of the filmmakers. Introduced odalisque style, wearing a gown and echoing the posture of a magical mermaid in a Méliès film, Ottinger receives the sailor with languid caresses. On this touching tableau the strange film

ends; among other performative gestures the pose 'claims' and affirms the preceding scene of lesbian sex.

Ottinger's authorial appearances in these early 16 mm films contextualize a moment of reciprocity in the more widely circulating *Madame X* that I found enormously consequential as a very young scholar writing about that film. In the last of the films the pair made in Constance, Ottinger appears briefly, again in mythical costume and orientalist make-up, here reading a book whose cover is prominently displayed: *Orlando* by Virginia Woolf. The filmmaker's character is introduced as the lost love of Madame X's life, also called Orlando. The narration proceeds to recount the beloved's death by lethal jellyfish, a primal scene that sparked the pirate captain's legendary cruelty. The signifier 'Orlando', already at work in *Laokoon and Sons* and later appearing in the title *Freak Orlando*, is transferred from the character and the book to name the pirate ship itself, whose crew is resurrected in the film's final scene to set sail again – another homage to the transformations undergone by the protagonist of Woolf's 1928 novel, her tribute to Vita Sackville-West. Across the three films, Ottinger's artistic collaboration and romantic and sexual relationship with Blumenschein are foregrounded, creating a mythology that invokes the male artist-female muse trope, while complicating its active-passive division of labour by suggesting the significance of Blumenschein's artistic contribution.

Chronologically, Ottinger's next cameo sees her walking into the episodic structure of *Ticket of No Return*, reading aloud from a mysterious book that is then passed among bystanders in Dadaist fashion. Like the physical copy of *Orlando*, the very presence of a book signals 'author'; this one resembles the large volumes Ottinger puts together when prepping a film. Of course, there are an array of characters that function as stand-ins, from the little person who acts as master of ceremonies in *Ticket* to Delphine Seyrig as Frau Doktor Mabuse (the yellow-press magnate who ensnares Dorian) and Lady Windermere. The talismanic book in *Ticket* anchors Ottinger's deliberate performance of authorship as threaded through and around her works, which combines the expressive tradition of German Romanticism and the trickster personae of the Dada artists whom she admired.

The author as collector

We learn about Ottinger's interest in the figure of the artist in *Paris Calligrammes* (2020), a chronicle of the influences and impressions Ottinger received as a young painter in Paris in the years leading up to the events of May 1968. The film is a rich invocation of the period, carrying all the weight of Ottinger's decision to make

an autobiographical film at this stage of her long career. But the film is also a very deliberate telling, retrospective and redacted, which refuses extensive biographical access. Instead, *Paris Calligrammes* is a portrait of a city at a moment in time: a title card tells us it is an homage to Paris as Wunderkammer. The Wunderkammer (cabinet of curiosities, literally 'wonder room'), the technique of displaying collections of marvellous and exotic objects that arose during the Renaissance, is a favourite conceit of the filmmaker and a useful way of approaching her practices of collecting, collage and display. Here Ottinger, who narrates the film's German version, is our host, and only more obliquely our subject.

The film opens with rich stories of the expatriate community centred around Franz Picard, whose German-language bookstore gives the film its title ('caligramme' was derived from a work by Apollinnaire). Ottinger pages through the guest book signed by the interwar luminaries who frequented the bookstore: Tristan Tzara, Joan Miró, the poet and Berlin Dada figure Walter Mehring. Subsequent chapters of the documentary recount the impact of the Algerian war and the anti-imperial activism of her friends, and introduce significant influences on the young artist, almost all of them male. Jean Genet's production of *The Screens*, the lectures of Claude Lévi-Strauss and the films of Jean Rouch are intertwined with Ottinger's tale of how she develops the skills and conceptual frame for her own confident contributions to Narrative Figuration, a French painting style developing in dialogue with Pop Art. Throughout the film, Ottinger, her camera and her editing of archival footage take up the position of *flaneur*, that figure of urban enchantment theorized by Walter Benjamin in his reflections on Paris as the capital of the nineteenth century (Benjamin, 1982): a wanderer and a witness, also implicitly male, as feminist commentators have explored (cf. Friedberg, 1993).

In his astute review of the film, Michael Sicinski (2020) argues persuasively that *Paris Calligrammes* bridges the apparent contradiction between the filmmaker's fictional works and her documentaries through its stress on the key role of surrealist principles of disruption. 'Part of the intellectual inheritance from the Surrealists was the sense of continuity between the aesthetic and the anthropological study of non-Western cultures', Sicinski (2020: n.pag.) explains, suggesting that surrealist primitivism underpins some of the filmmaker's more outrageous acts of cultural appropriation. *Paris Calligrammes* recounts how the architecture and collections memorializing France's colonial pillaging affected Ottinger's personal image bank. Tracing the frieze depicting the colonies' homage to the capital on the façade of the Palais de la Porte Dorée, now the National Museum of the History of Immigration, the camera betrays the fascination with ethnographic kitsch that Ottinger's voice-over deconstructs. Subtitled a 'landscape of memory', the exhibition accompanying the release of *Paris Calligrammes* at Berlin's own Haus der

Kulturen der Welt registers the felt forces of decolonization, Maoist sloganeering, anthropological inquiry and art-making that swirled around the young painter.[2]

Yet Sicisnki doesn't trace the link between racial/cultural difference and sexuality and desire in Ottinger's work to Dada and surrealism, perhaps because of *Paris Calligrammes*' own reticence about such matters. The film is about the origins of the *Künstlerin* – without dwelling on gender. Yet the gender rebellion that is missing in the narration is tantalizingly suggested in the visual evidence of Ottinger's self-fashioning in her early 20s. Black-and-white images used in the film, and to promote contemporary exhibitions of her paintings and objects from the period, feature the androgynous director with close-cropped, curly, dark hair, interacting with her artwork: she stands in front of a painting of Allen Ginsberg (dressed incongruously as Uncle Sam) wearing a dark turtleneck and round sunglasses, with her deadpan face encircled by the painting's speech bubble. Ottinger wears a bowler hat and stands behind a dressmaker's dummy painted with pop motifs (reminiscent of Sophie Taeuber's 'Dada Head' from 1920).[3] With the photos as evidence, one can infer that one of the faces in the narrative painting showcased in the film – a riotously coloured, Warhol-style grid of pop images – is her own. A section of *Paris Calligrammes* on the Cinémathqèue Française, which played a key role in the events and mythologies of 1968, opens on a black-and-white photo of young Ottinger posed in front of a poster of the Marx brothers as if she were the fourth sibling. Arms folded, her image gazes out through round glasses, prompting speculation about what her shtick in the act might look like (Figure 1.1).

Compared to *Paris Calligrammes*' footage of women wearing miniskirts, and even the striking chanteuse Barbara, who is profiled with a hint of fannish obsession, Ottinger's presentation is notably gender nonconforming. Queerness is thus inscribed but not referenced, leaving the viewer to calculate the working of desire in the film's equation of art, history, memory and cultural encounter. McRobbie, in speaking of 'Ottinger's erudite obsessions', implies that it is the collision of modes, of collecting and erotics, of desire bound up with cultural othering, that many find disconcerting in the filmmaker's work. It is precisely this nexus that is explored in the two recent short films with which I conclude.

Still Moving (2009, 29 min.) and *Aloha* (2016, 25 min.), commissioned shorts Ottinger made in the 2010s, attest to her career-long engagement with fantasies of cultural difference from a queer perspective. Although they are not overtly autobiographical, and the artist neither appears in nor narrates them, the shorts complement the memory work of *Paris Calligrammes*.[4] Interestingly, both films are tributes to legendary male filmmakers and thus reference canon formation, and indirectly, her own place in film histories and hierarchies. *Still Moving* was commissioned by Arsenal Institute for Film and Videokunst as part of a five-day Berlin event, co-organized by Susanne Sachsse, Stefanie Schulte Strathaus and

FIGURE 1.1: Ulrike Ottinger (in front of Marx Brothers poster) in Paris, 1965, *Paris Calligrammes*, 2019. Photograph by Ulrike Ottinger. © Ulrike Ottinger.

Marc Siegel, devoted to the legacy of queer American underground filmmaker Jack Smith. *Aloha* was produced for a Munich exhibition on canonical German filmmaker Friedrich Wilhelm Murnau. While Smith's queerness is at the root of his cult status, directly influencing Warhol and underground film more generally, Murnau, a key figure in Weimar-era German and 1920s Hollywood, was discreet in his sexual dissidence. Both collage films, the shorts recycle Ottinger's own photos and film footage, drawing heavily on the collaborative work with Blumenschein from the 1970s. The films thus return to the queer Ottinger of artifice and irony, the one who stays home, after decades of travelogue and documentary work. But if, as late works, they counterbalance her early shorts, they also reference the long middle of the filmmaker's career, raising pointed questions about the cultural imaginary the documentaries engage. Here the author appears as collector, putting the orientalist and primitivist legacies of the two films' honourees overtly on display. In this context, Ottinger's self-quotation is vulnerable and self-protective, provocative and seemingly oblivious.

Still Moving was released the same year as *Chamisso's Shadow*; instead of travelling halfway around the world, Ottinger opened her closet. A note at the

end of the 29-minute film tells us it is composed of anthropological artefacts from her father's Africanist collection and the contents of the director's own cabinet of wonders.[5] The individual objects' provenance is not listed, and they are brought together without regard to context or conventional estimation of value. The audience must wonder what we are looking at and hearing, even as we respond with wonder to the things we see and hear. The collections encompass carved wooden figures and masks, ornaments and fabrics, all juxtaposed with eclectic recordings, many featured in the sound montage of her early films. Exotica records by Yma Sumac, Yiddish folk classics and ethnographic recordings accompany animation of the African figures that gives them the appearance of possession. Excerpts from a German-language play produced in Japanese theatrical style add another twist to the transmutations of objects and persons. What do these uncannily jumbled cultural signs signify? Ottinger comments: 'My archive of objects is equal to the no less real archive of my memory' (ulrike ottinger [website], n.d.: n.pag.). Objects brought home from her father's travels as a sailor (he was also a painter), gifts and mementos from her films; these are things with which Ottinger lives every day. Yet since the memory that animates the juxtapositions is not directly accessible to the viewer, primitivist associations among chanting, blackness and threat dominate.

The Renaissance Wunderkammer literally objectified cultural differences, mapping the world with Europe at its centre. But they also fostered promiscuous associations as objects came into contact. In Ottinger's films and art exhibitions, the material object, whether prop or cultural artefact, condenses eroticism, imperialism, epistemophilia and self-inscription. *Still Moving* further explores the relationships among still photographs, screen images, three-dimensional objects and performance space; *Kammer* (room) of course shares a root with camera. Objects look back at us: notably in the case of a carved and painted African figure holding a movie camera (and wearing a pith helmet), which at the beginning of the film pans across a line-up of similar carved figures until the viewer/Ottinger's camera is fixed in its sights; this figure returns in an extradiegetic role after the film's credits (see Chapter 11, Figure 11.1). The Kammer and the camera, the wandering and the wondering, are intertwined.

In a thoughtful essay on the film in the online feminist film journal *Another Gaze*, J. Makary attempts to grapple with the viewer's position, writing that *Still Moving* asks us to

> confront our own associations with ethnographic and exoticised imagery and our opinions of Ottinger herself, who directs these complex operations with the insouciance of a magician or a naïf. That it is difficult to discern her subjectivity – or her awareness of it – makes for disorganised and potentially outraged viewing.
>
> (Makary, 2020: n.pag.)

This assessment seems to me on point in relation to the film and to Ottinger's work more generally. We are invited to 'step right up', but not directed how to take it all in. This is the host's prerogative. Does the work's queer context affect the angle of viewing?

As previously noted, Ottinger's short was first shown in 2009 as part of *LIVE FILM! JACK SMITH! Five Flaming Days in a Rented World*. The tribute to the legendary queer New York underground filmmaker Jack Smith, best known for the scandalous pan-sexual drag film *Flaming Creatures* (1968), featured performances and appearances from denizens of Smith's milieu and others influenced by his work. Ottinger addresses the event's theme of 'liveness' by animating her props. And she makes a direct connection to a shared, transnational queer subcultural history through a little gem tacked on to the end of *Still Moving*. Footage shot by Ottinger of Lil Picard's birthday party in Berlin circa 1974 makes both the cultural context and the retrospective charge of *Still Moving* more salient. Picard was a Weimar cabaret artist who, after emigrating in 1937, became an enduring figure in New York's counterculture art scene, performing at the Factory in the 1960s. Filming a joyous bacchanal, replete with wig play and champagne, on colour stock but MOS (a studio-era term derived from the malapropism 'mit ohne sound'), Ottinger takes up a role parallel to Warhol's. But *Still Moving* itself, with its display of objects holding esoteric meanings for the filmmaker, can also be understood as a curated performance on the order of Jack Smith's own version of live film. In famous performances in his New York loft, Smith ruled as master of ceremonies, bedecked in various veils and bijoux. Glamour and orientalism were intertwined for Smith, as in his well-known devotion to 'Queen of Technicolor', María Montez, star of classics of ethnic pastiche like *Cobra Woman* (1944).[6]

Still Moving's throughline is the ritual display of a set of photographs from the 1970s, most of them black-and-white glamour shots of Blumenschein in various exotic costumes, make-up and poses, including Chinese, Arabian and masculine drag. Each photo is gradually unveiled, as a postcard, piece of cloth or fan is slowly drawn right to left across the screen. The revelation gives the photos a sacral quality. Ostensibly the objects are moving, and the photographs are still, but the latter are 'moving' in a number of ways: the emotions evoked by remembrance, and the juxtaposition with moving elements in a repeated gesture of disclosure. The photos activate Walter Benjamin's notion of aura as the 'unique phenomenon of a distance, however close it may be' (1968: 222–23). Blumenschein's iconicity and her extraordinary facial expressions and postures – poignant even when absurd, even when uncannily stilled – as well as the display of the images as a cherished collection, celebrate Ottinger's lesbian authorship in the context of a tribute to the queer underground. Included among the unveiled images is the one of Ottinger and Blumenschein under the poster for *The Enchantment of the Blue Sailors* described above. Watching this collage

film confirms that the camp Ottinger is tied to the ethnographic one as closely as a shadow. Both discourses confront the marginal with the presumed centre, mingling them incestuously and challenging hierarchies of cultural value.

With *Aloha* (2016), commissioned by several partner organizations including the Friedrich-Wilhelm-Murnau-Stiftung, Germany's leading organization for film preservation, Ottinger pays tribute to a venerated figure in German national cinema. Rather than his Weimar or Hollywood masterpieces, she chose to focus on Murnau's passion project, 1931's *Tabu: A Story of the South Seas*, which was also his last film.[7] Murnau died in an automobile accident just before the *Tabu* premiere.[8] Originally a collaboration with Robert J. Flaherty, who had made the docufiction *Moana* (1926) in Samoa with his wife Frances, *Tabu* was ultimately produced independently by Murnau, filming with nonprofessional actors on location in Bora Bora. Intercutting *Tabu* with clips from her own work, especially her pirate film, *Madame X: An Absolute Ruler*, Ottinger traces an alternative German film history via two queer filmmakers' shared fascination with the South Pacific across time.

Tabu is a story of star-crossed lovers, a pearl diver and a young woman who is pledged to the gods, who encounter western culture and betrayal when they attempt to flee their island together. Murnau worked with locals as crew – *Aloha* opens with production stills from *Tabu*, including one with Murnau surrounded by young, bare-chested Polynesian men – and the film notably fetishizes the male pearl divers' bodies.[9] *Madame X* was inspired by tales of Chinese women pirates, and its Chinoiserie – the improvised junk Chinese Orlando, the styling of first mate Hoi Sin and Madame X herself – is patently fake. But the film's primitivist discourse is equally central and arguably more objectifying. Noa Noa, bare-breasted and mute, is introduced as a native of Tai Pi, 'rejected by her husband for infringing on a taboo', positioned as a figure of 'savage', sexualized innocence. Her name is taken from the title of Gauguin's *Tahiti* travel journal, in which he associates 'Noa Noa' with the scent of Tahitian women: 'A mingled perfume, half animal, half vegetable emanated from them; the perfume of their blood and of the gardenias – tiaré – which they wore in their hair. "Téiné merahi noa noa (now very fragrant)" they said' (1919: 12).[10] Noa Noa is selected by the pirate ship's motley crew to seduce Madame X as part of a manoeuvre to take the edge off the pirate's 'unbearable cruelty'. The performer's 'Polynesian' dance enacts a sexist trope, with a Native woman performing this time for a female figure of domination. The fact that she is played by an actor who presents as white (Roswitha Janz, who also is uncredited as Blumenschein-as-sailor's sex partner in *Blue Sailors*) may not mitigate the offense of the stereotype, but her offering of cauliflower and leeks instead of tropical fruits signals the self-aware parody of the appropriation.

Aloha creates a grammar and a loose narrative by intercutting scenes of encounter and pursuit (by ship and outrigger canoe); ceremony and spectacle; fishing and

feasting, from a handful of fictional and semi-documentary films. It is a fan vid edited to music derived from the sampled films' soundtracks (Murnau's film had a score by Hugo Riesenfeld but no synchronized sound) and Ottinger's eclectic collection of recordings. There is wit in the editing and in the incongruity of the exaggerated costumes and vivid colour of Ottinger's films, but the aura of the black-and-white excerpts from the 1930s films is disturbingly elegiac. Murnau's film emphasizes the authenticity of its location and participations, in part as salvage anthropology. The Pacific Islanders who appear in and worked on the film are doubly distanced: by time and by the photographic image as trace. Through montage, Ottinger implicates herself in ethnographic extraction.

Western tropes of the South Pacific as a site of ethnic/erotic fascination are perhaps most closely associated with painter Paul Gauguin and his circle of hedonistic heterosexual Frenchman. *Madame X*'s objectification of Noa Noa alludes to the gendered expropriation that Fatimah Rony calls 'visual biopolitics' in her brilliant retelling of the story of Gauguin's young model and housekeeper known as Annah La Javanaise, even as the film reinscribes its power dynamics (Tobing Rony, 2022).[11] *Aloha* refers to French interests in Polynesia, quoting Guillaume Apollinaire and including photographs of Henri Matisse visiting the shooting of *Tabu*. But the film also alludes to the queer German expatriate culture around figures like painter and translator Walter Spies, who helped popularize Balinese art and was prosecuted for homosexuality.[12] Indeed the South Seas fantasy is shored up by waves of European exploration, colonization, and warfare, queer sex tourism and American kitsch. *Aloha* includes excerpts from *Island of Demons* (1933), another ethnographic-fiction hybrid film, made in Bali by Spies, Viktor von Plessen and Friedrich Dalsheim. By intercutting these films with excerpts from her own, with their obviously fake locations and white actors, Ottinger both 'outs' Murnau and Spies and implicates their queer colonial fantasy in an alternative history of German cinema. Murnau left for Hollywood; Spies died during the Second World War when the Japanese bombed the Dutch boat in which he was being held as a German national. Born under the Nazi regime, and producing all her work in its wake, Ottinger repurposes their dreams of an elsewhere.

At the same time, she claims for herself a place in a fantasy that is historically male (whether hetero- or homosexual). In the context of the Pacific Islands, Margaret Mead, also cited in Ottinger's notes on *Aloha*, is an important female precursor, as Esther Newton bluntly states in the title of her book, *Margaret Mead Made Me Gay*. Growing up butch in a different cultural context but a similar lesbian generation as Ottinger, Newton (2000: 1) writes:

> Reading Margaret Mead's *Coming of Age in Samoa* was my introduction not only to the concept of culture, but to the critique of culture – ours. [...] Her voice had

reached into my teenage hell, to whisper my comforting first mantra, "everything is relative, everything is relative," meaning: there are other worlds [...]

Through Margaret Mead I grasped that my adolescent torments over sex, gender, and the life of the mind could have been avoided by different social arrangements. It is not that I imagined a better life in the South Seas. I was far from fancying myself in a grass skirt.

While Newton became an anthropologist, Ottinger imagined those other worlds.

Again, Ottinger's deployment of orientalist and primitivist tropes is nothing if not self-aware, but the collage-like construction of her films leaves their meanings provocatively unsettled. *Aloha*, like *Still Moving*, brings out the affinities between Ottinger's early and late work: the Polynesian word Aloha is used for both hello and goodbye and also signifies an untranslatable cultural specificity. At the end of *Aloha* we are treated to a snapshot of a prepubescent Ottinger, wearing nothing but a grass skirt. She is seated on what might be a canoe, anticipating the fake junk Orlando in Lake Constance in *Madame X* (Figure 1.2). Offering this image of herself – a cameo in effect – in *Aloha*, Ottinger exposes a creative, vulnerable child in postwar Germany to an enduring romance of western

FIGURE 1.2: Ulrike Ottinger, *Aloha*, 2016. Photograph from personal collection of Ulrike Ottinger. © Ulrike Ottinger.

renewal through a fantasized elsewhere in and as cinema. The child will grow to engage this fantasy in her art and to travel the world, shaping what she sees from her own location in history and culture. This essay has traced Ottinger's persona through her self-inscriptions – cameo appearances, narration and short film assemblages – not to resolve paradoxes in her work, but to give them dimension and provenance. Perversely, Ottinger situates herself within German orientalism and its practices of collection, documentation, exchange and display – as inflected by Dada, decolonial politics, lesbian feminism and the queer underground. Her authorial persona shadows the role of learned European traveller, remixes film history, queers cultural hierarchies and invites viewers to her cinematic Wunderkammer.

NOTES

1. *Ulrike Ottinger: Nomad from the Lake* is distributed by Women Make Movies in the United States.
2. Photos of the installation are available on Ottinger's excellent website: https://www.ulrike-ottinger.com/en/exhibition-details/paris-calligrammes-hkw-haus-der-kulturen-der-welt-2. Accessed 9 May 2023.
3. The scope of this collection of the previously unexhibited early work in painting is tantalizingly suggested in a sequence from the biographical film *Nomad from the Lake*, where it is shown all packed up and organized in the filmmaker's Constance home.
4. Some of the same images appear in the last section of *Paris Calligrammes*, which recounts the artist's turn to filmmaking after leaving Paris in the wake of the events of May 1968.
5. Ottinger's website also details these materials and describes the film thus:

 In a place far away and close by things live on by virtue of memory and the meanings bestowed upon them by human beings. My archive of objects is equal to the no less real archive of my memory. They animate each other and bring forth ever new and unexpected images and ideas. It is as if one were watching, as it takes shape, the play of thinking with its infinite interconnections.
 (ulrike ottinger [website], n.d.: n.pag.)

6. For an account of these performances, see Brecht (1986).
7. *Aloha* was one of five essay films commissioned for the exhibition, 'Friedrich Wilhelm Murnau, an Homage', at Lenbachhaus Munich, fall 2016. Alexander Kluge, Guy Maddin and Evan Johnson, Luc Lagier and a team from the University of Television and Film Munich each focused on a different Murnau film. https://www.lenbachhaus.de/en/visit/exhibitions/details/friedrich-wilhelm-murnau-an-homage. Accessed 9 May 2023.

8. The car was driven by young Filipino Garcia Stevenson, who was only fourteen and remained injured. See Anger (1981: 245–46).
9. Jeffrey Geiger (2007) positions *Tabu* as a key text in what he calls the 'homoerotic exotic'.
10. Quoted on the Cleveland Museum of Art's website, 'Paul Gauguin's Travel Journal', https://www.clevelandart.org/research/in-the-library/collection-in-focus/paul-gauguins-noa-noa. Accessed 9 May 2023.
11. See also Tobing's animated short *Annah La Javanaise*, distributed by Women Make Movies.
12. Ottinger's website notes mention Spies: https://www.ulrikeottinger.com/en/film-details/aloha-kopie. Accessed 9 May 2023.

REFERENCES

Anger, Kenneth (1981), *Hollywood Babylon*, New York: Dell.

Benjamin, Walter (1968), 'The work of art in the age of mechanical reproduction', in H. Arendt (ed.), *Illuminations*, New York: Schocken Books, pp. 217–51.

Benjamin, Walter (1982), *The Arcades Project* (ed. R. Tiedemann, trans. H. Eiland and K. McLaughlin), Cambridge, MA: Harvard University Press.

Brecht, Stefan (1986), *Queer Theatre*, New York: Methuen.

Friedberg, Anne (1993), *Window Shopping, Cinema and the Postmodern*, Berkeley: University of California Press.

Galt, Rosalind (2011), *Pretty: Film and the Decorative Image*, New York: Columbia University Press.

Gauguin, Paul (1919), *Noa Noa* (trans. O. F. Theis), New York: Nicholas l. Brown.

Geiger, Jeffrey (2007), *Facing the Pacific: Polynesia and the US Imperial Imagination*, Honolulu: University of Hawaii Press.

King, Homay (2007), 'Sign in the void: *Johanna d'Arc of Mongolia*', *Afterall*, 16, pp. 46–52.

Makary, J. (2020), *'Still Moving*: Ulrike Ottinger's shifting archive of identity', *Another Gaze*, 29, https://www.anothergaze.com/still-moving-ulrike-ottingers-shifting-archive-identity/. Accessed 9 May 2023.

Marchand, Suzanne (2001), 'German orientalism and the decline of the west', *Proceedings of the American Philosophical Society*, 145:4, pp. 465–73.

McRobbie, Angela (2009) 'Review of Laurence A. Rickels: *Ulrike Ottinger, the Autobiography of Art Cinema*', *Screen*, 50:2, pp. 260–63.

Newton, Esther (2000), *Margaret Mead Made Me Gay; Personal Essays, Public Ideas*, Durham, NC: Duke University Press.

Ottinger, Ulrike (2019), *Paris Calligrammes: A Landscape of Memory*, Haus der Kulturen der Welt, Berlin, 23 August–13 October, https://www.ulrikeottinger.com/en/exhibition-details/paris-calligrammes-hkw-haus-der-kulturen-der-welt-2. Accessed 9 May 2023.

Rickels, Laurence A. (2008), *Ulrike Ottinger, the Autobiography of Art Cinema*, Minneapolis: University of Minnesota Press.

Sicinski, Michael (2020), 'Open ticket: The long, strange trip of Ulrike Ottinger', *CinemaScope*, 22 September, https://cinema-scope.com/features/open-ticket-the-long-strange-trip-of-ulrike-ottinger/. Accessed 9 May 2023.

Sykora, Katharina (2022), *Zwischen Welten: Ulrike Ottingers Filme im Spiegel der angloamerikanischen und deutschen Kritik*, Göttingen: Konstanz University Press/Wallstein Verlag.

Tobing Rony, Fatimah (2022), *How Do We Look? Resisting Visual Biopolitics*, Durham, NC: Duke University Press.

ulrike ottinger (website) (n.d.), 'Still Moving', https://www.ulrikeottinger.com/en/film-details/still-moving-2. Accessed 9 May 2023.

2

Moving Artefacts: Objects and Their Agencies in Ulrike Ottinger's Films

Katharina Sykora

Introduction: Artefacts, autobiography and cinematic recollection

In her most recent film *Paris Calligrammes* (2020), Ulrike Ottinger reflects upon herself becoming an artist in Paris in the 1960s when she studied engraving at the world-famous studio of Johnny Friedlaender and developed her own style of painting. In one part of the film, she describes her artistic formation among a group of young French Pop Artists. We see photos that she made of skits performed by friends: Valentina blowing a bubble gum until it bursts on her mouth, Uschi drinking out of a big bowl until her features disappear behind the dish, Uschi posing seemingly naked behind a cardboard with her knickers and her pullover attached to it. All these motifs reappear in Ulrike Ottinger paintings of the time, arranged in sequences like comic strips. Photography appears here as a medium that both evokes and registers stagings that develop in time and therefore need more than one picture. The series also recall story boards and thus prefigure filmstrips. This becomes apparent in the way Ulrike Ottinger implements them in *Paris Calligrammes*. Transformed into celluloid they turn into a 'real film'. But Ottinger makes sure that the photographic sequences keep the medium's own specificity. She shows them not in one continuous take, but in jump cuts underlined by the music *Cinéma* that Eric Satie had composed for the experimental film *Entr'acte* by René Clair. This film had been designed for the intermission of Francis Picabia's theatre play *Relâche* and had its Parisian premiere on 27 November 1924. The visible montage character of *Entr'acte* and its placement as an

in-between piece is reflected in Satie's sound that mirrors the film's discontinuities and recalls the music that accompanies silent movies. The combination of the photographic sequences with Eric Satie's music in *Paris Calligrammes* intensifies this effect. It makes us feel like in a surrealist version of the cinema of attractions that overtly ignores the invisible cut as a dominant tool to induce the illusion of an uninterrupted time flow. The deliberate gaps between the images, and between image and sound point out the difference between the time of the photos in Ottinger's film, the time of her film and the time of the beholder.

Leaping from one image to the next we become aware of the palimpsest that constitutes her movie. The staged photographs imbedded in *Paris Calligrammes* thus explicitly counteract what could be called film's 'cannibalism', that is the tendency of mainstream movies to 'devour' every single object in front of the camera making it part of *one* integral medium and narration. Ottinger's film makes this visible, her photos perform an insurrection against this cannibalization by showing their materiality, their black and white aesthetics and their montage. As explicit objects they become disruptive elements within the filmic flow that draw our attention to them as both different from and constitutive to the movie. We realize that they originate in another time and place than the one Ulrike Ottinger filmed in the streets of Paris in 2018. They become crucial for her autobiographical look back since the photos work both as object and medium bearing witness to Ottinger's Parisian life and art in the 1960s. The implementation of photographic artefacts in *Paris Calligrammes* both accentuates this gap between different times and bridges it. Through this procedure, the photographic sequences turn into allegories of Ulrike Ottinger's individual artistic memory as well as allegories of the film's own capacities and limits to memorize. They become animatory objects that initiate the filmmaker's recollection, which is shown as fragmented in principle. Nonetheless Ulrike Ottinger ventures on, forming her memories and her recent observations into a personal narrative that at the same time knows of its montage character. One of the first sentences that Ottinger's autobiographical voice-over articulates in *Paris Calligrammes* expresses this paradox. She asks herself: 'How to make a film from the perspective of a very young woman that I was then with the experience of the artist that I am now, fifty years later?' Since this very dis/connection is inherent to film as a medium itself, Ottinger does not only reflect on her personal act of a twofold memorization but also makes us realize that the artefacts in *Paris Calligrammes* animate our recollection of a historical period and a specific location in manyfold ways: we see them through her and our own eyes and with our personal experiences that differ each time we see the film.

Circulating genders as artefacts

Ulrike Ottinger's shiftings between photographs, artefacts and film that enhance each other in their semantic, material, recollective and reflexive power have not only been central to her autobiographic approach in a documentary like *Paris Calligrammes* but to many of her feature and documentary films as well. Again, the photographic sequences in *Paris Calligrammes* ostentatiously get us on this track. Three photos showing a woman with hair rollers and high heels covering her body with a paperboard to which a piece of female underwear and a sweater are applied are a funny and complex display of the constitution of a 'real' body, its props, its pictures and its image. Putting the performer on a pedestal, backing her onto a window whose frame doubles and collides with the assemblage she holds, and illuminating her with daylight as if she were on stage, the sequence unfolds a subject matter central to Ottinger's whole cinematic work (Figure 2.1).

FIGURE 2.1: Photo staging with Uschi in Paris, 1967, *Paris Calligrammes*, 2019. Photograph by Ulrike Ottinger. © Ulrike Ottinger.

Starting with her first film *Laokoon and Sons* that she made after her return from Paris to Germany in 1972/73, hyper masculinities and super femininities are shown as highly refined artefacts. They appear as applications to different bodies and signify gender as mere surface phenomena. As part of an ongoing spectacular show, 'natural' and artificial gender signs like moustaches, bosoms, sailor hats or big cigars are often mixed and move from one physique to the next. Gender tokens mark distinctions only as collage, and as temporarily valid, they indicate the constant metamorphoses of bodily surfaces. This has an effect on the constitution of Ottinger's characters. They are role models in the literal sense. Genders are presented as loose but constituent parts of figures that are the result of highly stylized performances, 'figura' deriving from 'figurare', that means posing. As a result, the ambience of these figures becomes theatrical, too. With their radiant eccentricities, Ottinger's figures saturate their surroundings with artificialities and transform even the most banal place into a stage. Hence, the space in Ottinger's films is always marked by a double frame: the visible one of theatricality deriving from the effusiveness of every figure and their surroundings, and the invisible one of the cadrage set by the filmmaker who always does the camera work herself. In addition, Ulrike Ottinger often enhances the spectacular performances of her figures by showing them head-on. That makes us into theatrical beholders who are addressed directly as if sitting in a theatre audience.

Framing the real and the imaginary

Framing is a device that Ulrike Ottinger uses not only to underline the artificiality and versatility of her figures, their gender and their surroundings. It also indicates the entanglement of the real and the fictional world in her films. This is especially the case when she uses the frame as material artefact within her images. As object among objects, it then becomes the threshold between an inner space that it delimits and defines both as content and as aesthetic configuration, and an outer sphere that is supposedly unformed and less important. Both in her feature films and documentaries, Ulrike Ottinger subtly comments on how frames often mark the divide between scene and off scene, what is said and shown as central and what appears as mere enhancing device. Ottinger plays with the aesthetic capacity of the frame to structure the filmic image both as a plane and in its depth. In *Dorian Gray in the Mirror of the Yellow Press* (1984), for example, she makes the frame a key object of her narrative and a demonstrator of her aesthetic approach. In a central scene, the protagonists, dandy Dorian Gray and media mogul Dr. Mabuse, watch a colonial opera set in the time of the Spanish *conquista* of the Canary Islands that mirrors the future fate of the two modern beholders. Already

the setting is telling. The stage is not a built architecture but consists of different natural environments. The painted frame has been put in front of a seashore or a desert. In contrast, the theatre loge in which Dorian and Dr. Mabuse are located is a construction built by nature: a curved cave in a bizarre rock face. Standing there in his elegant tuxedo Dorian holds opera glasses before his eyes and focuses on the theatrical scene in front of him.

But *how* he sees and *what* he sees are two different shots separated by a filmic cut. Exactly in this moment the frame comes into play. It mimics the focusing function of Dorian's opera glasses, now transferred to the threshold between diegetic and theatrical scene. The frame as object makes the *dispositif* visible that also constitutes the gaze of the beholder in the movie theatre, a *dispositif*, however, that in mainstream films is hidden between the images. By showing the focusing operation of the frame as equivalent to Dorian's gaze through the opera glasses, Ulrike Ottinger discloses her own camera operation of the cadrage. And by displaying the frame's separating function that divides theatrical from diegetic space, historic from cinematic time, and culture from nature, Ulrike Ottinger makes a general statement of how we and the media constitute meaning: as judgements and practices based on inclusion and exclusion. Ottinger shows also that her frame is not completely hermetic by letting the opera actors and actresses be played by the same performers as their diegetic beholders: Dorian Gray and his counterpart, the Spanish infante on stage, are both played by 1960s fashion model Veruschka, and Dr. Mabuse alias the Spanish inquisitor is played by *nouvelle vague* star Delphine Seyrig. In the central opera scene, they transcend the theatre frame and enter into the filmic space and vice versa. The frame is thus operating here as threshold and connection, not as limit and boundary. It becomes a permeable object that reflects the other part of Ottinger's editing practice and its semantics. If her cuts are, on one hand, visible separations between the images, they are, on the other hand, also the very media through which she connects the unconnected, joins together the supposedly incompatible, mirrors the real in the imaginary and vice versa.

The latter is especially the case when the frames in Ottinger's films are artefacts that have their own imagery. In *Dorian Gray in the Mirror of the Yellow Press*, the opera frame is painted with allegories that are a reference to nineteenth-century symbolist artist Gustave Moreau, and in *Taiga* (1992) the painted wooden entrance to a Mongolian yurt shows colourful patterns that speak of the craftsmanship and artistry of the Nomads in this remote area of the world. Belonging both to art and the material world, these frames operate as tricksters intertwining the spheres of inside and outside, the staged and the unstaged, art and nature. This gives them a reflexive quality that comments on the mutual constitution of fiction and the real, saying that they are not antagonists but allies or even 'lovers' as Lady Windermere remarks in *Johanna d'Arc of Mongolia* (1989) in her prologue: 'Must imagination

shy away from encountering reality, or do they love each other?' she asks, 'Can they become allies? Do they change when they meet? Do they swap roles?' These are rhetorical questions to which Ottinger's entire film work gives the emphatic answer 'Yes'. Thus, the frames as artefacts in her films could be considered as visible 'gifts of love' that theatricality gives to reality and vice versa each becoming more brilliant and meaningful through the other. This way the environment around the wooden door frame in *Taiga* suddenly turns from unmarked reality to a highly symbolic background since the Mongolian nomads attached great importance to carefully install their yurts close to sacred sites. Thus, frames as objects in Ottinger's films not only reflect upon the focusing into the spatial depth to constitute meaning as we saw in *Dorian Gray in the Mirror of the Yellow Press*, but they also actively redirect our gaze horizontally to the margins of the image that are as significant as the centre.

Unboxing the old in the new and the new in the old

There are another kind of artefacts that mirror the way Ulrike Ottinger makes us see. In *The Korean Wedding Chest* (2008), the main actor of the narrative is a precious wooden box which contains the gifts a bridegroom-to-be offers his future bride. What makes the wedding chest into a potent social and intercultural agent is its twofold addressing in Ottinger's film. For those who are foreign to Korean culture, it contains objects whose meanings can be explained to them by unpacking the box in front of our eyes. From this perspective, the objects inside exercise a special power deriving from their mysteriousness that is the result of cultural difference. The presentation of the wedding chest and its contents then turn into secrets that are disclosed like in western fairy tales. For inhabitants of modern Seoul, however, the wedding chest contains well-known objects of tradition that not only build ties between two lovers but also keep the family-based Korean society together.

In *The Korean Wedding Chest*, we visit one of the most elegant wedding shops of the capital and witness how carefully the items are chosen and placed into the box: five small ornamented pouches containing different seeds that guarantee fertility, the pleasant character of the bride, happiness for the couple and the absence of bad spirits are positioned in the four corners and the centre of the chest that represent the cardinal points of the Korean cosmos. Colourful silks are then meticulously folded, wrapped in fine paper and stacked into the chest. Finally, the marriage proposal and birth certificate of the groom written on precious paper are put on top. After the chest is closed with an ornamented brass lock, it is wrapped into a blue and red silk cloth, the colours representing male and female. Then,

a white rope made from finest linen is twisted around it without any knot which symbolizes an easy and gentle relationship between the forthcoming couple. The rope serves as holder for the carrier of the box who has to transport it through the city of Seoul to the house of the future bride's parents. Helping to connect two formerly distant dynasties, it is the materialized promise of the generational continuity of both families since the white cloth is supposed to be unravelled on the first birthday of the future couple's eldest son and used as his diapers. In summary, the wedding chest, its content and its use in the preparatory ceremonies for the wedding are both of practical and symbolic value. The material agency of this important intergenerational artefact establishes and strengthens the bond between the young and the old, tradition and modernism. This is becoming evident during the following wedding ceremony when the couple alternates in wearing traditional costumes and western outfits, and when ancient rituals are seamlessly followed by high tech festivities. Like the disclosing of a wedding chest, Ottinger's film itself unwraps the story of a modern couple's marriage embedded in Korean tradition. She enfolds it again with an ancient saga telling the story of two ginseng roots, one woman, one man, that attempt to become human beings by studying the latter's behaviour and customs. After a while they are not distinguishable any more from humans and live as a couple in Seoul. But finally, they decide to leave the city again to find out 'what's old in the new, and new in the old'.

In her feature film *Twelve Chairs* (2004), Ulrike Ottinger also uses artefacts as transmitter between the old and the new. She shows the destruction abruptly imposed new social and economic structures can cause in impoverished societies after big upheavals. The basis of the narrative is the homonymous novel by Ilja Ilf and Jewgeni Petrow, two writers from Odessa, which was published in 1928. It is a satire about the clash between the relics of old Tsaristic society and the communist changes that the Soviet Union had forced on its population after the Revolution. The three protagonists represent the dominant social classes that formerly held the power in their hands: an aristocrat, a clergyman, an astute dealer and witty swindler. But Ulrike Ottinger's film is far from being a mere adaption of the historical story. She transfers it into the present day. Like in the late 1920s, the early years of the millennium marked a period in Middle and Eastern Europe when an old order had been replaced by a new one and the transformations and disruptions had become manifest. Thus, two layers of time are interwoven in Ottinger's *Twelve Chairs* that have structural similarities concerning fundamental social change, although politically they could not be more different. Whereas in the late 1920s communist euphoria about equality and modernization had partially turned into resignation about new forms of corruption, in the first decade of the millennium, global capitalism was on its way to infiltrate, absorb and destroy the rest of the socialist communitarian and centrally regulated economy. Ulrike Ottinger could

adopt the dialogues from the 1920s novel without big changes since they worked well as satirical analyses of both periods. In the visual field, however, she implemented certain artefacts to indicate the disruptive clash of the old and the new period. Like in her Berlin trilogy, Ottinger used the real structures of the urban and rural landscapes in the Ukraine as background for the narrative of *Twelve Chairs* and she did the same with the extras which she recruited from the streets of Odessa, Feodosia, Belgorod or from villages in the Crimean area or the Danube Delta. Since the appearance of the locations as well as the people had already become patchworks of the rundown old, and the promising but often trashy new, they were perfect allegories of what the plot was humorously commenting on. By showing two old ladies in front of a bus station using plastic bags with the imprints of *Chanel* which they could never afford, Ulrike Ottinger comments on western advertisements, but first of all she demonstrates the witty, matter of fact, use of the goods that capitalism offers and the pride that does not derive from this western artefact but from how people manage to live by facing the challenges of their time.

Discovering art in everyday life and creating everyday life in art

For her semi-documentary *Under Snow* (2011), Ulrike Ottinger visited the Japanese region of Echigo which has snow coming from the Eurasian continent covering the landscape for many months of the year. Hence, snow forms the everyday life of the people as well as their festivities and tales. Like in *The Korean Wedding Chest*, past and present are synchronized in the film through this magic medium of frozen rain which by its substance is already a promise of transition from the fluid to the solid, from flatness of pure white to massive weight on houses or igloo sculptures built by the Echigo kids. The main characters serve Ottinger as representatives of this transformation and as guides through a countryside that looks like out of a fairy tale. They are two students travelling from Tokyo to this northwestern area of Japan who suddenly turn into a couple from the nineteenth-century novel *Snowland Symphony* by Bokushi Suzuki. A parallel journey begins interweaving Ulrike Ottinger's visit to the snow landscape with the adventures of the two protagonists of the novel played by two Kabuki actors. This allows her to display a twofold curiosity. The first immerses the spectator in the world of Japanese ancient myths through the novel's narrative. The second follows today's practices of the people living with the fierce though beautiful element of snow most time of the year. Both perspectives have found their way into old fairy tales still vivid in Echigo. One of them which Ottinger recounts in the voice over of her film tells the fate of a woman weaving the fine crepe for which the region is famous since its manufacturing needs cold and moist conditions so that the threads do not

break. But a demon is after her and stains her immaculate fabric which means, in her community, social death since as a consequence she is unable to marry. This story is not illustrated by a staged narration in the film but is visually accompanied by today's practice to spread the crepe panels on the snow to enhance their colours and keep them flexible through humidity. To mount the weaves on the snow which is several meters high, a man walks with snowshoes around a quadrangular field, building a raft from which the textiles can be rolled out onto the snow. We follow each step of this procedure and at the end we are faced with a piece of land art: the strips of many pastel-coloured crepe panels on white background framed by the square raft look like a nonfigurative painting in a sublime countryside. The artifice of producing the crepe tissues is partially absorbed by their beautiful display in the snow. The very combination of setting and film shot makes them a piece of art on a second and third level. But paradoxically, the underlying fairy tale brings this abstraction back into the real. By making us share the hard work and its existential value for the weaver, we simultaneously keep her in mind as representing the original creator of such pieces of art in the first place. Ottinger's discovery of the crepe as a typical Echigo artefact thus becomes emblematic for the connection of tradition and present, art and everyday life. Its complex display individualizes the myth by grounding it in a hard craft but allegorizes and honours the artefact at the same time by embedding it in a cadrage that doubles its artistic perfection.

In *Madame X: An Absolute Ruler*, the circular narrative tells the story of women from all over the world that are frustrated with their boring lives or the obstacles that they encounter in their endeavours and follow the call of Madame X to search together for 'love, gold, and adventure'. However, after having set sail on their pirate ship, the power relations between them become as violent as in their former existences. In an atmosphere of jealousy and mistrust, an erotic affair is developing between Noa Noa, typifying the hyperbolic phantasma of women of the South Seas, and the leather-armoured absolute ruler. In the scene of Noa Noa's approach to Madame X, she brings fruit from her far away islands to appease the grim mistress. Noa Noa serves Madame X a carrot whose greens she shyly waves before the ruler's eyes, keeping more vegetables and fruit in reserve in her basket. And indeed, she succeeds in conquering the heart of Madame X with her exotic gifts. But are they really exotic? Yes and no: the carrots, leeks, parsley, and stem cabbage originate from the Lake Constance whose landscape is famous for its abundant agriculture, whereas the bananas are exotic in this Northern Alpine climate although not unusual in the local supermarkets. With her witty implementation of these humble objects, Ottinger once again opens up her game of swapping categories. As an attribute of naturalness, a leek or a carrot is overtly dysfunctional for a figure like Noa Noa and rather become an indication that she is a mere product of phantasy. At second sight, this proves to be a

phantasy from more than one origin: Gauguin and his paintings of an idyllic South Sea from whom Noa Noa's name is borrowed join the phantasies of ethnographic researchers and photographers, and last but not least also Ulrike Ottinger's own imagination enters this mix, though being one of the few that winkingly reflects upon its patchwork character. Exoticism here is shown as a strong seductive relation between two figures who see their counterparts as desirable other, but whose approach is always grounded in a hierarchy of power. Their encounters are thus doomed to mutual misunderstandings due to the different experiences and gifts they can offer each other. But the fictitious love story of Madame X and Noa Noa also speaks, if not of a possible happy end, at least of a happy beginning. We already get a glimpse of what will be the driving force of Ulrike Ottinger's lifelong ardent interest in transcultural exchanges.

Turning time, turning films: Artefacts as actors

Chamisso's Shadow (2016) has its starting point again in a fairy tale, this time the German Romantic novel *The Miraculous Story of Peter Schlemihl* (1813) by Adelbert von Chamisso. The central figure sells his shadow, an action which bestows him with seven-league boots that carry him swiftly through the whole world. Written before the invention of photography and film, this setting seems like a prediction of the essence of both media: the separation of body and image and the promise for the beholder to travel to faraway places within minutes. Chamisso himself embarked on a long expedition from Saint Petersburg across the Atlantic and Pacific to the Bering Strait, becoming an experienced natural scientist and ethnographer during this travel. Ulrike Ottinger steps into the footprints of both: the one of Adelbert von Chamisso by visiting the northern sea gate between Russia and Alaska that marked the centuries-old dream of a possible round trip of the world by ship; and the one of Peter Schlemihl transferring her experiences of the expedition into photos and film that in *Chamisso's Shadow* start their own life in the cinemas around the globe. Chamisso's, Schlemihl's and Ottinger's endeavours join a linear with a circular movement which is inherent in the medium of film itself. One scene features a speaking object that reflects upon this seeming paradox of unfolding time in both a sequence and a circle. We accompany Ottinger on her visit to Alicia Drabek, curator at the Aleutic Museum in Kodiak, the main city on the homonymous island and region situated between Alaska and Russia. Drabek is showing us a sculpture the size of her hands. It is a transformational piece that turns from a raven's head to a human face then back to the raven and into another human head when she turns it again. According to the Aleutic myth, the raven is the creator of the world with the capacity to transform everything, and birds

in general inhabiting the sky are considered messengers between the earthly and spiritual worlds. Thus, when the raven turns into a human it empowers mankind with superior abilities. This takes place during and through the movement of the artefact. Thus, when Alicia Drabek shows us the multifaced object it transforms not only from bird to human and vice versa but also from beautiful artefact into an animistic cult object and back into a museum piece. And what could be a better assistant to this contemporary shamanistic session than film? Once the film wheel is turning, it also transcends time and space, leads us into spheres that we could not possibly reach and brings us safely back to the place from where we started. Like Peter Schlemihl's seven-league boots around the world and the sacred Aleutic sculpture, film also induces a transformation that takes place in linear time and comes back to its beginning in a circular movement when the wheel is put once more into the projector. Alicia Drabek turning the Aleutic cult object in front of us thus mirrors the magic of cinema.

Ulrike Ottinger's short film *Still Moving* (2009) establishes another kind of 'returning' time through special objects. This again is meant in a double sense. On the one hand, the film goes back in time picking up objects from previous ages; on the other hand, it turns these objects into lively agents that are enriching the memory and thus are an animated gift returned to the past. There are in effect two pasts that Ulrike Ottinger immersed herself into, a personal and an artistic one. After the death of her mother she went through the residues in her parent's house discovering old letters, looking anew at the collection of African sculptures that her father had started when travelling as a young artist sailor along the African coast in the 1920s. She also found many examples of her own early artistic work like the engravings and paintings of her time in Paris or the collection of avant-garde art that she had displayed in her *Galerie Press* after her return to Constance in the early 1970s. Besides this personal approach, the second reference to the past in *Still Moving* is the work of American underground filmmaker Jack Smith whom the Berlin-based *Arsenal Institute for Film and Video Art* had dedicated the retrospective *Live Film! Jack Smith! Five Days in a Rented World* in 2009. In this context, Ulrike Ottinger was commissioned to produce a short film as homage to Smith. The film is not showing extracts of his movies; instead Ottinger casts motifs that she has in common with him: these are, for example, actors and actresses in old-fashioned dresses imitating exalted gestures from silent movies or aesthetics that are similar to his, like the ostentatious collage and montage principle. Most of the photos go back to the early performances with Tabea Blumenschein experimenting with costumes, gestures and miniature narratives that prefigured scenes in later films. Or she makes the African masks and objects of her father's and her own African collection come alive through shivering or shaking movements which were typical for Jack Smith's underground performances. But far from being a mere

nostalgic view back to a romanticized personal or artistic past, Ottinger suddenly changes the eroticizing shivers or ecstatic dances of her objects into threatening if not aggressive acts. The dance of the masks then turns into an attack against the camera or the wooden gun is aiming at the camera lens and the eye of the spectator accompanied by the sound of a machine gun. In these sudden moments, the artefacts strike back in a double sense: as objects activating personal memories that can be both gratifying and hurtful, and as objects that can let their own latent history pop up, which speaks of colonialism and its inherent violence. One of the main actors belongs to the genre of so-called *figures colons*, wooden sculptures which were produced by Africans depicting their colonizers in caricature forms. By exaggerating their typical features, the artisans reverse the colonial gaze. Ottinger picks up this potential and turns it against her own position by choosing a *figure colon* that represents a white filmmaker with his insignia of sun helmet, suit, tie and long nose, holding a camera in front of his eye (Figure 11.1). At the beginning of *Still Moving* this alter ego takes pictures of other *figures colons* but at the end of the film he turns in a full circle to Ottinger's camera. The showdown of this duel between two gazes seemingly ends in a stalemate. When the screen turns black we do not know who of both has stopped filming: Did the *figure colon* 'blacken' the image by shutting off his camera, or did Ulrike Ottinger turn off the light that she shed on the objects of her memory in the film?

Moving the beholder: Affective artefacts

Exile Shanghai (1997) prefigures this search for historical sediments in certain objects and extends it to specific places in which these artefacts emerge. Together Ulrike Ottinger makes them not only witnesses of a forgotten past provoking us to integrate them into our memories but also agents that move us emotionally connecting the past and our present not merely through the intellect but also through empathy. Parallel to interviews with Jewish people that lived in Shanghai under different conditions, for example as merchants from the Middle East since the nineteenth century, as migrants from Russia since the 1910s or, in 1937, as refugees arriving from Germany, the filmmaker strolls with her camera through the streets of the city and its rural surroundings looking for the relics of former Jewish existence in contemporary Chinese life. Different from *Still Moving or Paris Calligrammes*, she does not overtly trace and reactivate personal memories, although her mother's family shared the murderous persecution by the Nazis. Instead, she tries to grasp both the diversity and collectivity of Jewish people in Shanghai. The majority were victims of pogroms and fugitives from the Shoah. At first sight, we seem to attend an exploration of everyday Shanghai life, like in

Ottinger's *China: The Arts – The People* (1985) but step by step we recognize structures of western architecture or faded Latin letters on the front of buildings that were once the habitat of international Jewry in Shanghai. By emerging from their contemporary Asian surroundings, they hold their ground as material objects that are both fragments of a specific past and integral part of a vivid present which through them is characterized as a historical palimpsest.

This double perspective on past and present is evoked particularly in a scene in which Ottinger shows Jewish gravestones that had been transferred from a central cemetery to the periphery of the city in the early 1950s after the Jewish community had vanished under Maoism and most of the Jews of Shanghai had either died or emigrated to Palestine or the United States. The camera slowly travels over the countryside where the tomb stones poke out of a field here, and as part of a pavement or bridge there. The Latin and Hebrew letters are both enigmas for the Chinese peasants, the stones being mere objects of practical everyday use for them. This reawakening of their semantic and emotional meaning is very much enhanced by the sound that Ulrike Ottinger chose for this scene. It is Marietta's song 'Joy that True did Prove' from Erich Wolfgang Korngold's opera *The Dead City* of 1920. Korngold was himself an Austrian Jew who had to emigrate after the 'Anschluss' of his home country and went to Hollywood where he composed music for many movies. Wrapped into the immaterial sound of Korngold's music, the Jewish gravestones of Shanghai become material artefacts being planted in a specific time and place that at the same time transcend this limitation and emotionally stimulate us to empathically animate them.

This is also the case in the final image of *Exile Shanghai* over which run the end credits. It is shot on a big ship that leaves the harbour in direction of the open sea with a red flag fluttering in the wind. Underlying this long shot is a song by the then famous tenor Josef Schmidt '*A Song Goes Round the World*' whose chorus tells from the victory of love and friendship that against all obstructions will endure until eternity. If we know that as a Jew Schmidt had to leave Germany one day after the film's premiere in Berlin on 9 May 1933, in which the song was the leading score, and that he died in a camp in Switzerland in 1942 of cardiac insufficiency acquired during his years of exile, flight and encampments, and if we make ourselves aware of the fact that most Shanghai Jews had to leave the city under Maoism not later than the 1940s and early 1950s, and most of them moved to the West Coast of the United States, we understand the affective complexity of this red flag in the wind. It implies the departure of the refugees as both a continuity of their persecution and a hopeful new start into a promising future. At the same time, the red flag refers to a past in Chinese history that was grounded in the antifeudal, anticolonial and anticapitalist ideal of total social equality that – as can be seen in the last shot's images of heavy industry at Shanghai's 'riverbanks' – had

in the 1990s already started to turn into its opposite: a global economic superpower. Like the Jewish emigrants that Ulrike Ottinger interviewed in the Bay Area of the US West Coast who, in their memories, had come back to their beginnings in Europe before their exile around half the world, Chinese society once again seemed to have come full circle to a historical position where the promise of a better life shows at the horizon. The flag in the wind as a politically and historically charged artefact endowed with the emphatic song of tenor Josef Schmidt releases us with both strong and mixed feelings: of hope and its exposure to loss that seem to eternally take turns.

3

Wit and Humour – When Objects Look Back: Comical Constellations in Ottinger's Work

Gertrud Koch

It is important not to forget that Ulrike Ottinger's first works are paintings, paintings of pop art: pop art in Paris and in the sixties. Pop art always transgressed genre borders. There were the vertical and horizontal lines, there was formal excess and ironic praise for the ordinary, also the beauty in the vulgar, the ornamental in seriality and the play with proportions by oversizing as in the work of Roy Lichtenstein and Claes Oldenburg. Ottinger works with serial moments that contain narrative elements, sketches are forming out of a single plane. In her parents' house at Lake Constance, she allows the visitor to enjoy the wide view out of panoramic windows and encounter a strip of four panels, one of her paintings from the sixties titled Picture 1. Panel 1 shows a woman's head in profile with a bubble gum, Panel 2 shows, again in profile, the blowing up of the bubble, Panel 3 turns the axis at 90 degrees and shows now the face in front with the bubble nearby covering two-third of the face and Panel 4 returns to the view in profile, the burst bubble now covering the face like a mask (Figure 3.1). The four panels vary with the shirt, hair and background, giving the forming and deflating bubble the central narrative agency – it's not so much about the person but about the bubble gum and its curious adventures in a person's face. The stripes in the plane background going horizontally straight in the first two panels form arrowlike lines pointing to the event of the growing bubble, while in Panel 4 the stripes return as lightnings that just hit. One could argue that this is a kind of *Urszene* of the comical, like the slipping on a banana peel. But the difference comes from the twist in perspective: the moment the frontal view takes place, we are confronted with an action that unfolds, an action that comes out of a habit, the habit to blow up bubbles of chewing gum until they burst; like smokers form rings of smoke with

WIT AND HUMOUR – WHEN OBJECTS LOOK BACK

FIGURE 3.1: *BubbleGum*. Painting (one of a panel series of four) by Ulrike Ottinger, Paris, 1966. © Ulrike Ottinger.

their mouth, the consumer of bubbles train to blow up bubbles. The ordinary mastery derails when the bubble swing back right on the face of the performer. The match point of undecidability in the third panel, when face and bubble seem to become equal, slides away and leaves the perfect bubble as rubber rubbish on the face. As the person is kind of anonymized and abstracted in the formal variations of stripes and colours, one could argue that the emphasis here is on a kind of 'ethnographic' gaze, a study of a habit more than a psychological portrait. The interplay of formal and graphical patterns, of colour and serialization, locates the comical exactly at the border of action and material world. It remains open

who is the sidekick here: the subject or the object, the chewing gum eater or the chewing gum – the comical moment is not like in the scene of the banana peel the *Schadenfreude* at the fallen human but a smile at the pitfalls of perfectionism and the fragility of habits – it's more *comédie humaine*.

In this early painting, the specific proportionality in Ottinger's work is established. There is the serial unfolding of a scene in time and place and the slowly emerging climax of a viewpoint, a detail, the ornament evolving as a figure-ground relation. Some key stylistic formations in Ottinger's work are based on a preference for long duration and theatricality. This is the case when what seems at first glance to be juxtapositions, when one looks at theatricality in terms of dramatic action and not at a spatial concept of staging something in a concrete space. In Ottinger's work, there are theatrical moments in long shots and montages, installations and stage productions bringing this juxtaposition together with wit and understated humour. It is the way things, objects, persons look back at the spectator through the camera that creates a shadow theatre of comedy. In the above painting, this moment happens when the axis switches to the frontal view, but we don't see the full face, only half of it, one half covered by the bubble that takes the lead. When the bubble bursts right into the face, the gaze is on the spectator who becomes an observer. The interaction between the gaze that comes from the objects on the canvas, or big screen or just any screen, and the gaze that starts from the spectator's position determines the grid of wit: a visual joke unfolds. Visual jokes as linguistic jokes work as a specific rhetoric – it's not the image itself that is comic, but the way we look at it. The joke is directed at us. Insofar as one could argue that visual jokes and theatricality share common traits, they both are pointing, gesturing at something that the spectator should be aware of. The inner logic between observation and decentring the gaze of the spectator to a detail, an object or a situation, reminds us of another cinematic work, that of Jacques Tati. Tati emphasized panoramic long takes with a love for details.

> A typical situation of comedy: a hot summer day, an ice cream seller, a longing child. Charlie Chaplin would have distracted the ice cream vendor so that the child could steal ice cream; W. C. Fields would have stolen the child's ice; Buster Keaton would have invented an ice-fanning machine so that the scoop would not melt; Laurel and Hardy would have messed with it after pushing the child aside; Harpo Marx would have made a lot of scoops disappear into his coat pockets before the eyes of the stunned child. With Jacques Tati, however, nothing happens: the camera shows an ice cream truck, half-close, a sluggish ice cream seller, behind the ice cream truck a small hand stretches up, the ice cream seller exchanges two ice cream cones for the bill held up, continues reading, the two ice cream cones move, the ice cream vendor lifts his gaze, the camera takes over and slowly pans past the ice cream truck to the

tiny child, which now spreads its arms as if balancing the ice cream cones at the end of an equilibrium bar, carefully steps on the stairs of a hotel, step by step, at the end of the stairs, half-close the little boy pushing down the door handle, slowly turning the cones down 180 degrees. Cut: the door jumps open, below the two ice cones come into the picture, the little one disappears, nothing has happened.

(Koch, 1984: 181, trans. by author)

Ulrike Ottinger explains in a long conversation with Beate Ochsner and Bernd Stiegler the specific conditions she explores in the comical underlines of her work:

The longue durée is more likely to be found in the documentary works. I think that an everyday observation only becomes interesting when you look somewhere longer. If you perceive this only fleetingly, it is uninteresting. But if you look longer, you understand a dramaturgy of everyday life. This is quite fascinating for me personally.

(2022: 82)

In the following passages, she explains some of the sequences in her documentary films that open up into the 'dramaturgy of everyday life'. In her own view, she refers to the classical conditions of situational comedy – exemplified by one scene in her long documentary on China from 1985 *China. Die Künste – Der Alltag* in which small children at an amusement park are riding bumper cars:

The children who drive around in small cars, one of which is already missing its wheel, and then they are picked up by their mothers at some point. The children there don't wear nappies. They just have an opening at the bottom of their trousers and when they run away or sit down, it automatically comes apart and they can do their business. That's how it was. And when this little general with his cap is taken away by Mom, then the butt flashes out again briefly. That's not very funny when you tell it, but when you see it, it's very funny because there's a connection between the broken, very colorful cars and this pride with the cap. These are things where you just have to look long enough and then there is a certain dramaturgy of the everyday that is funny.

(Ottinger, 2022: 83)

By insisting that there is a difference between a joke that is told and a visual joke, Ottinger emphasizes a concept of the comical that is deeply embedded in the visual world of the ordinary. The ordinary is built on rules and patterns that are incorporated; they structure the lifeworld of a culture in a way that allows them to stay implicit, not spelled out linguistically – they manifest themselves as rules only to a distant observer who can read as Siegfried Kracauer recommended 'the surface' (Kracauer, 1995: 75). It's on the surface where the visual unfolding of actions and

movements takes place – it happens on the same plane. The comical moment in Ottinger's work develops from a very specific inscription of an ethnological gaze to an aesthetic transformation of the documentary. This entails departure from a strict empiricist, pseudo-neutral observational gaze; it establishes instead the gaze of a sympathetic traveller who participates temporarily, sharing a space and time continuum without occupying more than the space the camera takes. This gaze that shares in a smile of the ordinary side of life and shows in respect the cultural techniques performed by the hosts is very different from a colonial look that refuses to share and implement itself as a dominant position of taxonomy and typing.

The question of typing relates to another aesthetic performance of theatricality and comedy. In the fiction films of Ottinger, we find a baroque excess of ornamental costumes that are tailored to cut different types, sometimes paired with professions: the scientist, the forester, housewife, etc. Types that are emerging out of the visual cosmos of iconographies of theatrical costumes and social masquerade. In Italian commedia dell'arte, comical roles are based on types that are linked to narrative conventions as well as to visual masks and costumes. They are also playing with social and sometimes ethnic stereotypes: the good, the bad and the ugly, the young and the old, the rich and the poor, servant and master. The carnivalesque and burlesque from these older forms of comedy melt into forms of grotesque that have little in common with comical forms that aim to excite hilarious laughter. They point to an interplay of masks and social roles with erotic aspects (*Madame X*) as well as with deep layered bodily images and functions (*Freak Orlando*).

Umberto Eco made in his introductory essay on *The Frame of Comic Freedom* for his book on carnival a strict distinction between laughter and smile, between the comedy of laughter and the humour of smile. He emphasizes that in humour there is 'a shade of tenderness' (Eco, 2011: 8) that distinguishes it from the sadistic pleasure in comedy. In humour, there is no *Schadenfreude*, one could argue, but empathy with the fragility of humans, things and actions. 'Humour', Eco continues, does not pretend, like carnival, to lead us beyond our own limits. It gives us the feeling, or better, the picture of the structure of our own limits. It is never off limits; it undermines limits from inside. It does not fish for an impossible freedom; yet it is a true movement of freedom (Eco, 2011: 9).

What does 'freedom' mean in the aesthetic transformation of cultural, bodily and ethnic differences in a masquerade that comes with a smile? The smile stems from 'the picture of the structure of our own limits', hence from the insight in the need for, and the satisfaction of masking and dressing oneself, no matter how our body may be. We admire the costumes of everyday life in the *Tundra* as much as the excessive wardrobe of the travellers in *Johanna d'Arc of Mongolia*, or the generous gesture of a woman without legs in a voluptuous dress presenting herself

on a pedestal in *Freak Orlando*. By emphasizing height over shortness via a pedestal, we get indeed a visual impression of what it means to stay in a given structure without surrendering to it. The masks and costumes in Ottinger films are part of a performative play that veils and unveils limits and their transgressions as imaginary picturing – giving the whole concept of the picturesque a new sense: 'When a real piece of humour appears, entertainment becomes avantgarde: a supreme philosophical game' (Eco, 2011: 10). Eco's definition of humour echoes the characteristics of visual humour that plays with the intersections of the visible surface and the dilemma of representing the imaginary. The visual humour in Ottinger's work offers a model of queering the boundaries between the limitations of the material world and its transgression in picturing imaginary worlds.

My remarks on humour in Ottinger's work don't claim to point to some essential characteristics but are more to open up to specific moments *in* her work. What she herself refers to as *Theatrum Sacrum* would indeed be the shift to the opposite: rites, ceremonies and other performative practices that bear in themselves the power of transgression like rites of passage or *danse macabre*. But from here is another link to forms of the comical that come from the grotesque as the uncanny side of the comical. The turn into comedy, however, also denotes another border crossing – laughter and smile even in the blackest humour becomes a form of exhilaration that tends to be associated with lightness as an aesthetic category. Lightness becomes a form in the musical comedies and in dance, in burlesque shows and pop. In this, a potential of a playful relationship to the world builds up. Here too, we are dealing with the transformation of formerly fixed, canonized forms that become ornament:

> Ornament is one of the fundamental categories of art, along with architecture, sculpture and painting. It is an art with its own history, comprising all the shapes and patterns that human beings have applied to their buildings, their utensils, furniture, weapons and portable objects, their textiles and clothing, and even their bodies since prehistoric times.
> (Trilling, 2001: 14)

James Trilling's definition of ornament as art form allows us to not only bridge the aesthetic and the ethnological dimensions in Ottinger but also illuminate the similar affinity in pop art with its mixing of industrial ornaments and expressive subtexts. Trilling's classical definition of ornament as:

> The idea that patterns are not meant to be enjoyed for their own sake, so much as combined, overlapped, obscured by distance or uncertain light, and ultimately allowed to disappear into the texture of opulence is by no means confined to the European Rococo. A sleeveless over-caftan – the main garment in a Mongolian

woman's costume – comprises at least half a dozen different patterns. When we include the other garments and the jewelry, especially the lavish hair ornaments in silver, coral and turquoise, the impression of opulence is very similar to that achieved with lace in the Meytens portrait. Here, too, no attempt is made to cheat with sloppy ornament.

(2001: 26)

In many films, singing and dancing play a role, while sketches and performances take place many times over. It's no coincidence that Ulrike Ottinger also directed comedies for the theatre stage and opera. As a production for the avantgarde festival *Steirischer Herbst* (*Styrian Autumn*) in Graz 1999, she directed *Das Verlobungsfest im Feenreiche* (*The Engagement Feast in the Fairy Kingdom*) by Johann Nestroy, one of the most sophisticated Austrian play writers of the nineteenth century, who is famous for his farces with singing. Ottinger binds the Austrian farce together with the Japanese Kabuki Theatre. In an interview with Mathias Grili, Ottinger (ulrike ottinger [website]: n.d.: n.pag.) comments:

It is also interesting how he dealt with theater traditions even in the revolutionary period of the pre-March period and how he worked with a variety of elements in this play. Nestroy describes social breaks. And there have been and still are in Japan. The collision of all these breaks should be manifested in the performance: the form of the magic game that Nestroy chose for his play has structure and content-related facets similar to the classic Kabuki theater.

The mixture of farce and Kabuki leads to another grid of ornamental interweaving. There are Japanese yodelers on stage; costumes from both theatrical worlds are morphing. In a sketch from the preparation of the stage production, we get a brilliant example of the visual humour in Ottinger's work (Figure 3.2). On the left column, we see a traditional Japanese male hair style, binding the hair like a brush from the back to the top of the head. On the right column, we see a traditional Austrian hat that is decorated with a similar looking brush of hair, the so-called Gamsbart (a tuft of chamois hair worn as decoration on a hat in Alpine regions). The migration of forms takes place in this series not only between two cultures but also between two species as the Austrian part is not about human but animal hair.

In *Freak Orlando*, there is a similar transition from a short man to a large dog that are both covered by the same skin pattern. The skin as screen of ornaments is also mirrored in the flag that points to the procession as a performance riding under a flag, a strange church procession in which species intermingle and become all parts of a totemistic ritual. As there is no narrative message that gives a mythical frame for the appearances, the character

FIGURE 3.2: Charcoal drawings in preparation for *Das Verlobungsfest im Feenreiche*. Ulrike Ottinger, Berlin, 1999. © Ulrike Ottinger.

of the grotesque prevails. 'The joke is the priest in disguise who marries every couple' (Paul, 1813: 175). The history of the word 'grotesque' is of Roman origin and refers to the bizarre ornaments of plants, animals, magical creatures and humans with which the Roman underground grottos were decorated. In the Renaissance, these ornaments were rediscovered and served Raphael as models for his decorations of the papal loggias in 1515. Since then, the term 'grotesque' has not only circulated colloquially but has also become part of aesthetic theories and theorems. Friedrich Schlegel, the Romantic, already saw in the grotesque an aesthetic of chaos and the satanic, but also, 'Nothing is funnier than and more grotesque than old mythology and Christianity; that comes because they are so mystical' (Schlegel, 1974: 902). This already points not only to the 'modern' aesthetics of the grotesque but also to its proximity to myth. In Ottinger's sense of humour, the historical and ethnological sense of rituals and performative objects is neither denied nor celebrated – it is taken as a cultural practice in a lifeworld that has equal distance to others – a generous view of a director of the *comédie humaine*. And as such it has no definite end, it can end

after 20 or 280 minutes; it will always be only moments of a bigger play, and so one could conclude with Adorno. 'Then the inconclusive ending also unravels: as a balancing, an artful non liquet. Indecision becomes the result. Expressive character and understanding of form become intertwined; only the enigmatic humour illuminates the whole form' (Adorno, 1997: 224, trans. by author). Humour becomes a function of form – while life forms have underlying world constituting rules, aesthetic forms have underlying lives and constitute a world of their own; humour is a way of looking at those discrepancies.

REFERENCES

Adorno, Theodor W. (1997), 'Der getreue Korrepetitor: Anweisungen zum Hören neuer Musik', in *Gesammelte Schriften, Band 15*, Frankfurt a. M.: Suhrkamp Verlag.

Eco, Umberto (2011), 'The frame of comic freedom', in Thomas A. Sebeok (ed.), *Carnival!*, Berlin, New York: De Gruyter Mouton, pp. 1–10.

Koch, Gertrud (1984), 'Das lautlose Lachen im Käfig des Bildes – Jacques Tatis Konstruktionen des Komischen: Nachwort', in Brent Maddock (ed.), *Die Filme von Jacques Tati*, München: Raben Verlag, https://archive.org/details/daslachenimmitte0000lego/mode/2up. Accessed 5 September 2023.

Kracauer, Siegfried (1995), *The Mass Ornament: Weimar Essays*, Cambridge, MA and London: Harvard University Press.

Ottinger, Ulrike (2022), 'Ich traue den Bildern grundsätzlich alles zu', *AUGEN BLICK: Konstanzer Hefte zur Medienwissenschaft Heft,* 84, Herausgeber und Redaktion dieser Ausgabe: Beate Ochsner und Bernd Stiegler, pp. 7–108.

Paul, Jean (1813), *Vorschule der Aeststhetik*, SWL 5, https://www.projekt-gutenberg.org/jeanpaul/vorschul/titlepage.html. Accessed 5 September 2023.

Schlegel, Friedrich (1974), *Historisches Worterbuch der Philosophie*, in Joachim Ritter (ed.), Basel, Band 3, Darmstadt: Wissenschaftliche Buchgesellschaft.

Trilling, James (2001), *The Language of Ornament*, London: Thames and Hudson.

ulrike ottinger [website] (n.d.), web page, https://ulrikeottinger.com/de/buehnenwerkedetails/das-verlobungsfest-im-feenreiche-von-johann-nestroy access 27.22.2023. Accessed 13 December 2023.

PART TWO

THE CITIES

4

Ulrike Ottinger and the Fashion Imagination in *Bildnis einer Trinkerin* (1979)

Angela McRobbie

In the late 1960s the only place for clothes in West Berlin was C&A, so to find something extravagant or extraordinary you had to travel to Amsterdam or London.

(Claudia Skoda cited in Sack, 2021: n.pag.)

In the rather impoverished and not at all glamorous Berlin of the 1970s, the storerooms of the retailers for tailor's goods were still filled with the precious items of the prewar era, for which there were no longer any buyers: valuable pearl embroideries for belts, collars, bags, feather arrangements, some of which were made from entire birds, in all conceivable colours, tightly woven coat fabrics of wide-ranging structure and fantastic patterns, fur linings of silk and flowing, shiny, marbled, reflective materials of all kinds. You could buy boxes of it for little money. In the thrift shops of the American military, their remnants – clothing of a very different style, better suited to photo-novelas – under the motto 'Pay for two and get the third for free'.

(Ottinger, 2022)

Introduction: Fashion and estrangement

The boldness and wit with which Ulrike Ottinger brought the city of West Berlin into the vista of cinematic imaginaries with her 1979 feature film titled *Bildnis einer Trinkerin* (Ticket of No Return) is remarkable and still not fully acknowledged beyond specific academic circles and artworlds. Viewed back then, the film

possessed an energy and an exceptional self-confidence. There were two extended feminist academic responses to the film, the first by Miriam Hansen (1984) and the second by Kaja Silverman (1996). Both of these film scholars understood the film to be a major contribution to feminist cinema, one that opened up rich avenues for advancing debates on woman, masquerade, the image, the gaze and spectatorship. These responses were also very much of their time, with Hansen, in her not only theoretically driven but also enamoured account, reflecting on the questions of pleasure, fetishism and the wider feminist reception of the film, and Silverman pursuing an unswerving Lacanian feminist pathway through the film, and producing, in some sections of her paper, a scene-by-scene analysis of its engagement with issues of women, narcissism and the image (Hansen, 1984; Silverman, 1996). Alongside these contributions were shorter but also notable pieces by Mueller ([1981] 1982), Kuhn (1985), De Lauretis (1985), Silverman (1987) and White (1987).

The perspective I adopt here, and many years later, is much less anchored in feminist psychoanalytic thought. It would be important (and overdue) to consider the whys and wherefores that might explain the decisive shift in feminist film research away from this terrain of psychoanalysis, particularly the Lacanian tradition. More recent feminist theorizing in visual culture has asked us to consider the matters arising around the affective economy that specific art works engender; there is much more discussion about queer feelings, time and duration, about memory and the film archive. Individual queer artist studies have also made a re-appearance (Stacey, 2019). Here, I take the step of breaking some of the conventions of auteurship studies by proposing that attention be given to the collaborative role played by the lead actor in *Bildnis einer Trinkerin*, Tabea Blumenschein, who as a fashion designer, actor and model, brought to bear on her performance a productive and subversive tension to the aestheticism of the director's camerawork. (In this respect I am following the perspectives developed recently in queer film studies by Jackie Stacey in her illuminating essay on the actor Tilda Swinton, and also by Sophie Mayer in her discussion of 'queerscapes' and 'auteurpoetics' [Mayer, 2015; Stacey, 2015].) Tabea Blumenschein in her role as the unnamed 'Madame' performs according to Ottinger's vision, but she also stakes a distance from being a mere cipher for debates about women and beauty. While both women, on each side of the camera, share the aim of challenging the heteronormative idea of women being the object of the male gaze, the actor will not be subsumed by the narcissism which is also one of the film's abiding fascinations. She is no simple beauty, no cinematic muse. As Silverman sees it, it is the myth of Narcissus that drives the (quasi) narrative (Silverman, 1996). And while this would see the Madame, who swings back and forwards from self-love to self-hatred across the course of the film, drink herself almost to oblivion, in fact there is no clear dénouement. We cannot be sure, when she stumbles over on the steps of the

Bahnhof Zoo Station, that the closing scene of the film that follows, marks her own death drive, now complete. It is an ambivalent ending, a kind of fashion as well as a cinematic triumph with Madame seemingly encased in a wall of mirrors, but upright, walking, and with her high heels clicking. And if there are currents of desire circulating through the scenes, we are immediately reminded that struggles in love and sexuality for power and control are not the sole prerogative of heterosexuality. Ottinger openly avows the battleground of lesbian desire, as she also did in *Madame X: An Absolute Ruler* from 1976.

There is a sense then that the unnamed Madame is actively making a claim to the film, to the celluloid that bears her own image. This accounts for some of the tension. Through the vocabulary of punk fashion, she disavows the role of being a merely elegant lady let loose in Berlin. She foregrounds her attachments to various popular and vernacular elements: the seedy bars, the drab ice-skating rink, the badly lit passageways by the Wall. By adopting here a perspective that is informed more by cultural studies than by film theory, I hope to answer questions such as: 'Where does the energy come from?' 'What underlies the provocative and urgent sexual politics?' This is not a matter of weighing up the unique vision of the auteur director as against the cultural currents of the time. Rather, I will consider the value of the collaborations and the friendship circles and indeed the nightlife, and how these came to be absorbed into the already established and more erudite interests and obsessions of the filmmaker. (The interview in this volume with fashion designer and friend Claudia Skoda gives a vivid account of the evening excursions, see Chapter 16.)

The film itself is arranged around a series of highly stylized settings, encounters and scenes, as the camera follows the wanderings of a young woman who arrives at Tegel Airport with a one-way ticket (a 'ticket of no return'). The voice-over, in slightly kitschy terms, regales her as a legendary beauty. She is extravagantly dressed, changing her outfits throughout the course of the film. Her aim is to drink as much as she can and for as long as she can, against a backdrop of the divided city. She picks up and befriends a homeless alcoholic woman (played by the sculptor Lutze) and her cold gaze is only interrupted with a few brief scenes of enjoyment in a pub where she and the new friend are joined by the singer and punk musician Nina Hagen. Another short scene of pleasure takes place in her hotel room when she shares a champagne bubble bath with the homeless woman who cannot believe her luck finding herself suddenly surrounded by such luxury. The film ends in Bahnhof Zoo with the play of mirrors, a theme throughout, reaching a crescendo and with the focus on stiletto shoes registering the auteur's intentionality to claim a place within the repertoire of classic (Hollywood) cinema, albeit with a gender twist. In each of the locations, Ottinger's camera draws attention to and lingers on the composition of the image. Narrative time is disrupted to allow

the director to explore a technique that would establish her own distinctive cinematic style. There is a constant shift from the slowed down gaze of the camera, so that it almost becomes a photograph, to a moving image with an emphasis on tilted camera angles that mimic the inebriated state of the woman drinker, creating an inverted or upside-down aesthetic. The effect is to produce an atmosphere of estrangement from what, at the time, might have been referred to as 'bourgeois society'.

The dramaturgy of punk fashion reinforces this sense of disequilibrium, of things and persons being about to topple over. Arguably the motif of punk (and of youth culture) brings with it the shot of energy needed to sustain Ottinger's artistic ambitions in a context of low budgets and to bolster the scale of the project she was embarking on. She must also have been aware that she would be courting controversy. Ottinger was challenging the feminist and lesbian cultural politics of the time by making a film in which the main character seems to exude a steely narcissism. Ottinger also satirizes her imagined (feminist?) critics in the guise of three loudly didactic women (also a Greek chorus) described as 'social scientists' who, dressed in drab tweeds and harshly angled hats, shadow the punk-queen figure of Tabea Blumenschein. These ladies (named as Common-Sense, Statistics and Social Question) deliver an absurd (and so humorous) series of mini-lectures about the dangers of alcohol. As Miriam Hansen notes, when first screened the film was 'ruthlessly panned' in the journal *frauen und film* and elsewhere (Hansen, 1984: 98).

Ottinger turns the city of semi-deserted and derelict spaces into a stage set for the fashion designer, punk musician and artist Tabea Blumenschein. The city reveals itself as a place for counter-cultural living, a space of chance encounters with various other social outcasts. A good deal of attention is paid to the actual locations, such that, as Hansen points out, space triumphs over time and narrative is relegated to the side lines. There is the dingy light of the run-down skating rink, the tacky anonymity of the casino, the empty cocktail lounges, the working-class pubs. It is in the drab ordinariness of the locations that the city presents itself to the Madame. Fashion is the primary source of colour and energy. The stiletto heels and the loud colour-block outfits are brought into a dialogue with the chilly ice-laden coal-sooted urban landscape of the divided city. It is easy to forget how dark and gloomy and empty Berlin was in the late 1970s. Residential streets were almost wholly unmodernized, the grey, indeed blackened buildings were still riddled with bullet-holes. Young people in the western sector had space to experiment with alternative living, there were squats and communal living spaces, an anti-bourgeois spirit pervaded so much of everyday life, from the socialized childcare (*Kinderläden*) to the whole range of activities designed to encourage young people to develop a strongly anti-authoritarian outlook. It

was a city of subsidized social projects and the dominant strand of feminism that developed in those years from the mid-1970s was about the struggle for equality: at home, in work, in the field of sexual reproduction, for the rights of sex workers and against male violence. The emerging movement of feminist filmmakers reflected these concerns in the largely realist cinema that developed (Hansen, 1984).

Ottinger departed dramatically from this feminist collectivist impulse. Her film, from the opening shots, establishes itself as the product of an auteur director devoted to an avant-garde, a counter-realist cinema. It is the spirit of punk and the attention paid to shabby lesbian bars in rundown neighbourhoods, to slot machines in working-class pubs, to various other off-beat locations, to abandoned spaces, to semi-ruined buildings and to a cast of social outsiders, that indicates the presence of an artist interested in the underbelly and to what nowadays would be labelled the psycho-geography of the city. Fashion provides Ottinger with a plausible grammar of feminine queerness. The cinematography and the many fashion stills from the film, as well as the hundreds of photographs taken of and with Blumenschein in the 1970s (recently published to mark Ottinger's donation of the entire collection to the Berlinische Galerie), playfully explore the possibilities of contesting the heteronormative gaze, as well as subverting the patriarchal conventions of fashion photography. Much of the energy of these 'Night Sessions' is the outcome of the collaboration and the romantic partnership between the two women (Ottinger, 2022). The ideas tried out in the photo-shoots are subsequently refined and more fully developed in the feature film where fashion's capacity for the undermining of sexual norms anticipates Butler's *Gender Trouble* and *Bodies That Matter* (Butler, 1990, 1993). The many outfits consistently debunk and undermine ideas of fashion as an authentically feminine artifice. Blumenschein designed the various costumes that play a leading role as objects in and of themselves, but her active investment in the items, the way she wears the elaborate coats, dresses and trouser suits, as well as the three or four evening gowns challenges both the idea of woman as a mere clothes-horse, and likewise of the model as a kind of empty vessel. The lurking spirit of punk insolence indicates the presence of a vibrant female agency.

In this same vein and drawing on the psychoanalytic vocabulary of 1970s feminist film theory, notably Laura Mulvey's essay 'Visual pleasure and narrative cinema', as well as Mary Ann Doane's analysis of femininity and masquerade, Hansen makes the point that the theatricalized element of masquerade in Tabea Blumenschein's fashion creates a sense of distance (Doane, 1982; Hansen, 1984; Mulvey, 1975). With fashion de-naturalized in this way, gender itself becomes more fluid and less fixed. Femininity can be donned as easily as it can be relinquished, and this point is made when Madame briefly fantasizes herself in the back of a taxi as a leather jacket-wearing and moustachioed young man with greasy slicked back hair.

The clothes across the course of the film are so obviously staged and worn as if in quotation marks, that they contribute directly to an atmosphere of estrangement in the daytime and night-time peregrinations. This also gives the effect of a distance from heterosexuality, emphasized by the Madame's sharp refusal of any gestures of male interest (a point also made by Silverman). And likewise both Hansen and Silverman note that as the film progresses the outfits become increasingly metallic and brittle, culminating in the final scenes where Blumenschein is wearing a silver foil full-length dress. These authors suggest that it is as if the many mirrors she has looked into (and smashed) have now become somehow part of her fused identity, the woman has become her ideal-image. But this supposes a kind of binarism around the problematic of woman and the feminine ideal, which arguably the film in its queer poetics destabilizes or even refutes. Maybe indeed she is not even woman? We could see that final scene with Blumenschein in the silver foil dress as a culmination of the previous sequences which have by this point become a kind of visual play on the part of the director, a choreography, albeit one that is charged with tension. If the film opens with a swirling red coat, it ends with a long, layered, winged, silver and net, hand-crafted evening dress, an item that would not at all have been out of place at a punk gig in a sweaty basement.

The question arises then as to whether Blumenschein's performance corresponds with the theory of masquerade as originally developed by Rivière and extended by Mary Ann Doane (Doane, 1982; Rivière, [1928] 1986). Rivière considered the way in which women achieving professional status alongside male counterparts will feel obligated or pressured by prevailing cultural norms to disavow their achieved standing by rather ostentatiously displaying some of the accoutrements of conventional decorative femininity, albeit with some sense of distance. The requirement to assuage the fears of men by these affectations of frailty gives rise to some anger on the part of the woman, resentful if not furious that she must go through with this charade. However, the historical circumstances wherein these shows of exaggerated femininity become visible in public as recognizable tropes will invariably be times, moments or locations (such as Hollywood) of gender retrenchment, of a patriarchal insurgency (McRobbie, 2008). But Madame's insistence on the punk motif across each of her appearances creates something other than the ladylike caged anger of masquerade. Punk turned fashion into a kind of spiky rebarbative weaponry (Hebdige, 1978). In this respect, it is, in this film, the collaborative partnership of the actor and the director that proposes a historicity, one that records the potential feminist freedoms of this moment in the late 1970s and early 1980s for young women, that could be glimpsed, prior to the encroachments of the more fully capitalist, and then neoliberal retrenchments of the years that followed. (In this respect, I am following the lead of Carter and Yoon in Chapter 8 of this volume.)

Fashion also allows Ottinger to retrieve from history (and to reinstate) a cosmopolitan vernacular of feminine artifice that was also something of a disguise, a way of evading scrutiny, a means of achieving anonymity and thus of evoking the blasé attitude (Simmel, [1903] 1971). Through her painterly approach Ottinger orchestrates a marriage of sorts between punk fashion and the memories evoked of Weimar 'painted ladies' and expressionist fashion as a bold statement, an abrasive or razor-sharp cultural form. She and Tabea Blumenschein ruminate on the pleasures of aberrant desires, of a deviant femininity of wild decoration, self-ornamentation, elaborate eye make-up and what in punk grammar was called 'confrontation dressing'. Indeed, the three films, *Madame X: An Absolute Ruler* from 1976, *Bildnis einer Trinkerin* from 1979 and *Dorian Gray in the Mirror of the Yellow Press* from 1984 all reveal the elusive talent of Tabea Blumenschein, only recently fully recognized (at least in Berlin) following her death in 2020 (Meinert, 2018). She brings to *Bildnis einer Trinkerin* a tension from the everyday world of urban youth culture which opens out and enlivens the Ottinger repertoire, such that their collaboration takes on a visual effervescence.

The archaeology of the wardrobe

It will be for fashion historians in years to come to meticulously document the lavish costumes, the pieces of clothing and all the garments that have populated the films, photographs and art works of Ulrike Ottinger. The fashion archivists will need to foreground the important place these have occupied across her entire oeuvre, especially those accoutrements historically connected with femininity, since it is in this sphere that we find her most concentrated visual and aesthetic attention. There is much to be done in this regard. There needs to be an archaeology of wardrobe for this whole body of work. And this would include an account of how the pieces evolved from the drawing board through to execution. Even if we just restrict ourselves to the feature films from 1977 to 1984, there is a cornucopia of things. And over the years, there are tailored coats, dresses, boots and shoes, leather catsuits, silver tunics, shirts, blouses and magnificent hats. There are also framed tapestries of coats, dresses, headpieces and so on, prepared in this hand-crafted format as if in anticipation of future shows and exhibitions (a selection of which were on display at the Balade exhibition in the Institut Français in Berlin in 2021). There are exaggeratedly bright plastic scarlet crinoline dress sculptures (like that worn by Delphine Seyrig in *Freak Orlando* see Chapter 19, Figure 19.1). There are thick files of artist drawings, paintings of ideas for costumes and of course the photographs (Sykora, 2001). It is the fashion items which bring the painterly and compositional elements to the foreground. Ottinger's fascination

with, and absorption in, the power of things and the whole world of objects in her later ethnographic documentaries is anticipated in this respect.

Nowhere is this thing-like quality and the 'social life' of the dress more vivid than when Ottinger in *Freak Orlando* has two elderly men resplendent in full-length wide-skirted ballgowns, low necked, black taffeta-like material. Rickels notes that the image 'was inspired by Goya's Caprichios' (Rickels, 2008: 158). Their scrawny aged necks and grey-white chest hair are fully in sight. This is no drag act, just withered male bodies in feminine evening dress with one of the men playfully pulling at the beard of the other. Dresses are centre stage in these early feature films. Ottinger lifts items like the archetypal dress out of the hands of the more usual wearers, and bestows on them her own magical (queer) powers, so that whether they land on a male or female body, old or young, it makes no difference; they retain this sense of sculptural set-apartness. By making women's dresses (as well as suits and coats) become strange and even outlandish pieces, Ottinger exposes the arbitrariness of the gender system which so naturally ascribes this or that mode of clothing to subjects who are thereby, and by this point absurdly so, to be understood as male or female. The clothes dramatize the director's fascination with the gender system, while also demonstrating her painterly interest in colour, in composition and in stagecraft.

Fashion becomes an enormously malleable thing in Ottinger's hands. It merges at points with costume, but then it reasserts itself once again as fashion. It is a plastic, multi-media form, fluid and architectural. In *Bildnis einer Trinkerin*, it works choreographically as a set of movements, or moving objects, partnering the wearer with the buildings, with the Wall, with tunnels, railway sidings, coal slagheaps, working-class bars, with flat wastelands stretching out in front of the drab post-war blocks of social housing and with the kitschy tourist landmarks like the Moby Dick tourist boat. There is a whole of panorama of grey-skyed scruffy Berlin. Extravagantly colourful dress brings its own spatial logic, accentuating how Ottinger frames her images, still and moving. As she said in interview 'In some instances, I too, decide to freeze the film. One can look at a photo for as long as one wants. In film on the other hand each picture moves so quickly that one does not have the chance to understand the cause of one's pleasure or lack of pleasure' (Ottinger, interviewed in Mueller [1981] 1982: 33).

For Ottinger, the idea of popular culture resides primarily in the repertoire of classic Hollywood cinema with its own delirious obsessions: its music performances, the showstopping outfit, the hat with a lacy veil, the shimmering dress, the high-heeled shoes. At this point in her career and right through the Berlin trilogy, she establishes that she, as an artist, is more than able to match this cinematic sense of delirium, delirious herself perhaps with the power she discovers from being behind the camera and with having Tabea Blumenschein perfectly understanding what she needed to do, while also injecting her own subversively subcultural agenda.

This accounts for something like the atmosphere of accomplishment that the work creates. If there are invariably touches of Hollywood (Silverman refers to the *Gilda* moment in *Bildnis einer Trinkerin*), there are also and unfailingly references to the avant-garde, for example, in the cameo appearance of the well-known artist Wolf Vostell in an absurdist scene where he and others are sat round a dinner table, eating loudly, and where he, as Hansen notes, is wearing a 'coat of bread loaves' (Hansen, 1984: 98; Silverman, 1996: 65). This sheer sense of confidence and accomplishment based on the unique partnership of actor and director finds the fullest expression in a single intimate photograph, from three years prior to *Bildnis einer Trinkerin*. It is a joint self-portrait shot on auto-cue by Ottinger. (The work is titled *Self-timer with Tabea Blumenschein-, Erdmannstrasse 12, 1976*. Ulrike Ottinger Archive.) She and Blumenschein are posed in their Schöneberg apartment. Ottinger, dark-haired and wearing a light masculine- style tweed suit, is seated and she looks direct to the camera, solemn but engaging, almost girlish. Blumenschein is standing close beside her with slicked back hair and dark eye make-up. She strikes a model pose, arched, throwing her head back, with a glass of wine in one hand a cigarette in the other. In a tailored white shirt and black trousers she is toasting their success. On the wall behind them are three line-drawings by Blumenschein and a photograph of an indigenous hunter. The image featured in the exhibition titled *Interplay Tabea Blumenschein Ulrike Ottinger* at the Berlinische Galerie in April 2022 (Ottinger, 2022).

There is always something playful and experimental going on. The vast collection of images published in the Hatje Kantz editions will hopefully be the subject of much further discussion among fashion and film scholars in years to come (Ottinger, 2022). There is nothing quite like it for the reasons of the actor and director each exploring their obsessions and fascinations with film, fashion, sexuality and gender, in a way that defies the usual genres. They are fashion photographs without ever being presented or exhibited as such. They look like film stills but only a small number were ever officially designated as such. Some are reminiscent of the images from the Andy Warhol archive for their night-time informal compositions, but unlike that body of work they bear a feminist imprint, their invoking of queer sexual desire is warmer and less chemical.

The pop fashion aesthetic

The to and fro movement between the single slowed-down image and the flow finds a resolution in the idea of the tableau, a much-favoured feature of Ottinger's work. Here she 'arrests' our gaze. In *Madame X* and in *Bildnis einer Trinkerin*, the camera frequently remains for several seconds on the artfully made-up face of Blumenschein (the classic Hollywood reference). From the drawings to the

film stills that also became posters, to photographs that have all the qualities of the glamourous fashion shoot, to photographs that later came to be exhibited in their own right, to the elaborate dresses and costumes that appear on screen and in all the collaborations with Tabea Blumenschein and with the designer Claudia Skoda, there is no doubt about the director's intentions. She has mastered not just the art of cinema but also the techniques of conventional, high-end or upmarket fashion photography. We might assume however that this genre was not within the realm of ambition of the auteur director, even though she is clearly conversant with the Man Ray images and the various Surrealist fashion experiments. Mastery, of course, is associated with a patriarchal legacy and it is a guise that Ottinger playfully adopts, as if a requirement for her to pursue her own distinctive aesthetic project. It is also what gives her a queer license to undertake her filmmaking ambitions at a furious rate, taking on the full unapologetic persona of the auteur.

Bildnis einer Trinkerin also draws on the repertoire of the British punk subculture of the mid-1970s. This influence comes from Blumenschein who was clearly attracted to the style and to the abrasive do-it-yourself (DIY) sounds of punk music. (Her interest in subculture was lifelong, key to her later professional identity.) It is also from the aura and attitude of Blumenschein in the film that we witness the punk debunking of conventional beauty. This produces one of the strands of tension across the film, as if she, the Madame, wants to challenge the constraints of the beauty myth routinely imposed on women. With her over-the-top make-up and her 'crazy' clothes and wild behaviour, there is an attempt to refuse and subvert mainstream objectification. In one short scene she is standing aloft on a piece of open scaffolding performing a punk song, screeching out an ode to Berlin and accompanied only by a lone drummer seated out of her sight and directly below. She makes no effort to display any expertise as a singer; instead in typical punk style (and famously associated with female bands like the Slits and with Poly Styrene), she performs with an amateur or DIY enthusiasm. In *Madame X*, and more emphatically in the film from 1981, *Freak Orlando*, there are pornographic items which also figured in the early punk imagination, but which of course also pre-dated it, and that had their own underground history in the various sexual subcultures. Ottinger foregrounds the cheap fabrics and the general air of 'put-togetherness', the DIY signature style of punk, the collage and the clash, and she does this with a kind of gusto, for sure no other German film director was really thinking about punk at that time. Even if the punk repertoire came primarily from Blumenschein, Ottinger with her interest in surrealism and the Dada movement made something unique from this hybrid.

This pop fashion aesthetic (which she had also explored in her earlier pop art paintings from the 1960s and exhibited for example, at the Berlin n.b.k

in 2011 celebrating the award of the Hannah Hoch Prize, and in 2021 at the Gallery of Contemporary Fine Art in Berlin) has allowed Ottinger to avoid the highbrow chill of the avant-garde but without losing the tag of experimental art. Here pop is about things, rather than, say, about people or the popular classes. Ottinger's modernist reflex (*pace*, Susan Sontag, 1967) is to elevate pop into a more sanctified space. Punk's original expressions (led by arch-Dadaist and admirer of the Situationists, Malcolm McLaren) were not in art, but in fashion and music. These more popular forms were forged in the hands of British working-class youth at that time, and it was a distinctively working-class aesthetics of disruption that emerged, a class-led style of dissent (Hebdige, 1978). The vague sense of tussle we feel in the early films of Ottinger manifests itself as a tension as to what the status of pop was to be. It would be tempting to read it as something of a class struggle with Blumenschein bringing the street and elements of Berlin working-class culture to the work. This spirit of punk does not undermine or overthrow the avant-garde intentions of the films, but neither is there a harmonious marriage. (It would be relevant to draw attention to some overlap of interests between Ottinger here and Derek Jarman whose affection for punk was widely acknowledged). Ottinger seeks to, if not tame, at least contain this subcultural force, with painterly strokes and carefully composed images. She uses the subcultural vocabulary to improvise on a pastiche of haute couture, and with such a sense of street theatre that the outfits are immediately flagged as bizarre and for sure 'unladylike'. The various ballgowns are rough at the edges, with DIY touches, as mentioned above, the final dress (in scenes shot in the U-Bahn tunnels and stairwells at Zoologischer Garten) is made from silver baking foil tacked together and coming apart showing the Madame's bottom as she staggers up and then down the stairs. And when combined with garish punk make-up and hair styles and pillar-box red lipstick, these pieces loudly debunk the elegance of classic items such as the evening dress or the ladies' suit.

Without punk, the fashion ensembles in *Bildnis einer Trinkerin* would have relinquished their power and their meaning. If they were merely glamourous coats and dresses in the Hollywood style, Madame would simply have been a wealthy bored woman, in search of some adventures through the streets of Berlin, striking an image more like those found in the street scenes and interiors of Helmut Newton's photographs. The cheap and garish punk aesthetic in contrast gave voice to the sublimated forms of social anger with which the subculture more widely was associated. There is a prolific use of montage, collage and surrealist-type dream sequences all accompanied by an anti-naturalist use of sound 'exquisitely engineered by Margit Eschenbach' (Hansen, 1984: 101). The lightly orchestrated and melodic score of Peer Raben opens and closes the work, and it

establishes the essay-type format that will unfold and that ends in the landmark Bahnhof Zoo.

Likewise the first shots focus on the click-click sounds of Madame's high heels and the final scenes repeat the sound of the teetering stiletto shoes. Alongside these tropes which flag the film's cinematic heritage, there are the bold and bright strokes of colour which run as sequences right through and across the film in the form of Blumenschein's wardrobe which moves from brilliant reds to sunny yellows, to mauves, blacks, to watery pale blues to the final sequence of shimmering silvers. In effect, the visual conversation is between the figurations of punked up femininity, the city as a semi-abandoned heterotopia and hence a space for sexual minorities and others, and the role of the artist-director as a keen flaneur. The presence of the auteur's own hand is marked with characteristic wryness in the brief night-time scene towards the end of the film when Ulrike Ottinger herself makes an appearance sitting with a book in hand, on a bench in an empty and forlorn city underpass. She is dressed in a drab masculine-style raincoat with her dark curly hair loosely falling around her shoulders. In a setting which prefigures so many Almodóvar scenes, a dishevelled transwoman sex-worker tumbles out of a taxi, and slumps in tears on the bench next to Ottinger. It is a rare moment of intimacy and solidarity.

Arrivals and departures: The sexual geography of desire

'Fashion is the mould within which modernity is cast' wrote Walter Benjamin, who also understood fashion to be a kind of threshold concept, evoking dreamlike states (Benjamin cited in Wollen, 2003: 138). In its cycles of repetition, where the new frequently entailed a reworked resurrection of the old, fashion dissolved the linearity of time, and so countered the bourgeois myths of progress. Fashion delivered the new with all kinds of shocks and 'nervous stimulation'. At the same time, it retrieved things from the past that had only recently been discarded, abandoned as *passé*, and this led Benjamin to attribute to fashion an ability, a 'tiger's leap' backwards and forwards to imagine glimpses of a more utopian social world. Benjamin developed further Baudelaire's account of fashion and the kinds of anonymous, deviant women, who wore elaborate outfits in their city wanderings. Benjamin also brought the flaneur into more direct contact with the social geography of the streets, passageways, arcades and labyrinths, the 'underworld of our great city' as Baudelaire had put it, and this is a trope pursued by Ottinger especially in the sequence when dressed in a 'baby blue' shoulder-less leather dress Madame stumbles in the early morning light along the canal path, through an

overgrown wasteland against a backdrop of large industrial barges slowly moving along the water.

But it is the idea of arrival that remains key to the Ottinger work. The images that open her early films are presented with such (mock) grandeur that we are aware of her behind the camera, as the master of ceremonies being invited into her world. The curtain always rises. She makes a grand entrance. The Madame makes a startling arrival in the echoingly empty Tegel Airport in a red coat, pillbox hat, white high heels and cheap garish plastic sunglasses. In the scene that follows, she descends an elegant Charlottenburg staircase in full evening dress, with outsize satin bow in her hair and wearing outsize tubular spirals of Man Ray gold earrings. Ottinger's bold, seemingly self-aggrandizing stance also reflects the scale of her ambition in a male-dominated field. It was unusual for a woman director of that period, and it raises all sorts of questions. How does the work resonate now, four decades later? Was she 'too much' the *auteur*, something that was an anathema to many feminist artists and critics at the time who saw this kind of figure as an invention of patriarchy?

We might consider the term of 'mastery' as providing Ottinger with a tool for her own artistic departure. It licensed her to embark on her own worldly travels. It is a forgivable vanity as well as something that she has repeated, by 2020, with a self-mocking wryness and an authorial smile as evident in the opening sequences of *Paris Calligrammes*. There she offers a humorous parody of her own grand arrival in Paris aged 19, by means of an unreliable 'bubble car' (a favoured icon of the Swinging Sixties). The warm mellifluousness of her own contemporary voice-over conveys and gently ribs the scale of her youthful dreams. Certainly, there was no room for self-doubt in this 'portrait of the artist as a young woman'. She quickly finds a place for herself in the social circles of the many émigré and literary figures who gathered around the famous bookshops and cafes at the time, and she also becomes a habitué of the bars and underground gay clubs of the period. It is then with the grand entrances and magnificent arrivals that Ottinger presents herself and introduces her work to the world. Ottinger's three main characters, Madame in *Bildnis einer Trinkerin*, Dr. Mabuse and Dorian in *Dorian Gray*, are also wild projections of these artist ambitions. There is a woodenness about the acting which heightens the anti-naturalist effect, reminding the viewer that they are in reality the product of the Ottinger imagination (Hansen, 1984). The powerful 'tiger's leap' she takes into making experimental film and the accompanying sense of self-importance (with flashes of humour) can be read as an acknowledgement of her desire to understand how power works in a psycho-sexual sense, also as a set of structures that would otherwise quash and impede women's movement in the city as well as in the world of art and cinema.

ULRIKE OTTINGER

Conclusion: Queer spaces

Each of the following three scenes from *Bildnis einer Trinkerin* sees fashion, in the hands of Ottinger, do a certain kind of work in relation to the themes of gender, change, freedom and the city. In the opening sequence, this effect is introduced almost immediately through the floor-level camera angles that follow Madame's arrival in Tegel Airport. The voluminous folds of her coat compliment exactly the quite bizarre and eccentrically feminine architecture of the airport (now by 2023 no longer in use). How strange and remarkable it was, with a brutalist exterior and hexagonal structure accompanied by a seemingly incongruent series of small circular arrival and departure gates. There was something almost flouncy about these protusions. Designed by architects Gerdan Marg and Partner, and opened in 1974, arguably, no airport ever had such proportions, with a sloping concourse and the protruding micro-lounges. Ottinger accentuates the reds of the airport interiors with the crimson red outfit, the scarlet nails, the hat and the bright lipstick. The figure of Madame becomes part of a visual mapping, a psycho-geography. The cinematic space in those opening scenes comprises huge panes of glass, a passport control box, more windows, sliding doors, floors and seats, with the Madame in her heels, stopping and starting between these points. Trolleys clash and a businessman's suitcase spills its content out onto the floor. What is being established here is an awkward and wayward relationship that marks the woman's entrance to these 'ready-made' queer spaces of the city itself.

In an otherwise cold and impersonal scenario there are a few moments of warmth and friendship in that scene of jollity among the three women, Madame, Lutze and Nina Hagen and again this is expressed as a play of colour. It begins with Hagen performing an angry and provocative punk-style song with lyrics referring to rape and sexual violence. She then descends from the grubby pub stage screaming with delight to welcome the arrival of Madame. Nina Hagen is even more vividly punk in her piled-high and messy jet back hair, deep red lips and thick black eyeliner that stretches right across her cheekbones. She is wearing a kind of black satin catsuit with narrow white stripes running down. The other women (Madame and Lutze) are attired in what seem to be second-hand ballgown-type outfits creating an explosion of colour from mauve (Madame) to off-white (the homeless woman) to a dramatic black (Nina Hagen). The intimacy here takes place in a working-class bar, a shabby intimidating space, but again one that is, in its low status and low-income location, at least open to the presence of these deviant women drinkers (Figure 4.1).

This is not the case in the Café Möehring sequence on the more fashionable Kurfürstendamm from which Madame is eventually ejected for a small act of vandalism. (She throws a glass of brandy at the window of the café.) She has arrived

FIGURE 4.1: Tabea Blumenschein, Lutze and Nina Hagen, *Bildnis einer Trinkerin*. Photograph by Ulrike Ottinger, Berlin, 1978. © Ulrike Ottinger.

in a canary yellow trouser suit and coat, with white lapels made of remnant-type waxed cotton fabric. Underneath she is wearing a white nylon see-thru blouse. And from under the bright yellow pillbox hat, there are two long drapes of scarf in the same nylon fabric. The dramatic effect is made more pronounced by the cheap white plastic sun specs. These crystallize the jarring punk element. Ottinger makes the point with one of her lingering tableau-type shots. The yellows and whites descend down from the top right of the screen and are picked up with the white tablecloth upon which are three empty glasses. This picture could be taken as an 'edgy' urban fashion photograph, the figure at its centre is self-involved, indifferent to the surroundings, engrossed in the pleasures of being a sole woman drinker, in an elegant café (Figure 4.2). It is tempting here to invoke a prefiguring of Butler's trope of 'heterosexual melancholy' (Butler, 1993). But the small act of vandalism and the vibrant colours indicate that Madame's melancholy is not predicated on some sort of miserable repression of desire. Unlike in the genre of fashion photography where there is the trope of the cool and unavailable woman, there is no sense here that the woman has been forced to give up a same-sex love object

FIGURE 4.2: Tabea Blumenschein, *Bildnis einer Trinkerin*. Photograph by Ulrike Ottinger, Berlin, 1978. © Ulrike Ottinger.

and has thus preserved it melancholically, in the form of an idealized femininity. Madame has made no secret of her disinterest in heterosexuality. If the alcohol stands for some unspecified or undesignated 'other', and if her love of spectacular self-display betrays frustration with the limits of those modes of femininity deemed appropriate for cultural intelligibility, the desire, made real through the wardrobe of punk and its paraphernalia, is to be able to break through the confines of gender's many entrapments and to refuse those requirements.

If we read Madame's enigmatic aloofness through this subcultural lens, then we can infer its social dimension as hinging on a realization that despite the energy behind this urban adventuring, there still lurks a hostile world that is unwelcoming to the likes of her. She asserts her right to remain illegible, and to be able to roam the street, enjoying the cafes of the Kurfürstendamm. From the underground passages to the overground overgrown urban locations, she is expressing her own desires for heterotopic spaces of belonging. Madame's fantastic outfits and her unsteady urban strolls chime well with Walter Benjamin's attribution to fashion a capacity for glimpses of utopian possibilities (Wollen, 2003). The punkified brilliant yellows are not compensatory for her own enforced heterosexual repression,

but instead they signal the envisaging of something other than the present constellation of West German mid-to-late 1970s values that are complicit with the limited place accorded to women within the dominant political and cultural imaginaries of that time. This 'something other than' comes into vision not in the form of a direct social referent, but rather in the use of the repertoire of the urban subculture to ruminate on the plasticity of gender and desire. If this essay opened with some comments about the film's earlier reception by feminist film theorists, it may be appropriate to close with my own rationale for, nearly 45 years later, going back to a film I saw for the first time in the space of the Birmingham Arts Lab cinema not long after it came out. Others, over the years have hailed the film as a masterpiece, my aim here has been twofold, to consider its achievement as partly the result of a successful collaboration with the lead actor and fashion designer Tabea Blumenschein and to draw attention to Ottinger's sense of mastery as a self-conscious device that allowed her to make her own grand entrance into the male-dominated world of film production. Despite being on the other side of the camera she is also that 'woman' in the ballgown coming through the elegantly arched doorway in Charlottenburg. The film, for both actor and director alike, and back in 1979 created a visual language to convey gender's mercurial capacity, its sensuous fluidity, its temporal identities.

ACKNOWLEDGEMENT
Note of thanks to Ulrike Ottinger for personal communications regarding specific items of clothing and jewelry.

REFERENCES
Butler, Judith (1990), *Gender Trouble: Feminism and the Subversion of Identity*, New York and London: Routledge.
Butler, Judith (1993), *Bodies that Matter: On the Discursive Limits of 'Sex'*, New York and London: Routledge.
De Lauretis, Teresa (1985), 'Aesthetic and feminist theory: Re-thinking women's cinema', *New German Critique*, 34, pp. 154–75.
Doane, Mary Ann (1982), 'Film and the masquerade: theorizing the female spectator', *Screen*, 23, pp. 30–43.
Hansen, Miriam (1984), 'Visual pleasure, fetishism and the problem of feminine/feminist discourse: Ulrike Ottinger's *Ticket of No Return*', *New German Critique*, 31, pp. 95–108.
Hebdige, Dick (1978), *Subculture: The Meaning of Style*, London: Methuen.
Kuhn, Annette (1987), 'Encounter between two cultures: Discussion with Ulrike Ottinger', *Screen*, 28:4, pp. 74–79, https://doi.org/10.1093/screen/28.4.74.

Mayer, Sophie (2015), *Uncommon Sensuality: New Queer Feminist Film Theory*, Amsterdam: De Gruyter.

McRobbie, Angela (2008), *The Aftermath of Feminism*, London: Sage.

Meinert, Philipp (2018), 'Glamour in the tower blocks', Kaput: Magazin für Insolvenz & Pop, 15 June, htpp://www.kaput-mag.com/rainbow_de/tabea. Accessed 5 September 2023.

Mueller, Roswitha (1981–82), 'Interview with Ulrike Ottinger', *Discourse*, 4 (Winter), pp. 108–25, https://www.jstor.org/stable/44000265. Accessed 5 September 2023.

Mulvery, Laura (1975), 'Visual pleasure and narrative cinema', *Screen*, 16:3, pp. 6–18.

Ottinger, Ulrike (2022), *ZusammenSpiel Band1: fotographien*, Berlin: Hatje Kantz.

Rickels, Laurence A. (2008), *Ulrike Ottinger: The Autobiography of Art Cinema*, Minneapolis: University of Minnesota Press.

Rivière, Joan ([1928] 1986), 'Womanliness as masquerade', in V. Burgin, J. Donald and C. Kaplan (eds), *Formations of Fantasy*, London: Methuen, pp. 35–44.

Sack, Alexander (2021), 'Modern since 1973: Claudia Skoda tells her story', *032C Magazine*, 5, 27 August, https://032c.com/magazine/claudia-skoda-tells-her-story. Accessed 5 September 2023.

Silverman, Kaja (1996), 'From the ideal ego to the active gift of love', in *The Threshold of the Visible World*, New York: Routledge.

Silverman, Katja (1987), 'Fragments of a fashionable discourse', in Tania Modleski (ed.), *Studies in Entertainment*, Bloomington: Indiana University Press.

Simmel, Georg ([1903] 1971), 'The Metropolis and mental life', in David Levine (ed.), *Georg Simmel on Individuality and Social Forms*, Chicago: University of Chicago Press.

Sontag, Susan (1967), 'Notes on "camp"', *Against Interpretation*, London: Eyre and Spottiswoode, pp. 111–53.

Stacey, Jackie (2015), 'Crossing over with Tilda Swinton: The mistress of flat affect', *International Journal of Politics Culture and Society*, 28, pp. 243–71.

Stacey, Jackie (2019), 'Butch Noir', *differences: A Journal of Feminist Cultural Studies*, 30:2, pp. 30–71, https://doi.org/10.1215/10407391-7736035.

Sykora, Katharina (2001), *Film.kunst: Ulrike Ottinger, Die Deutsche Kinemathek*, Berlin: Kettle, pp. 1–76.

White, Patricia (1987), 'Madame X of the China Seas: A study of Ulrike Ottinger's Film', *Screen* 28:4, pp. 80–95.

Wollen, Peter (2003), 'The concept of fashion in the Arcades Project', *Boundary 2*, 30:2, pp. 131–42, https://doi.org/10.1215/01903659-30-1-131.

5

Ottinger's Berlin: Exotic of the Everyday

Esther Leslie

Berlin is the adopted home of Ulrike Ottinger and, since her arrival in the city, she has used it as a setting for films that explore the extraordinary aspects that lurk in the everyday. Berlin is a location that, in the films, harbours strangeness within it. This strangeness is not just in the bars or the places of nightlife where, understandably, a drinker might succumb to distortions and hallucinations; it is also in the everyday environments of department stores and the streets, spontaneous stages for a cast and cavalcade of characters who displace the ordinary and draw a connection between the banal and surreal worlds, the familiar and the freakish. Ottinger's films bridge between familiar parts of the city – streets, shops, bars – and its unfamiliar, sometimes overlooked, corners – long walls on backstreets, factory landscapes along the river. Or they combine, in one shot, something that is well known, well-traversed and something – or someone – enigmatic or anomalous.

The film by Ottinger titled *Usinimage* (1987) opens on a bridge. It is the bridge to an electricity power station, and its name is Siemenssteg. This bridge crosses the Spree, the river that winds through Berlin, linking Alt-Lietzow to the power station in Charlottenburg, which brings electrical current to the inhabitants of Charlottenburg, a district in the West of Berlin. In the opening moments of *Usinimage*, the bridge appears with a banner affixed to it, bearing the film's title and the name of its maker. Its words are in red and white and blue colours, the colours of the French Republican flag, the Tricolore, adopted in 1790, and modified by Jacques-Louis David in 1794. This flag – its colour scheme drawing on the traditional red and blue colours of Paris, worn as a cockade by the militia of the National Guard – is a gesture at liberation or a pointing away from the city that we see on screen, with its factories and infrastructure and difficult history. A republican force is emblazoned in Berlin. This appearance evokes multiple histories of enmity and amities in Franco-German relations, from the days of Charlemagne, through Napoleonic

occupation, to wars of the late nineteenth and twentieth century and the economic settlements of the European Union. In the film, children skip across the bridge, dressed in red-white-blue outfits of paper, waving French flags, also made of paper. They are singing in French. The bridge is a bridge between two worlds or many worlds – work life, home life, production, leisure, differing city parts with different social status. Here in the film it is a document of Berlin reality. It is a bridge that leads to a power station and will be traversed as it has been traversed for 100 years. It is also a fiction. These children are dressed for the film. Their costumes are wild. The bridge is dressed for the film. The image is one that is historically faithful, in the sense that it maps a history of international relations that have been and are on-going, including the history of nation-friendship societies, which make efforts to bridge once warring peoples. Every German city has a French-German Society – the one in Berlin was founded by Albert Einstein, Otto Dix, Georges Duhamel, André Gide, Konrad Adenauer and Thomas Mann. The image of the bridge is also a surreal one, an absurd one – children dressed in paper skipping across an industrial relic on a chilly Berlin day, nearly a thousand kilometres from Paris. Inside this span between document and staged absurdity, with carnival occurring in the industrial wastescape, are to be found Ottinger's films. *Usinimage* melds the French word for factory (*Usine*) with the French or English word for image. The factory or power station (a not uncommon presence in Otinger's films) is in view: Usine. But it might also be suggesting something else – for the title sounded out seems to have the word cinema caught inside it – 'u – cinema – ge'.

This is city in film, on film, as film. *Usinimage* is a film of recycled images, gleaned from some of Ottinger's films until that date, found footage, in a way, if it is possible to find footage that is already your own. The recycled imagery is set alongside some documentary images. It appears like a location scout's showreel of the wildest environments that might be sought out for a dystopian drama. And yet, this is everyday Berlin. If the settings are extracted from previous films, recycled and strung together, this city that was a void on East German maps, was *still* a void on East German maps in 1987 when *Usinimage* was made, is mapped from its edges, from its interstices and from its seemingly un-map-worthy parts. It was parts that were different at least to the more common filmic images of the city, which showed Berlin as a drab, placeless place and the only genre applicable – spy films with exchanges of personnel on the far fringes, at the Glienicke Bridge, spanning the Havel in the West of the city. A different bridge. Another genre. Another unreality.

Usinimage moves between filmed locations and film locations: places that exist and are recognizable from daily business in the city and spaces that are hidden away, remarkable as image, even if they are ordinary to the process of production and distribution and another type of everyday business. The film – or each film it

draws from – depicts a world of the non-film, the city outside its representation in film, a place of work and leisure and a world for film, a profilmic world. It is, in more clichéd terms, showing the real world – workaday, unreflected – and the mirror world of film, which involves how it is staged and dressed. Both these things occur at once. After the bridge episode, with its colourful banners and children, the scene shifts to an industrial site with large concrete pipes. These appeared in *Freak Orlando* – where Berlin, location for 'a small theater of the world' (ulrike ottinger [website], n.d.: n.pag.), is inhabited by a cast of 'freaks', in the manner of Tod Browning's *Freaks* from 1933, and with reference to Virginia Woolf's gender-shifting protagonist from 1928. The camera looks through the pipe. It becomes like an extension of the lens. The filming through the pipe frames the landscape or cityscape. It is making a landscape come into being too, making an image that did not exist before, except this one did, but to other ends. We see again.

And then, again, from another perspective, the title of this film, *Usinimage*, unravels as 'us in image'. And if it is us in the image, then we are enjoined to see ourselves within this picture of a city of marginal people, of survivors of bleak times, of people, who have not made for themselves 'such comfortable arrangements' in 'an uncomfortable situation', as Walter Benjamin put it in relation to earlier waves of Berlin avant garderie, from the papier-mâché clenched fists of 1910s' expressionism to the cool cynicism of New Objectivity, one hyperbolic in its feelings, the other having sold them off to the highest bidder, as poetic amusement (1999: 424). The Berlin that appears in Ottinger's films is distinctly Berlin – it is a document of a place, of places that are specific to that city and recognizable as the bridges, the industrial structures, the housing stock. And it is also not. Berlin, or parts of it, less traversed parts, edges, desolate zones, offer themselves up as a stage, not a comfortable one, but one that makes a good image. It is a view on the city from its strangest and sometimes inaccessible parts. Or it looks upon what is known already through a defamiliarizing framing or an implausible and incongruous act in a space. We who are in the image of this Berlin caught on film embrace the uncomfortableness of life inside a pipe or in the shadow of the Olympic Stadium or in a graveyard or on the vast roof of a gas tower. This is Berlin. This is why we came here after all. What brought Ottinger here and to what was she drawn?

Berlin in *Usinimage* appears as a city of industry (Figure 5.1). Industry is the stage here and the locations are often those that are not in the buzz and centre of the city, or even their anarchist margins in Kreuzberg. Rather the film records the corners that are not overlooked so much as overlooking, for they are the locations of vast structures that are not accessible to the inhabitants of the city who do not work there. That is not its usual face, at least not to the outside world, which saw it, especially in these days of the later 1980s, as a stage for political tensions, the

FIGURE 5.1: Industrial Landscape Berlin, *Usinimage*. Photograph by Ulrike Ottinger, Berlin, 1987. © Ulrike Ottinger.

folding points of East and West blocs. Berlin (West) was the *Frontstadt* ('frontier city'), torn city of the Cold War, encircled by a wall, a playground prison, where some of the rules of the West did not apply. It was junk space, a hole, a void that could be all the more frantically populated by experiments and under-the-radar actions, because neither East nor West wanted it in sight. This meant it was a place of large cheapish flats, with high ceilings bearing stucco elements and shiny parquet floors: the first made the *Hochbett* ('high bed') possible, the second invited mattresses without bedframes. *Kachelofen* ('tiled stoves') provided the only heat; toilets were sometimes in communal hallways. Such space, unwanted by most, made possible the squatters, the collectives and communes, brought together to discuss and argue in spacious kitchens, in *Wohngemeinschaften* ('communal households'), and there were the bars. This was a self-conscious city. It could incubate, in the 1980s, the Berlin School of the Ready-Made, with its repurposed objects from everyday life, such as the Consumer's Rest Lounge Chair, made of a barely transformed supermarket shopping trolley.[1] This was not just a reference – however ironically – to consumerism, for good or ill. It was also a venerating gesture towards the protagonist of countless May Day Riots.

The Berlin shopping cart smashed through countless windows and was used to carry away stock from Kreuzberg supermarkets.

The Berlin School of the Ready-Made came out of Berlin in the 1980s and it went along with the shifting of the city. It was, it could be said, becoming somewhere in this period. As the 1980s arrived, Berlin (West) took a step towards – once more – hosting an art scene, and this in the mode that existed in other parts of West Germany. In 1977, some art students opened a gallery in what Martin Kippenberger called 'the toughest territory in the city' (as cited in Felsch, 2021: 140). It was in shadow of the wall at Moritzplatz and the artists painted intensely coloured neo-expressionist paintings with city scenes and exaggerated bodies. These artists, it is said, frequented the bars nearby and their night-time excesses became a part of what it meant to live the artistic life (Felsch, 2021: 151). Underlining this commitment to intoxication, in 1979, the Galerie am Moritzplatz had a show titled 'Alkohol, Nikotin fff'. Martin Kippenberger managed the nearby punk club SO36 at this time, the time when he appeared in Ottinger's drink-soaked *Ticket of No Return*.

This Berlin of art events and a burgeoning 'scene' of fashionable bars snowballed in the 1970s and 1980s, as some sort of reanimation of a Berlin of cabarets, cafes and art movements from before the years of the Second World War. When Wolf Vostell undertook a 'happening' in front of the Free University in West Berlin in 1967, it seemed incongruous to bring together avant-garde performance and political action. He unfurled a roll of wallpaper that bore an image of student radical Benno Ohnesorg bleeding from a fatal head wound, inflicted by a policeman in a demonstration. Vostell was threatened with violence by leftist students. Helmut Lethen, student radical at the time, recalled in his memoir: 'We looked at Vostell with indignation. [...] He appeared like a ghost of the *bohème* that we thought was dead and buried' (2012: 91). Vostell had been undertaking performances in the Rene Block Galerie since the mid-1960s and he made assemblages and dé-collages of the detritus of the German past, gleaned from flea markets – Nazi-era radios, wrecked cars, barbed wire, newspapers (Mesch, 2008: 17, 55). These were ready-mades that brought with them sometimes present, sometimes decrepit but still resonant German ideologies and atrocities. It was activity such as this that drew Ottinger to Berlin, to help develop – or document – this world of cultural rebellion, of what would soon become graffitied punkish bohemia, spreading Eastwards in West Berlin into Kreuzberg. Ottinger observed in an interview that she decided to go to Berlin because some 'friends made Happenings there' (Kelsey, 2020: n.pag.). Indeed, she came in 1973 to document in a 12-minute film Vostell's Happening, *Berlinfever*, an exploration of the 'psycho-aesthetics' of the car, undertaken through a series of ritualistic actions performed by a Berlin-based experimental art collective, ADA or Aktionen der Avantgarde in a wasteland. What struck her about Berlin at this time was that 'this was a city where you could see

German history' (Kelsey, 2020: n.pag.). She saw the soot on the façades of the coffee houses, but also in the faces of the people. The environment marks itself on bodies. History comingles with the city and its people.

In a while, these experiences and these people and the differing parts of the city of Berlin found their way into her films: the people of the burgeoning Berlin culture scene such as Wolf Vostell, Nina Hagen, Martin Kippenberger, the locations of Berlin, especially, the bars that define the city from the Weimar years onwards, but strikingly again in the 1980s,[2] the industrial sites, established in Berlin in the nineteenth century and the gardens and parks of an eighteenth-century courtly Prussian city. The many ages of Berlin, including its present, could be a stage. It already was a stage – or had a stage, for political pronouncements by political figures from the East and the West in the days when the Berlin Wall was new – it raged behind Lyndon B. Johnson in 1961 and again, with Willy Brandt in 1964, John F. Kennedy in 1963 and others. The wall was a backdrop to countless peregrinations in the Cold War – but it is not the focus of Ottinger's films. Other long walls appear, those that skirt cemeteries or parks or industrial sites. Still the Berlin Wall determined the landscape, left corners of the city, or whole districts, somewhat stranded. What had been centres became margins. This cultivated cultures in the shadows – and the very existence of the wall and that of split city meant that the West of Berlin, a Front-City, a subsidized city, was not attractive to the affluent sections of the West German populace. The 'rental barracks' of the nineteenth century, with their high ceilings, briquette stoves, painted wooden floors and stairway toilets, were available for low rents or for squatting and they housed communal households where, owing to Berlin-West's 'Sonderstatus', until 1990, as a 'four-sector' city under allied control, males living there permanently were exempt from Germany's military service for 18–28 year olds, as well as from the alternative *Zivildienst*. But Ottinger's films take place not in communal households but rather in outside and public zones, in shops and bars, on streets, in parks and wastelands, on gas towers, bridges and in factories. Outside made the best stage and the city itself could be a player. In 1982, the New York publisher, Semiotext(e), published a Berlin-focused volume, *The German Issue*. In an interview in the volume, the playwright Heiner Müller stated that one of the advantages of Berlin was that: 'One can see the end of history more clearly from here' (Lotringer, 1982: 52).[3] He underlined how the wall was 'a sign for a real situation, the situation the world is in. And here you have it in concrete' (Lotringer, 1982: 82).

Did Ottinger turn her camera onto Berlin in order to bring into focus the end of history? Her films captured if not an end to come, then repeated ends, or a glimpse at much that had gone before in waves of catastrophe. The resonant site of the 1936 Olympia Stadium appears in *Freak Orlando*. The Olympic Rings echo

the concrete pipes in another part of the film, but these potent rings cannot have the Nazi taint wiped from them. What they signified once can be compromised, though, by a new set of people, the freaks who move towards it, in an effort to counteract the multiple signs around the site: Keine Besichtigung, No Sightseeing. The Olympic Stadium is too visible a site, too freighted a location perhaps, and it bleeds too much awful history. There are other, less familiar, even defamiliarized locations in Berlin that absorb more camera time, become sights to be seen. More striking, more open to filmic transformation, are the sites that a 'flaneur' such as Ottinger comes across, real but little-known places that allow the city to reproduce itself:

> Berlin needed to have all these stocks of coal, of food, of everything. So this coal is, in *Freak Orlando*, prominent, of course. Then because, from these coals hills, by wind, a lot of dust was coming through the city. So they covered it with this green plastic. It looked like a crystal.
>
> (Kelsey, 2020: n.pag.)

The recorded locations show the city at all levels. The city appears as it is below – in the sewers that carry away the waste. Sites of production on the ground are depicted, and these reach beneath and above, to mine, to store, to supply. The vast spherical gas towers around which the freaks gather are concrete and real and they supply gas, but they also appear like globes that are worlds – and as such they echo that towering structure, a sphere on a pole, which soared above the Berlin Wall and showed the forbidden West to Eastern tourists and reminded the westerners always of a division, a cut through the city. These are real structures but the syntax is utopian and dystopian at once. The figures in *Freak Orlando* carry a structure through the Berlin cityscape, in the shadow of the gas towers and to the summit of the crystal coal hills. It looks like a kind of Tatlin Tower, or Monument to the Third International (1919–20), an architectural configuration against which the fluctuating gauge of revolutionary ambition can be measured in the appearances and disappearances of a model of a building that was never brought into being, a building that remained a monument to something that undid itself: the revolution. Tatlin's 'Monument to the Third International' or the Tatlin Tower, with its spirals and scaffolds, representing qualities of iron, glass and steel that would have been hard to come by when it was first conceived, has been patched together in miniature form at regular intervals, since its first appearance in street parades in the young Soviet Union, when it too was carried aloft by the new inhabitants of a promising new age, this avant-garde suggestion of new communities. The conic pyramid in *Freak Orlando*, carried through the city, might too be a hint at a utopian architecture, at some of the

trial efforts at making new buildings for the freak community, just as were the *Wohngemeinschaften*, the communes, the squats – experimental trials in a flimsy form of possible futures.

Berlin is always a historical palimpsest – divided city, it faces back into horror pasts that, through acts of negation, meld with expanded possibilities of experimental, non-fascist life. It piled historical event upon historical event along the fold of the line of division, until that line was erased or forcibly breached. Ottinger marked the results of a recombination of states in a long documentary film, located in Berlin and surrounding Brandenburg: *Countdown*. The countdown was not directed at the geographical merging of city or national parts, but at its economic reflection: monetary union, or the day when the German D-Mark would become the sole currency of a (re)united Germany. Its interest is in everyday life, the non-dramatic events of existing in a space that changes around one. There are extraordinary experiences – to walk on what was once a death strip, to chip away at a wall that had cut a city apart. There is also banality, which may have tinges of exoticism for some: adults developing their consumer selves, waiting in lines at cheap stores that sell goods impossible to get for so many years or setting up more and less legal markets, children playing in streets, as they always have done. The picture produced is less a levelled one of ideological and political unity and more a sense of chaotic but germinating disunity.

Still, that might seem too positive a take on a history of a location and it is not always the Berlin that is returned to in the frequent returns to Ottinger's work. The Berlin Trilogy is evoked in relation to that persistent image of Berlin as 'World Capital of Negativity', as it is named, for example, in a screening of *Ticket of No Return* at Studio Camp in Mumbai in 2009, along with Berlin-based *Possession*, directed by Andrzej Zulawski (1981).[4] The film notes for the screening observe how the name Berlin derives from 'swamp' or 'built on sand'. It evokes a variety of critical assessments of the city: Blanchot's idea of the city as 'a political abstraction', the negative diagnoses of a variety of commentators including Franz Wedekind, Alfred Döblin, Walter Benjamin and Klaus Wowereit, Mayor of Berlin from 2001 to 2014, who famously declared Berlin to be 'poor, but sexy'. Some of the names listed might appear in an Ottinger roll call. The film notes continue by defining negativity: negation, denial, politically disempowered apathy and politically engaged repudiation, and so on. It concludes: 'Commonly cited causes of negativity: bad weather, bad food, bad housing, the Great Depression, the Cold War, the German Reunification (see: Berlin)'. All routes lead back to Berlin. And it is a city in which, in the final part of the notes, the meaning to them of Berlinerish negativity as expressed in the portrait of an alcoholic is revealed:

TO CAPTURE THE SPIRIT OF A CITY, expression - 1. to drink oneself to death: to capture the spirits of a city (to never return from a city); 2. to find the monster one's wife is having an affair with: to chase the ghosts of a city (to be possessed by a city); 3. to build a wall around a city.

How these films might capture spirit is presented multiply: alcohol, ghosts, the making of a special enclave, with its Sonderstatus. Is the spirit of the city captured in Ottinger's work? Its excess and intoxication, its ghosts, its cultivation of alternatives in the margins, its restarts of historical time – all this is spirit of a city at a particular time. In the films, there is a view of an other Berlin, beneath, above the surface one, extended, a document and fantastical at once.

As I was researching this essay, I came across a scene that was being passed around on social media.[5] It was a short video of a woman, in January 2022, on Adalbert Bridge in Berlin, confronting a swan that had flown up from the Spree River and was disoriented. The woman, elderly, forceful in her walk, confidently wrestles the bird, as if she had spent her life doing it, pulling back its wings, retracting a webbed foot, as it hisses and struggles. She flings it over the bridge and it gets its water legs again, back in a familiar environment. The scene is mad, heroic and has a brutality about it. It is a Berlin day. Some testify that the woman is a newspaper seller near the bridge. The bridge is a real thoroughfare, a place of everyday transporting. The bridge is a stage, a place for heightened reality to transpire. It is ordinary and it is extraordinary, a paper seller and a Leda wrestling her oppressor, giving and ungiving at once. Like a film by Ulrike Ottinger.

NOTES

1. Philipp Felsch (2021: 268, 278, 366) mentions the design school in his study of Merve Verlag. For further exploration, see Borngräber (1987 and 1988).
2. Diedrich Diederichsen, in *Sexbeat* (1985: 187), records the phenomenon of late-night bars and their significance to a burgeoning scene.
3. In 1996, Merve published a reflection on this scene, titled *Geniale Dilletanten* with illustrations by Tabea Blumenschein, who was the lead character in *Ticket of No Return*.
4. A URL points still (September 2022) to the remains of this set of film screenings on 11 and 12 January 2009, titled 'Pirate Cinema 2' on the cinema's rooftop. The films shown under the heading Berlin, World Capital of Negativity were *Ticket of No Return* and *Possession*, directed by Andrzej Zulawski (1981). https://studio.camp/events/pc2/. Accessed 7 September 2023.
5. Stored variously, including: https://www.independent.co.uk/tv/lifestyle/stranded-swan-bridge-berlin-video-v33481de6. Accessed 7 September 2023.

REFERENCES

Benjamin, Walter (1999), *Selected Writings, Volume 2, 1927–1934* (eds M. Jennings, H. Eiland and G. Smith), Cambridge MA: Belknap Press and Harvard University Press.

Borngräber, Christian (ed.) (1987), *Berliner Design-Handbuch*, Berlin: Merve.

Borngräber, Christian (ed.). (1988), *Berliner Wege: Prototypen der Designwerkstatt*, Berlin: Ernst & Sohn.

Diedrichsen, Diedric (1985), *Sexbeat: 1972 Bis Heute*, Cologne: Kiepenhauer & Witsch.

Felsch, Philip (2021), *The Summer of Theory: History of a Rebellion, 1960–1990*, Cambridge: Polity.

Kelsey, Colleen (2020), 'Ulrike Ottinger's house of fucked-up fantasy', *Garage*, 28 August, https://garage.vice.com/en_us/article/g5p37q/ulrike-ottingers-house-of-fucked-up-fantasy. Accessed 9 May 2023.

Lethen, Helmut (2012), *Suche nach dem Handorakel: Ein Bericht*, Göttingen: Wallstein.

Lotringer, Sylvère (1982), *The German Issue*, New York: Semiotext(e).

Mesch, Claudia (2008), *Modern Art at the Berlin Wall: Demarcating Culture in the Cold War Germanys*, London: I.B.Tauris.

ulrike ottinger (website) (n.d.), 'Freak Orlando', https://www.ulrikeottinger.com/en/film-details/freak-orlando-2. Accessed 2 November 2023.

6

Prater (2007): Cinema's Carousel

Mandy Merck

Part one: A linear preface

Originally a hunting ground for the Austrian nobility, the 'prater' or meadow northeast of Vienna was opened to the public by Emperor Josef II in 1766. While much was retained as a woodland park, the establishment of inns, coffee houses and bakeries secured its reputation as the 'Wurstel Prater', a place for holiday congregation and feasting. Throughout the nineteenth century the site flourished as an amusement park and, with the colonial impetus of the century's trade-cum-culture fairs, was chosen to stage the World Exhibition of 1873. This global aggrandizement was subsequently sustained by the creation of 'Venice in Vienna', a miniature copy of the Italian city complete with canals and a replica Rialto Bridge, and an 'Ashanti village' whose African inhabitants were displayed to the curious. In 1897, the park's most famous attraction, the 200 foot high 'Riesenrad' or Giant Wheel, rose above the city, where – after its post First World War rebuilding and that of the surrounding park after the Second World War – it circles today above scores of contemporary and antique exhibits, rides and arcade games. (Figure 6.1) As one of the world's oldest amusement parks, asserting its age in lovingly reconstructed carousels and ghost trains, the Prater proclaims its 'charming historic feel', but this is not the sentiment evoked by Ulrike Ottinger's documentary. The intercutting of early film footage, childhood recollections and the casual racism of its historic attractions with the nerve-shredding plunges of its contemporary rides leaves the taste of what one commentator recalls as 'cotton candy and vomit'. If, as Kristen Whissel (2007: 128) has complained about Ottinger's 1989 *Johanna d'Arc of Mongolia*, 'imperialist discourses […] make it a pleasurable phantasy about cultural exchange', this later film is far more disturbing in its continuous turning back to the past. As Sam Bodrojan (2020: n.pag.) has observed, *Prater* 'is

FIGURE 6.1: Riesenrad, *Prater*. Photograph by Ulrike Ottinger, Berlin, 2007. © Ulrike Ottinger.

Ottinger at her most technically adept and self-critical, refusing to let history in all its ugliness die in the face of spectacle'.

At the Prater, a variety of machines circle endlessly in order to move while staying in place. In this carnival, time – the ritualized recurrence of historic festivals – is turned into space, a place for pleasurable circulation. In his memoir of early twentieth-century Vienna, Stefan Zweig (2009: 22) recalls the park's annual Flower Parade, 'where three hundred thousand people enthusiastically greeted the "upper ten thousand" in their beautifully decorated carriages'. These public events drew together the concentric circles that until the defeat of the Austro-Hungarian Empire in 1918 enclosed the palace, nobility, higher officials, industrial magnates, petty bourgeoisie and proletariat. Hierarchical but contiguous, Hapsburg Vienna could enjoy industrialized leisure at its most advanced, from animal to steam to the electrically lit and powered revolutions of drums, wheels, cranes, hoists and cables in dizzying rides that moved to music cranked from barrel organs. Together with their speed and vertiginous descent, its attractions traditionally included tests of strength and marksmanship, the bodies of 'freaks' and anatomical waxworks, foreigners with outlandish costumes, magicians and their glamorous assistants, wild and caricatured animals and the spectacle of the spectators themselves – watching, flirting, competing, dancing, spinning, screaming in space.

As for history, this film suggests that it moves in circles too. *Prater* conveys us to the past via the cinema, an attraction at the amusement park from 1895, when the Edison peephole viewer known as the Kinetoscope showed *A Bar Room Scene* (William K. L. Dickson (dir.), 1894), a regrettably lost film of a political discussion involving a Democrat, a Republican, a policeman and a bar maid. The following year, 15 Kinetoscopes were installed in a viewing parlour in the park. By 1900 its first cinema, Kino Stiller, was opened, followed in 1902 by Palast Kino, Kino Klein (later renamed Kyrstall Palast) in 1903 and several more after that (Dassanowsky, 2007: 8–9). But in the Prater, the addition of moving pictures to other mechanisms of mobility, speed and spectacle turned a new twist in what Tom Gunning (1986: 63–70) has memorably described as 'the cinema of attractions'. Before film exhibitions became a staple at the Prater, the park itself – its arcades, crowds and rides, especially the Giant Wheel – became an attraction in the cinema. Following the first Lumiere screening in Vienna in March 1896, the company sent two operators to the city to film its sights, including the Prater and its Wheel, which were shown to Emperor Franz Joseph that same year (Dassanowsky, 2007: 7). In an historical coincidence, the park was simultaneously established as a major site of early film viewing and making. This remarkable conflation of location and exhibition is not the least dizzying aspect of Ottinger's documentary.

In 2005, Christian Dewald and Werner Michael Schwarz co-edited a study of films made at the park, *Prater Kino Welt: Der Wiener Prater und die Geschicte das Kinos* and released a compilation DVD of footage filmed there since 1900. These 39 films offered Ottinger a ready-made library for her own project, but not one she over-relies on. Her documentary's credits list Erich von Stroheim's *Merry-Go-Round* (USA, 1922), Gustav Ucicky's *Die Pratermizzi* (Austria, 1926), Willy Schmidt-Gentner's *Prater* (Austria, 1936) and Kurt Steinwender's *Wienerinnen – Schrei nach Liebe* (*Viennese Women – Cry for Love*, Austria, 1952). Uncredited archive footage also appears, including the 1900 French film *Kobelkoff* (director unknown), celebrating the remarkable skills of its eponymous subject, 'the human torso', a Russian performer able to drink, shoot and dance despite being born without arms or legs. By this date, the international circus star had married the daughter of an actor from the Prater and was begetting a carnival dynasty of six children, whose descendants are interviewed in Ottinger's film.

As a 'freak' of spectacular status, Kobelkoff is reminiscent of the gallery of queer eccentrics ('Siamese twins, beggars, pilgrims, dwarfs, bearded women, and transvestites' [Pidduck, 1990: n.pag.]) Ottinger features in her 1981 film, *Freak Orlando*. The director also casts Veruschka von Lehndorff – the fashion model and star of her 1984 satire of media celebrification, *The Portrait of Dorian Grey in the Yellow Press* – as the comic strip extraterrestial Barbarella, recapitulating Jane Fonda's portrayal in Roger Vadim's 1968 adaptation. A traveller from

outer space exploring the inner space of the Prater, the blonde in her silver catsuit confronts the park's red-eyed King Kong (Figure 6.2), their encounter recalling Fay Wray's role in the original film as well as Wray's portrait of a working-class Viennese betrayed by her aristocratic lover in Erich von Stroheim's 1928 *The Wedding March*.[1] Not shown, but inevitably looming in the cinematic memory of the park, are non-Austrian productions like Carol Reed's *The Third Man* (UK, 1949), the James Bond film *The Living Daylights* (John Glen, USA, 1987) and Richard Linklater's *Before Sunrise* (USA, 1995). But most relevant to Ottinger's historical perspective is another American film, albeit one based on a Zweig novella and directed by a German, *Letter from an Unknown Woman* (Max Ophuls, USA, 1949).

Ophuls's film pursues the theme of female sexual and class victimization in a spiralling plotline whose teenage heroine falls in love with the celebrated musician living in a Viennese flat above her family's. They are parted when she moves from the city but meet twice again – and both times the musician fails to recognize her. This circularity is evident in the turning staircase of the apartment building where Lisa (Joan Fontaine) first sees the pianist Stefan (Louis Jourdan), the Riesenrad at their evening in the Prater and Stefan's piano repetition of the waltz they dance

FIGURE 6.2: Veruschka von Lehndorff, *Prater*. Photograph by Ulrike Ottinger, Berlin, 2007. © Ulrike Ottinger.

to that night. These form part of an elaborate spool of music and images that Stephen Heath (1981: 155) observes 'are found, shifted, and turned back symmetrically, as in a mirror'. The sense of deja vu is made explicit in Lisa's voice-over ('Night after night I returned to the same spot') and Stefan's dialogue ('How else could we dance this way unless we danced together before?'). At their wintry visit to the park, the couple take refuge in a Hale's Tours style railway car, an early twentieth-century attraction in which a series of tourist views revolve around a gently rocking passenger compartment mounted on a circular platform. Eventually told that there are no more countries left, Stefan replies 'Then we'll begin all over again.' The allusion to this cinematic precursor signals not only the circular nature of their romance but also of history itself, whose impasses are vividly represented by the dissolute pianist's own lack of resolve: 'I always tell myself I'll begin again next week. And then when next week comes it's this week, so I wait for next week again.' If this is Nietzsche's eternal return, the necessity to live 'life as you now live it ... innumerable times again' (2001: 194), there is a way out for Stefan and Lisa. At the film's end, discovering that she has died, he consents to a duel with her vengeful husband. A close-up of the turning wheels of a carriage announces his departure to it; as he leaves he glimpses her ghostly image.

Part two: A circular film

Ottinger's portrait of the Prater opens with a relic from its past, a doll that winks but cannot speak – a vintage ventriloquist's dummy whose moving mouth is silent, save for the clicking of its jaw. The location is the Viennese park in the twenty-first century. To the theme song of a coin-operated puppet clown, a series of mechanical figures – dark-hued demons with fangs and claws, racing pigs, sundry skeletons, a one-eyed ogre – move speechlessly until the ominously laughing King Kong bids 'Come one, come all!' In a quick sketch of film history, we are first offered moving images, then musical accompaniment, then synchronized sound. Fittingly, the opening voice-over is from the autobiography of the Vienna-born director Josef von Sternberg,[2] declaring:

> Every last nook of this tremendous amusement park belongs to me ... Shooting galleries, puppet shows featuring the devil, clowns in white face and domino costumes, boats that swooped down with a splash, leather-faced dolls that groaned as you slugged them, flea circuses, sword swallowers, somersaulting Lilliputians, men on stilts, snake charmers, jugglers, acrobats, swings that make the ladies' skirts fly up, so you see if they're wearing underpants.
> (Sternberg, 1965: 8)

Sternberg's recollection is rhapsodic, its inventory overwhelmed by the extent of the sensations on offer, and Ottinger's film follows suit, adding image after image in sustained montage sequences of the park's historic and present-day attractions. The list, or litany, as Rosalind Galt (2011: 294) points out, is a key feature of Ottinger's mise-en-scène, prompting critics to respond with their own lists, and Sternberg's memoir suggests that the Prater exerts a similar effect. The melange of multiple sensations he evokes is further intensified by the combination of colour in Ottinger's present-day shooting and the black-and-white of her source films. The dizzying oscillation between them, patently signifying present and past, multiplies times as well as sights. As the memoir is read, the saturated primaries of her digital palette yield to the black and white of selected archive footage[3] that could have been filmed by Sternberg for his own Prater drama, a 1928 story of class and gender betrayal titled *The Case of Lena Smith*. (Destroyed by Paramount to escape tax liabilities in the 1940s, it is now known through an illustrated reconstruction and a recently discovered four-minute excerpt, in which three country girls arrive at the park in their dirndls and their innocence. One will marry the officer who watches her gape as a magician levitates his assistant but all such elevations prove illusory: the young man will refuse to acknowledge his wife, consigning her to servitude in his parents' home.)

In place of this film, *Prater* provides vignettes from still and moving images of the 1920s–30s – waving crowds, muscle men, a python coiled round a woman's arm, tattooed ladies, a company of tiny people and a carousel decorated with a central mast carved in the image of 'Califati' – in Sternberg's description 'a giant Chinaman with a moustache longer than a horse's tail' (1965: 9). The mast commemorates Basilio Califati, a magician who first appeared at the Prater under the name 'Salamucci' in 1820. But as a nineteenth-century portrait attests, this early entrepreneur, born in Trieste of Greek parentage, was not Chinese. The figure may depict Califati in costume for his act: the fascination with Chinese conjurors in the period led one Cornish man to perform as 'Professor Ching' in 1820s–30s Britain, while an actual Chinese magician Zhu Liankui, stage name Ching Ling Foo, was later impersonated by the New Yorker William Robinson as Chung Ling Soo (Goto-Jones, 2014: 1451–76). This fascination survives at the Prater, where Ottinger films a contemporary conjuring act introduced by an assistant in Chinese costume sounding a brass gong. Little is known about Califati's life, but he achieved considerable success, running a carousel, a billiard room and the park's first miniature train with locomotives named 'Hellas' and 'Peking'. As the film observes, his empire was fittingly succeeded by that of the Kobelkoff family, children of the limbless Russian who sired his own dynasty – including several carousels, the towering Toboggan slide, a restaurant shaped like a whale and

four contemporary female descendants who indignantly recall the refusal of the Viennese authorities to let this 'freak' marry his Prater bride in the city.

Where, as Whissel (2007: 127) claims, *Johanna d'Arc of Mongolia* 'displaces the social formation in which racism has been most problematically circumscribed in recent years: the nation', this accusation cannot be levied at *Prater*. Ottinger's controversial satire of an ethnographic expedition captured by a group of nomadic Mongolian women is argued to efface the racist underpinnings of such exploration by travelling away from their European source. *Prater* by contrast remains in the imperial capital, to which racialized spectacle – and racialized subjects – are imported for exhibition. However, the film's interest in the foreign-born proprietors of the Prater's concessions extends to their foreign customers, complicating any simple equation of exotic spectacle with exploitative objectification; in one contemporary sequence, the park's appeal to international spectators presents an opportunity to reverse the expectations of the ethnographic gaze. As Hans Olden sings 'I'd Like a Photo of You' in Willy Schmidt-Gentner's 1936 *Prater*, a group of South Asian tourists don Western film costumes to have themselves photographed for a sepia-toned keepsake. Here, Ottinger offers what might be imagined as a response to Whissel's critique of the scene in *Johanna d'Arc* in which two members of the expedition witness a festival game in which Mongolian women wage mock battle with poles decorated with European images. The Prater visitors who become the 'subject and object of their own gaze' (Whissel, 2007: 141) are not white Europeans. Moreover, in ironic allusion to her comparative captivity narrative, *The Searchers* (John Ford, 1956), the chosen costumes of these 'Indians' are cavalry uniforms and Victorian dresses.

As Homi Bhabha (1984: 125–33) maintains, such scenes of colonial mimicry are never unambiguous, suggesting as they may either mockery of or assimilation to a ruling ideal, or indeed the ease of their subsumption into a wider imperial gaze. However one reads this example of reverse appropriation, it cannot withstand the film's overwhelming evidence of the spectacularized exoticism which the park has historically purveyed. In its most disturbing sequence, historian Werner Schwarz describes the transplantation of an entire African village and its 100 plus inhabitants to the Prater in 1896. There they could be scrutinized around the clock by curious visitors, so fascinated with the erotic lure of these batik-clad 'Ashantis' (and sundry spear clutching others, including the world famous 'wild men of Borneo') that rumours spread of the elopement of seven Viennese women to Africa with their Bedouin lovers. The display of such 'primitives' was a feature of colonial fairs at the turn of the century: the Chicago Columbian Exposition of 1893 combined 'circus entertainments, concession stands, and ... representatives from numerous "savage" groups, including Samoans, Javanese, American Indians, and Dahomeyans of Africa' (Tavel Clarke, 2007: 50), while the St. Louis World's

Fair of 1904 contrasted Patagonian 'giants' with central African 'pygmies'. In the name of anthropology, subordinated peoples were offered as spectacle and science, proof of the higher evolution of their exhibitors. Where actual exotics were not available for import, the park offered illusory travel to them via a pre-cinematic array of panoramas, dioramas and simulated railway tours such as that taken in Ophuls's film. One surviving device from this period, a 'head in the hole' mural dating from the rise of comic photography as a fairground attraction, allows Schwarz to be pictured boiling in the pot of caricatured cannibals, diabolically fanged and clawed. Thus, the contemporary European commentator is literally inserted into the past, but as victim rather than oppressor.

At the Prater, this colonial tourism had its local counterpart in the class relations that made the park an erotic hunting ground for the Viennese aristocracy (Lunzer, 2009). A contemporary shooting gallery, in which three contestants fire at a target which responds by spraying them with water, yields to an excerpt from *The Merry-Go-Round* (1923) written and initially directed by the Vienna-born Erich von Stroheim, before being replaced by Rupert Julian for his legendary extravagance. Opening with cityscapes of the cathedral and the Riesenrad, followed by a sobering vignette of a mother bidding her child goodbye before jumping from a bridge, the story is the perennial one of an aristocratic officer pretending to be an ordinary salesman to deceive a poor woman, an organ grinder at the Prater. Not only did Stroheim and Sternberg remake this story, in 1945 Christopher Isherwood also parodied it in his fictionalized account of working with the Austrian director Berthold Viertel, *Prater Violet*:

> The period is the early twentieth century, some time before the 1914 war. It is a warm spring evening in the Vienna Prater… The swings are swinging. The roundabouts are revolving. There are freak shows, gypsies telling fortunes, boys playing the concertina … There is a girl named Toni, who sells violets … as she wanders down the alleys carrying her basket, light-hearted and fancy-free, she comes face to face with a handsome boy in the dress of a student. He tells her, truthfully, that his name is Rudolf. But he is not what he seems. He is really the Crown Prince of Borodania.
> (Isherwood, 1945: 33–34)

In the scene that Ottinger borrows from *The Merry-Go-Round*, Count Maximilian (Norman Kerry) arrives with a party in an open carriage and wins two dolls by shooting four hearts in an arcade. Over it, a text from the author of the original *Bambi*, Felix Salten, is read, declaring 'When aristocrats want a laugh, they masquerade as "the people" and come to the Prater, ride the Carousel … go to the shooting booths and try out the guns. That's not proper. They should be hunting on their own lands, out on the prowl when the grouse are mating and

shooting bears.' In Von Stroheim's film, a young beauty (Mary Philbin) becomes Count Max's trophy. In Ottinger's, the blonde Barbarella played by Veruschka takes up the bow, wins a toy chimp, taunts the menacing King Kong and roams the park in her own carriage until she and her furry companion arrive at the hall of mirrors. A sustained sequence of the mirrors' warping and multiplying of her image, already that of an aristocratic German model costumed as a cartoon alien, makes a further contribution to the Prater's transformation of its visitors' identities.[4] In their grotesque reflections, the silver-clad goddess of the hunt surveys her several selves, swinging her baby chimp between her legs. Is this, as Laurence Rickels (2008: 195) argues, 'interspecies birth'? The erotic connection between white woman and black beast continues with a puppet show in which a naive Austrian tourist travels to New York and encounters King Kong: 'You are so completely different [or other, *anders*] from the men back home', she trills, only to be seized by the roaring animal and apparently killed. The park's modelling of black men as primates – from mechanical jazz bands with monkey musicians to talking gorillas – is ubiquitous. The obsessive presentation of their threat to white women stays with the spectator into the next scene, an apparently anodyne one of visitors dancing to an electric oompah band – until you notice how blonde they all are.

The religious traditions that underwrite these secular pleasures are vividly recalled by the contemporary Austrian writer Herbert Wimmer, who emerges from the haunted house describing his arrival with hundreds of provincial children to celebrate their confirmation in St. Stephen's Cathedral. Again, 1930s footage of the park's remarkably unchanging attractions is marshalled in his remembered preference for this ride, through a *danse macabre* of the hell awaiting sinners, over the terrifying prospect of the roller coaster. The choice of amusement – torture in the next life or a potentially fatal descent in this one – underlines the morbidity on offer. Ottinger intensifies the peril with point of view shots from the lead carriage of a contemporary coaster, plunging into an apparent abyss until a last minute lurch to safety. (The mounting of the camera at the front of locomotives was itself a feature of early cinema's 'ghost trains'.) Interspersed with archive shots of cheerful children undergoing this rite of passage, these dizzying drops accompany Wimmer's recollection of:

> the steaming bodies of ten year olds in new suits, hot clouds of fat and sugar, the lingering smoke from cap guns, the cologne of our godparents and other adults, the axel grease of torturous rides, cotton candy and vomit, beer and wine and fire cracker vapours.

'My Prater – Your Prater?' asks Wimmer's wife, the writer Elfriede Gerstl, her head inserted into another vintage mural – on a platter about to be served by one

cartoon pig to another. (The porcine diner invokes another suggestion of the term 'Wurstelprater' – the sausage-like physiques of its gourmandizing clientele.) 'Mixed emotions or a paradise of phobias?' Continuing the film's relentless inventory, Gerstl proclaims 'there's much more', concluding with the terror of getting 'lost in your reflections in the hall of mirrors, no exits anywhere'. Much more. A vintage poster of a carnival barker urging customers into the Kinematograph yields to another scene of *The Merry Go Round*'s aristocrats laughing at the park's fat lady, then a photograph of the Tyrolian giantess Mariedl and images of sundry Lilliputians, before a reading from the Weimar novelist Erich Kastner introducing the Panopticum, a waxwork museum operating at the Prater for more than a century. With its obscenely dissected Venus and the perennial 'orangutang who stole the girl in white', its purportedly scientific exhibitions served up sensation – sex and violence, conjoined twins and uncannily modelled celebrities: 'Faux people stare back at you, frozen in rigid poses'. Such fare was holiday consumption in the original sense of the term: Kastner counts up 3000 visitors on Sundays, twice that on Catholic 'holy days', half the country at confirmation. But in the early twentieth century, the Prater risked becoming a ghost town itself, 'in part because it had to compete with the cinema, that other arbiter of the sensational'.

The answer, according to contemporary 'carnie' Alfred Kern, was to incorporate the cinema into the park. Tracing his own family's carousel concession back to Calafati, he describes his grandfather's conversion of one such roundabout into a cinema in 1905, then a larger one with sound, an additional one with a planetarium and still another. During the war, their film collection, as well as the family jewellery, was destroyed by fire, but by 1947 the family had erected a tent for its renewed variety show and begun work on a shiny new ride. Kern's account of the park's resurrection is set to a jukebox playing Bill Haley & His Comets, as a couple jitterbug between a montage of 'Autobahn' and 'Autodrom' road racing and bumper car rides, fitted out in gleaming chrome for the motorists of the postwar Prater. Together with its resurgence, the generational succession remarked in these interviews with carnival families are themselves evidence of the park's continual renewal in its own historic image.

Recalling this period, writer and Ottinger collaborator Elfriede Jelinek[5] declares that her favourite ride was in the revolving teacups of an attraction apparently inspired by Lewis Carroll. Briefly escaping the supervision of her mother on outings with other relatives, the young Elfriede gloried in 'the Prater's radiance and abundance ... which seemed itself to elude all control'. Half a century later, she ruminates on the paradox of such freedom, created as it was 'by a machine we submit to', a technology that makes little children 'feel big for a time'. A child's expansions and contractions in another wonderland come to mind. The effect of such technology, 'always the newest of the new', is to make the rider 'appear like new,

though in fact the same as ever'. The same as ever: the adult Elfriede is filmed in the twenty-first century facing out from a surviving mural of a blonde grabbed by a gorilla. Once more the threat of miscegenation is to be overcome, like that of the rides whose exhilarating speed and height make little children feel big.

An interview with another member of an old carnival family, one that ran coffee and guest houses in the Prater from 1922, takes the chronology backwards, to the bands that played in the interwar park, and then forward to its wartime portrayal in Nazi propaganda films ('Races Mixing in Vienna's Prater').[6] Over images of smiling German soldiers enjoying its amusements, Gerhard Amanshauser's autobiography of his teenage service in the SS is read. Arriving in 1941 as a teenage member of an SS detachment installing a telephone line in the park, 'ignorant and numbed, I stared out at the Oriental world of the circus, at its uncanny, half-demonic carved figures' – figures he would help to destroy when the SS turned the park, its exhibitions, rides, inns and cinemas into a firewall to halt the Soviet invasion of 1945. The fascination and anxiety presented by the racialized other arrive at its inevitable conclusion: the threat so clearly conveyed by the Prater to its visitors – of death, destruction, ghostliness – is meted out to the park itself. 'There was', as Elias Canetti recalls his nanny saying, 'enough room in hell for the whole city of Vienna'.

Canetti's first sight of its fires was at a park reconstruction of the 1908 earthquake of Messina, described in a reading from his childhood memoir, *The Tongue Set Free*. His belief that what he saw then meant the end of the Wurstel Prater is belied by the film's quick cut from its postwar ruins to one of its contemporary terrors – a space capsule launched with its screaming passengers into the night sky. The day begun with a wooden dummy ends with a final litany of the park's high-tech attractions – the Break Dance, the Circus Hoopla, the Flip and the Tagada, a Chinese update of the old Rotor centrifuge decorated with giant images of Elvis in *Blue Hawaii* and a Hiroshige wave. Asian Pacific futurism arrives at the home of Califati. In a bravura montage of their illuminations, the heavens explode with lights. At ground level, seven youths gather at an electrified punchbag to show off their slugging power, over and over in a conspicuously repetitive three minutes. Arms spread wide, an ageing blonde dances alone in circles. The credits begin to roll over a vintage recording of 'Schön ist so ein Ringelspiel', a 1930s hymn to the carousel composed by Hermann Leopoldi, before he was sent to Buchenwald.

Afterword

Reflecting on repetition in *Letter from an Unknown Woman*, a 'death-dealing' narrative manifest in first the image and then the sound of the words 'By the time

you read this letter I may be dead', Stanley Cavell (1996: 171–72) asks 'where is the instant of difference to come that makes repetition a new step, a path, a circle with a little larger diameter?' From its release in 2007 onwards, viewers of *Prater* might have asked the same question about the national history that revolves within it. Conceived after the far right arrived in government in 2000, after some of the most restrictive asylum laws in Europe were introduced in 2003, the film's theatrical life has been paralleled by Austria's closing of its border with Slovenia in 2015 to stop migrants fleeing war in the Middle East, the 2017 banning of full face veils in public spaces, followed by the coalition of the Conservative People's Party with the far-right Freedom Party and the re-election of its leader as Chancellor in 2020. Continued dependence on Russian gas binds it to 'neutrality' on the country's invasion of Ukraine. Viewed from this perspective Ottinger's 'returning images', as Cavell terms the ghostly repetitions in Ophuls' film, insistently remind us of 'the relation of film as such, always coming after, immortalizing events, to death'. It is difficult to watch them now without fear of worse to come. Ottinger's documentation of the Prater as the site and subject of early cinema foregrounds both the medium's– and the park's – preservation of its colonial attractions. Her contemporary filming highlights its retention of their racist motifs. The film's revelation of their ugly survival 'makes repetition a new step', demanding a departure from this hall of mirrors.

NOTES

1. In this sophisticated reprise of the earlier *Merry Go Round*, a high-angled introduction to Vienna includes statues of the Virgin Mary and an armoured knight, the Iron Man. On the feast of Corpus Christi, the two principals combine in 'the greatest religious and military celebration of the year' at St. Stephen's Cathedral. There Prince Nicki (Stroheim), a playboy cavalry commander, encounters Mitzi (Fay Wray), a harpist at her father's restaurant, in the crowd before the cathedral. In a sustained scene the two flirt, with Mitzi admiring the mounted Nicki from a symbolically low angle. This infuriates Mitzi's suitor, the butcher Scheni, who denounces Nicki 'as one of them swells that don't do nothing … and we're paying for it'. As they wait for the procession to begin, Nicki presents Mitzi with a bouquet of violets and removes his glove so that she can see that he isn't married. The couple's tryst takes place on the banks of the Danube, where Mitzi says the Iron Man sometimes appears as a harbinger of death. Surrounded by apple blossoms at their next meeting Mitzi asks Nicki if he'll always love her, and then sees the Iron Man above the river, a vision Nicki dismisses as fog. Despite news of Nicki's impending marriage to the heiress of a corn plaster magnate, Mitzi refuses to marry Scheni. Only when he arrives outside the Cathedral to shoot Nicki at his wedding does she agrees to marry him. After the Wedding March sounds, Nicki and the heiress leave the cathedral in a carriage. Asked by her if he knows the tearful

2. Ottinger does not identify the quoted texts, the excerpted films or the on-camera interviewees as they occur in the film, listing them instead in the credits. For the purposes of exposition, I will identify them in context, but readers will note that this confers a pedantic 'documentary' feel to its spool of sensations.
3. Within this compilation, it's possible to identify shots from *Die Pratermizzi* (Austria, Gustav Ucicky, 1926), in which a rich dandy (Igo Sym) out with a pretty cashier (Anna Ondra) struggles up the moving steps of the fun house, with the bold woman taking the lead.
4. The fluidity of body image and self-perception in this sequence is reminiscent of another Prater film featuring King Kong, the 2004 short *Plasma* by the Austrian director Mara Mattuschka, in which a woman's reflected images become her new reality.
5. Ottinger has directed two of Jelinek's stage plays, *Clara S.* (Stuttgart, 1983) and *Begierde und Fahrerlaubnis* (Graz, 1986).
6. The film is *Deutschland auf der Leinwand – Der Prater* (*Germany on Screen – the Prater*, director unknown), a 1942 Nazi propaganda film narrated in Russian to attract defectors from the East to the war effort.

girl they pass, he denies it but agrees that apple blossom will always remind him of their marriage. The Iron Man heaves with laughter.

REFERENCES

Bhabha, Homi (1984), 'Of mimicry and man: the ambivalence of colonial discourse', *October*, 28, pp. 125–33.

Bodrojan, Sam (2020), 'Ulrike Ottinger in six contradictions', *Metrograph*, 9 March, https://metrograph.com/ulrike-ottinger-in-six-contradictions-2/. Accessed 28 June 2023.

Cavell, Stanley (1996), *Contesting Tears: The Hollywood Melodrama of the Unknown Woman*, Chicago: University of Chicago Press.

Dassanowsky, Robert von (2007), *Austrian Cinema: A History*. Jefferson: McFarland.

Galt, Rosalind (2011), *Pretty: Film and the Decorative Image*, New York: Columbia University Press.

Goto-Jones, Christopher (2014), 'Magic, modernity and orientalism: conjuring representations of Asia', *Modern Asian Studies*, 48:6, 1451–76.

Gunning, Tom (1986), 'The cinema of attraction: early film, its spectators and the avant-garde', *Wide Angle*, 8:3–4, 63–70.

Heath, Stephen (1981), 'The question Oshima', in *Questions of Cinema*, London: Macmillan.

Isherwood, Christopher (1945), *Prater Violet*, New York: Random House.

Lunzer, Martina (2009), 'Vienna's Prater district on film, or: Looking at the world again', *Senses of Cinema*, 50, https://www.sensesofcinema.com/2009/feature-articles/viennas-prater-district-on-film/. Accessed 28 June 2023.

Nietzsche, Friedrich (2001), *The Gay Science* (ed. Bernard Williams, trans. Josefine Nauckhoff and Adrian Del Caro), Cambridge: Cambridge University Press.

Ophuls, Max (dir.) (1949), *Letter from an Unknown Woman*, USA: Rampart Productions.

Ottinger, Ulrike (dir.) (2007), *Prater*, Germany: Kurt Mayer Film, Ulrike Oettinger Filmproduktion and Westdeutscher Rundfunk (WDR).

Pidduck, Julianne (1990), 'Freaks amour', *Mirror* (Montreal), 15 November, n.pag.

Rickels, Laurence A. (2008), *Ulrike Ottinger: The Autobiography of Art Cinema*, Minneapolis: University of Minnesota Press.

Stroheim, Erich von (dir.) (1928), *The Wedding March*, USA: Paramount Famous Lasky Corporation.

Tavel Clarke, Michael (2007), *These Days of Large Things: The Culture of Size in America, 1865–1930*, Ann Arbor: University of Michigan Press.

Whissel, Kristen (2007), 'Racialized spectacle: Exchange relations and the western in *Johanna d'Arc of Mongolia*', in J. Stacey and S. Street (eds), *Queer Screen*, Abingdon: Routledge.

Zweig, Stefan (2009), *The World of Yesterday: Memoirs of a European* (trans. Anthea Bell), London: Pushkin Press.

PART THREE

CHINA, MONGOLIA, JAPAN, KOREA

7

Rewriting the *Ethnos* through the Everyday: Ulrike Ottinger's *China. Die Künste – Der Alltag*

Cassandra Xin Guan

What is holism once the line between the local worlds of subjects and the global world of systems becomes radically blurred?

(George E. Marcus, 1986: 171)

A seemingly trivial misapprehension botched the translation into English of the German title of Ulrike Ottinger's ethnographic documentary *China. Die Künste – Der Alltag* (1985). The filmmaker was persuaded by Susanne Hoppmann-Löwenthal, wife of the expat Frankfurt School philosopher Leo Löwenthal, that the closest approximation of *der Alltag* was 'everyday life'. This was deemed to be a mouthful, so Ottinger renamed her film 'China: The Arts – *The People*'. Somehow it did not occur to Hoppmann-Löwenthal, who also translated the film's dialogue and intertitles, to nominalize the English adjective, whereby *der Alltag* would be rendered, more clearly and expediently, as 'the everyday'.[1]

The semantic slippage is not without conceptual significance insofar as the invocation of an ethnic subject in the English title postulates an artificially unified viewpoint that obscures the recursive and heterogenous temporality of everyday life. Ottinger's documentary practice, in point of fact, resists the fixing of vernacular culture to an ethnic milieu conceived in substantialist terms. As Patricia White observes in her commemorative essay on the Berlin-based filmmaker, 'the *view* of the cultural other is the central challenge and concern across Ottinger's oeuvre' (2022; n.pag., emphasis added). In contrast to critical approaches that posit an all-signifying subject/observer on one side, and a postulated aestheticized 'Other' on the other side, I will demonstrate that Ottinger's documentary eye sees the

ethnographic subject not from the outside, but rather through a kind of view-within-a-view inscribed in the field of culture under observation. This reflexive vantage point corresponds to the constitution of the West as 'Other' in modern Chinese culture, a ritualized procedure aptly described as 'searching for the self in one mirror' (Ge, 2018: 123). Instead of a transparent window opening onto another world, Ottinger's China documentary, like a trick mirror, refracts rather than reflects the desire of the ethnographic subject.

As a contribution to the critical reception of Ottinger's travel ethnographies, the present essay seeks to exert pressure on the symptomatic displacement that transformed *China. Die Künste – Der Alltag* into *China: The Arts – The People*, to: (1) illuminate the dialogism and polyvocality of what appears at first glance to be a 'straight' ethnographic film and (2) answer George Marcus's call to 'explore new and more effective ways in which ethnographic texts can take account of the manner in which world-historical political economy constitutes their subjects' (Marcus, 1986: 168). With these two objectives in view, I will reread the documentary film of Reform-era China as a historical index *and* a critical representation of what Jason McGrath calls the 'going to market' of Chinese culture and society in the 1980s, drawing attention to the complex constraints in which the transition from a planned to market economy left its imprint on the forms and techniques of everyday life (McGrath, 2008: 1). In particular, I will look at the film's mediation of the relationship between centre and peripheries, economics and aesthetics, official ideology and popular culture to elucidate the critical salience of a representational strategy that envisages the Other, not as an identity, but as a drama of self-differentiation inextricably enmeshed with the political economy.

As an important step towards clearing the ground for a new reading of *China* as a documentary representation sensitive to the revolutionary ruptures of post-socialist modernity, I ask at the outset of this essay, somewhat rhetorically: who author(ize)s the representation of China in this work of visual ethnography? Etymologically, the word *ethnography* is an amalgamation of the Greek words *ethnos* ('people', 'folk', 'nation') and *graphé* ('writing', 'drawing'); in concert the two terms denote people or nation writing. The activity of writing, however, presupposes a subject, or author, and an object, or text. Films like Ottinger's *China* and Bernardo Bertolucci's *Last Emperor* (1987) are conventionally interpreted as texts *about* China, because, as James Clifford quipped, texts in the West conventionally come with authors attached (1986: 17). In reality, the authorship of the European auteur in these international co-productions is sharply curtailed by the authority of the party-state, which imposes limits on her creative vision and influences vernacular cultural expression through direct and mediated methods of governance. To decipher this amphimictic scene of representation, it is not enough to maintain that the textual practice of documentary ethnography is caught up in

the 'invention', not merely the description, of cultures. If ethnography is not, as it was once thought, the detached observation of self-enclosed cultural systems, if, on the contrary, the ethnographic milieu exercises 'selectionist' pressure on the work of representation, then it behoves us to understand the directions and levels of determinacy between ethnic identity and historical change.

Is ethnicity inscribed in an immanent process of *autopoesis*, or is the ethnic identity of a given community written from elsewhere? What are the documentary strategies that could capture the plastic *form* of social praxis without reference to a stable ethnic identity? Questions such as these remain relevant in contemporary debates about visual anthropology and its artistic appropriation because a volatile ambivalence characterizes the constitution of subject and object in ethnographic representation, as recent trends in anthropology have insistently if not consistently underscored (De Certeau, 1986; Fabian, 2014; Fardon, 1990; Marcus and Fischer, 1986; Povinelli, 2002; Taussig, 1992). The consciousness of reciprocal causality between subject and object in the work of ethnographic representation compels us to rethink the creative potential of auto-ethnography, or self-representation in Ottinger's sensitive portrayal of everyday life in Reform-era China. The arrival, or rather return, of the European *auteur*, who has discarded the rose-tinted glasses of the friendly fellow traveller to assume a posture of 'independence', is an under-theorized cultural event in the history of China's 'Reform and Opening'. The dramatization of what Annette Kuhn has called 'the encounter of two cultures' in films such as *The Last Emperor* obscures the present-day terms of the East-West encounter, specifically the role of the 'silent partner' in these international co-productions (Baschiera, 2014: 399–41; Sklarew and Spitz, 1998: 37–56). To put the work of criticism on a comparative foundation means, first of all, establishing the position of *China* in Ottinger's oeuvre as an inaugural moment of transnational collaboration and exchange, and then look at the recorded ethnographic content from the other side, as it were, to interrogate the condition of possibility for this recording.

China is the first of Ottinger's travel ethnographies and the first of three films she made in the People's Republic of China. As such, this four-and-half-hour-long observational documentary originally produced for West German television has received surprisingly little attention from Ottinger scholars, especially compared to the two subsequent China films: *Johanna d'Arc of Mongolia* (1987) and *Exile Shanghai* (1994) (Grisham, 1992, Harjes and Nusser, 1999; King 2007; Longfellow, 1993; Trumpener, 1993; Villarejo, 2002; Whissel, 1996). Apart from an interview with Kuhn published in *Screen* shortly after the film's initial release and a short essay by Janet Bergstrom that appeared in *Camera Obscura* a few years later, the Anglophone academic literature on Ottinger has

given short shrift to a pivotal work that the filmmaker identifies as a turning point in her career:

> In my previous films I have dealt with the themes of exoticism, minorities and their differing role behaviour within their own culture. Now I am interested in expanding this theme, in getting to know a 'real exoticism' in a foreign land and in a different culture. I am attempting to conduct a visual discourse with my camera about exoticism as a question of point-of-view [sic].
>
> (Ottinger, n.d.: n.pag.)

The reluctance to engage with Ottinger's experimental discourse about another culture stems from two contradictory impulses. On the one hand, those who saw Ottinger as a representative of the queer and feminist wing of New German Cinema were initially confused by her foray into documentary filmmaking. The perceived absence of an authorial stamp led Mandy Merck to wonder out loud whether documentaries about China tend to fall into a style dictated by a shared setting. *China*, she maintains, looks more like Antonioni's *Chung Kuo* (1972) and Joris Iven's *How Yukong Moved the Mountains* (1976) than previous films by Ottinger such as *Freak Orlando* (1981) or *Dorian Gray in the Mirror of the Yellow Press* (1984) (Kuhn, 1987). On the other hand, the critical controversy generated by *Johanna d'Arc of Mongolia* and kept alive throughout the 1990s reduced *China* to a footnote in polemics for or against Ottinger's 'ethnographic turn'. Participants in this debate regarded the 1985 documentary as a preparatory sketch for the theatrical features that followed, treating it by and large as critical fodder rather than an object of analysis in its own right.

Doubly marginalized in the Anglophone reception of Ottinger's directorial corpus, *China* is a hard-to-see and under-studied work precisely because it fails to further the two well-established critical narratives about Ottinger's exploration of non-western cultures. Over the years, these narratives have hardened into entrenched positions. For Ottinger's supporters, the body of work she created beginning with *China* 'calls attention to the textual strategies of traditional documentary to challenge the notion of a "real" Orient' (Harjes and Nusser, 1999: 248). Other, more critical voices have accused the West German director of establishing in the same body of work an 'imperialist nostalgia', 'a participatory racialized spectacle' and an 'elaborate equation between aesthetic liberty, free markets, and traditional cultures' (Trumpener, 1993: 96–97; Whissel, 1996: 58–59, 62). While arriving at radically different conclusions about the political effect of Ottinger's films, the two critical perspectives converge in equating textual strategies of representation with relations of power in the real world. The ethnic Other is seen by both sides as a textual function, a rhetorical fiction invented by the experimental

documentarian either to deconstruct notions of authenticity, universality and cultural essentialism, or to reinscribe orientalist tropes in an unreconstructed colonial imagination. As I will argue in detail, the problem with these apparently divergent yet secretly consonant critiques is the idealist assumption that the filmmaker is fully in charge of the meanings produced by her representational activities, and that the film text somehow *constructs* meaning on its own rather than referring to an unfinished reality that incorporates multiple and often contradictory viewpoints and evolves over time.[2]

As Thomas Love points out in his contribution to the present volume, Ottinger's exploration of cultural exoticism and ethnographic fascination exposed her to searing criticism from feminist and postcolonial theorists (Hansen, 1984: 95–108; Mueller, 1982: 108–25; Whissel, 1996: 41–67). Yet, those who castigate Ottinger for exoticizing non-western cultures often proceed to normalize in their own interpretive practices the perspective of an idealized western viewer as the universal consumer of cultural differences in world cinema. Considering the critical pressure applied to films such as *Johanna d'Arc of Mongolia*, one cannot help but marvel at the near absence of research into the real spaces and cultures depicted in them and the terms and conditions of their representation. It is entirely in keeping with the tenor of postmodern deconstruction in the US academy that Kristin Whissel, while undertaking an exhaustive analysis of the orientalist and Hollywood western tropes recycled by the film, never acknowledges the actual location of *Johanna d'Arc of Mongolia* (China's Inner Mongolia and Mongolia the country), or explore its political implications. As a result, her reading of *Johanna d'Arc* as a racialized spectacle organized around imperialist nostalgia ultimately rests on a facile analogy between the political geography of the American frontier and a Mongolia emptied of historical coordinates and cultural specificity.

What propels such literally misplaced readings is almost always an unconscious act of transference akin to the Kleinian mechanism of projective identification that enables the poststructuralist film theorist to conflate the limitation and biases inherent to her own viewing position with the discourse of the realist film. She rejects its representations as inadequate and/or malignant, realizing in this way a tendency of post-1970s film theory to flatten the complex historical terrains that condition practices of signification to a formal relationship between the film 'text' and the so-called spectator, its implied subject. In attributing the 'failure' of signification to the documentary filmmaker, without asking for *whom* this failure matters, the self-righteous critic runs the risk of paradoxically erasing other social ontologies and other ways of seeing by privileging, once again, the unhappy consciousness of the western subject, albeit in a negative form. According to Katie Trumpener, *China* celebrates the euphoria experienced by 'the aesthete who enters a deeply foreign culture for the first time and, unable to understand

its verbal and visual language, feels free to hear and see the culture as pure music or pure form' (1993: 96). This is obviously the description of a particular mode of viewing available to foreign consumers of the film rather than an ahistorical 'textual effect'. And yet Trumpener accuses the documentary film of fetishism, of equating the (to her) inaccessible with the culturally authentic and suppressing the memory of its own role in inventing what it records.

To counteract the reductive operation that fixes the meaning of the film text in the name of a self-reflexivity that amounts to solipsism, I suggest distinguishing between the self-evident meanings manifest in a specific context of reception and the interpretive possibilities latent in the work of art, including those spectatorial positions that are textually available but have been practically disabled by material and/or ideological constraints. In the case of ethnographic films, the possibility of contradictory forms of reading arises because representational truths are inherently *partial*, because they are, as Clifford has argued in another context, at once committed to a particular version of reality and necessarily incomplete (Clifford, 1986: 1–26). As someone interested in issues of documentary realism and non-western modernities, I would like to extricate Ottinger's practice as an experimental ethnographic filmmaker from sweeping pronouncements more descriptive of the critical terrain on which late twentieth-century battles over postmodernism and alterity were fought than the actual series of open-ended and power-laden encounters that determine the discourse of visual ethnography. As we will see, far from celebrating traditional cultures outside out of market relations, Ottinger's documentary of Reform-era China is a sensitive study of their entanglement and reciprocal constitution. In contrast to self-reflexive forms of critical ethnography, the practice of observational 'recording' has the merit of epistemological modesty.

For certain poststructuralist filmmakers, the solution to the mono-vocality of the traditional documentary form is a reflexive form of self-observation that foregrounds the constructed nature of the ethnographic fiction and the partiality of the observer. Other ethnographers, however, take the commitment to actuality seriously. James Clifford, for example, underscores that 'dialogical modes are not, in principle, autobiographical; they need not lead to hyper self-consciousness or self-absorption' (Clifford, 1986: 15). Building on this insight, my essay will turn to the other side of the ethnographic experiment to elucidate the dialogical processes that proliferate in the complexly represented space of *China*. Unlike a controlled study in the human sciences, the ethnographic film as a work of art does not contain its own interpretation. The consciousness of a third party, the spectator and reader, plays a critical role in the circuit of meaning production. In the present instance, my own position as a reader of the experimental documentary film, which has never been shown in mainland China, is determined by structural forces that dramatically transformed the position of China in the global economy and dissolved the

Cold War geopolitical boundaries still operative at the time of Ottinger's first visit. The critical stance I have adopted in this essay consequently reflects a historic moment in which globalization has made Ottinger's characterizations of China the country as 'a culture absolutely alien to our own' anachronistic to any ear and further reflects a subject position marked by bilingual consciousness and diasporic displacement, from which I can interpret documentary images of Reform-era China from two distinct vantage points. Complicating the Eurocentric and unidirectional outlook of earlier critics, my reading of *China* will follow a recursive trajectory that traces the dialectical constitution of self and other in a series of closely observed cultural worlds animated by the global movement of capital.

What textual constructivists tend to forget is that 'ethnography is historically determined by the moment of the ethnographer's encounter with whoever he is studying' (Crapanzano, 1986: 51). In the case of *China*, the proverbial author function obscures the fact that Ottinger made numerous concessions to the ethnographic milieu, which came, not pristine and compliant, but rather with an obdurate communist state bureaucracy attached to it. The filmmaker flew into Beijing in the fall of 1984 with the intention of shooting a documentary in the autonomous region of Inner Mongolia. (Information about the making *of China. Die Künste – Der Alltag* were gathered in a series of oral interviews I conducted with the filmmaker in December 2021.) Unlike the militant European filmmakers who came to document the Chinese Revolution and Cultural Revolution (Chris Marker [dir.], 1954; Michelangelo Antonioni [dir.], 1972; Joris Ivans [dir.], 1975), Ottinger was not interested in the official culture of communist China but the residual cultures of its ethnic minorities. The quest for a 'real exoticism in a foreign land' has no use for Soviet style architecture and revolutionary choreographies of the mass ornament type. Fortunately for her the mid-1980s were an opportune moment to observe folk culture (*minjian wenhua*) in the PRC. Between the politicization of popular culture in the 1970s and its commodification in the 1990s, there was a fleeting moment of heterotopia when state socialist ideology receded enough into the background to permit the tentative expression of local and traditional customs, while vernacular cultural practices subsisted outside of market relations. Nevertheless, Inner Mongolia was considered politically sensitive, so filming permission was not granted to the foreign documentarian despite persistent lobbying on Ottinger's part. Disappointed in her first objective, Ottinger retrained her sight on another subject: she petitioned the Chinese government to go to the southwest to film ethnic minorities there. From the month of October to December, the film crew met daily with officials from The Ministry of Culture in the historic Beijing Hotel, until the two sides eventually agreed to an exact trajectory of sightseeing that would begin with the historic parts of Beijing and culminate in the scenic province of Yunnan, where Ottinger would be able to survey 'model'

ethnic minorities whose ways of life were already exoticized in internal Chinese representations.

The three-part structure of *China* thus follows a travel itinerary laid out in advance, from which the film crew did not and indeed could not stray. On each day of shooting, they were taken to the specific location agreed upon in advance by Chinese functionaries assigned to the production by the Ministry of Culture. The interpreter, Ting-I Li, was a bilingual resident of East Germany who accompanied Ottinger to China and skilfully mediated the relationship with the central and local authorities. As she had done on all her previous films, Ottinger acted as her own cameraperson, while Bernd Balaschus performed the role of assistant cinematographer and Margit Eschenbach operated the sound equipment. Shooting began in the northern capital Beijing – 'China's great puritanical and spartan administrative centre' as Ottinger reminisces (Kuhn, 1987: 75) – where the film crew made the usual inspection of Hutong dwellings, the Forbidden City, Summer Place, the traditional Chinese apothecary Tong Ren Than and acrobatics at Temple fair (filming coincided with the Chinese New Year holidays). Then it was onwards by train to Chengdu, the provincial seat of Sichuan – 'a more lively province, almost baroque' (Kuhn, 1987: 75) – where the film crew attended a performance of Sichuan opera, spent time people watching in the Heming Teahouse, and explored the historic town of Dujiangyan with busy markets and ancient Buddhist temples from the Tang and Song dynasties. Finally, the team of foreign filmmakers and Chinese guides ventured into the remote southwestern province of Yunnan where they observed people at a flower and bird market in the capital city Kunming, filmed a traditional dance of ethnic youth before the iconic lime stone formations of Shilin, and went on to the Dali Autonomous Prefecture, a remote scenic region populated by the Bai ethnic minority. The final scene of the film shows a Bai community gathering in an outdoor courtyard to watch the romantic musical *Five Golden Flowers*, a 1950s minority film that remains popular among the ethnic community it exoticizes.

Bergstrom thought that *China*, in comparison to Ottinger's earlier films, captures the happy side of Difference insofar as art and life coincide. 'The film is completely positive', she writes, 'The China that Ottinger shows us is an example in which social signs are not oppressive, especially because we see artistic expression in all facets of daily life' (Bergstrom, 1988: 44). Her reading of the film thus positions Ottinger's documentary practice squarely within what Marcus would call 'the anthropological tradition of ethnography' with its strong commitment to holistic representation and, failing that, to the representation of an unattainable holism. Like those who criticize Ottinger for failing to enter the lifeworld of the ethnographic subject, Bergstrom attributes a wholeness to Chinese culture as represented in the film, celebrating the state of prelapsarian plenitude

that supposedly characterizes social relations in a non-western milieu. In this instance, however, the view of the ethnic community as not only integral but also knowable – from within if not from without – obscures the critical fact that the foreign observer is already inscribed in the field of culture as a *point of view*. That of the western tourist, to be specific, was being carefully prepared for at this moment in time: where she goes and what she sees was choreographed in accordance with state administrative directives that were themselves part of a centralized plan to liberalize the Soviet-style economy of the Maoist period (McGrath, 2008). From the perspective of the Ministry of Culture, the production of an ethnographic documentary by a foreign director presented an opportunity to run, in effect, a controlled experiment of the tourist itinerary that would eventually generate billions of revenue and transform the regional economy of remote but scenic provinces such as Yunnan.[3] We cannot therefore analyse the politics of visual representation in Ottinger's documentary film without reference to the administrative logic that determined the West German film crew's sightseeing itinerary, which played a critical role in China's economic reform since the 1970s (Burkett and Hart-Landsberg, 2005; Lippit, 2005; Shirt, 1993). From this perspective, the resulting travel film appears first and foremost as the record of a *movement*. The meaning of this movement, moreover, only becomes available when we re-view Ottinger's ethnographic documentary, made and broadcasted on West German public television, not from the perspective of the tourist who forgets herself in the euphoria of aesthetic contemplation, but from the internal dynamics of the society which never loses sight of *her*.

Even though the foreign documentarian can only see through a glass darkly, as it were, Ottinger's interest in vernacular and popular expressions of culture dovetailed with the ethnographic concerns of 'Fifth Generation' cinema and the 'root-seeking' (*xungen*) movement in Reform-era Chinese literature. The coincidence suggests the desire of the Other is not only a problem *of* but also a problem *for* ethnography. Instead of fixating on the filmmaker's subjective point of view, we should interrogate the visibility of *folk* culture (*minjian fenhua*) as an objective feature of the ethnographic milieu. Why did figurations of presocialist agrarian communities come to the forefront of Chinese national consciousness at this moment in time? Undoubtedly, the lifting of Cultural Revolution-era taboos set the stage for an organic and spontaneous revival of traditional beliefs and practices after 1979. A further contributing cause of the root-seeking fever was the experience acquired by students 'sent down' to labour (*xiaxiang*) in the countryside during the latter stage of the Cultural Revolution. What had been hitherto repressed can now be safely practiced at the local level and accorded representation by a generation of urban intellectuals more familiar with the lifeworld of peasant communities than their historic predecessors. Yet, beyond the agenda of cultural

liberalization, I would postulate a more fundamental objective in the valorization of peasant and minority cultures during the early Reform period.

In his study of mainland Chinese culture during the transition from a planned to a market economy, Jason McGrath renders a concise account of what he calls the condition of postsocialist modernity:

> China's reform era – from late 1978 to the end of the century and beyond – has from the start been characterized by the ever-expanding reach of the market in society. The initial market reforms of Deng Xiaoping were limited to production in rural households and villages, where formerly collectivized farmers were allowed to sell their surplus produce privately on the local market and villages were encouraged to set up small industries and keep the profits for themselves. Throughout the Deng era and the Jiang Zemin era that followed, these market reforms expanded inexorably (if not steadily) to the point that the Chinese economy was formally integrated into the global capitalist system by its admission to the World Trade Organization (WTO) at the turn of the century.
>
> (2008: 2)

McGrath invites us to examine how cultural texts from this period, that is, the 1980s and 1990s, have 'reflected, and reflected *on*, the "going to market" of Chinese culture and society'. As a travelogue whose point of view coincides with that of the tourist, *China* conveys this larger movement from a planned economy and ideologically unified culture (organized, at least in theory, around the satisfaction of collective needs) to a market economy and pluralized culture (animated by the glorious desire to get rich) – a process McGrath describes as 'a transition from (state) heteronomy to (relative) autonomy' (McGrath, 2008: 9).

In *China*, the ethnographer's desire to capture precapitalist forms of life on the eve of their vanishing found its proper theatre in the busy marketplace and teeming fairground. Arriving just in time to film the first fruits of the rural market reforms, Ottinger captured her best visual material in the newly reopened spaces of commercial exchange: a western-style dance hall in Beijing, a temple fair in Chengdu, a bird-and-flower market in Kunming and a farmer's market in Zhoucheng Town near Dali. The reading of these visually alluring and sensorily abundant environments as sites of local autonomy and ethnic pluralization involves, however, a misrecognition of the governmental imperatives underlying the project of cultural liberalization. When westerners think about China's economic reform, they tend to picture the spectacular accumulation of financial and real estate assets in the so-called special economic zones such as Shenzhen. The pre-eminence of the glittering coastal cities, however, obscures the economic importance of the countryside in the development of China's productive forces at the initial stage of

capital formation. Indeed, peasant economy, due to its 'lightness' (i.e. not being capital intensive), had been on the cutting edge of free market economic reforms. Long before Deng Xiaoping made his historic 1992 'southern tour' to the coastal economic zones, various policies were instituted to extend market reforms to the rural economy. In the 1985 documentary film, we see the flowering of the semi-privatized peasant economy in a long scene from the outskirts of Chengdu, showing enterprising farmers from the countryside around Jinma River bringing surplus produce to town to sell on the free market. The picturesque procession of carts and bicycles laden with vegetables and live poultry is anything but an ahistorical genre painting. On the contrary, here is an indexical representation of the creative force of private initiative just then unleashed in rural China by deliberate policy changes in the centralized political establishment.

Marcus maintains that 'ethnographies have always been written in the context of historic change: the formation of state systems and the evolution of a world political economy' (Marcus, 1986: 165). This is certainly true of *China*, an avant-garde documentary in the most literal sense. What I mean is that filming (in) rural China opened a path of development and exchange, injecting monetary currency (not without difficulty) into a credit-based economy founded on a system of familial and political obligations rather than abstract relations of exchange. Moving into the vast hinterland of southwestern China, the film crew braved harsh living conditions – often sleeping in unheated political meeting rooms decorated with posters of Mao – and struggled to navigate a cashless economy unused to the demands of a film production unit. In the process, they became the pioneering representative of a transnational flow of material and symbolic values that would revolutionize the social relations of rural China.

The extent to which the rural regions Ottinger visited had hitherto subsisted outside of the world market can be seen in the following instance of misrecognition: a peasant woman in Yunnan asked the German filmmaker if she is Japanese, having formed hitherto no mental image of other races or cultures. Two things can be said of this anecdote: first, such a parochial state of consciousness would become unthinkable a few years later, once the village hearth is adorned by a television set; second, the moral of the story is not to be the otherness of traditional peasant culture but the critical role of the documentarian in shattering the precapitalist worldviews of local subjects while establishing imaginary relations and symbolic networks essential to the expansion of the world market. In accomplishing this task, Ottinger inadvertently undertook a work of salvage ethnography, that is, carrying out a representational project which erodes the enclosed social systems it seeks to document in the very process of inscription. Indeed, the fascination of watching *China* today stems in part from the estranging effect of encountering afresh the aura of locales that have been exploited to death by a massive tourist

industry. For contemporary subjects implicated in the Chinese economic miracle (that is to say, practically everyone but especially those with mainland Chinese roots), nostalgic contemplation of a pre-postsocialist past is impossible to disentangle from uncanny awareness of the forces of development already in motion and which moves the needle of filmic representation (Figure 7.1).

Before turning to examine the formal implications of constructing an ethnography sensitive to the context of historical political economy, I want to briefly address another aspect of the Other's desire: namely, the anxiety provoked by the gaze of this Other's Other, that is to say, by the instalment of a point of view situated outside the field of culture (invoking thereby a phantasmatic Outside to the symbolic order) without which the subject of ethnography cannot be properly constituted. The reaction of the state bureaucracy to the work of representation they sanctioned is extremely telling in this regard. As Ottinger recalls, the Chinese functionaries who shadowed the production team were frequently perturbed by her desire to capture reality on the fly during production and wary of her professed interest 'not only in culture, but the culture of their everyday life' (Kuhn, 1987: 75). Does the resistance of the state bureaucracy to the unplanned

FIGURE 7.1: *China. Die Künste – Der Alltag*. Photograph by Ulrike Ottinger, Berlin, 1985. © Ulrike Ottinger.

moment in documentary representation betray an authoritarian urge to conceal reality beneath an ideal image? Ottinger herself takes this view, but I would argue the matter is more complex. In the end, the only part of the film that the Chinese embassy in Bonn, after reviewing a rush, requested Ottinger to censor (a request she politely declined) was a bathetic scene set in the Beijing Railway Station, showing homeward-bound workers on the train platform during the peak travel season ahead of the Chinese New Year, waiting in unguarded attitudes of distraction and fatigue. The Chinese ambassador personally conveyed to Ottinger over a friendly meal the official objection that the scene shows China and its people in a bad light. This fascinating reaction suggests that the anxiety provoked by the prospect of foreign observation is not, ultimately, a question of *what* the Other sees but is fearful rather of the unsupervised moment when *the self* might be exposed without adequate preparation or camouflage and consequently lose its imaginary integrity. The very fantasy of such a 'shameful' experience, as Antonioni and other western directors discovered to their chagrin, is enough to whip up frenzied opposition to the film production in question regardless of the work's actual content or political message (Barthes, 2012: 29–32; Eco, 1977: 8–12). While bewildering to the well-intentioned ethnographer, the unpredictable reaction of the Chinese public is consistent with the official practice of simultaneously inviting and obsessively managing the anxiety-provoking gaze of the Other through theatrical forms of self (re)presentation.

I emphasize the political organization of desire in Reform-era China not to subordinate the work of art to its social context but to dialecticize the subject and object in a traditional work of ethnography. Contrary to rendering a determinist account of culture, awareness of the material and ideological constraints imposed by the Chinese state puts Ottinger's creative decisions into the framework of a dialogic relationship. We see the state dictating to the filmmaker what she may or may not film, while she, on her part, quietly subverts the parade of national heritage sights by cutting down the documentary's didactic elements to a bare minimum and turning attention itself into a political form. As camera person, Ottinger used the method of *caméra-stylo* (literally, 'camera pen'), a concept advanced by Alexander Astruc in the 1940s, to record whatever seemed to her worthy of attention: 'I travelled everywhere with my camera on my shoulder, ready to film at any given moment' (Kuhn, 1987: 75). Her cinematography directs attention to the information-rich environment in such a way as to diffuse and occasionally puncture the iconic tableaus carefully prepared for the foreign visitor. The visual detail springs to life through a process of looking that the filmmaker repeatedly likens to the unfolding of a traditional Chinese scroll (Kuhn, 1987: 75). At the Puzhao Temple, the film carries our gaze irreverently upwards and over the curved eaves of the temple roofs to linger in fascination at clay and wooden figurines of gods and

beasts, silhouetted against the sky. The unplanned quality of these camera movements and their delightful détournement brings to mind the perceptual activities of a preliterate child whose distracted gaze wanders from sight to sight, taking in the manifold wonders of the world without pre-established schema or symbolic hierarchy. A gentle form of visual comedy is achieved simply by waiting for the incongruous detail to emerge and create a ripple in the homogenous passage of time. The roving eye of the camera meanders aimlessly, alighting now and then on a satisfying detail, taking its pleasures without ceremony and winking occasionally at us.

The Chinese bureaucracy, in short, exercised control over the *content* of her representations, but Ottinger could speak a language of style. In its final form, the film is the result of both collaboration and contestation between the foreign documentarian, who sought to circumvent official iconographies with a mediative way of looking, and the ethnographic milieu that organized its own representation through the eyes of the Other but could not fully control what the documentarian chose to pay attention to. What structurally enabled and what functionally constrained Ottinger's creative impulse – contributing therefore to the final *form* of the documentary film – constitutes in my view the dialectical work of ethnographic representation, whose proper subject is not a culture frozen into immobility by the desire of the tourist in quest of a '"real" example of unoppressed Difference', *pace* Bergstrom, but the internal dynamics of a society on a verge of radical transformations (Bergstrom, 1988: 46).

The misrecognitions and projective identifications that bedevil the critical reception of Ottinger's documentary arise, in my view, from the failure to conceptually integrate the closely observed cultural worlds of local communities with global analyses of China's 'Reform and Opening' (*gaige kaifang*) during the 1980s. Readings that espouse ideals of cultural holism invariably ignore the incipient process of social fragmentation and ideological ruptures that were set into motion by structural readjustment of a state-socialist economy. The more difficult question is: did *China* make visible – was Ottinger herself aware of – the internal contradictions of Chinese society as a documentary representation? If adopting a posture of epistemological modesty necessarily commits the ethnographer to an affirmative vision of alterity, then Ottinger's recording of everyday life in China would be a symptom rather than an analysis of the obsessively managed encounter between two cultures. Admittedly, Ottinger does not make explicit the conditions of this recording – we do not find out, for example, about the interference and constraints the film crew had to navigate to make the film – but she is not a naïve pawn of the state's agenda. On the contrary, *China* makes visible without commentary the *gap* between state ideology and everyday social practice – an unspoken interval animated by ambivalence, illegitimacy and misrecognition – as

that on which the entire program of 'Reform and Opening' turns. In this way, it exposes the contradiction that matters, namely, a topology of the not-One that structures the developmentalist agenda of Chinese state capitalism and the private initiative that it seeks to unleash. As a filmmaker, Ottinger shows us how to interpret local-level processes without reference to a stable ethnic identity. At a formal level, the travel ethnography stages a movement that connects the centre (Beijing) to the periphery (a remote village in Yunnan). At the start of this journey, state ideology and everyday life are so intimately entwined as to be indistinguishable from one another. We see their interpenetration in the social realist drama of an 'ordinary neighbourhood' at the Nationalities Theater (*minzu juyuan*), in which professional actors who are salaried employees of the state attempt to represent the mundane aspirations and petty concerns of the average citizen. Conversely, an abashed taxi driver, when under question, echoes back the party line on sundry issues from public housing to urban sanitation.

The most conspicuous action of a centralized political establishment that claimed to represent the interest of the masses and the development of the country's productive forces appears in the streets of the former imperial capital. In the Hutong district of old Beijing, Ottinger's camera pans slowly over the window of a photography studio, where coloured photographs of rosy cheeked children posing in model vehicles of various kinds are prominently displayed. In the nearby streets and playground, the camera dallies with real-life children, ranging from wide-eyed toddlers to elementary school students wearing the red handkerchief of the Young Pioneers. Seeing the film today, one is struck by the film's attraction to these well-turned-out children, who are the first fruits of China's One Child Policy and who would become the beneficiaries of the Chinese economic miracle, which coincided with the lifespan of this particular generation of Chinese citizens. In a film that deliberately avoids the iconography of modernity, we see nevertheless the future of the nation being written in family planning posters showing the ideal middle-class Chinese family: a heterosexual couple showering affection upon a single progeny. Is the state not a co-author of this *ethnos-graphé*, or people writing, that inscribes the mother of all 'difference' into the body politics of the nation?

At the other end of the movement that binds the periphery to the centre, the local to the global, Ottinger documented a well-attended outdoor screening of the national-minority film *Five Golden Flowers*. The event took place in the main square of a traditional Bai village, which became filled with genial, mirthful people of all ages long before nightfall. The scene would have been a familiar sight in socialist China: until television sets became commonplace in the 1990s, mobile teams of state-employed film projectionists (*fanyingdui*) would travel from village to village to show movies for free on a temporary screen. The significance of this form of popular entertainment in rural China has been persuasively analysed by Xin Liu in his

ethnographic account of post-Reform peasant communities. According to Liu, the practice of congregating when the travelling cinema comes to town created an important occasion for rural communities to make sense of rapidly evolving social relations in the period of economic reform. He points out that, however, the production of cultural form on these occasions rarely pertains to the content of the films shown:

> Whenever there was a movie, people would pass on the good news, but what movie was being shown was seldom part of the information – and few would bother to ask. Even after seeing it, hardly anyone remembered the movie's name or plot. If one asked, the likely answer would be something like, 'Oh, who knows, some men and some women ... They were doing things in it'. Here the movie itself is the content of this activity, but how its viewing is organized and talked about is its form. What is important is to tell each other the news, to go to the viewing, to share with others a moment of happiness. What is actually watched is of only secondary importance.
> (Liu, 2000: 118–19)

On the political implications of such a split, Liu observes that ideological doctrines imposed on local people from outside may be easily transformed into an empty form that has no effect on actual practice. A gap is thus opened between the prescriptions of state ideology and the practice of the everyday. In her analysis of Chinese socialist cinema's multisensory environment, Jie Li reaches a similar conclusion: instead of following the narrative, what really mattered to rural audiences was the quality of 'hot noise' (*renao*), that is, the potential of outdoor-screenings to become 'festive occasions for mass congregation, spectacle, noise commensality, intimacy, and nightlife against a backdrop of poverty, hardship, and dreariness'.[4] On the basis of oral interviews she conducted with people who recall these events, Li argues that socialist cinema did not hold homogenous meaning for rural audiences; its members were members of 'an unruly crowd whose hot noise eluded, even subverted, state control' (2020: 10).

With her meandering, irreverent gaze, Ottinger's cinematography strives to make the gap between ideology and everyday life visible, dwelling on the surplus forms of enjoyment that deflect the call of interpellation. She shrewdly identifies this gap in the confrontation of the Bai community with its own idealized representation in state-socialist cinema and shows us an encounter of two cultures defined not by sympathy or antipathy but rather by the freedom of misrecognition. The villagers who turned out to watch *Five Golden Flowers* could relish the sight and sound of the Maoist-era musical melodrama – some handsome men and beautiful women are smiling and flirting; the colour is luxurious and the songs cheerful; the fanciful costumes of the actors are a treat for the eye, etc. – without recognizing themselves in the subject positions prepared for them by state-socialist ideology. Instead of

identifying with the Mandarin-speaking characters and their performance of Bai ethnicity, audience members from the ethnic community in question recognized themselves in the form of the event, in the light, the noise, the crowds and the festival atmosphere, as well as the inevitable breakdown of technology and the comedy of errors that ensure, all of which Ottinger foregrounds in her documentation of this scene. The travelling cinema functions therefore as a self-referential allegory: an ethnography film within an ethnographic film. It shows that ethnicity as culture form is historically contingent rather than ontologically inherent to a certain social group. Through a cinema of experience, collective identity becomes a work of self-representation that renders individual and collective identities intelligible to a provisional community without reference to a repertory of stock ethnic signifiers.

The act of writing divides, separates the subject of ethnography from itself. For Bergstrom, Ottinger succeeds because 'the film underscores *our* cultural difference as observers, yet links *us* to something we share with *these people*' (1988: 46). For me, the real political question is not whether the film marks 'our' difference from 'their' culture but whether it allows the culture of the other to appear as difference to itself. Are the 'people' of *China* forever the subject of a representation which proceeds from and returns to address the West as 'Other'? In this essay, I have tried to sidestep the problem of 'cultural exoticism' raised by and about Ottinger's ethnographic work in order to avoid privileging the consciousness of the western spectator (the universally assumed 'we' of representation and knowledge) at the level of interpretation, focusing instead on the production of a shared and antagonistic reality in documentary filmmaking and the ethnographic work of solidarity, which is to collaborate in someone else's auto-critique. Along the way, I have attempted to disarticulate the meaning of the film from the positionality of the filmmaker by shedding light on how internal developments in China, such as the enormous development of market systems in rural China since the 1970s and evolving state policy regarding the nationalities, mediated Ottinger's portrait of its people and how she, in turn, mobilized the mimetic properties of film to remediate the signifying practices of the vernacular. *China*, I argue, captured the gap at the very heart of the 'people', and in this way the posture of epistemological modesty that Ottinger adopted in no way reflects an uncritical espousal of cultural holism. In the final analysis, the ethnography of a culture is written under circumstances created by its people as much as it is a writing of the people.

NOTES

1. Ulrike Ottinger, private interview with the author, at the filmmaker's Berlin residence, 19 December 2021. Unless otherwise noted, all the details about the production history of *China* were based on the author's notes from this interview.

2. To be sure, Ottinger herself has contributed to this bias by insisting on her position as an auteur who assumes creative responsibility for all aspects of film production. She staunchly maintained that '[all] my films to date have been scripted, directed and filmed exclusively by me. I also take responsibility for art directing' (Kuhn, 1987: 78).
3. In the 2000s, the Ministry of Culture, which supervised all three of Ottinger's productions, was renamed the Ministry of Culture *and Tourism*.

REFERENCES

Barthes, Roland (2012), *Travel in China* (ed. Anne Herschberg Pierrot), Malden: Polity Press, pp. 29–32.

Baschiera, Stefano (2014), 'From Beijing with love: The global dimension of Bertolucci's *The Last Emperor*', *The Journal of Italian Cinema and Media Studies*, 2:3, pp. 399–415.

Bergstrom, Janet (1988), 'The theater of everyday life: Ulrike Ottinger's China: The arts, everyday life', *Camera Obscura*, 19, pp. 42–51.

Burkett, Paul and Hart-Landsberg, Martin (2005), *China and Socialism: Market Reforms and Class Struggle*, New York: Monthly Review Press.

Clifford, James (1986), 'Introduction: Partial truth', in James Clifford and George E. Marcus (eds), *Writing Culture: The Poetics and Politics of Ethnography*, Berkeley: University of California Press, pp. 1–26.

Crapanzano, Vincent (1986), 'Hermes' dilemma: The masking of subversion in ethnographic description', in James Clifford and George E. Marcus (eds), *Writing Culture: The Poetics and Politics of Ethnography*, Berkeley: University of California Press, pp. 51–76.

De Certeau, Michel (1986), *Heterologies: Discourse on the Other* (trans. Brian Massumi), Minneapolis: University of Minnesota Press.

Eco, Umberto (1977), 'De Interpretatione, or the difficulty of being Marco Polo [On the occasion of Antonioni's China film]' (trans. Christine Leefeld), *Film Quarterly*, 30:4, pp. 8–12.

Fabian, Johannes (2014), *Time & The Other: How Anthropology Makes Its Objects*, New York: Columbia University Press.

Fardon, Richard (1990), *Localizing Strategies: Regional Traditions of Ethnographic Writing*, Edinburgh: Scottish Academic Press.

Ge, Zhaoguang (2018), *What is China? Territory, Ethnicity, Culture, and History* (trans. Michael Gibbs Hill), Cambridge, MA: Harvard University Press.

Grisham, Therese (1992), 'Twentieth century Theatrum Mundi: Ulrike Ottinger's *Johanna d'Arc of Mongolia*', *Wide Angle*, 14:2, pp. 22–36.

Hansen, Miriam (1984), 'Visual pleasure, fetishism and the problem of feminine discourse: Ulrike Ottinger's ticket of no return', *New German Critique*, 31, pp. 95–108.

Harjes, Kirsten and Nusser, Tanja (1999), 'An authentic experience of history: Tourism in Ulrike Ottinger's exile Shanghai', *Woman in German Yearbook*, 15, pp. 247–63.

King, Homay (2007), 'Sign in the void: Ulrike Ottinger's *Johanna d'Arc of Mongolia*', *Afterall*, 16, pp. 46–52.

Li, Jie (2020), 'The hot noise of open-air cinema', *Grey Room*, 81, pp. 6–35.

Lippit Victor D. (2005), 'The political economy of China's economic reform', *Critical Asian Studies*, 37:3, pp. 441–62.

Liu, Xin (2000), *In One's Own Shadow: An Ethnographic Account of the Condition of Post-reform Rural China*, Berkeley: University of California Press.

Longfellow, Brenda (1993), 'Lesbian phantasy and the other woman in Ottinger's *Johanna d' Arc of Mongolia*', *Screen*, 34:2, pp. 124–33.

Kuhn, Annette and Ulrike Ottinger (1987), 'Encounter between two cultures: A discussion with Ulrike Ottinger, introduced by Annette Kuhn', *Screen*, 28:4, pp. 74–79.

Marcus, George E. (1986), 'Contemporary problems of ethnography in the modern world system', in James Clifford and George E. Marcus (eds), *Writing Culture: The Poetics and Politics of Ethnography*, Berkeley: University of California Press, pp. 165–93.

Marcus, George E. and M. M. J. Fischer (1986), *Anthropology as Cultural Critique: An Experimental Moment in the Human Sciences*, Chicago: University of Chicago Press.

McGrath, Jason (2008), *Postsocialist Modernity: Chinese Cinema, Literature, and Criticism in the Market Age*, Stanford: Stanford University Press.

Mueller, Rosewitha (1982), 'Interview with Ulrike Ottinger', *Discourse*, 4, pp. 108–25.

Ottinger, Ulrike (n.d.), 'China: The arts – the people', ulrike ottinger (website), https://www.ulrikeottinger.com/en/film-details/china-the-arts-the-people. Accessed 21 September 2021.

Povinelli, Elizabeth A. (2002), *The Cunning of Recognition: Indigenous Alterities and the Making of Australian Multiculturalism*, Durham, NC: Duke University Press.

Shirt, Susan L. (1993), *The Political Logic of Economic Reform in China*, Berkeley: University of California Press.

Sklarew, Bruch H. and Spitz, Ellen Handler (1998), 'Interview with Bernado Bertolucci', in Bruce H. Sklarew, Bonnie S. Kaufman and Diane Borden (eds), *Bertolucci's The Last Emperor: Multiple Takes*, Detroit: Wayne State University Press, pp. 37–56.

Taussig, Michael (1992), *Mimesis and Alterity: A Particular History of the Senses*, New York: Routledge.

Trumpener, Katie (1993), '*Johanna d'Arc of Mongolia* in the mirror of Dorian Gray: Ethnographic recordings and the aesthetics of the market in the recent films of Ulrike Ottinger', *New German Critique*, 60, pp. 77–99.

Whissel, Kristen (1996), 'Racialized spectacle, exchange relations and the western in *Johanna d'Arc of Mongolia*', *Screen*, 37:1, pp. 41–67.

White, Patricia (2022), 'The cosmos according to Ulrike Ottinger', The Criterion Collection, https://www.criterion.com/current/posts/7880-the-cosmos-according-to-ulrike-ottinger. Accessed 5 September 2023.

Villarejo, Amy (2002), 'Archiving the diaspora: A lesbian impression of/in Ulrike Ottinger's 'Exile Shanghai', *New German Critique*, 87, pp. 157–91.

Zhaoguang, Ge (2018), *What is China? Territory, Ethnicity, Culture, and History* (trans. Michael Gibbs Hill), Cambridge, MA: Harvard University Press.

8

A Timely Education: *Johanna d'Arc of Mongolia* (1989)

Erica Carter and Hyojin Yoon

In November 2013, Germany's major political parties were jostling for position in a then forthcoming coalition government. At the eleventh hour, the parties added to the coalition agreement a clause of special significance for German film. A group of prominent cineastes, film scholars, archivists and critics had submitted a petition demanding action to preserve, restore and digitize Germany's endangered analogue film heritage. The petition rubric, 'Filmerbe in Gefahr' ('Film Heritage in Danger'), encapsulated the signatories' fear that chemical decomposition would lead in the foreseeable future to the loss of 'most films from the previous one hundred years' (Anon, 2013: n.pag.). The petition was duly heeded. A passage in the coalition agreement of 26 November 2013 committed the negotiating parties to future resourcing to safeguard, digitize and disseminate German film heritage. Funding in the scheme's early stages of 1 million Euros annually was raised in 2019 to a yearly sum of 10 million, dispensed for film digitization over a ten-year period by the German *Filmförderungsanstalt* (Federal Film Board [FFA]).

Ulrike Ottinger, however, had read the runes of the digital transition well before November 2013. Ottinger's film practice is marked by a singular attention not just to duration as a poetic quality evident in her camera's signature long takes or tableau composition, but to durability as a material requirement for films destined for as-yet-unknowable afterlives. Already in 1995, new prints for a major retrospective at the Deutsche Kinemathek had restored to public visibility a back catalogue of thirteen films from more than two filmmaking decades (Hanisch et al., 1995). In 2013, Ottinger pre-empted the Federal state's embrace of digital futures when she won further digitization funds for five major features, including her 1979–84 Berlin trilogy, *Exil Shanghai* (1997), and *Johanna d'Arc of Mongolia* (1989). By the late 2010s, Ulrike Ottinger Filmproduktion was amongst the most

regularly successful of Germany's independent producers in garnering digitization funds from the FFA (Carter, 2022: 40).

Ottinger's commitment to her films' serial restoration and recirculation suggests a filmmaker confident of her works' recurrent timeliness. That confidence is validated by the numerous curators, programmers and critics who have championed Ottinger's filmmaking across five decades. Her personal website lists up to 50 solo exhibitions since 1990, spanning locations from Paris, Berlin and Rome, to New York, Ekaterinenburg or Gwangju. There have been at least a dozen international retrospectives since 2007 alone; a panoply of critical collections and monographs; and in 2023, a Berlin event series in Ottinger's honour to mark the handover of Ottinger's archive to joint custodianship by the Akademie der Künste and Deutsche Kinemathek.

This catalogue of curatorial tributes, alongside awards including for Avant-Garde Achievements in Fine Art (Warsaw 2022), Lifetime Artistic Achievement (Hannah Höch Prize, Berlin, 2011), the Montreal Audience Jury Prize (1989) or the Berlinale Camera at the 70th Berlin Film Festival edition (2020), confirms the capacity of Ottinger's films to speak to changing historical moments and audience or critical sensibilities across global locales. This chapter uses a study of one of Ottinger's best-loved titles, *Johanna d'Arc of Mongolia*, to probe in more detail this capacity to address the mutating local and global circumstances of historical experience. The case we make for *Johanna d'Arc*'s historicity downplays questions of historical representation and meaning, centring instead on imagination and aesthetic experience as resources both for sensed experiences of past utopias and for a counter-imaginary of viable futures. In a recent essay on the historical poetics of German cinema in an earlier period – the long period of ascendancy of German silent cinema from 1910 to 1930 – Michael Wedel calls for attention by film scholars to the 'minuscule forms of historicity' that become evident not in some extra-cinematic domain of historical experience, but in 'the poetic texture and affective economy of the films themselves' (Wedel, 2019: 1, 180). Wedel's approach to film via a historical poetics is mirrored by other writers we draw on below, including Sarah Cooper, Rosalind Galt, Hermann Kappelhoff and Edward Said. In a two-part account of Ottinger's *Johanna d'Arc*, we first consider how a film apparently inattentive to its tumultuous historical moment – *Johanna d'Arc* was released in 1989, the year of the fall of the Berlin Wall – in fact engages the spectator in a playful reimagination of the historical narratives cementing East-West division across four-and-half postwar decades.

Drawing on Sarah Cooper's account of the 'imagined image' as a resource both for imaginative recall of buried pasts and projective renarration of plausible futures, our reading of *Johanna d'Arc* thus locates the film first in the historical moment of 1989 (Cooper, 2019). In a second move, we consider the resources

this film offers for our own troubled geopolitical times. *Johanna d'Arc*'s first act conjures memories of imperial and interwar Mitteleuropa as playgrounds for a post-Cold War East-West imaginary. In its second act, the film moves, we will argue, to explore aesthetic practices that foster cross-cultural rapprochement not just in this film's late 1980s moment, but across the longer history of a shared pedagogy of love. Flaubert's novel *Sentimental Education* is both a prominent plot object in this film and a cipher for its engagement with the pedagogical eros as a motivating force for intercultural rapprochement and commingling. Our essay's second part is devoted accordingly both to Flaubert's Orientalist version of a sentimental education and to Ottinger's riposte: her vision of a transcultural pedagogical erotics that is, for us, both a source of this film's wisdom, and of its enduring appeal.

Mitteleuropa reimagined: Johanna d'Arc *Act 1*

Johanna d'Arc of Mongolia premiered at the Berlin International Film Festival (the Berlinale) on 14 February 1989. The film follows a motley band of European women travellers first on a Trans-Siberian journey across Central Europe and Russia, then south-eastward on the Trans-Mongolian railway from Ulan Ude to the Inner Mongolian steppes and the Gobi desert. It has multiple protagonists: the ethnologist Lady Windermere (Delphine Seyrig), a specialist in Central Asian language and folklore; her protégée, the fresh-faced backpacker Giovanna (Inès Sastre); the musical star Fanny Ziegfeld (Gillian Scalici); the group's Mongolian host, Princess Ulun Iga (Xu Re Huar); and the three Kalinka Sisters (Jacinta, Else Nabu, Sevimbike Elibay), a troubadour trio whose rendering of the Yiddish lovers' duet *Bay mir bistdu scheyn* becomes a leitmotif for the film's unfolding stories of cross-cultural love.

Despite its transcultural casting and East-West setting, the film seemed to many 1989 critics far removed from the *perestroika* moment registered elsewhere in the Berlinale programme. Amongst the festival's Eastern European highlights were several previously banned Czech and Soviet films, a handful of treasures from Bulgarian archives, and a first Berlin screening of East German director Frank Beyer's *Der Bruch* ('The Break', 1988). Beyer's comedy heist film captured in its title what was in this festival edition a recurrent emphasis on epochal fracture. *Der Bruch*'s fictional account of a 1946 train robbery revived familiar crime film tropes of a social and moral order collapsing in the wake of Nazi defeat. That theme continued in Marcel Ophüls's Klaus Barbie documentary *Hotel Terminus* (1988). Centring on SS officer Barbie's involvement in the Nazi genocide, *Hotel Terminus* evoked in microcosm the larger historical rupture of

European fascism. Ophüls's film resonated then, as did in more popular register Frank Beyer's neo-noir comedy-thriller, with the cognate historical caesura whose signs were palpable at the February Berlinale: the crumbling of Eastern European authoritarian state socialism, and its final disintegration with the fall of the Berlin Wall in October 1989.

Johanna d'Arc seems initially anachronistic in this context. The film is a game in three acts: the first an assemblage of set piece performances in train compartments and an opulent restaurant car; a second act a journey in the wake of the hijack, whose shift from studio to location shooting liberates Ottinger's camera to roam across undulating steppe and desert landscapes; and a brief epilogue when Lady Windermere and her companions return to the train to reflect with Princess Ulun Iga on their mutual encounter, celebrating its pleasures with the Kalinka Sisters' final rendering of the Yiddish theatre number and Andrews Sisters popular hit *Bay mir bistu scheyn*.

That *Johanna d'Arc* will shun historical verisimilitude is clear from the very first shot. A startling close-up eschews the geographical logic of classical cinema's establishing shot, plunging the viewer instead into an unsettlingly close encounter with a painted scenery flat. Soft green hues suggest a forest, its trees abstracted into sinuous vertical figures, time and movement insinuated by the dubbed sound of a steam locomotive and wild rushing wind. That it is sound and voice which will add depth and context to this film's often emphatically two-dimensional spatial arrangements is confirmed when Lady Windermere's voice over intones dreamily (and in English), 'Tundra. The wild, wild tundra'. The camera pulls back to frame Milady in profile against a train window, her body a stylized figure artfully posed to mirror the contours of a Chinese vase that balances the shot on screen left. The camera rises in a slow pan to caress the compartment walls. Sundry artefacts – Oriental engravings, silk scarves, more vases – suggest themselves as visual ciphers for the epistemological and ethical puzzle that will haunt this film. Cue Lady Windermere:

> ... things we read – the imagination – the confrontation with reality. Must imagination shun the encounter with reality, or are they enamoured of each other? Can they form an alliance? Does the encounter transform them? Do they exchange roles?

Compressed within this short but compositionally complex shot sequence, Lady Windermere's questions acquire emblematic weight, locating this not so much as a narrative opening, but rather the beginning of a cine-philosophical rumination on film in its relation to empirical reality, imagination and truth. The film's speculations turn on a question that perennially vexes aesthetic philosophy: that of the relation between cognition as a route, via reason, to knowledge and understanding;

and the imagination as a faculty that enables ethical encounters with the surrounding world. The densely ornamental opening sequence of *Johanna d'Arc* places the film firmly on the side of aesthetic experience as a route to an expanded imagination of old and new worlds. In its opening act, *Johanna d'Arc* can be described as a train movie: a genre constellation that has moved historically between documentary modes stressing the train's technological production of modern experiences of speed, acceleration and shock (viz. the Lumière brothers *L'arrivée d'un train en gare*, or Walter Ruttmann's *Berlin Symphony*); travelogues where the train is a prosthetic sensory organ endowing human vision with mobile and panoramic perceptual capacities; and classical studio films where the railway carriage becomes the mise-en-scène for romantic melodramas or thrillers of chamber-drama intensity: Hitchcock's *The Lady Vanishes* (1938), Ernst Lubitsch's *Angel* (1937) or von Sternberg's *Shanghai Express* (1932), a film whose queer intercultural eroticism – palpable in memorable encounters between Marlene Dietrich and Chinese American star Anna May Wong – make it an obvious intertext for Ottinger's film.

Johanna d'Arc belongs then (if mischievously and playfully) within the latter group of train-movies-as-chamber-drama. The film's strategies of cinematic worlding invoke the mannered aesthetics not just of the studio era but also of earlier moments when the train movie, indeed cinema itself revelled visibly in its own capacity for illusion. Opening credits introduce each protagonist, in the manner of early film stars, with an appropriately stylized title card. The film studio as fabricated world is further connoted by a mise-en-scène of cramped interiors, where time and geography are mediated through cultural artefacts and images, stories and fables, sounds and musical fragments, the stuff of things that we imaginatively touch, taste, or otherwise sensuously ingest (viz. the film's emphasis on gourmet eating, a feature to which we return briefly below).

Lady Windermere speaks in *Johanna d'Arc*'s first sequence of 'maps' of the train's Trans-Siberian eastward route. But we see nothing of maps as graphic representations; it is instead through images, gestures, sounds and stories that the film's cognitive map emerges. Geographical coordinates are given in incidental comments, at a breakfast party late in Act 1 for instance, when the ceremonial disembarkation at a new command post of a certain Officer Alexander Boris Nikolay Nikolayevich Muravyov (Nougzar Sharia) locates the train in the Sino-Russian border town of Kultuk. In the same conversation, the Yiddish theatre artiste and dandy Mickey Katz (Peter Kern) reveals his destination as Harbin, a Chinese staging post favoured from the late nineteenth century by Russian immigrants, later by luxury travellers pursuing designs and fashion items from Paris and Moscow. Katz and the Major now disembark, disappearing into a Russian landscape made tangible to this film's viewer not through rolling external vistas, but in exotic images, artefacts and performed vignettes that sketch an imagined

historical geography stretching eastwards from Central Europe to the Chinese borderlands.

The preeminent cartographer of this transnational imaginary is Lady Windermere. Milady's ethnographic collections – assorted *objets d'art*, but also oral narratives and folktales – prefigure in the manner of Donna Haraway's speculative fabulations ('real stories that are also ... speculative realisms') the 'partial and flawed translations across difference' that *Johanna d'Arc* will undertake in the European-Mongolian encounters of its second act (Haraway, 2016: 10). The geography of the group's Trans-Siberian journey is rendered perceptible, though not objectively visible, in set-piece performances by other characters. Russia, both Tsarist and Soviet, is evoked in all its grandeur and imperial excess by Mickey Katz's 'boyar wedding feast' in the restaurant car: six eggs nested in a 'small wreath of Russian salad', a 'little' borscht ('don't forget the sour cream!'), a stuffed roast swan in full plumage, a 'stately zakuska' comprising sturgeon in aspic, assorted caviar with hot butter and sour cream, blini, guinea-fowl liver, kidneys in Madeira sauce, mushrooms, salad, salmon pâté, a 'rosebud wreath of turnips' and so on (Figure 8.1).

FIGURE 8.1: *Johanna d'Arc of Mongolia*. Photograph by Ulrike Ottinger, Berlin, 1988. © Ulrike Ottinger.

The Kalinka Sisters render Russianness in a differently excessive musical performance first of the nineteenth-century folk classic 'Kalinka', then 'Podmoskovnye Vechera' (Moscow Nights), a 1950s Russian composition later recycled by Western European jazz musicians including Kenny Ball and the Dutch ensemble New Orleans Syncopators. Russia's shifting political fortunes across two centuries are charted meanwhile in the family story of Officer Muravyov, a raconteur who claims as his ancestor the Governor of Eastern Siberia Nikolay Nikolayevich Muravyov, and who celebrates his great-grandfather's liberalism (the historical figure who bears this name was committed to abolishing serfdom), while himself cracking down on border infringements by nomad families in the 'godforsaken outpost' of Kultuk.

Act 1's most insistent spatio-temporal emphasis, however, is on the cosmopolitan Jewish, Romani, migrant and exile heritage of Central Europe. *Johanna d'Arc*'s expansive vision of *Mitteleuropa* as a multiethnic territory of shifting borders and intersecting transit zones is, again, not so much made optically perceptible, but rather, sensuously and imaginatively present through its embodiment in storytelling and musical performance. Mickey Katz's Harbin theatre engagement, we learn from his small talk with Lady Windermere, is in Harbin's Yiddish opera house. He has ancestral links, he explains, beginning in the Harbin fish cannery that bears the family name; but family connections stretch to Katz's New York pickle emporium, embedding his family narrative in long histories of Jewish migrations across the Eastern European borderlands and westwards to the United States. A performance in the restaurant car by the Kalinka Sisters reinforces the spectator's sensed awareness of diasporic affiliations stretching from East Central Asia to the United States, as it shifts from Russian popular song, through a number from the repertoire of Italian Romani performer Moira Orfei, to a camp rendering with Mickey Katz of an Al Jolson number from *The Jazz Singer* (1927), 'Toot Tootsie Goodbye'.

We now have a first answer to Lady Windermere's opening question. Ottinger is by her own account a director for whom history is 'seen and felt' in the moving image (Ottinger in Sherlock, 2019). Historical temporalities and spatialities may not be cognitively graspable; but they are, she avers, in some way made available in her films to sensuous apprehension and tacit knowledge. In *Johanna d'Arc*, accordingly, a cramped railway compartment becomes the mise-en-scène for imaginative encounters with historical realities that may be perceptually absent, but that are precisely for that reason all the more intensely experienced in story, gesture, image, artefact, sound and song. The film's attention to sound and voice is especially significant. Delphine Seyrig's voice as Lady Windermere has the mellifluous quality of a warm flowing stream; her onscreen listeners are visibly captivated, and we too bask in the state of imaginative reverie that the film's often hypnotic use of close sound invites. Tinkling teacups in her salon create a similar mood of

floating intimacy, readying us to engage a faculty of inner vision that brings into sharper focus the stories the film's protagonists tell, sing or otherwise enact.

The mental images these stories conjure range in scale from the widest of historical landscapes to tiny gestures from lives lived in the interstices of epochal struggles for land and life. All, though, are invested with what the film scholar Sarah Cooper calls 'vivacity': an aesthetic quality that Cooper attributes not just to the image on screen, but to what she terms the 'imagined image': an entity that is for her pervasive in film spectatorship, and that is certainly manifest in Ottinger's filmmaking, in *Johanna d'Arc* as elsewhere in her *oeuvre*. The imagined image, writes Cooper, is a product of the dual vision (or more properly, audio-vision) that is attributable to film spectatorship. The experience of film viewing, Cooper suggests, is at once oriented to the 'vivacity' and 'substance' of perceptible sound and image, and to more ephemeral imaginative entities conjured in the mind's eye and in a virtual space-time beyond the image frame. In Ottinger's case, 'vivacity' would thus refer only in part to the vibrancy of her characters' performances, to this film's rich colour palette, or to its exquisite visual tableaux. *Johanna d'Arc* also engages – and Lady Windermere's question underlines this – imaginative capacities for projection (the 'projective thought process' of what may soon eventuate, whether in the film's evolving narrative, or in the spectator's lived life); for remembering (where memory may range from earlier moments in the film, to life experiences recalled to make sense of the film's present puzzles); or for what Cooper calls, following Eisenstein, 'imagineity': a faculty demanding the 'combined work of imagination and memory', and lending to memory a futurity that derives from the mind's capacity to figure the past anew (Cooper, 2019: 27, 24, 31).

Seen in this light, the *Johanna d'Arc* of the 1989 Berlinale emerges no longer as an outlier in the Festival's engagement with the geopolitical convulsions of that climacteric year. Ottinger's film appears instead as conjuring, in story, art and song, 'imagined images' of the tumultuous histories of East and Central European or East Asian empires, the archaism of their social hierarchies, their cosmopolitan modernities or in the film's Romani, queer and Jewish cultural references, the genocidal impulses unleashed by imperial powers including but not exclusively the Nazi 'Third Reich'. Summoned into what Cooper might call 'vivacious' present life is at the same time a more ambivalent, demotic and future-oriented Central European modernity. In 2004, the literary historian Ursula Keller would write in this connection of a reemergent *Mitteleuropa*: no longer the bounded entity of the long Cold War, but a cultural 'mosaic, network, fabric, narrative, an open, porous and self-transforming context' (Keller, 2004: n.pag.). Keller's description seems pertinent to *Johanna d'Arc*, with its dense latticework of myths and stories, its meandering conversations and honeyed sound. That Keller was writing fully fifteen years after *Johanna d'Arc*'s release attests to Ottinger's capacity already in

the crisis moment of 1989 to imagine into being a *Mitteleuropa* of multiple centres, plural peripheries, fractured histories and culturally contested borderlands.

Viewed through the lens of Sarah Cooper's imagined image, *Johanna d'Arc* appears then profoundly historical, engaging as it does a historical imagination of futures past and of present transformations in geopolitical space and time. What *Johanna d'Arc* emphatically does not offer is, however (heaven forbid), a blueprint for a cultural or a geopolitical future. On political matters especially, including the vexed questions it raises of orientalism and ethnic difference, the film does not have an obvious didactic voice (though it does centre on teaching, as we shall shortly see). Frau Müller-Vohwinkel, admittedly, begins the film as a singular exception. In a scene towards the end of Act 1, she joins Fanny Ziegfeld for a Mongolian high tea that the waiter informs them is 'good against heat and cold'. Fanny eats the waiter's proffered delicacies with gusto; Frau Müller-Vohwinkel, by contrast, covers her cup in a tense gesture of bodily refusal. She may be by profession a teacher whose intellectual know-how might have lent authority to her narrative voice. Her reliance on the abstractions of authorized knowledge (the Baedeker) produces however a fear of sense experiences (tasting); indeed it takes a catastrophe – a later scene of shamanic metamorphosis – to release her now ecstatically open body into freer communion with her surrounding world.

For the film's other protagonists, Ottinger offers a gentler route to cross-cultural insight. Ottinger belongs amongst the filmmakers described by Sarah Cooper as privileging the 'image-making capacity of the imagination ... opening up the possibility for spectators to peruse the mental space in which images can be formed and transformed' (Cooper, 2019: 20). It is however, Cooper further notes, a feature of audio-vision in the film theatre (unlike for instance in video games, interactive cinema or social media) that it directs perception and sensation along prescribed sequential pathways; thus even in the case of digital projection, the image moves inexorably in theatrical screenings through the linear time of the projected film.

Image-making in cinema is for Cooper therefore a form of 'freedom within constraint', where imaginative processes oscillate between 'authoritarian directedness' and the 'gentler' path of what she terms 'guided image-making' (2019: 32). Cooper's comments find echoes in commentaries on guided knowledge inserted by Ottinger herself into *Johanna d'Arc*'s first act. Mickey Katz talks parenthetically of Lady Windermere's 'pedagogical eros'; Milady herself is bountiful in the instruction she offers to other protagonists in Mongolian language, customs and mores; Fanny Ziegfeld reads Flaubert's *L'éducation sentimentale* (Sentimental Education, 1869), a novel that shares with *Johanna d'Arc* a genesis in a political turbulence: not the 1990s collapse of twentieth-century state socialism, but an earlier shift from socialist utopianism to disenchantment in the revolutionary moment of 1848–51 (Flaubert, 2016).

These pedagogical references suggest, we want now to propose, a newly nuanced understanding of the politics of cultural difference underpinning *Johanna d'Arc*. We turn now to the film's specific forms of 'guided image-making' and directed knowledge, considering at greater length the questions of sentiment, taste and senses of commonality towards which Ottinger gestures, whether in her artful placing in the mise-en-scène of Flaubert's novel, or in the film's potpourri of related intertextual references to an imagination guided towards understanding through cinematic encounters with unfamiliar worlds.

A sentimental education

It is early morning. Officer Muravyov is woken by a merrily tap-dancing adjutant, Alyosha (Christoph Eichhorn). He packs Alyosha off to find 'the usual' breakfast (French cognac); a point-of-view shot reveals Fanny Ziegfeld in the compartment's opposite corner; Muravyov salutes her: 'Good morning Madame. I hope I haven't disturbed you too much.' 'Quite the contrary', Fanny responds. 'I spent the night in Frau Müller-Vohwinkel's compartment.'

Fanny's quip situates this scene in dialogue with the performance tradition that she herself embodies as a Broadway star. Her revelation of night-time bed rotations recalls on the one hand the sexual romps of bedroom farce à la Gustave Feydeau or Jean Poiret, whose 1973 queer comedy romance *La Cage aux Folles* was adapted in 1983 for the Broadway stage (Benyon John, 1995).[1] The scene gains literary heft, however, from Fanny's ostentatious display to camera of her morning reading matter: Flaubert's *L'éducation sentimentale*. That novel, admittedly, contains its own fair share of bedroom larks and adulterous passions. Protagonist Frédéric Moreau's most enduring liaisons are with married women, Marie Arnoux and Madame Dambreuse. He consorts with both while intermittently courting the novel's coquettish courtesan and polyamorous lover, Rosanette Bron. But the novel's core concern is not to titillate (sexual references are rare); it is, rather, to show by telling how mature love may be cultivated in the febrile climate of mid-nineteenth-century European popular revolution and liberal dissent.

L'éducation sentimentale belongs, as literary historian Patrick Coleman explains, in an Enlightenment lineage spanning moral philosophy (he cites in this connection Adam Smith's 1758 *Theory of Moral Sentiments*), and early forerunners of the bourgeois novel including Laurence Sterne's *A Sentimental Journey and Other Writings* (1768) (Coleman, 2016: vii–viii). The German romantics continued the tradition in philosophical debates on aesthetic education whose founding texts included Friedrich Schiller's *Briefe über die ästhetische Erziehung* ('Letters on Aesthetic Education', 1795), and in literary works

that prefigured Flaubert with a focus on love as a force that could 'remystify the world ... (and) rediscover its lost beauty, mystery and magic' (Beiser, 2003: 104). Flaubert shared with the writers of German Romanticism a preoccupation with his protagonist's 'initial instruction in love ... the sensual discoveries of one's sexual awakening' (Coleman, 2016: vii). But his 1869 novel also explored the 'opinions and judgements' that emerge in and from the awakening of sexual passion. Sexual and sensual experience are filtered in *L'éducation sentimentale* through intellectual reflections that are shared amongst friends and associates, and that 'test and refine' the 'complex of impulses' constituting desire (Coleman, 2016: viii). Alongside Frédéric's female admirers, Flaubert's novel is populated by a panoply of socially emblematic figures: the bourgeois manufacturer Arnoux, the banker Dambreuse, the feminist drudge La Vatnaz, the bohemian Hussonnet, the socialist Deslauriers, the artist Pellerin and so on. Interactions with these intricately networked friends and associates help instil in Frédéric the appropriate sensitivity to a 'differentiated structure of feeling' (Coleman, 2016: ix). We see this sensitivity unfolding in lengthy passages of dialogue on shared matters of aesthetic and social concern, and in descriptions of cultural artefacts and decorative interiors that articulate in aesthetic form the opinions, class affiliations, tastes and sensibilities of this fluctuating social group.

Ottinger's flamboyant shot of Fanny reading situates her film in evident dialogue with Flaubert's novel. The two works share a narrative focus on a young person's education into love: in Flaubert, Frédéric Moreau, in Ottinger, the eponymous Johanna/Giovanna. In both, there is an emphasis on milieu, mediated through manufactured artefacts (vases, paintings, sculptures, furniture), that make of aesthetic taste a tie binding social collectivities. Both have casts of characters whose conversations modulate the protagonists' emerging passions, teaching them discernment, and preparing them intellectually as much for disappointment as for fulfilment in love – so Giovanna and her princess will not end the film in Edenic union in the Mongolian wilds, but in a more prosaic bond as boss and worker in a Mongolian restaurant in the Parisian metropole.

Ottinger, of course, also talks back to Flaubert's novel. Her first riposte is a queer feminist reclaiming and refiguring of *L'éducation sentimentale*. The women in Flaubert's narrative share a mutual and often malign visual fascination: Rosanette spies on her rival Marie Arnoux; her factotum La Vatnaz lurks in doorways to uncover Rosanette's secrets; Madame Dambreuse is vengeful: she shadows her love rivals, engineers Marie Arnoux's ruin, then claims the latter's jewel box as a fetishized trophy. In *Johanna d'Arc*, this relay of female gazes is pointedly recast, in Act 1 in tightly framed scenarios of fascinated looking; in Act 2, in performances at the Princess's summer festival that queer Flaubert's narrative of intense female watching, refiguring it as a shared delight in female spectacle, fuelled by what

Princess Ulun Iga will term in the film's closing scene the 'mutual exotic attraction' that drives cross-cultural exchange.

But Ottinger's vision of a capacious sentimental education shaped around mutual curiosity involves more than a feminizing and queering of her protagonists' desiring gaze. A breakfast conversation in Lady Windermere's compartment reveals a further ambition: to reshape the pedagogical conditions under which desire and love transcend the bounds of individual passion, becoming instead modes of social affect engendering senses of translocal commonality and mobile community. The camera cuts from Fanny, Flaubert in hand, to a smorgasbord of regional delicacies shared by Lady Windermere, Giovanna, Frau Müller-Vohwinkel and Mickey Katz. The *Oberstudienrätin*'s accompanying disquisition on the annual Mongolian Butter Week festival stirs Giovanna to an irritated outburst. 'Do you get everything you know from that dreadful Baedeker?' Frau Müller-Vohwinkel relents: 'perhaps your pedagogical eros is more pronounced than mine.' 'Ah yes', Mickey Katz affirms, 'pedagogical eros. A thankless vice.'

This brief but important exchange embeds Giovanna's sentimental journey in a cultural history distinguished from Flaubert's by its differently sexed and gendered understanding of the cultural history and social pedagogy of love. In an important study of Europe and love in cinema, Luisa Passerini, Jo Labanyi and Karen Diehl highlight the Eurocentrism of concepts of belonging 'characterized by particular kinds of love relationship'. Those concepts are traceable, they suggest, to a late eighteenth-century moment 'when sensibility came to be posited as the basis of sociability'. The emotional fulcrum of this emergent bourgeois structure of feeling was a conception of romantic love concocted from 'back-projected' refigurings of medieval tradition: thus 'the Romantic sensibility that started to emerge in the late eighteenth century became conflated with Provençal troubadour culture', and 'the Romantic elaboration of an individual self, whose authenticity is expressed in a complex inner emotional life, came to be conceived in terms of the particular ways of loving associated with medieval courtly love' (Passerini et al., 2012: 5).

In the breakfast sequence from *Johanna d'Arc*, we see Ulrike Ottinger engaged in a feminist reorienting of this European and Eurocentric tradition. In the introduction to this chapter, we called the Kalinka Sisters troubadours; but their performance modes and ironizing commentaries owe more to the twelfth- and thirteenth-century female troubadours, or *trobairitz*: Provençal singers whose love songs are said to have been directed at other women, and who haunt this film as a queer presence unsettling heterosexual codes of conduct for romantic love (Tomaryn Bruckner, 1992). Frau Müller-Vohwinkel's teacherly comments recall, meanwhile, debates in feminist pedagogy and educational philosophy that reframe love as a social emotion fuelled by the force that Frau Müller-Vohwinkel herself terms 'pedagogical eros'. Four years after *Johanna d'Arc*'s premiere, the

African-American feminist theorist and activist bell hooks would write of an erotic pedagogy of the body that refuses the 'legacy of repression and denial that has been handed down to us by our professional elders, who have been usually white and male'. hooks's demand for a feminist critical pedagogy that 'dares to subvert the mind/body split' by recognizing 'the place of passion and erotic recognition in the classroom' is rooted in conceptions of eros as a mutual passion fuelled by shared 'embodied experience' of cultural milieux and concrete life-worlds (hooks, 1993: 58, 60). Kerry T. Burch, in her philosophical account of this 'postpatriarchal eros', draws on hooks, alongside Audre Lorde, and Frankfurt School theorists including Adorno, Horkheimer and Marcuse, to reclaim eros similarly as the impetus for pedagogical endeavours that 'spread over the canvas of everyday life ... refigur(ing) operations of power within classroom settings', and opening space for students 'to name the world and imagine a different one' (Burch, 2000: 157, 161). As Burch attests, this is however no project for an achieved classroom utopia, but an incomplete endeavour framed by always unfinished 'Socratic conversations' that 'foreground dialogue', 'privilege the emotional, imaginative domain of consciousness' and contain the 'pedagogical imperative' to 'deconstruct' teacherly authority, while recognizing unequal power and knowledge as persistent features of the 'democratic political education' to which a feminist pedagogy aspires (Burch, 2000: 163–67).

Ottinger's film has clear affinities with these intersectional feminist writings on love's pedagogy. But she is more insistent in her foregrounding of the power play involved in teaching love. There is for instance a disquieting ambivalence in Lady Windermere's coaching of Giovanna. Her exotic stories and culinary delicacies are the stuff of a pedagogical experience that is certainly erotic; but it is also stifling – as we see when a door that Giovanna opens from Milady's bedroom reveals an antechamber that is flooded with location sound (rushing wind), but whose dark panelled walling blocks access to the open landscapes for whose whirlwind exhilarations Giovanna yearns. A further sceptical note is sounded when Mickey Katz names pedagogical eros a 'thankless vice'. Katz's pedagogical reference is less indebted to feminism, than to the queer interwar performance culture to which he reveals himself as indebted in his rendering of Al Jolson's 'Toot, Toot, Tootsie, Goodbye'. Peter Kern's camp performance at once memorializes and ironizes a song identified by critic Andrew Sarris as redolent of interwar 'raffish modernity', but historically tainted by Jolson's racial commitment in *The Jazz Singer* to blackface minstrelsy (Sarris, 1977: 40). In Katz's boyard feast, his excesses similarly invite the spectator to ethical judgement. His request for a roast swan is prompted by a nineteenth-century oil painting on the restaurant wall, highlighting an imbrication between two concepts of taste that will pervade the film. Katz's excessive consumption in this luxuriant feast reveals a taste that oscillates between aesthetic pleasures deriving from visual objects – here, a painted swan – and taste as a bodily

sensation that in this scene demands consumption to excess, and indeed, violence perpetrated on an animal body: the butchery of a protected avian, served now on a grotesquely oversized platter and stuffed with alien flesh.[2]

Katz, then, is established in this scene as a figure whose tastes oscillate between pleasure in visual beauty and the hedonistic 'vices' (Katz's own term) of tastes for bodily ingestion and sensory excess. Katz's subsequent invocation of pedagogical eros invites the viewer to scrutinize further the ethics of aesthetic regimes that swing between the beauty and cruelty of taste in its aesthetic and bodily sense. In its references to Weimar queer performance modes, Katz's burlesque travesty of a US-American Jewish star in the 'Toot Tootsie' number suggests a rooting of his version of pedagogical eros in queer aesthetic theory and interwar sexual politics. As Richard Dyer explains, Weimar writers and artists turned to pedagogical theorists including Gustav Wyneken and Hans Blüher for accounts of 'the homo-erotic dimension of male adolescent development, and in particular the importance of the erotic bond between pupil and teacher, boy and man'. Such theories found expression, Dyer continues, in films including Wilhelm Prager's 1925 documentary feature on Weimar body culture, *Wege zu Kraft und Schönheit* ('Ways to Strength and Beauty'), and Richard Oswald's gay melodrama and *Aufklärungsfilm* (sex education film), *Anders als die Anderen* ('Different from the Others', 1919). Those films helped establish Weimar film culture as the site of an unprecedented sexual openness. Yet in their debt to classical aesthetic ideals, homo-erotic hierarchies and teacherly authority, they also reproduced, Dyer suggests, bourgeois ideals of aesthetic purity and class and generational hierarchy, while excluding female desire and female subjectivity through their focus on male homo-eroticism and the masculine pupil-body (Dyer, 2002: 2–34).

Act 2: After orientalism

Is there then, finally, a version of sentimental education and the pedagogical eros that evades, at least temporarily, its cruelties and hierarchies? Our (affirmative) answer derives from a further refiguring of Flaubert that Ottinger undertakes in the film's second and third acts. *Johanna d'Arc* has been a recurrent focal point for disputes whose crux is Ottinger's orientalism: her assumed penchant for racialized spectacle, and her putative othering in this film as in others of East Asian cultures (Alvarez, 2017; Knight, 1998; Longfellow, 1993; Whissel, 1996). Ottinger's recourse to Flaubert in *Johanna d'Arc* might seem to confirm her Orientalist sensibility. Flaubert, after all, was exemplary for Edward Said of a European literature steeped in the 'general group of ideas' that situate 'the Oriental' as 'a kind of ideal and unchanging abstraction' (1978: 8).

But Said is a resource also for identifying Ottinger as a filmmaker whose work certainly cites, but also upturns and transforms the Orientalist stereotype. A turning point in Flaubert's own sentimental education was an experience that echoes Ottinger's Oriental journey in *Johanna d'Arc*. In 1849, Flaubert set off for Egypt; he would remain in that country and environs for eighteen months, and conduct there a passionate affair with the dancer and courtesan Kuchuk Hanem. According to Said, the affair fuelled Flaubert's fascination with the Orient as the source of 'sexual promise (and threat), untiring sensuality, unlimited desire'. Said sees Kuchuk Hanem as a source in Flaubert's eyes of 'all the version of carnal temptation' to which his male protagonists are subject (Said, 1978: 188). Patrick Coleman names a more immediate connection between Kuchuk Hanem, and the fictional Frédéric Moreau's great love in *L'éducation sentimentale*, Madame Marie Arnoux. There are echoes, he writes, between Flaubert's diary description of his first sighting of Kuchuk Hanem, 'surrounded by light and standing against the background of blue sky' and Frédéric's first view of Marie Arnoux, who appears to him in the novel as an 'apparition ... etched out against a blue sky' (Coleman, 2016: xiii).

Consider now our first view of Princess Ulun Iga in Ottinger's *Johanna d'Arc*. The end of Act 1, and with it, its European model of an education in love, is presaged by a comment from Frau Müller-Vohwinkel. As screeching wheels bring the train to a standstill, the film's very first location shot shows a band of warrior women approaching across the desert. 'Look!' exclaims the *Oberstudienrätin*. 'A camel caravan! How romantic!' This comic moment (this is, of course, a hijack) confirms Müller-Vohwinkel as an Enlightenment figure reliant on abstract knowledge without sense experience; she looks but does not touch, taste, or truly see. The limits imposed on Müller-Vohwinkel's judgement by a fear of sense experience are counterposed in a subsequent image that is both a final nod to Flaubert and the inaugurating moment of a new adventure in intercultural exchange. Low-angle camera reveals Princess Ulun Iga framed in long shot against an azure sky. Is it by chance that her figure recalls Kuchek Hanem, 'surrounded by light ... against ... blue sky'? If so, then will this new Act rescue Flaubert's Egyptian lover and muse from the white Oriental masquerade of Madame Arnoux? Does it announce instead – for instance in the subsequent shots of female warriors with spears and arrows drawn for battle – both the militant agency of Mongolian women in their own self-construction and a new chapter in *Johanna d'Arc*'s investigation of the aesthetics and politics of taste, eroticized sentiment and gendered belonging?

Our answer relates to the second Act's refiguring of European temporalities and tastes, as well as of its orientalizing imagination and modes of aesthetic judgement. To understand Ottinger's visual aesthetics, the film scholar Rosalind Galt has drawn on the director's interest in East Asian scroll painting, which stimulates the viewer's focus on details and fosters a piecemeal look (Galt, 2011: 293–94).

Galt's analysis is persuasive for Act 2 of *Johanna d'Arc*, when fluid pans stress, as in a scroll, the horizontal continuity of the Mongolian grassland, while alternating in scale with tightly framed interior shots that introduce both protagonists and spectators to Mongolian culture, rituals, stories and artefacts. These scrolling images have their own temporality: fixed angles of long duration, interspersed with mesmeric slow pans, offer time to dwell in the images, suggesting a mode of viewing based on dedicating time to the object of the look. That this spectatorial mode involves a loss of mastery of time is confirmed by an exchange between an agitated Frau Müller-Vohwinkel, a more accommodating Lady Windermere, and the Kalinka Sisters in their characteristic role as elucidatory chorus or *trobairitz*:

> Müller-Vohwinkel: What will they do with us now?
> Lady Windermere: We must have a little patience.
> Müller-Vohwinkel: My schedule, my hotel bookings ... this ruins everything.
> Kalinka sisters: We have dates to keep, too ... a concert tour through various Chinese provinces. But we have all just witnessed an overwhelming steppe drama. So who wants to speak of time or annoyances?

As the Kalinka Sisters intuit, and Müller-Vohwinkel will later learn, their situation demands that they renounce pre-established schedules to follow life's rolling pace amongst their Mongolian captors. After this sequence, the film's European protagonists do exactly this, frolicking and giggling with their Mongolian counterparts, tasting blood and mare's milk, engaging in ritual performance and experimental play. Their actions depart in two ways from the education in European taste and sensibility proposed by Flaubert's novel. They first bypass Flaubert by gesturing to a pre-Romantic aesthetics of the beautiful. When Müller-Vohwinkel abandons her hotel bookings, and the Kalinka Sisters their concert tour, they renounce the commercial activities that finance Flaubert's Parisian bourgeoisie, but that are associated in earlier, eighteenth-century aesthetic philosophy with what Kant terms the 'purpose' and 'interest' that is an obstacle to the pursuit of the beautiful and disinterested love (Kant, 2000). The film takes recourse here to modes of aesthetic thinking that predate Romanticism, but that provide a resource for refiguring the European aesthetics of Schiller, the German Romantics, or indeed Flaubert to feminist and decolonial ends. The Romantic concept of aesthetic education, as Frederick Beiser explains, broke with a central tenet in Kant, which is that common sense (*sensus communis*) arises *sui generis* through an experience of beauty that binds aesthetic community in the shared pleasure of cognition and sensory experience without pre-existing concepts or purpose (Beiser, 2003: 90).[3] Ottinger's film seems to invite a return to Kant by exploring taste as a faculty enabling aesthetic

judgements by disinterested subjects whose shared aesthetic experience is a pathway to commonality.

But there is here, as ever in Ottinger's case, both a movement backward in time to earlier understandings of communities built on shared aesthetic sensation, and forward to a contemporary moment that understands common sense not in the Kantian terms of universal human community, but as 'the experience of particularity of any community: the experience of politics' (Kappelhoff, 2015: 24). The feminist philosopher Christine Battersby identifies what she calls the 'fleshiness' of embodied female experience (she writes in this context of physiological dependence, pregnant embodiment, the feminine monstrous) as discrepant elements in western aesthetic philosophy since Kant. A concern with 'mere materiality and … immanence' is coded as feminine, she observes, and disavowed (Battersby, 2007: 135). Ottinger's protagonists in *Johanna d'Arc*'s Act 2, however, embrace feminine experience in all its fleshiness and monstrosity. A shamanic encounter engineers in Frau Müller-Vohwinkel a bodily metamorphosis that is perhaps this film's most dramatic (and hilarious) challenges to western models of bounded personhood. Other protagonists explore through touch and taste the immanent beauty of intercultural encounters. The political energy of this feminist reworking of common sense to become a quality achieved through haptic experience and gestural mimicry is reinforced by Ottinger's decolonial refiguring of Orientalist tropes. Edward Said identifies in Flaubert's accounts of Kuchuk Hanem a dialectic of attraction and repulsion centred on fleshly sensations of touch and smell. 'What he specially liked about her', writes Said, 'was that she seemed to place no demands on him, while the "nauseating odor" of her bedbugs mingled enchantingly with the "scent of her skin, which was dripping with sandalwood"' (1978: 187; Flaubert in Steegmuller, 1973: 220, 130). Ottinger's protagonists, by contrast, revel in haptic and gestural communicative modes that evoke shared tastes, and with them, new horizons glimpsed through a reinvented mode of transcultural pedagogical love. The film's second act has a loosely episodic structure shaped by performances for a summer festival staged by the Princess and her followers for and with their European guests. In the absence of a common language, Mongolian and European characters essay commonality through haptic experiences of touch, gestural mimesis, rhythmic movement, storytelling, ritual, play and song. The emergence in this context of a refined version of love's pedagogy is evident in the burgeoning passion of Giovanna and the princess. In scenes of performative mimesis, Giovanna learns to mimic her lover's gestures, repeating her sacred rituals, hunting deer in borrowed furs, riding horses, or savouring with her the fresh mare's milk that holds for the princess a sacred meaning (Figure 8.2).

We are returned here to Lady Windermere's opening question: 'Must imagination shun the encounter with reality, or are they enamoured of each other? Can

FIGURE 8.2: *Johanna d'Arc of Mongolia*. Photograph by Ulrike Ottinger, Berlin, 1988. © Ulrike Ottinger.

they form an alliance?' The love of Giovanna and the princess provides a tentative response. Giovanna and the princess grow their mutual passion by sharing aesthetic experiences, as well as judgements of taste evinced in the delight they show in each other's company. Their capacity for intuitive shared judgements suggests a moral value that recalls more recent (twentieth-century) writing on aesthetic community and the political potential of communication through shared sensibility and mutual judgements of taste. In her *Lectures on Kant's Political Philosophy*, Hannah Arendt locates a political potential in the judgement of taste by virtue of its universal communicability (1992: 40). Although aesthetic judgements are subjective, they involve consideration of possible judgements by others. We see those negotiated judgements emerging in conversations amongst *Johanna d'Arc*'s protagonists that continue throughout their Mongolian sojourn, as they compare experiences and search for shared meaning and sense. Though single characters are shown in sequential vignettes to have unique personalities and experiences, they test their commonality in shared stories of their sense experiences, or through aesthetic judgements that they compare with others, and on which they reach agreement through mutual acts of creative poeisis that locate each imaginatively in the place of the other. The viewer is invited to participate in this

shared imaginary through her own sensory experience of the diegetic world. In a sequence where the princess leads Giovanna to a shrine to partake of mare's milk, multiple alternating long and extreme long shots induce for instance in the viewer a distanced enjoyment of the images. The shots' long duration and slow pace, however – closer to strolling (or scrolling) than running – induce in us the same patient appreciation of this lovers' tableau in which we earlier saw the characters acquiescing in their discussion of the new temporality of their temporary Mongolian home. Just as each character mobilizes her imaginative faculties to create a mutually shared world, so too, then, we are invited to encounter the other through imagination, and learn in so doing new modes of being in unfamiliar worlds.

Coda

This suggests, finally, two kinds of timeliness for Ottinger's *Johanna d'Arc*. We earlier quoted Michael Wedel, whose interest is in film as a site of convergence between aesthetic practices proper to the medium and cultural, social or political transformations in a given historical space and time. As a multimodal ensemble deploying all the resources of mobile audio-vision, film can render aurally and visually sensible historical transformations through which filmmakers and audiences live. Of special concern to Wedel are the historical ruptures that films embody not primarily semiotically, through realist narrative or symbolic reference, but through aesthetic features – abrupt kinetic shifts, dislocated vision and sound – that generate in the spectator the contradiction, disorientiation or 'epistemological shock' that are the experiential concomitants of European history in the twentieth century's first three decades.

In a final chapter of his book, Wedel addresses the question of rupture through Fritz Lang's *Die 1000 Augen des Dr Mabuse* ('The Thousand Eyes of Dr Mabuse', 1960). He links the film's labyrinthine cinematic poetics to 'the double legacy of the Nazi past', and the 'criminal energy' of a previous Lang protagonist, the Dr. Mabuse of his 1922 *Dr. Mabuse, der Spieler* ('Dr. Mabuse the Gambler', 1922) (Wedel, 2019: 191). Though equally labyrinthine, Ottinger's poetics of rupture is quite different. *Johanna d'Arc*'s first act, we have suggested, stirs into the cauldron of late 1980s geopolitics a profusion of narratives, performances, sensations and memories from an imaginary pluralist and culturally heterogeneous *Mitteleuropa*. In Wedel's terms (and borrowing too from Jacques Rancière), the film's historicity might be seen to derive, then, from its capacity to render sensible through performative excess, speculative fabulation and other strategies common to Ottinger's baroque aesthetic, the current and future cultural potentialities of the world-historical events of 1989 (Rancière, 2013).

In Act 2 the film shifts gear. We have identified in *Johanna d'Arc*'s Mongolian sequences an aesthetics of immediacy, haptic intimacy, material and bodily affinity, and immanence. *Johanna d'Arc* offers these as resources for modes of intercultural engagement grounded in sensed experiences of commonality, and in communicative modes that rearticulate shared sensation as an ethical and political demand. At the time of writing (the early 2020s) that demand has special urgency. The globalizing tendencies of 1989 have been superseded by resurgent authoritarian nationalisms that redraw and police social and national boundaries, internally through state securitization, and externally, through trade wars, neo-imperial expropriation, or military aggression. The Covid-19 pandemic and environmental crisis have sharpened awareness of planetary survival as a shared concern, even while official politics regularly refuses the politics of care and common ethical purpose that our emperilled world demands. As a resource for imagining and experiencing commonality-in-difference differently, this film is timely indeed.

NOTES

1. The 1890s 'master farceur' Feydeau seems a likely referent by virtue of the fin-de-siècle style that pervades *Johanna d'Arc*'s first act. Actor and writer Jean Poiret wrote the French original of the gay farce *La Cage aux Folles* (1973). The play is however more widely known in its Broadway incarnation.
2. Mickey Katz's order is reminiscent of the 'rôti sans pareil', a swan stuffed with other fowl including goose, pheasant, chicken, duck, partridge, thrush and garden warbler.
3. Cf. Immanuel Kant:

 > If we wish to discern whether anything is beautiful or not, we do not refer the representation of it to the object by means of the understanding with a view to cognition, but by means of the imagination (acting perhaps in conjunction with the understanding) we refer the representation to the subject and its feeling of pleasure or displeasure. The judgement of taste, therefore is not a cognitive judgement, and so not logical, but is aesthetic – which means that it is one whose determining ground cannot be other than subjective.
 >
 > (2000: 41)

REFERENCES

Alvarez, Catalina (2017), 'Towards another cinema (after Kidlat Tihimik and Ulrike Ottinger)', *Cinephile*, XI, pp. 12–17.

Anon. (2013), 'Hilferuf zum Filmerbe', 5 December, https://www.nd-aktuell.de/artikel/917095.hilferuf-zum-filmerbe.html. Accessed 23 May 2023.

Arendt, Hannah (1992), *Lectures on Kant's Political Philosophy* (ed. Ronald Beiner), Chicago: University of Chicago Press.

Battersby, Christine (2007), *The Sublime, Terror and Human Difference*, London and New York: Routledge.

Beiser, Frederick C. (2003), *The Romantic Imperative: The Concept of Early German Romanticism*, Cambridge, MA: Harvard University Press.

Beynon John, S. (1995), 'Georges Feydeau', in P. France (ed.), *The New Oxford Companion to Literature in French*, Oxford: Oxford University Press, https://www.oxfordreference.com/view/10.1093/acref/9780198661252.001.0001/acref-9780198661252-e-1783?rskey=mrTp0t&result=2. Accessed 23 May 2023.

Burch, Kerry T. (2000), 'Postpatriarchal representations of eros in the twentieth century', *Counterpoints*, 114, pp. 143–74.

Carter, Erica (2022), 'Activating the archive. Feminism and German women's film heritage, 2010–2020', *Feminist German Studies*, 38:1, pp. 27–53.

Coleman, Patrick (2016), 'Introduction', in Flaubert, G. (ed.), *Sentimental Education (1869)* (trans. H. Constantine [French]), New York: Oxford University Press, pp. vii–xxix.

Cooper, Sarah (2019), *Film and the Imagined Image*, Edinburgh: Edinburgh University Press.

Dyer, Richard (2002), *Now You See It: Studies in Lesbian and Gay Film*, 2nd ed., London and New York: Taylor and Francis.

Flaubert, Gustave (2016), *Sentimental Education (1869)* (trans. H. Constantine [French]), New York: Oxford University Press.

Galt, Rosalind (2011), *Pretty: Film and the Decorative Image*, New York: Columbia University Press.

Hanisch, Michael, Gregor, Erika and Schmidt-Zäringer, Anja (1995), *Ulrike Ottinger*, Berlin: Freunde der Deutschen Kinemathek.

Haraway, Donna (2016), *Staying with the Trouble: Making Kin in the Chthulucene*, Durham and London: Duke University Press.

hooks, bell (1993), 'Eros, eroticism and the pedagogical process', *Cultural Studies*, 7:1, pp. 58–63.

Kant, Immanuel (2000), *Critique of the Power of Judgement, 1790* (ed. P. Guyer, trans. P. Guyer and E. Matthews), Cambridge: Cambridge University Press.

Kappelhoff, Hermann (2015), *The Politics and Poetics of Cinematic Realism* (trans. D. Hendrickson), New York: Columbia University Press.

Keller, Ursul (2004), 'Writing Europe', in Ursula Keller (ed.), *What is European about the Literatures of Europe?* Budapest: Central European Press, https://books.openedition.org/ceup/1622. Accessed 23 May 2023.

Knight, Julia (1998), 'Observing rituals: Ulrike Ottinger's *Johanna d'Arc of Mongolia*', in I. M. O'Sickey and I. von Zadow (eds), *Triangulated Visions: Women in Recent German Cinema*, New York: State University of New York Press, pp. 103–16.

Longfellow, Brenda (1993), 'Lesbian phantasy and the other woman in Ottinger's *Johanna d'Arc of Mongolia*', *Screen,* XXXIV:2, pp. 124–36.

Ottinger, Ulrike (dir.) (1989), *Johanna d'Arc of Mongilia*, Germany: La Sept Cinéma, Popolar-Film and Zweites Deutsches Fernsehen (ZDF).

Passerini, Luisa, Labanyi, Jo and Diehl, Karen (2012), *Europe and Love in Cinema*, Bristol: Intellect.

Rancière, Jacques (2013), *The Politics of Aesthetics* (ed. G. Rockhil, trans. G. Rockhil), London: Bloomsbury.

Said, Edward (1978), *Orientalism*, London: Penguin.

Sarris, Andrew (1977), 'The cultural guilt of musical movies: *The Jazz Singer*, 50 years after', *Film Comment*, 13:5, pp. 39–41.

Sherlock, Amy (2019), 'Following Ulrike Ottinger to the end of the world', *Frieze: Contemporary Art and Culture*, 208, January–February, https://www.frieze.com/article/following-ulrike-ottinger-end-world. Accessed 23 May 2023.

Steegmuller, Francis (ed.) (1973), *Flaubert in Egypt: A Sensibility on Tour* (trans. F. Steegmuller), Boston: Little, Brown & Co.

Tomaryn Bruckner, Matilda (1992), 'Fictions of the female voice: the women troubadours', *Speculum: Medieval Academy of America*, 67:4, October, pp. 865–91.

Wedel, Michael (2019), *Pictorial Affects, Senses of Rupture: On the Poetics and Culture of Popular German Cinema, 1910–1930*, Berlin and Boston: De Gruyter.

Whissel, Kristen (1996), 'Racialized spectacle, exchange relations, and the western in *Johanna d'Arc of Mongolia*', *Screen*, XXXVII:1, pp. 41–57.

9

Exil Shanghai as Audio-Visual Archive and Cross-Cultural Collage

Tim Bergfelder

Exil Shanghai (1997) fits chronologically and methodologically into the second phase of Ulrike Ottinger's filmography, following a shift from her earlier fantastical and surreal explorations of queer desire and 'otherness' in the 1970s and early 1980s towards a more ethnographic, documentary approach from the mid-1980s onwards. The film has been perceived by some critics as 'Eurocentric' (Rickels, 2008: 154). This is not a new charge, as the director's engagement with different cultures has on various occasions been problematized (Trumpener, 1993; Whissell, 1996). As I will expand further below, for other critics *Exil Shanghai* does not properly fit into the template of what is expected from a documentary about Jewish exile and diaspora, and how to represent this narrative 'appropriately'. In this chapter, I revisit *Exil Shanghai* in the first instance as a pioneering cinematic contribution to an ongoing and contested discourse of remembering the history and culture of wartime Shanghai. Subsequently, I analyse the film in more detail, especially its dual structure that divides past and present, before moving on to an aspect that has so far been neglected in previous scholarship, namely the film's use of music.

Shanghai as exoticist trope and as history

In order to contextualize Ottinger's depiction of Shanghai, it is worth remembering that in the western popular imagination the city has featured for a long time as an exoticist trope where 'the East' and 'the West' connect and intermingle, a place associated with exotic adventure and danger, sophistication and decadence. This

Shanghai of the popular imagination is of course, as Robert Bickers has noted, rooted in the racist discourse of nineteenth- and twentieth-century imperialism, according to which China was 'feminised, and portrayed as a temptation, bluntly sexual most of the time' (Bickers, 1999: 49). In Chinese historiography, on the other hand, this period is characterized by 'racism, rape, murder, brutality... [and] the routine violence of everyday colonialism' (Bickers, 2012: 7). Consequently, an anti-urban bias in Chinese official discourse continued into the early decades of the PRC where Shanghai was perceived as a 'bastion of decadence and evil' which served as 'a constant reminder of a history of national humiliation' (Lee, 1999: xi).

Despite its racial hierarchies and a topography divided into national concessions, the treaty port of Shanghai was a city of migrants. These obviously included citizens of the colonizing powers, but also subjects of other parts of the British Empire, and other countries. Crucial to an understanding of *Exil Shanghai*, and repeatedly referred to throughout the film, are the distinct waves of different kinds of Jewish migrants to Shanghai who cohered not into a single Jewish community, but who maintained separate cultural and linguistic identities. The Sephardi/Baghdadi Jews (mainly arriving from the British Raj in the nineteenth century) ended up near the top of the treaty port class pyramid, at least economically. Subsequently there were two waves of Ashkenazi Jews from the Russian Empire (the first ones arriving after the Russo-Japanese War of 1905, and the second after the October Revolution of 1917), and finally approximately 20,000 primarily German and Austrian (and to a lesser extent Polish, Dutch and other) refugees from Nazi persecution arrived between 1937 and 1941 when the borders closed permanently (see Bei, 2013; Eber, 2012; Kranzler, 1976; Ristaino, 2002). Moreover, the migrants in Shanghai were not only foreigners. Indeed, the only Chinese witness featured in *Exil Shanghai* starts her story by saying 'We moved here before the Jews came', suggesting that her family too was originally not from Shanghai. Gabriel Tsang confirms that Shanghai's Chinese inhabitants were largely

> immigrants from other Chinese provinces, coming as a result of intensified urbanization and capitalization that demanded a large labour force. In 1933, there were 971,397 Chinese residents living in the International Settlement, the core residential district in Shanghai at that time; 910,874 of them were from more than twenty provinces, occupying 93.7% of the Chinese population in Shanghai.
>
> (2020: 52)

The demise of Shanghai as a treaty port occurred in two stages: after the Battle of Shanghai in 1937, Japan occupied the Chinese-administered parts of the city, before taking over the foreign-administered sectors in 1941. Most British and

American residents of Shanghai faced immediate internment, a history that is perhaps best known in the Anglophone world through J. G. Ballard's autobiographical novel *Empire of the Sun* (1984). Jewish refugees from Austria and Germany, on the other hand, were interned separately in a ghetto in the former part of the International Settlement in the district of Hongkou. Unlike most of the Anglo-American internees, they shared their enclosure with Chinese residents in Sino-Western terraced houses separated by narrow alleyways called *longtang*, which originally had been built after 1870 as a measure to eradicate the predominant wooden shantytowns (Tsang, 2020: 54). In contrast to other nationalities, the Russian-Jewish immigrants were mostly spared internment, which caused resentment and led to accusations of collaboration with the Japanese from those that had been forced into the ghettos. As I note below, these divisions are alluded to in *Exil Shanghai*.

The evolving legacy of Jewish Shanghai

In the mid-1990s when Ulrike Ottinger embarked on *Exil Shanghai*, the history of the Hongkou ghetto was not well publicized, either in the West or within China. As Jennifer Michaels has noted (Michaels, 2019: 208), an academic study on the subject by David Kranzler had been published as early as 1976, but the period when the topic resurfaced more prominently was the early to mid-1990s. Alongside the appearance of other memoirs, two of Ottinger's interviewees, Rena Krasno and Georges Spunt, had published autobiographical accounts prior to *Exil Shanghai* (Spunt in two separate volumes in 1967 and 1968; Krasno in 1992), which gives their testimony the 'practiced and perfected' impression that has been noted by Laurence Rickels (2008: 158).

Exil Shanghai was not the first film about the Shanghai ghetto, as there had been earlier German, Canadian, Belgian and Israeli examples (Eber, 2012: 213–19), but it was the first film that eschewed archival footage, instead opting to film in China itself. Ottinger's original plan to balance the testimony of survivors of Jewish Shanghai (all of whom settled in California) with the testimony of Chinese witness accounts of the period accompanied by contemporary footage of what remained of the Jewish ghetto in 1990s Shanghai was only partially achieved. Rickels has documented in detail (2008: 153–54) how Ottinger experienced a considerable amount of covert censorship from Chinese officials during her shoot. As a result, except for a single interview with a Chinese woman, none of the other envisaged Chinese witness accounts made it into the film, while only glimpses of physical reminders of Jewish Shanghai (such as the poignant images of the remnants of a Jewish cemetery towards the end of *Exil Shanghai*) survive. Rickels notes that

the background setting for the slapstick censorship routine to which Ottinger was subjected was the large-scale rapid-fire transformation of Shanghai into a modern megalopolis. The old Hongkew (sic), together with the traces of the history Ottinger was trying to document, kept on vanishing by the block on a daily basis.

(2008: 154)

Most of the documentary films about Jewish Shanghai that precede and follow *Exil Shanghai* differ from Ottinger's film in significant respects. First, the diachronic approach that contrasts past and present adopted by Ottinger is replaced by a strictly synchronic and chronological one. Documentaries such as Paul Rosdy and Joan Grossman's *Zuflucht in Shanghai: The Port of Last Resort* (1998) and Dana Janklowicz-Mann and Amir Mann's *Shanghai Ghetto* (2002) focus exclusively on the period between 1937 and 1945, with the earlier Baghdadi and Russian migrants and their history receding from view. Instead of contextualizing its narrative in the history of Shanghai as a treaty port created by the forces of imperialism, *Shanghai Ghetto* begins its story in Germany with the escalating persecution of Jews. Second, unlike Ottinger's film, most prior and later films rely heavily on archival footage while only sparsely engaging with present-day Shanghai. Paul Rosdy, one of the makers of *Zuflucht in Shanghai*, acknowledges this omission when he notes that his film 'shows very little of the city of Shanghai', but that it 'makes a point of emphasising the assistance provided to émigrés by the Shanghailanders' (Rosdy, 2020: 68).

In the intervening years since *Exil Shanghai*, interest in the topic has proliferated. Alongside numerous memoirs and collections of witness accounts published since 1997 (Eber, 2008), there have been exhibitions at the Jüdisches Museum in Berlin (Barzel et al., 1997) and Vienna in 2020/21 (Pscheiden and Spera, 2020). Novels tackling the subject include *Farewell Shanghai* (2004) by the Bulgarian author Angel Wagenstein (Michaels, 2020: 123). In a more populist vein, 2010 saw the release of a Chinese animated children's film, *A Jewish Girl in Shanghai* (Lyons, 2022), and in 2019 the graphic novel *Shanghai Dream* by Philippe Thirault and Jorge Miguel was published. More importantly, since *Exil Shanghai*, the official Chinese attitude towards the Jewish legacy of Shanghai has changed dramatically (Jakubowicz, 2009). While large sections of the old Hongkou did disappear as Rickels predicted, China began to recognize the considerable soft power asset of a history in which China features as a 'positive and caring nation in order to foster global trade and diplomacy' (Michaels, 2019: 219). These insights facilitated the preservation and renovation of some of the *longtang* architecture in Hongkou, as well as the establishment of the Shanghai Jewish Refugee Museum, housed in the former Ohel Moshe Synagogue (Shanghai Jewish Refugee Museum, 2022).

ULRIKE OTTINGER

Exil Shanghai: *The interviews*

Shot on 16 mm stock and lasting over four and a half hours, *Exil Shanghai* divides into five parts, each focusing on an interview with selected witnesses. The first part features Rena Krasno (born Rabinovich 1923 in Shanghai into a family of Russian Jews who had arrived in the city in the early 1920s), the second part introduces Rabbi Theodore Alexander (1920–2016), born in Berlin and his wife Gertrude, born in Vienna, who belong to the late 1930s migration wave, and who arrived via a lengthy sea journey (and in the case of Gertrude also involving a detour via the *Kindertransport* to Britain). The third part features Inna Mink (born 1928 in Shanghai) whose family came from Russia after the revolution via the Northern Chinese city of Harbin. The fourth part features Georges Spunt (1923–96), whose parents came to Asia from Russia and Vienna in the early decades of the twentieth century, while the fifth part focuses on Geoffrey Heller (1924–2017), another Berliner who originally fled with his brother via the *Kindertransport* to Britain in the mid-1930s, but who later joined his parents in Shanghai.

The individual parts all follow a similar pattern, switching between on-location footage in Shanghai and the interviews, with the interviewees' voice-over forming a bridge. All the interviewees are filmed in their homes in California. Except for Theodore Alexander who speaks German throughout his interview, the others speak English, although some slip in phrases or words in other languages such as Russian and French. The camera set-up for the interview sections is static, framing the interviewees in medium close-up and close-up; there are no reaction shots of Ottinger as interviewer, nor is her voice heard, although her presence is acknowledged in the section with the Alexanders. As is customary in most of Ottinger's documentaries, she refrains from commenting almost completely, barring some isolated explanatory captions. The camera occasionally wanders off to capture the surroundings of the homes. This is particularly telling in the case of Krasno, whose house looks like a veritable Chinese emporium, filled with jade dragons, wooden drawers, Buddhas, and porcelain; and Spunt, who is surrounded by ostentatious mirrors. In contrast, the homes of the Alexanders and Heller are plain and generic, while Mink is filmed in her garden. Nevertheless, even in the plainer homes, treasured mementoes of the Chinese past emerge, such as the Alexanders' Chinese wedding certificate scroll and Heller's photo album with its embroidered cover featuring a classical Chinese scene.

As mentioned before, with some of the interviewees one has the sense that their memories have been rehearsed and perfected over decades, unlike Mink and Heller whose testimonies include awkward silences, nervous coughs and laughs, and mix-ups. The most confident interviewee is Krasno who immediately announces her authority with her first sentence 'Well I am an old China hand, the member of a dying race one could say'. Clearly knowledgeable about the history

of treaty-port Shanghai (Krasno was a board member of the Sino-Judaic Institute, and still remembered on the organization's website, 2022), her testimony provides a history of colourful anecdotes about Jewish Shanghai.

Krasno's more personal memories include her time in a French School where European politics intervene in the clash between a Pétainist Philosophy teacher and the Gaullist psychology lecturer. She mentions the Hongkou ghetto and visited it once to meet a German acquaintance. But elsewhere she qualifies the hardship of the ghetto by saying 'I have spoken to Chinese people for whom the refugees seemed rich.' Krasno's interactions with the Chinese appear to have been mostly with household staff. Otherwise, she confesses that 'I wasn't particularly interested in inspecting the Chinese sections. We went to the movies, Deanna Durbin, Shirley Temple', and admits that 'no one I knew was interested in Chinese culture'. The interview (as indeed all the others) ends with the liberation by the Americans and Krasno's departure from Shanghai.

Unlike the previous interview, the recollections of the Alexanders focus initially on their respective odysseys to reach Shanghai, their separate adjustment to their new environment, their attempts to find jobs, their first meeting, dating, getting married and their eventual internment in Hongkou. Alexander recounts how Hongkou witnessed the emergence of little pockets of *Mitteleuropa*: 'Little Breslau, little Frankfurt, little Berlin, and little Vienna', the establishment of cafés, restaurants and shops, but also love hotels. Asked how the refugees and the Chinese got on with each other, Alexander answers: 'We mostly suffered together under the Japanese occupation.' Alexander also pointedly notes that 'Russian Jews were left alone because they collaborated with the Japanese'. This is followed by a Chinese woman remembering: 'We were old friends and neighbours. Life was really hard. I was still too young, but my parents knew them. My parents were very sad when they left.' As in the first interview, the liberation of Shanghai brings the segment to an end.

The third interviewee, Inna Mink (born Ginzburg), begins by recalling how her parents escaped the pogroms in Russia and eventually came to Shanghai. Although she remembers an idyllic and privileged childhood, she is also acutely aware of the racial inequalities of the imperial system. She recounts that 'poverty was horrendous', and she remembers corpses of starved Chinese children being collected on the streets. Mink talks about meeting her future husband, a refugee from Vienna who had been in a concentration camp. After her wedding, Mink lived with her husband in Hongkou, where she remembers Austrian cakes and bakeries, but also food rationing, unemployment, black market trading, beggars and lepers, curfews, and Allied bombs hitting hospitals in the district. 'There was death and disease, and it was time to go.' With a final look at a photo album of her childhood friends, Mink recalls who went where after the war.

Georges Spunt in the fourth segment recalls a lavish and bohemian lifestyle, with an eccentric grandmother, glamorous aunts and an army of Chinese servants who dote on little Georges whom they call the 'money child'. As Spunt grows up,

he decides to become a designer. The arrival of refugees from Austria and Germany is registered by Spunt through the opening of a fashion salon run by a flamboyant (and presumably gay) couple of two male couturiers from Munich one of whom (allegedly) 'put Marlene Dietrich in slacks' and who 'dressed the queens of the European film'. The Japanese takeover meant that German and Austrian Jews had a 'hard time', but as for Spunt and his social circle, 'nobody wanted to go to the ghetto'. Instead, Georges talks about his visits to the cinema (his favourite was Bette Davis) and hotels, mentioning, almost in passing, that 'the Park Hotel was a place where a lot of gays used to go. The 3rd Floor Bar was the cruising bar'. Towards the very end of the interview Spunt returns to the topic of homosexuality and his time in wartime Shanghai more generally by saying:

> Gay life before the war was all *en cachette*. Of course, we didn't call it gay in those days, because we didn't know what gay meant. All the other synonyms for gay are just as repulsive, it doesn't matter what you call it. We never knew whether the next day might not be the last…And that created a very devil-may-care attitude, because we wanted to have fun, we wanted to have love, and we wanted to have everything that we could while we could.

The final interviewee, Geoffrey Heller, is the only one who at times looks visibly uncomfortable being interviewed. He recalls the flight from Europe on an ocean liner as an adventure, while he adapted quickly to Shanghai as a new home, finding a job. The forced move to Hongkou is remembered as traumatic, with food shortages and temperature extremes being mentioned. A specifically fond memory concerns venturing outside the city on walking trips, guided by a book called *Shanghai Country Walks* written in 1932 by Edward Sheldon Wilkinson, an employee of the Shanghai Municipal County Service. Heller recalls petty biases and national stereotypes characterizing the interaction between Austrians and Germans, while expressing his admiration for the civilized nature and dignity of the Chinese in the face of adversity. Heller recalls how soon after the war he first discovered that relatives had been murdered in the Holocaust. Initially intent on staying in Shanghai ('we had become attached to Chinese friends'), the political situation forces him to leave for San Francisco. 'And that's the end of the story'.

Exil Shanghai: *1990s Shanghai*

Ottinger's film juxtaposes the interviewees' accounts with footage of Shanghai shot in the mid-1990s. This unusual strategy, as I noted before, distinguishes *Exil Shanghai* from other documentaries on the subject. While Ottinger uses photographic stills

and other historical images (advertisements, newspaper articles), she employs them sparingly. In some instances, the contemporary footage matches the oral accounts that precede it or that are audible in voice-over. Thus, when the interviewees mention the Hongkou ghetto, the film cuts to scenes of contemporary Hongkou; accounts of long sea journeys are accompanied by pans across the Huangpo River and the Shanghai Port; accounts of parties and nightlife are accompanied by nocturnal neon-lit images of the city, or interiors of treaty port-era hotels on the Bund. When Inna Mink recalls an incident in Hebrew class at school, where her disruption was answered by the teacher's prediction that she would end up as a fishwife, the film cuts to scenes featuring a contemporary fishmonger at a Shanghai wet market. After the Alexanders recount their wedding, the film cuts to modern-day wedding preparations, with brides and grooms being made up for photo shoots in a bridal shop. And when Geoffrey Heller recalls his country walks, the film cuts to rural scenes from the ancient water town of Zhujiajiao, featuring farmers, fishermen, canals, boats and temples.

However, the matches between the interviews and the contemporary footage are not consistent. Often, the contemporary footage is autonomous of the oral accounts, and even the 'matching' scenes work equally well on their own. Indeed, sometimes they extend their 'usefulness' to the interviewees' accounts, as explored further below. Ottinger presents different views of the city which alternate between emphases on architecture (most prominently the colonial-era buildings of the Bund), street scenes and human activities. 'Ethnographic' depictions include cyclists traversing the city in the rain (Figure 9.1), pedestrians looking straight at the camera, sometimes curiously, sometimes indifferent and occasionally playing up, laughing at or posing for the filmmaker. Street food sellers are seen hand-pulling noodles, or standing over steaming vats of dumplings, or juicing sugar cane; we see wet markets selling meat and vegetables; a herbalist is mixing potions; old women are making tea in an alleyway; middle-aged Chinese enjoying collective dancing and T'ai Chi exercises. Seen together, these scenes, as Amy Villarejo has noted, resemble the kaleidoscopic urban feel of a 1920s city symphony (Villarejo, 2002: 181). What Ulrike Sieglohr has identified as a key feature of Ottinger's documentary approach also applies here:

> [Ottinger] adopts an exploratory rather than a voyeuristic gaze in approaching the 'foreign' culture by keeping the camera at a distance, refraining from penetrating zooms, and letting images and sounds speak for themselves.
> (2020: 220)

This approach, however, has not been met with universal approval. In a review of *Exil Shanghai*, *Variety*'s critic Dennis Harvey complained that

participants' recollections soon begin repeating one another's insights. Location-shot segs [sic] also grow interminable, dwelling on a latter-day bridal shop or playground at useless length. With no cumulative thesis or narrative momentum, watching *Exile Shanghai* becomes its own form of viewer exile.

(1997: n.pag.)

In a similar vein, the eminent Israeli sinologist Irene Eber (herself a refugee from Nazi persecution) and a major expert on the history of the Jewish refugees in wartime Shanghai summarized Ottinger's film rather brusquely: 'Long sequences of present-day Shanghai. No archival footage. Poorly edited, has no focus' (Eber, 2012: 218). Complaints about the film's length and editing have been directed at many of Ottinger's later films, and of course betray a bias against slow cinema more generally. However, there is something else at stake in Eber's comments.[1] Eber argues that the history of the Jewish refugees in Shanghai represents a lesson to be learnt as a 'story of survival, even of heroism, and of stubbornly defying fate' (2012: 3). This characterization may help to explain this history's re-emergence in recent decades, and to some extent its adaptability into popular novels and films. Eber's description is not only one of the most enduring narrative tropes in western culture, but it also offers a more upbeat narrative than traditional accounts of the Holocaust. The history as it features in *Exil Shanghai* fails to conform to the ideal exile documentary that Eber envisages (her expressed preference is for the much more slickly produced *Shanghai Ghetto*; Eber, 2012: 216–17). As the *Variety* review quite rightly observes about Ottinger's film, there does not seem to be a 'cumulative thesis' nor 'narrative momentum' (Harvey, 1997).

By broadening the focus to include previous phases of Jewish migration and by juxtaposing the past with the present, *Exil Shanghai* raises questions about the legacies of western colonialism in China and the absence of the Chinese from standard accounts of exile in Shanghai. It also addresses ambiguities in the relationship between different groups of migrants, exiles and between ethnic and sexual minorities. In her reading of Ottinger's film, Shambhavi Prakash (2018: 70–71) has drawn productively on Michael Rothberg's concept of multidirectional memory. Rothberg suggests that 'by foregrounding the "impurities" that characterise all identities, the framework of implication de-moralizes politics and encourages affinities between those who are positioned as victims and those who have inherited and benefited from privileged positions' (Rothberg, 2019: 20–21).

Several scholars have offered alternative ways to read the director's collage of past and present. Eva Meyer notes that

> You hear something that you do not see: a story about the exile of European Jews in Shanghai during World War II. At the same time your gaze wanders around scenes of everyday life in present-day Shanghai, as it were all happening now...You miss a

commentary illustrating your sense of reality, though it is exactly this that provides you with the reality of difference.

(Meyer, 2007: 39)

For Kirsten Harjes and Tanja Nusser, 'Ottinger's gaze is informed by the interests of the photographer and the tourist, rather than those of the historian' (Harjes and Nusser, 2000: 253). However, while I concur that there are elements of the tourist gaze to Ottinger's approach, I am not fully persuaded by the way in which photographic, tourist, traveller and ethnographic gazes conveniently collapse into a single explanatory framework. At least, Ottinger's 'tourist' view of 1990s Shanghai is distinctly different from how an ordinary tourist in Shanghai in the present would experience the city. For example, arguably one of the most iconic 'sights' of contemporary Shanghai, the Oriental Pearl Tower in Pudong only makes its first and rather fleeting appearance nearly an hour into the film. One of the biggest draws for tourists in Shanghai, the old Chinese quarter, only emerges very obliquely in Geoffrey Heller's account with a few images from the classical Yu Garden, while other famous sights such as the iconic Huxinting teahouse or the City God Temple do not appear at all. Harjes and Nusser note that Ottinger's footage of 1990s Shanghai 'educates us more about the period in which her pictures were taken, and about the gaze of the current observer, than about the history of these buildings' (Harjes and Nusser, 2000: 255). At the same time, what makes *Exil Shanghai* such a fascinating rediscovery decades after it was made is that its city scenes capture Shanghai precisely on the cusp of once again regaining its

FIGURE 9.1: *Exil Shanghai*. Photograph by Ulrike Ottinger, Berlin, 1997. © Ulrike Ottinger.

place as a global metropolis and becoming a tourist destination, as the film's gaze prefigures the change of sites into 'sights'. Nowhere is this more apparent than in the scenes shot in the suburban water town of Zhujiajiao, which since Ottinger filmed there has been transformed into a theme park version of a 'Chinese Venice'.

Exil Shanghai *as audio-visual archive*

Considering that Ulrike Ottinger has been well known throughout her career for her imaginative and purposeful use of aural as well as visual strategies, it is surprising that few studies of *Exil Shanghai* have explored the former aspect in much depth. As I argue in this section, music constitutes a crucial layer to the historical collage the film creates. While the function of diegetic street sounds in the film and the bridging device of the voice-over have been acknowledged by critics, the use of music is not discussed in great depth. Prakash refers to 'different genres of music' (Prakash, 2018: 72) while Harjes and Nusser mention the use of 'Schellack records (78s) dating back to the 1930s and 1940s' (Harjes and Nusser, 2000: 252); the assumption in both cases being that the music used is merely providing a historically authentic acoustic background. To some extent, this perception is understandable, as the music included in the film is not listed in the credits and spans a wide range of genres, including Weimar-era German popular song (*Schlager*), late Romantic opera, Viennese waltzes, 1930s and 1940s Chinese yellow music (defined by Andrew Jones as a form of jazz 'which fused Western instrumentation and harmony with largely pentatonic Chinese folk melodies', Jones, 1992: 11; see also Jones, 2001), traditional Chinese instrumental music using the *pípá* (a type of lute) and the *erhu* ('a two-stringed fiddle'), contemporary Mando-Pop and Yiddish klezmer music. Moreover, all the vocal pieces are played without subtitles.

Closer study reveals that the music in *Exil Shanghai* has been carefully selected,[2] partly to complement the narrative and images, and partly to open or allude to dimensions and histories the film does not explicitly address in either the Shanghai footage or in the oral accounts. The first interesting example of juxtaposing music and visuals occurs in the pre-credit sequence of the film where the images depict Chinese cyclists in colourful raincoats (Figure 9.1); the music chosen to illustrate this is a waltz called 'Wiener Praterleben' (Vienna Fairground Life), composed in 1892 by the Jewish composer Siegfried Translateur. The piece with its memorable whistling refrain became better known in 1920s Berlin under the title 'Sportpalastwalzer', as it became the theme tune for a popular recurring six-day cycle race at the city's Sportpalast venue. After the Nazis came to power, the piece was banned owing to Translateur's Jewishness. The composer himself died in 1944 in the Theresienstadt ghetto.

In the section featuring the Alexanders, where the couple recount their sea journeys, we see images of Shanghai's port while listening to the song 'Ein Schiff fährt nach Shanghai' ('A Ship Sails for Shanghai'). German singer Mimi Thoma sings of a young woman saying goodbye to her sailor lover who departs for Shanghai and never returns. The song and its lyrics with its melancholic focus on departures and longing, complement the Alexanders' narrative and the harbour images well, but an additional layer of meaning is added if one knows that the song was originally written by the Austrian-Jewish composer Wilhelm Grosz (under the pseudonym Hugh Williams) in 1935 in British exile. With its English title 'Red Sails in the Sunset', the song became a popular hit for numerous performers including Bing Crosby, Nat King Cole and The Platters, although in most of the later versions the connection to exile narratives is not pronounced.

When Inna Mink recalls the grim everyday life in Hongkou, the soundtrack plays 'Irgendwo auf der Welt' ('Somewhere in the World'), sung by Lilian Harvey in the Ufa film *Ein blonder Traum* ('A Blond Dream', 1932). The lyrics offer a poignant commentary to Mink's narrative ('I never give up hope that somewhere in the world there is a little happiness. If I knew where it is, I would go into the world, because I would like to be happy for once') and again, both the song's music and lyrics were written by artists who were forced into exile (Werner Richard Heymann and Robert Gilbert, respectively).[3]

Georges Spunt's interview begins with a photo of him as a child, sitting with his legs crossed on a chair. This is accompanied by an instrumental version of the song 'Ich bin die fesche Lola' ('Naughty Lola'), written by the Jewish composer-lyricist team Friedrich Hollaender and Robert Liebmann for Marlene Dietrich in *Der blaue Engel* ('The Blue Angel', 1930), which includes a memorable scene of Marlene sitting cross-legged on a big vat. Ottinger uses the acoustic references to Dietrich to acknowledge her status as both exile heroine and queer icon. Dietrich is, as mentioned earlier, namechecked by Spunt in his account, and she is referenced twice more in this section, once as an image on a film magazine cover, and through a second musical allusion with another song from *Der blaue Engel*, 'Nimm' Dich in Acht vor blonden Frau'n' ('beware of blonde women').

Two performers are heard in *Exil Shanghai* on more than one occasion, and their selection as well as their affinities with each other is again significant. The first one, Joseph Schmidt (1904–42) continues the theme of exile and Jewishness. Born into an orthodox Jewish family near Chernivitsi (at the time of his birth Austria-Hungary, later Romania and then Ukraine), Schmidt received his early vocal training as a *chasan* in his local synagogue. Jens-Malte Fischer argues that Schmidt had one of the greatest potentials as a tenor but that his early death prevented him reaching the peak of his abilities (Fischer, 1993: 204). Nevertheless, between 1929 and 1933 Schmidt was the most popular tenor on German radio (hence the term 'radio

tenor') and starred in several early sound films. His career declined after the Nazis forced him into exile and attempts to restart his career elsewhere in Europe were short-lived. He eventually died aged 38 and stateless in a Swiss internment camp (see Detre, 2020; Loacker and Prucha, 1999: 88; Tryster, 1995: 193).

After Schmidt's death, his tragic biography has frequently become an emblematic symbol for the experience of exile more generally and his signature song 'Ein Lied geht um die Welt' ('A Song Goes Round The World') from the 1933 film of the same title and banned by the Nazis in 1937 (Wulff, 2010: 201) has become something of an exile anthem (it was also written by two exile artists, the composer Hans May and the lyricist, screenwriter and filmmaker Ernst Neubach). This is despite or perhaps precisely because the song itself is melodically and lyrically upbeat, suggesting resilience and even triumph, as it concludes with the line 'time flies, but the song remains forever'. It is no coincidence that *Exil Shanghai* ends with this specific song, accompanying an image of empty deckchairs on a river cruiser.

In a more melancholic vein, Schmidt's voice accompanies the scenes of the Jewish cemetery with the piece 'Glück, das mir verblieb' ('Happiness that remains') from Jewish composer's Erich W. Korngold's opera *Die Tote Stadt* ('The Dead City', 1920) that ends with the line 'Death will not separate us. If you must leave me some day, believe there is an afterlife'. Almost akin to compiling a 'playlist' of exile songs, Ottinger also includes Joseph Schmidt's renditions of 'Der Emigrant' ('I want to flee across the sea, I am searching for a way, for hope'), and 'Heimatlied' ('My homeland, why did I have to leave you, the foreign land is empty, my heart is heavy'). Popular songs such as these have often been dismissed as lightweight and derivative in their adoption of international popular musical registers. But as Brian Currid has argued in his insightful reading of the Joseph Schmidt film *A Song Goes Round the World*, 'it is crucial to understand the *Schlager* as registering the possibility of resistant formations that could make material and experiential the conditions of modernity' (Currid, 2000: 173).

The other performer whose voice features more than once across *Exil Shanghai* is the singer and film star Zhou Xuan (1920–57), remembered as one of China's 'Seven Great Singing Stars', by her nickname 'Golden Voice', as the 'biggest crossover star' between film and music (Yeh, 2002: 93), and even as 'the most celebrated vocalist in the history of mainland Chinese popular music' (Ma, 2015: 56). Zhou Xuan's acoustic presence in *Exil Shanghai* serves as a reminder of the modernity of Chinese 1930s Shanghai that is absent in traditional accounts of European exile in Shanghai and treaty-port imperialism, or which becomes replaced by exoticized evocations of an 'ancient', alien, and unchanging China. What the latter represses is a rich urban culture in 1930s Shanghai that encompassed literature, newspapers, music and cinema, and which was both modernist and popular. Female stars such as Zhou Xuan embodied this modern mass culture, as 'movie actresses were some

of the most upwardly mobile and visible women in 1920s and 1930s Shanghai' (Chang, 1999: 128).

In an interview with Rickels, Ottinger revealed that in preparation for *Exil Shanghai*, she became interested in 1930s Chinese cinema, which Miriam Hansen (listed in the credits of Ottinger's film as an advisor) argued 'represents a distinct brand of vernacular modernism, one that evolved in complex relation to American – and other foreign – models while drawing on and transforming Chinese traditions' (Hansen, 2000: 13) and which 'produces the local, a local vernacular modernism, in and through the process of cultural translation' (Hansen, 2000: 19). Reflecting on the cross-fertilization of popular music and film during this period, Sue Tuohy noted that the 'genres of music heard in Shanghai dance halls and concerts, from Strauss waltzes to revolutionary songs, were recontextualized in the genre of Chinese films' (Tuohy, 1999: 203), while Jonathan Stock has pointed out that 'records were widely sold in urban areas and were played publicly in hotels, night-clubs, restaurants, bars, and shops' (Stock, 1995: 123).

In *Exil Shanghai*, Zhou Xuan's songs do not feature in Krasno's account which represents the segregated hierarchies of the treaty-port order. Early in the Alexander section we hear her rendition of 'Yé Shanghai/Shanghai Nights', which captures the heady hedonism and the isolation and despair of the sleepless city, which in retrospect from the early morning 'seems like a dream'. The song 'He Jia Huan' which runs over the Alexanders' account of the end of the war both celebrates victory over Japan and the happiness of a family reunion. In the Inna Mink section, as she recalls bombing raids, we hear Zhou Xuan expressing her loneliness and sadness in the song 'Gao su wo'. With its Latin-inflected rhythm and melody, and its melodramatic lyrics about the life of a showgirl torn between joy and regret, 'Ge nu zhi ge' fits Georges Spunt's story, while 'Su Zhong Qing', the story of a girl hoping for a romantic evening with her boyfriend but is afraid to reveal her true feelings, accompanies Georges telling about his visits to the cinema and comes soon after his first confession of his secret gay life.

It is worth noting that the leftist Chinese cinema of the 1930s and Zhou Xuan's popular songs addressed similar themes and sentiments as Joseph Schmidt's *Schlager*, with their focus on migration, exile and the longing for home. Guo-Jin Hong reminds us that 'a prominent spatial trope in 1930s urban melodrama emphasises the traffic between rural and urban regions' and that 'forced migration to Shanghai is a common theme in 1930s leftist cinema' (Hong, 2009: 221). Similarly, partings, loneliness and eventual reunions are recurring themes of Zhou Xuan's songs. Zhou Xuan herself died young, at almost the same age as Schmidt. The vernacular modernism she embodied went into its own 'exile', side-lined and dismissed by the ideological purity of the Cultural Revolution. In an interesting coincidence at about the same time in the 1990s when the history of the Shanghai exile resurfaced in public

memory, the history of pre-war Chinese Shanghai was being rediscovered. Zhou Xuan's music was re-released and was part of a nostalgic renaissance of pre-war and war-time Shanghai. As Jonathan Stock comments 'Shanghai's pre-revolutionary history as a thriving commercial city had not only become respectable, it had become something to emulate' (Stock 1995: 129). The Shanghai renaissance included films such as Ang Lee's *Lust, Caution* (2007), the latter based on a novella by Shanghai-born author Eileen Chang, and featuring a song made famous by Zhou Xuan. Zhou Xuan's song 'The Blooming Years' also has a prominent function in Wong Kar-wei's *In the Mood for Love* (1999). Jean Ma notes that

> the inclusion of 'The Blooming Years' in *In The Mood for Love* concatenates the longings of this displaced community for a lost homeland, the desires of the film's characters for lost or unrealized loves, and perhaps the director's nostalgia for the disappeared milieu of his childhood.
>
> (2015: 1)

Conclusion

As I have argued in this chapter, *Exil Shanghai* should not be read as a linear account of the story of the war-time Jewish ghetto in Shanghai and its communities. Instead, it is a complex and multilayered collage, or as Prakash has perceptively suggested 'palimpsests that reveal the co-existence of moments, events, and historical processes in the present' (2018: 76). Discussing the archival function of *Exil Shanghai*, Amy Villarejo invokes Jaques Derrida's conception of 'archive fever' understood as the 'compulsive, repetitive, and nostalgic desire for the archive' (2017: 91), and one can certainly see how the film invites viewers to share this 'fever' with the director.

The juxtaposition between different kinds of witnesses, and between different acoustic and visual layers that complement and contrast each other, does not lend itself neatly to the heroic narrative of survival and resilience that some viewers might be looking for. Instead, *Exil Shanghai* encompasses the intertwining histories of nineteenth-century imperialism, anti-Semitism, twentieth-century exile and the socio-political and cultural trajectory of China in the twentieth and twenty-first century as a continuum. This in turn opens an opportunity to establish affinities, synergies and potential solidarities across cultural and historical boundaries and across multiple identities.

ACKNOWLEDGEMENT
I am grateful to Jia Kang and Yuan Li for translating the lyrics of Zhou Xuan's songs.

NOTES

1. Eber's personal collection is referred to by Ottinger as a source in her acknowledgements in the end credits of *Exil Shanghai*.
2. The end credits of *Exil Shanghai* suggest that at least some of the used material originates in the collection of musicologist and historian Raymond Wolff (1946–2021). Wolff, born in New York as the son of German-Jewish émigrés, began collecting records from the early decades of the twentieth century after he moved to Berlin in 1971. Wolff also played a small part in Ottinger's *Südostpassage*. As a historian he researched aspects of Jewish-German history and in later years became known for his activities to restore the synagogue in his grandparents' village of Staudernheim near Mainz (Graf 2021).
3. Other singers who have recorded the song include The Comedian Harmonists and Nina Hagen.

REFERENCES

Barzel, Amnon et al. (1997), *Leben im Wartesaal – Exil in Shanghai 1938–1947*, Berlin: Schriften des Jüdischen Museums, Jüdisches Museum im Stadtmuseum Berlin.

Bei, Gao (2013), *Shanghai Sanctuary: Chinese and Japanese Policy toward European Jewish Refugees during World War II*, Oxford and New York: Oxford University Press.

Bernstein, Lisa and Chu Chueh Cheng (eds) (2020), *Revealing/Reveiling Shanghai: Cultural Representations from the Twentieth and Twenty-First Century*, New York: SUNY Press.

Bickers, Robert (1999), 'Britain in China: Community', in *Culture and Colonialism 1900–1949*, Manchester: Manchester University Press.

Bickers, Robert (2012), *The Scramble for China: Foreign Devils in the Qing Empire 1832–1914*, London: Penguin Books.

Chang, Michael G. (1999), 'The good, the bad, and the beautiful: Movie actresses and public discourse in Shanghai, 1920s–1930s', in Yingjin Zhang (ed.), *Cinema and Urban Culture in Shanghai 1922-1943*, Stanford: Stanford Univrsity Press, pp. 128–59.

Currid, Brian (2000), 'A song goes round the world: The German Schlager, as an organ of experience', *Popular Music*, 19:2, pp. 147–80.

Derrida, Jacques (2017), *Archive Fever: A Freudian Impression, Reprint Edition*, Chicago: University of Chicago Press.

Detre, Laura (2020), 'Joseph Schmidt and Czernowitz: A story of ethnic fluidity', *Journal of Austrian Studies*, 53:3, pp. 63–70.

Eber, Irene (ed.) (2008), *Voices from Shanghai: Jewish Exiles in Wartime China*, Chicago: The University of Chicago Press.

Eber, Irene (2012), *Wartime Shanghai and the Jewish Refugees from Central Europe: Survival, Co-Existence, and Identity in a Multi-Ethnic City*, Berlin and Boston: Walter de Gruyter GmbH & Co. KG.

Fischer, Jens-Malte (1993), *Grosse Stimmen: Von Enrico Caruso bis Jessye Norman*, Stuttgart: J. B. Metzler.

Graf, Hans-Dieter (2021), 'Kämpfer gegen das Vergessen: Raymond Wolff gestorben', *Allgemeine Zeitung*, 3 May, https://www.allgemeine-zeitung.de/lokales/mainz/vg-bodenheim/nackenheim/kampfer-gegen-das-vergessen-raymond-wolff-gestorben_23624125. Accessed 16 April 2022.

Hansen, Miriam Bratu (2000), 'Fallen women, rising stars, new horizons: Shanghai silent film as vernacular modernism', *Film Quarterly*, 54:1, pp. 10–22.

Harjes, Kirsten and Tanja, Nusser (2000), 'An authentic experience of history: Tourism in Ulrike Ottinger's *Exil Shanghai*', *Women in German Yearbook: Feminist Studies in German Literature and Culture*, 15:1, pp. 247–63.

Harvey, Dennis (1997), '*Exile Shanghai*', *Variety*, 5 May, https://variety.com/1997/film/reviews/exile-shanghai-1200450007/. Accessed 16 April 2022.

Hong, Guo-Juin (2009), 'Meet me in Shanghai: Melodrama and the cinematic production of space in 1930s Shanghai leftist films', *Journal of Chinese Cinemas*, 3:3, pp. 215–30.

Jakubowicz, Andrew (2009), 'Cosmopolitanism with roots: The Jewish presence in Shanghai before the Communist Revolution and as a brand in the new metropolis', in S. Hemelryk Donald, E. Kofman and C. Klein (eds), *Branding Cities: Cosmopolitanism, Parochialism, and Social Change*, London and New York: Routledge, pp. 156–71.

Jones, Andrew F. (1992), *Like A Knife: Ideology and Genre in Contemporary Chinese Popular Music*, Ithaca: Cornell University Press.

Jones, Andrew (2001), *Yellow Music: Media Culture and Colonial Modernity in the Chinese Jazz Age*, Durham, NC: Duke University Press.

Kranzler, David (1976), *Japanese, Nazis & Jews: the Jewish Refugee Community of Shanghai 1938–1945*, New York: Yeshiva University Press.

Krasno, Rena (1992), *Strangers Always: A Jewish Family in Wartime Shanghai*, Berkeley: Pacific View Press.

Lee, Leo Ou-fan (1999), *Shanghai Modern: The Flowering of a New Urban Culture in China, 1930–1945*, Cambridge, MA.: Harvard University Press.

Loacker, Armin and Martin Prucha (1999), 'Österreichisch-deutsche Filmbeziehungen und die unabhängige Spielfilmproduktion 1933–1937', *Modern Austrian Literature*, 32:4, pp. 87–117.

Lyons, Erica (2022), 'Animating Jewish-Chinese friendship: A story of lasting friendship', *Asian Jewish Life: A Journal of Spirit, Society and Culture*, http://asianjewishlife.org/pages/articles/summer2010/AJL_CoverStory_AnimatingRelationships.html. Accessed 17 April 2022.

Ma, Jean (2015), *Sounding the Modern Woman: The Songstress in Chinese Cinema*, Durham, NC: Duke University Press.

Meyer, Eva (2007), 'Ulrike Ottinger's chronicle of time', *After All: A Journal of Art, Context, and Enquiry*, 16, pp. 39–44.

Michaels, Jennifer E. (2019), 'Restoring and utilizing the past: The Shanghai Jewish Refugees Museum', in Amy K. Levin (ed.), *Global Mobilities: Refugees, Exile, and Immigrants in Museums and Archives*, London and New York: Routledge, pp. 205–22.

Michaels, Jennifer E. (2020), 'Shanghai: City of sin – city of hope: Representations of Shanghai in memoirs by Jewish exiles and in literary texts about the diaspora,' in Lisa Bernstein and Chueh Cheng (eds), *Revealing/Reveiling Shanghai. Cultural Representations from the Twentieth and Twenty-First Century*, New York: SUNY Press, pp. 123–42.

Ottinger, Ulrike (dir.) (1997), *Exil Shanghai*, Germany: Ulrike Oettinger Filmproduktion and Transfax Film Productions.

Prakash, Shambhavi (2018), 'Representations of Jewish exile and models of memory in Shanghai Ghetto and Exil Shanghai', in Joanne Miyang Cho (ed.), *Transnational Encounters between Germany and East Asia since 1900*, London and New York: Routledge, pp. 62–81.

Pscheiden, Daniela and Danielle Spera (eds.) (2020), *Die Wiener in China: Fluchtpunkt Shanghai/Little Vienna in Shanghai*, Vienna: Jüdisches Museum Wien, Amalthea Signum Verlag.

Rickels, Laurence (2008), *Ulrike Ottinger: The Autobiography of Art Cinema*, Minneapolis, and London: University of Minnesota Press.

Ristaino, Marcia Reynders (2002), *Port of Last Resort: The Diaspora Communities of Shanghai*, Stanford: Stanford University Press.

Rosdy, Paul (2020), 'Shanghai – Kamera ab', in Daniela Pscheiden and Danielle Spera (eds), *Die Wiener in China: Fluchtpunkt Shanghai: Little Vienna in Shanghai*, Vienna: Jüdisches Museum Wien/Amalthea Signum Verlag, pp. 66–73.

Rothberg, Michael (2019), *The Implicated Subject: Beyond Victims and Perpetrators*, Stanford: Stanford Univesity Press.

Shanghai Jewish Refugee Museum (2022), 'About us', https://www.shhkjrm.com/node2/n4/n6/n30/n39/index_K76.html. Accessed 17 April 2022.

Sieglohr, Ulrike (2020), 'Two women filmmakers: Ulrike Ottinger and Angela Schanelec', in T. Bergfelder, E. Carter, D. Göktürk and C. Sandberg (eds.), *The German Cinema Book*, 2nd ed., London: British Film Institute, pp. 218–27.

Sino-Judaic Institute (2022), Homepage, https://sinojudaic.org/officers. Accessed 17 April 2022.

Spunt, Georges (1967), *Memoirs and Menus: The Confessions of a Culinary Snob*, Boston: Chilton Books.

Spunt, Georges (1968), *A Place in Time*, New York: G.P. Putnam's Sons.

Stock, Jonathan (1995), 'Reconsidering the past: Zhou Xuan and the rehabilitation of early twentieth-century popular music', *Asian Music*, 26: 2, pp. 119–35.

Thirault, Philippe and Jorge Miguel (2019), *Shanghai Dream*, Los Angeles: Humanoids Inc.

Trumpener, Katie (1993), '*Johanna d'Arc of Mongolia* in the mirror of Dorian Gray: Ethnographic recordings and the aesthetics of the market in the recent films of Ulrike Ottinger', *New German Critique*, 60, Special Issue: 'German Film History', pp. 77–99.

Tryster, Hillel (1995), 'The land of promise (1935): A case study in Zionist film propaganda', *Historical Journal of Film, Radio and Television*, 15:2, pp. 187–217.

Tsang, Gabriel F. Y. (2020) 'The architectural structure of prewar Shanghai: Analysis of the longtang setting in Street Angel (1937)', in Lisa Bernstein and Chu Chueh Cheng (eds.), *Revealing/Reveiling Shanghai: Cultural Representations from the Twentieth and Twenty-First Century*, New York: SUNY Press, pp. 37–52.

Tuohy, Sue (1999), 'Metropolitan sounds: Music in Chinese films of the 1930s', in Yingjin Zhang (ed.), *Cinema and Urban Culture in Shanghai 1922–1943*, Stanford: Stanford University Press, pp. 200–21.

Villarejo, Amy (2002), 'Archiving the diaspora: A lesbian impression of/in Ulrike Ottinger's *Exile Shanghai*', *New German Critique*, 87, Special Issue: 'Postwall Cinema', pp. 157–91.

Wagenstein, Angel (2007), *Farewell Shanghai*, New York: Handsel Press.

Whissell, Kirsten (1996), 'Racialized spectacle, exchange relations, and the western in *Johanna d'Arc of Mongolia*', *Screen*, 37:1, pp. 41–67.

Wulff, Hans J. (2010), '"Ein Lied geht um die Welt" (1933/1958): Wandlungen des Sängerfilms oder Der Sänger Joseph Schmidt als Genrefigur und als historische Person', *Lied und populäre Kultur (Song and Popular Culture)*, 55, pp. 199–208.

Yeh, Yueh-yuh (2002), 'Historiography and sinification: Music in Chinese cinema of the 1930s, *Cinema Journal*, 41:3, pp. 78–97.

10

Hochzeiten[1]

Laurence A. Rickels

To begin means to make a difference. An old conception is to be presented anew and it is the task of the production to make of this a Hochzeit.

(Meyer 1999: 8)

Invited by the Women's Film Festival in Seoul, Ulrike Ottinger made a documentary on location in 2008, which resulted in two films, the short, *Seoul Women Happiness*, which she submitted to the festival, and the feature, *The Korean Wedding Chest*, which she took home with her. For the feature film, Ottinger wrote a fairy tale, which draws on and adds to the legends surrounding the cultural significance of the Ginseng root. All legends extend from what's in the name 'Ginseng', namely a root word meaning 'person'. The anthropomorphism in the name is attributed to the leg-like roots rendering the human figure standing upright.

Among the Ginseng root's cure-all properties there is also an aphrodisiac benefit that suggests a fit with Freud's speculation in *Civilisation and Its Discontents* on the alignment of the visual sense, sexuality and the social group in the evolution of the human species (Freud, 1961). It was by assuming the upright stance that homo sapiens pulled up and away from the sense of smell and its libidinal guidance. Sexuality came to be dominated instead within the visual field by the genitally centred body. What followed was coupling in a family setting, the control release that staggered the immediate overstimulation.

In *The Korean Wedding Chest*, the overriding significance of marriage is the interchange of old and new within an ontology of visual representation. Ottinger's fairy tale, the film document's supernatural preamble and frame, relates the emergence into the visual field of a couple of ancient Ginseng roots, husband and wife since before the origin of the human species. Drawn upward by a fire-breathing dragon's ruckus on the earth's surface, the roots are transformed into

human lookalikes. But like vampires they have no images of their own. 'Because they had no pictures of themselves, they couldn't prove that they belonged together, nor that they were in fact of the same kind as men. Thus, they decided to submit to the long and difficult procedure of becoming human.'[2]

This procedure requires in the first place the ceremony of marriage or, in fact, remarriage. The Ginseng man and the Ginseng woman, attended by their friends among flora and fauna, tie the knot again, this time in human terms. By these terms they acquire images of themselves, which means they can now enter human society. But following fulfilment of their residency requirement, they almost forget that their mission is thus only half accomplished. Yes, they were to dwell among men, but their purpose was to understand them.

> Then one day the Ginseng woman said to the Ginseng man: 'Let's go again and roam the world and see what's new in the old and old in the new.'
> On a cold winter day, they set off on their way.

Stanley Cavell sees in Nietzsche's Eternal Return 'the call … he puts by saying it is high time, a heightening or ascension of time; this is literally *Hochzeit*, German for marriage, with time itself as the ring' (Cavell, 1981: 241). One more heightening, the superlative *höchste Zeit*, means the other 'high time', the time that is running late, the time of nearly no time left, the time, just in time, for placing a bet. Wedding is etymologically related to the German word for bet, *Wette*. The diversity of marriage rites and their histories around the world can be organized under the economy of three overlapping trajectories: deception, exchange and revenge. Marriage introduces a standard of exchange into what would otherwise be a free-for-all, with the women as the prizes. Nietzsche observed that the marriage tie was, in the beginning, seen to transgress against the rights of the community (of men) (Nietzsche, 1967). For each marital contract or exchange, there were excluded parties who, at a loss, sought to get even. That's why in certain cultures the bridesmaids (the 'Beauties') wear the same dress, which originally was the same as the bride's, so marauding rival suitors could not readily find the bride and carry her off.

In the world's canon of nuptial ceremonies, the Korean ritual of the wedding chest reroutes the standard of exchange known in English as the bride's dowry and in German, more ambivalently, as her *Mitgift*.[3] The Korean ritual pays a debt to the parents of the bride and, in one ceremony associated with the transfer of the chest, offers the tribute in the context or contest of a bet. On the night in question the suitor and a group of friends pitch camp in front of the bride's home and pitch the sale of the chest to anyone and everyone who can offer the best price. The bet that is on, therefore, is whether the intended recipients of the gift, the parents of the bride, can intervene in the sale and secure the chest. All's fair and the outcome of the bet

can be influenced with lures. Envelopes of money cast in their way just a few steps away draw the salesmen closer to the front door. When they still hesitate, food and drink are offered, and when that doesn't seal the dealing, the 'Beauties' arrive to offer the ultimate draw. While they are caught up in this star distraction, the bride's family brings inside the isolated leader of the pack and the chest (Figure 10.1).[4]

FIGURE 10.1: *The Korean Wedding Chest*. Photograph by Ulrike Ottinger, Berlin, 2008. © Ulrike Ottinger.

The interpersonal setting of this subterfuge masks that at the intrapsychic level such rituals are carried out to stop in their tracks the evil spirits who would reprise their role in the coupling like the funeral meats furnishing forth the marriage tables. What's rotten at the start of *Hamlet* provides the reading ground for visitation by vengeance-seeking ghosts. In this setting of a haunted reception, Melanie Klein reformulated Freud's reflections in 'The Taboo of Virginity' on the identificatory coordinates of marital difficulties, which Stanley Cavell summons in elaborating his affirmative sense of remarriage in *Pursuits of Happiness* (Cavell, 1981: 241; Freud, 1967; Klein 1975a).[5] Remarriage is often an upgrade, Freud mentions in passing by raising to consciousness the programming attending couples in crisis and in therapy. When difficulties are faced in marriage, the husband is still working through the relationship to his father, while the wife is still going at it with her mother. In a corner of her 1935 essay 'A contribution to the psychogenesis of manic-depressive states', Klein observes that marriage, which for her is always remarriage, succeeds only by integrating the internal or ghostly parents. If the integration is not achieved, a parent residing in the inner world can become a 'dangerous ghost' (1975a: 283), which however means for Klein that the ghost must be appeased, not put to rest. Brought together again (or re-paired) after they have been separated out in the course of early development as individual whole objects from the pathogenic combo of the primal scene, the internal parents share in the coupling of their living children.

Remarkable for her unique handling of incest, Klein's conception of the Oedipal bond in marriage has a less controversial run in her understanding of mourning. In Klein's 1940 essay 'Mourning and its relation to manic-depressive states', her case subject Mrs. A., who is grief stuck in the grave of her son, at first felt that 'her loss was inflicted on her by revengeful parents' (1975b: 359).[6] In the course of her mourning work, she experiences 'in phantasy ... the sympathy of these parents (dead long since), who shared her grief as they would have done had they lived'.

> The tears which she shed were also to some extent the tears which her internal parents shed, and she also wanted to comfort them as they – in her phantasy – comforted her.
> (Klein, 1975b: 359)

Rituals supplied a synonym for marriage, 'tying the knot', which, like a primal antithetical word (or phrase) according to Freud, also means its opposite (Freud, 1957: 153–61). There were nuptial rituals for which it was more to the point that knots be untied prior to the night that's the night. A related ritual, the couple's clasping of left to left and right to right hands, doesn't describe a knot so much as it performs the interweaving or interlacing of strands preliminary to tying the knot

or not. The not knot is basic to the Korean rituals of binding bride and groom, which Ottinger's film documents. The bindings that enable the party of the groom to carry the chest to the bride's family must not, the film instructs, be knotted. The interwoven strands comprising the bindings must always be available for unravelling and reweaving. Although Freud's concession that weaving was woman's sole contribution to prosthetic technicity continues to cause consternation (Freud, 1964: 132), the connection goes to the very art of his authorship as well as to the central role of mourning and unmourning in his conception of psychic reality. When you tour the Freud Museum in Hampstead, London, you witness alongside the mementos of Freud's two-year stay there the large loom in the study that represents Anna Freud's copresence, survival and far longer stay. The explanatory card cites father Freud on weaving and the dream work. The ultimate caption would be the legend of Penelope's loyalty to the missing at her loom, winning time from substitution – the recycling of funeral meats for the wedding feast – by interweaving weaving, unravelling and reweaving.

During the scene in *The Korean Wedding Chest* in which wedding gowns are modelled for the clients, Ottinger shows her edits with the kind of showmanship we associate with the very first films in history: the model exits on the right and enters again on the left and so on. What is not seen could also be a weaving of the movement of circling models. At one point she reaches back through the prehistory of film, in which the magic of editing often conveyed the supernatural, and lets a model disappear mid-screen and reappear suddenly without continuity or context. Given the overall composition of the sequence, it's still possible to see, in contrast to the magic shows of Georges Méliès, for example, that Ottinger isn't so much tying and cutting apart the knots to posit presence or absence but seems rather to be weaving together and pulling apart strands that don't stand in opposition.

All the prepwork in the wedding studios in contemporary Seoul leading the couple to the altar goes down the aisle to the photographic portrait. The clients are at home with the incessant corrections they undergo in preparation for their photo ops. The staging is as old as the East Asian theatre traditions that integrate the work of assistance rather than hide the incessant interruptions of the performance of puppets or actors. That the show must go on in concert with the machinery of staging admits a copresence with absence suggestive of the spirit realm and corresponds to Klein's elaboration of psychic inheritance. The participants in the process leading to the wedding celebration are caught up in the interweaving of the show to be presented and the assistance and preparation that's not behind the seen. At the end, we witness with the closing titles a series of wedding photographs dating back to the start of the twentieth century.

In *The Korean Wedding Chest*, Ottinger again addresses, this time through the turn to or the return of old themes and techniques of weaving, the spirit realm

of photography and film in her signature mode of affirmation in mourning. This stance was evident, for example, in the sequence in *Exil Shanghai* in which the souvenirs of the interviewed couple's wedding in the shadow of their flight from Nazi persecution are shown in alternation with the documentary evidence of the contemporary Chinese production of marriage ceremonies. This montage juxtaposition amounts to a jubilant externalization of the couple's own affirmation against all odds, de- and re-contextualizing the traumatic past. Ottinger doesn't discount the effects of separation and exclusion, but she also doesn't get stuck on the cutting of losses. Instead, room is made both for the absence and for affirmation.

In her second digital feature, Ottinger shows us what is old in the new. Certainly, the digital medium unties the knot or cut of editing that once opposed film and video. Less a new and improved medium that opposes itself to what came before, the digital relation offers instead a supplemental synthesis: wide-open access to all prior media, genres. It is the virtual Eternal Return of all the names and events in history but with each reprisal fitting an entry in the digital archive divested of the original oppositional setting. The digital film interweaves, then, not only among all the possibilities that the editor contemplates but also between media.

While Ottinger found in *The Korean Wedding Chest* a form for the departure of digital editing from analogy with the cut, in the Japanese setting of her next film, *Under Snow*, she continues to explore the old and the new in digital filmmaking, beginning with an exploration of composition between selection and sorting out. All the cultural attractions of Japan continue, reinscribed but intact, set off against the extreme winter conditions of the Echigo district, which remains snowbound until May. Beyond adaptation or survival, the denizens of the so-called 'snow country', a mountainous region facing Siberia, bind by the art of everyday life the impingements upon their continuity of being. Early in the film we attend the preparation of a meal for many guests by a team of cooks. Each serving is composed in discrete bowls out of items filling separate pans. But then we watch as something left over in one pan is placed at another starting point in the assemblage process. Later on in the film, we watch the laying out of strips of crepe in the snow, each dyed another monochrome shade. But when the final strip in this series doesn't fit at the end of the line, it is lifted up again and carried to the other end of the composition. What exceeds conclusion is a new beginning.

The work of composition, which Ottinger's camera documents, is taken up by the camera itself. The exploration of the interior of a temple includes a close-up of one golden detail, on which the camera holds for an inordinately long time. When the camera pulls back, we see that the 'same' detail was exchanged for one belonging to another view of the temple's interior, before which we have been transported in this way. Here the wrenching out of context of one detail or element is at once identified as irreversible and serves as starting point for another scene or

composition. Attention to the destiny of what is left over, whether in excess of or ill-fitting what was planned, supplements the focus on sampling, sorting, selecting during composition and grounds it in the psychic-metabolic processes of memory. At the meal following the kitchen scene, the diner eats samples lifted from many serving bowls. The camera, also sampling, offers us images of composed dishes, which are intercut with the ongoing scene of the diner's sampling and eating. The sampling dynamic leaves behind compositions in memory, the messenger of time, while leaving out and taking in the composition in parts.

The internal route of the dynamic of composition is introduced at the film's opening. We enter the film together with the documentary camera while the voice-over tells of an earlier journey through the snow country and of the traveller's pen drawings and notations, which led to a book-length study of the local customs, dialects, industries and the snowflakes themselves. This opening evocation of Bokshi Suzuki's 1837 book *Hokuetsu Seppu (Snow Stories of North Etsu Province)* captions the images of the snow country folding out on screen as the pages on which the film stylus inscribes its document. What drew Suzuki's work of documentation onward was the inner world he discovered when he decided to study the snowflakes under his magnifying glass. He found inside the compelling formal composition of the snowflakes, which relied on recurring elements and forms, the other realm of the snow crystals, in which discrete singularities appeared without end. Magnification, Walter Benjamin underscored in writing about unconscious optics, introduced the prospect of new media-technical representations of the art of memory (1985: 237). Photography's capacity for entering upon the unseen was not only paralleled by Freud's unpacking of the unconscious but even staged in the séances of modern Spiritualism.

In *Under Snow*, Ottinger takes up Suzuki's documentary brush, conjoining history and legend, the seen and the unseen, iterability and singularity in a self-reflexive work of composition and remembering – sorting, selecting, keeping in and letting go – between worlds. In what is perhaps her most boundary blended or breached documentary work, Ottinger actively samples among contemporary and historical, factual and fictional materials to skew, sort out and compose the film narrative. Following the introduction of Suzuki's *Snow Stories* as model documentary travelogue, two 'contemporary' figures arrive by train for a sojourn in the snow country bringing along Suzuki's compendium of the local legends for guidance. But Suzuki's tome is their spirit guide, and already during their first night the page turns, and the travellers are transformed by a fox spirit's longing to live her love in the past into a supernatural couple of the Edo period. This pair traverses the film, even or especially the recognizable documentary scenes, soon to be followed by another inter-cutting story of three blind musicians, which in turn yields the fable of their adopted son, who grew up to become the kind of master of song

attracting love and envy in all the wrong places. Betrayed by intrigue the singer is condemned to a life of mining on the island of Sabo. The story of this singer is the only one not enacted or personified in *Under Snow*. The concluding sojourn in Sabo is narrated only by voice-over and subjective camera. The singer's plaint echoes down the narrow passages of the mines and across the ages in concert with the history of oppression and exile.

Intercut with a museum tour of the former gold mines in which amusement-park robots engage in the now historical labour of this underworld, we follow ubiquitous pans of the coast to concluding images of the turbulent sea. It is the film's highest affirmation of its medium nature as open documentary encounter with the other and the time to come. At the time of the premiere of *Under Snow*, Ottinger was already planning to retake with camera in hand Adelbert von Chamisso's voyage to the Bering Sea. His voyage concluded the 1814 story *Peter Schlemihl*, through which Chamisso, who came to Berlin as a refugee from the Revolution in France, secured literary fame against all odds. At the end of the story, the eponymous hero bestows the botanical samples collected on his magical trip around the world upon his friend 'Chamisso', who, then, outside the fictional word, would become a recognized botanist by the samples he brought back in 1818 from his actual voyage on the 1815 Russian expedition. The name 'Schlemihl' is a word belonging to the urban argot Rotwelsch, in which German, Yiddish, Romanian and Hebrew met and crossed over. By the title alone Chamisso's contribution to the German literary mainstay of selling one's soul to the Devil is at the same time an adventure in the annals of what Deleuze and Guattari termed 'minor literature' (Deleuze and Guattari, 1986).

The artefact of Chamisso's double life is a readymade for Ottinger. Out of its mix of fact and fiction one might indeed construct a continuity shot with the filmmaker's driving motivation and momentum: the reversal of traumatization and internalization into outward bound adventure. Ottinger's oeuvre has alternated between bringing back in her art cinema the missing persons of 'Old Europe' at home in and to world culture (and home on the target range of majority intolerance) and going out to meet the other in her documentary travel encounters at new frontiers.

Peter Schlemihl decides to become a miner to lose the loss of his shadow in the underworld and escape his persecuted loser role. En route he replaces his city footwear with appropriately sturdy boots. But these turn out to be 'seven-mile boots', in which, stepping out of his self-punishing commitment to mining, he travels step by step long distances on fast forward around the world. Chamisso exchanged the import of the industry of mining in the genealogy of modern machine technology for a dream trip to the threshold of the optical unconscious, anticipating the switch from the industrial to the mediatic era of technologization, a feat of literary augury that awaited the film medium for its full projection. Somewhere between fulfilment of Chamisso's fantasy and the wide-open prospect of the next

documentary project, the conclusion of *Under Snow* is the ultimate *Hochzeit*. It takes off from the island prison of mining and trauma, loses itself at sea and finds itself anew at a new beginning in Ottinger's oeuvre.

NOTES

1. For this essay, I combined and retrofitted two reviews: 'Magni-Fire: On Ulrike Ottinger's *Under Snow*', in *ARTUS 2011-2012: The Collector's Edition*, ed. Paul Foss and Laurence Rickels (Chicago: Intellect, 2013), 230–35, and 'The untied: On Ulrike Ottinger's *The Korean Wedding Chest*', in *artUS*, 29, 2010, 54–59. Since the cutoff point in my earlier Ottinger study meant that I concluded with *Prater*, I am here extending my reading to include these two East Asian fantasy documentaries.
2. I am quoting from the brief text of the fairy tale that comprises the opening voice-over in *The Korean Wedding Chest*. For the international versions of *The Korean Wedding Chest* and *Under Snow*, I read the fairy-tale voice-overs.
3. The gift bestowed in English is etymologically related to the *Gift* that in German spells poison. The close relation between giving and poisoning means that not only German history but also the German language makes forgiveness (another gift/*Gift* etymon) a highly problematic endeavour.
4. The short film *Seoul Women Happiness* shows the elements and performance of the contemporary version of the ritual, which forgoes the contest and the bet staggering the bestowal of the gift of the chest.
5. In my study *SPECTRE*, I read Klein's contributions to psychoanalysis through the Elizabethan traditions the German analyst chose to inherit when she shifted her thought to the English language. Between Shakespeare's ghost of Hamlet's father and Klein's inner world as the preserve of our objects of identification, we witness a secularization of the belief system hosting evil spirits or, more to the point, we recognize the haunted relationship to the recent past as secularization. In my study, it is the underworld organization SPECTRE, which Ian Fleming added towards the end of his life to the world of James Bond, that occupies the foreground.
6. Mrs. A. is Klein's proxy, the analyst having also recently lost her son, Hans. See my reading of the interlocked cases in *SPECTRE*, 31–38, 48–53 and 116–18.

REFERENCES

Benjamin, Walter (1985), 'The work of art in the age of mechanical reproduction', *Illuminations: Essays and Reflections* (ed. Arendt, trans. H. Zohn), New York: Schocken Books, pp. 217–51.

Cavell, Stanley (1981), *Pursuits of Happiness: The Hollywood Comedy of Remarriage*, Cambridge, MA and London: Harvard University Press.

Deleuze, Gilles and Félix Guattari (1986), *Kafka: Toward a Minor Literature* (trans. Dana Polan), Minneapolis: University of Minnesota Press.

Freud, Sigmund (1957), 'The antithetical meaning of primal words', *The Standard Edition of the Complete Psychological Works of Sigmund Freud (SE)* (ed. and trans. J. Strachey), vol. 11, London: The Hogarth Press, pp. 153–61.

Freud, Sigmund (1957), 'The taboo of virginity', *SE*, 11, pp. 193–208.

Freud, Sigmund (1961), *Civilization and Its Discontents*, *SE*, 21, pp. 64–145.

Freud, Sigmund (1964), 'Femininity', *New Introductory Lectures*, *SE*, 22, pp. 112–35.

Klein, Melanie (1975a), 'A contribution to the psychogenesis of manic-depressive states', in *Love, Guilt and Reparation and Other Works, 1921–1945*, New York: The Free Press, pp. 262–89.

Klein, Melanie (1975b), 'Mourning and its relation to manic-depressive states', in *Love, Guilt and Reparation and Other Works, 1921–1945*, pp. 344–69.

Meyer, Eva (1999), *Glückliche Hochzeiten*, Frankfurt a/M: Vittorio Klostermann.

Nietzsche, Friedrich (1967), *The Will to Power* (ed. W. Kaufmann, trans. R. J. Hollingdale), New York: Random House.

Ottinger, Ulrike (dir.), *The Korean Wedding Chest*, Germany and South Korea: Ulrike Oettinger Filmproduktion and International Women's Film Festival Seoul.

Rickels, Laurence (2008), *Ulrike Ottinger: The Autobiography of Art Cinema*, Minneapolis: University of Minnesota Press.

Rickels, Laurence (2013), *SPECTRE*, Fort Wayne: Anti-Oedipus Press.

PART FOUR

SHADOWS OF THE PAST: HOARDS AND COLLECTIONS

11

'Paris–Berlin et le monde entier': Ulrike Ottinger's Points of Departure

Dominic Paterson

When you are working with images, you can't help but enter that movement, that fine, splendid difficulty of the relation between order and disorder.

(Didi-Huberman, 2015: 89–90)

Every passion borders on the chaotic, but the collector's passion borders on the chaos of memories … For what else is this collection but a disorder to which habit has accommodated itself to such an extent that it can appear as order?

(Benjamin, [1931] 1999: 61)

Picture the work of Ulrike Ottinger in your mind's eye: imagine her images. What do you see? Maybe specific examples of the artist's singular vision rush to make their claim. After all, to have witnessed any of the extraordinary film sequences which introduce viewers to Tabea Blumenschein as the eponymous lead in *Madame X: An Absolute Ruler* (1977), or as 'She', the drinker in *Ticket of No Return* (1979), is to have these seared into memory. Likewise, Veruschka von Lehndorff as Dorian Gray (1984), or Magdalena Montezuma as the androgynous heroine of *Freak Orlando* (1981), imprint themselves decisively in the viewer's imagination – how easily they can be recalled even if seen only once! On the other hand, with equal vividness, you might conjure up one of Ottinger's photographs – some of those associated with *Freak Orlando*, perhaps? Why not that which pictures a hermaphrodite, skirts raised, gazing Narcissus-like at their own reflection? Or could it be another, showing Therese Zemp as the 'Living Torso' smiling radiantly,

regally, as she sits atop a column? Or, yet again, a person with dwarfism made up as a piebald-skinned herald outside Berlin's Olympic Stadium, accompanied by his canine doppelgänger? The provisional examples offered so far centre on extraordinary, non-normative re-imaginings of the human subject, which are indeed something of an Ottinger speciality. It is equally plausible, however, that one would call up an immaculately framed landscape or cityscape, whether in a photograph or a film – shot in Paris or Vienna, say, or Siberia, or China, or South Korea or Japan. I write these words and a shot from *Under Snow* (2011) comes immediately to my mind: lengths of coloured fabric laid across a field already blanketed by snow – a sight that seemingly emanates from another age while being nonetheless unprecedented, like so many in Ottinger's cosmos.

However varied they are in tone and type, all these images possess a mnemonic momentum of their own: any might well leap into our consciousness, bidden or not. But for those with even a passing knowledge of such works, I suspect, no single image could ever stand for long as a sufficient representation of Ottinger's teeming, heterogenous corpus. However intensely or forcefully memorable single images or scenes from her work might be – and it is the case that they are unusually impressive in this sense – it is characteristic of Ottinger that they are always also points of departure. Startlingly arresting, they hold our attention in order to call us on to other visions, other images. They move us through time and place, from fantasy to reality, across the highest and lowest planes of culture, challenging and changing such categories as they go. Multiplicity, motion and mutability are their very essence.

Why should this be so? From what source or sources does this multifaceted mobility derive? What is the importance to Ottinger's artistic project of its internal diversity and momentum? And what about her work makes her viewers, in turn, collectors of its remembered fragments to such a striking extent? This text will offer some possible, partial, answers to these questions. I will invoke some eminent theoretical figures in support of my responses to them, but a first clue may lie, straightforwardly enough, in the artist's own trajectory. From a young age, Ulrike Ottinger's life has been devoted to art. Pursuing that devotion led her from Constance to Paris and back, thence to Berlin and, from there, to many other parts of the world. Most of all, her creative vocation has meant, in parallel with her own intrepid journeying, embarking on an exploration of what images can do, of what they can become, of how they are shared. To these ends, still and moving images abound in her practice. Moreover, her work often draws on the abundant personal archive of historical objects and images – some inherited, most accumulated through her lifetime. She has garnered new image resources from all the places she has lived and from all the places she has travelled to. These gleanings burst forth in her films, photographs, exhibitions and books.

Ottinger is, then, both an inveterate collector and a prolific maker of images. In her hands, photographs and films do not just proliferate, however. They also play out a multiplication or expansion of the ways in which images, both still and moving, relate to each other and relate to the personal and cultural archives from which they emerge and into which they enter. As Katharina Sykora insightfully notes, this transformed relatedness pressures the very designation of Ottinger's image collections as an 'archive' (Sykora, 2005: 289). They might better be termed a 'hoard' or a 'cornucopia', insofar as they are not assembled or reassembled according to the application of an external schema or hierarchy, but function instead as 'active participants' in the context of a life 'guided by conscious aesthetic principles' (Sykora, 2005). As they often move from historical, art historical, pop cultural or ethnographic sources to take up new places within Ottinger's own artistic constellations, her collected images have (at the very least) dual identities: they are partly rooted in their historical pasts, and partly imbued with newly crafted personal values and meanings. Thus, to take just one example, Goya's lacerating images of broken bodies are restaged in the 'Goya Episode' within *Freak Orlando*. Here they double as images representing a particular moment in world history (that of the Inquisition) and are at the same time allegorical forms within the film's fantastical, carnivalesque and decidedly queer vision of gender play, time-travel and transgressive embodiment. For Walter Benjamin, 'the most distinguished trait of a collection will always be its transmissibility' ([1936] 1999: 61). This quality indeed distinguishes Ottinger's interwoven collection-oeuvre, in which images are continually being transmitted into new contexts and transmuted into new forms.

We can trace this active, animate and animating role of found or taken images throughout the stages of the artist's working processes. Ottinger's films usually begin with the production of visual 'scripts' that take the form of artist's books. Into these books, drawings, magazine clippings, postcards and photographic images travel, to be collaged and annotated. Still images of this sort, therefore, constitute an important form of pre-production for Ottinger's films – they set them in motion. The books themselves travel onto the set and continue to cast their spells there, as is wonderfully illustrated in a set of photographs that document Ottinger on location, showing her research to members of the local cast of *Johanna d'Arc of Mongolia* in 1988.

The resulting films transpose the books' collagist logic of juxtaposition and heterogeneity into the unique grammar of their framings and cuts, and in so doing they move stills into image flows. Conversely, Ottinger's photographs sometimes adopt the style of the 'film still' genre, though she purposefully differentiates them from actual stills – they are emphatic works in their own right, not mere derivations from, or advertisements for, the filmic work proper. Moreover, Ottinger's still photographs have become mobile in her use of them in installations over the past

two decades or so. 'It is the event of appearance, of showing and seeing, which is at the core of their being', Sykora writes of Ottinger's photographs, 'they vibrate sympathetically as pre- and post-images in every new performance and bring forth an overlapping of superimpositions that grow constantly denser' (2005: 289). If to imagine one of Ottinger's images is to have it quickly joined by another, and then another, this is therefore quite understandable: such layering or proliferation recapitulates what is already at work in the works themselves. Not only that, but it also echoes how Ottinger handles her images within the spaces afforded by both cinema and the art world.

In 2018, I had the privilege of assisting Ottinger as she arranged the photographs, films, drawings, books and archival materials that made up *Still Moving*, her first solo exhibition in the United Kingdom. The show took place at The Hunterian Art Gallery in Glasgow, opening to coincide with the city's biennial festival of visual art. In the process of installation, Ottinger's works were quite literally mobile: placements and groupings were subject to constant experiment and revision, and much time was spent, much attention was paid, as we moved works from wall to wall. These recapitulations of the installation were not a matter of indecision, still less a case of 'anything goes'. Reviewing *Still Moving* for *The Guardian*, Adrian Searle rightly noted that 'formal rigour' is a vital feature of the artist's oeuvre (Searle, 2018). This is no less true of her ingenious engagement in exhibition-making – an under-remarked but crucial aspect of her practice – than it is of individual works. Searle also perceived in the exhibition 'a call to artistic freedom'. It is precisely a synthesis of liberty and precision that I remember as characterizing Ottinger's approach to placing works within the gallery. Though careful planning had attended the lead-up to the exhibition, in practice no preconceived schema or chronology determined what went where. Rather, it was a case of allowing images to encounter each other anew, of seeing what energy (pictorial and thematic) could be generated through unexpected proximities that were improvised but not arbitrary. And so geographical locations from Germany to the Canary Islands, Mongolia and the South Pacific found themselves arrayed in new configurations. Bodies of all kinds joined forces to confront the viewer in a uniquely assembled community, existing only temporarily in this place and time. And times, too, were freely distributed around the gallery walls, both in terms of the works' own dates of production (which were largely irrelevant to the sequencing) and the historical moments they represented within Ottinger's imaginary, which moved with abandon through the centuries. Her constelled installation of images was heterotopic and heterochronic, then, like the imaginary space of the cinema, and like those Foucauldian 'other spaces' of culture that frequently appear in Ottinger's works, from the cemetery to the fairground (Foucault, 1998: 180–83).

This abandon, this freedom, does not take place without constraints, and not only those mandated by 'conscious aesthetic principles'. It emerges quite intentionally from a specifically historical understanding of culture. In her text 'Stations of Cinema: A Short Tale on Storytelling in Free Images', Ottinger outlines a global, even cosmological, horizon for the act of composing stories with visual as well as oral means. She identifies an age-old dramaturgy that takes the form of 'stations' and refers to this as 'a structural skeleton that can be filled with the past' but which is equally accommodating to collective views of the present and the future (Ottinger, 2001: 53–56). Derived, she contends, from early human experiences of nomadic life and exposure to the seasons, the diverse modes of this dramaturgical structure serve both as mnemonic aids and 'to provide orientation and lend ideas form, a highly-condensed abstract form'. Her own artistic project, she implies, has a continuity with these devices and structures. But the task of storytelling with images today is complicated, she knows, by the narrow uses to which it has been bent by commercial cinema and advertising, complicated, too, by our own changing relationships to nomadic existence. Reflecting on this vexing situation, Ottinger states that 'we have to fill the skeleton with new stations and new images'. But, then, she asks:

> What stations, if mankind has surely divided itself into those that continue to live as nomads, the refugees and migrant workers who have to make inconceivable efforts to face continuously changing demands and dangers ... and the sedentary, the established ones that have every advantage on their side, whose intelligence and ability to react is no longer called for, unless they carry the world home and involve themselves with it directly. I'm interested in describing how interconnected our narrative forms, our ways of finding images, our (film) arts are with our experiences, which possess infinite differences beyond the two basic models of human existence, that of the nomadic, and that of the sedentary.
>
> (Ottinger, 2001: 56)

To reclaim our relationship with the past and orient ourselves in the world today, Ottinger argues, we need both 'turbulent and quiet stations', both motion and stillness, arrayed across that infinite range of modes of life. Here again, we might note a resonance with Benjamin, for whom the two constitutive paradigms of the storyteller were 'someone who has come from afar' and 'the man who has stayed at home ... who knows the local tales and traditions' (1999: 84). It was axiomatic for Benjamin that 'the figure of the storyteller gets its full corporeality only for the one who can picture them both'. Ottinger, we might say, has fully imagined and embodied both these roles: not only by alternating her dwelling in Konstanz, Paris and Berlin with journeys elsewhere but also in treating her places of residence as

points of imaginative departure in their own right, as when Lake Constance stands in for the Far East in *Madame X*, when Berlin's urban palimpsest becomes the set for *Freak Orlando's* episodic world history or the artist's own home is the stage for colonial encounters in *Still Moving* (2009).

When he limned the figures of the resident and the itinerant storyteller, Benjamin was pondering the fate of literature in an age where the forms of life that generated oral storytelling were disappearing, and the advent of industrialized warfare rendered experience itself almost unspeakable. He would conjecture elsewhere that film might be the medium through which human beings could collectively 'innervate' – which is to say, corporeally absorb and rework – these profound shocks delivered by modernity (Hansen, 2004). For Ottinger too, film itself, 'switching between single image and sequence, between tableau and narration', is indeed ideally suited to that vocation, and film qua station cinema 'at the same time makes the ordering and anarchy of images possible' (Ottinger, 2001). Ordering and anarchy, that is, not as a binary opposition, but as a continuum from which specific images draw their force and in which they take their place. Thus, the violent anarchy of world history is innervated in the personal aesthetic ordering Ottinger makes of it; an oppressive ordering of experience and difference is resisted in anarchically 'free' images. In her phrasing here, we again glimpse something of the heterogeneity and ambivalence that makes up any seemingly 'single' image in Ottinger's work.

Hanne Bergius has noted that the principles of station cinema are uncannily foreshadowed in the work Ottinger made as a young painter in Paris (Bergius, 2011). While we were installing *Still Moving* in Glasgow, Ottinger was in the midst of preparations for *Paris Calligrammes* (2022), her cinematic recollection of the circumstances in which her thinking and making first flourished. That film, through visual juxtaposition and a narration structured and de-structured by personal memory, confirms Bergius' point. Aside from the heady intellectual stimulus afforded by Fritz Picard and the German émigrés associated with his bookshop, or by visits to the Sorbonne and acquaintance with thinkers such as Louis Althusser, Pierre Bourdieu and Claude Lévi-Strauss, it is clear that Paris gifted Ottinger a first mature aesthetic vocabulary too, through the emergent synthesis of Pop and realism forged by a nexus of artists associated with *figuration narrative*. Given that Paris in the 1960s was a crucial point of departure for the artist, I would like to linger in that milieu briefly. I will do so less in a spirit of reconstructing a specific, evidenced chain of influence or of actual contacts, but by pulling into proximity certain ideas that can be traced to that time and place. This gathering, like many of those in Ottinger's work itself, is a fabulation, an imaginary encounter. It turns on two figures who, like the artist, found themselves departing Paris in the late 1960s, though for somewhat different reasons: Édouard Glissant (who returned to his birthplace of Martinique, having been banned from France

in the early 1960s for his political activities) and Michel Foucault (who took up a temporary teaching positioning in Tunisia).

I begin with the latter. Although Foucault's unconventional analyses of paintings by artists including Hals, Goya, Magritte, Manet and Velásquez are well known, a short text on the work of his friend and contemporary Gérard Fromanger is overlooked in comparison. Of considerable interest in its own right, I will cite it here because what Foucault has to say about Fromanger's particular version of *figuration narrative* has considerable relevance to Ottinger's practice too. 'Photogenic painting' was written as the catalogue essay for Fromanger's exhibition *Desire Is Everywhere* in 1975 (Foucault, [1975] 1999) Among Foucault's preoccupations here is the artist's technique of using found images from mass media sources, as well as his own deliberately informal street photographs, as the basis for paintings. Fromanger projected these images onto his canvas in a darkened studio, and, without any preliminary drawing, used ordinary commercial paint to reproduce the resulting image. This ephemeral moment in the studio in which photograph and painting mix spurred Foucault to a bravura celebration of the hybridity and representational capacity in images, and a polemic against the puritanical aspects of modernist 'medium specificity' and abstraction. Modernism's 'gloomy discourses', Foucault laments, have directed us to prefer signs to likenesses, 'the grey regime of the symbolic to the wild flight of the imaginary' (Foucault, [1975] 1999: 89). He invited his readers to rethink these preferences and these terms.

To that end, 'Photogenic painting' offers a historical reading that reframes the relationship between painting and photography, and seeks, through Fromanger's work, to give it a new meaning. Foucault opens the essay by quoting Ingres: 'photography is no more than a series of manual operations' (Foucault [1975] 1999: 83). What if painting could be described this way too, asks the philosopher in response. 'And what if one were to combine them, alternate them, superimpose them, intertwine them, if one effaced or exalted the one by the other?' he wonders (Foucault, [1975] 1999: 83). We pass swiftly, in this passage, from the derogated term 'manual' to the hymning of a more adroit, and more manipulative, handling of images. Foucault's lexicon here is equally well fitted to Ottinger (both as painter and filmmaker) as it is to Fromanger.

Foucault's (1975: 83) second paragraph begins like his first, with Ingres: 'Photography is very beautiful, but one cannot admit it'. This remark is countered with an evocation of Fromanger's work that, again, might extend to encompass Ottinger's *Peinture Nouvelle*. 'When painting re-covers the photograph', Foucault writes, 'occupying it insidiously or triumphantly, it does not admit that the photograph is beautiful. It does better: it produces the beautiful hermaphrodite of instantaneous photograph and painted canvas, the androgyne image' ([1975] 1999: 83). This last phrase gives us another way of figuring the complexity of Ottinger's image-making as it passes

from painting to film and photography: we might call it androgynous, its complexity being that of the both/and as well as the neither/nor, and implicitly connected to an escape from the regimes of legibility that govern norms of gender, sex and sexuality.

To ground this exuberantly provocative notion of the androgyne in historical terms, Foucault provides an account of photography's emergence that revalues its entanglement with the non-artistic and non-specialized. Rather than seeking photography's essence in its origins, he salutes its later diffusion into myriad hybrid forms:

> The years 1860 to 1880 witnessed a new frenzy for images, which circulated rapidly between camera and easel, between canvas and plate and paper – sensitised or printed; with all the new powers acquired there came a new freedom of transposition, displacement, and transformation, of resemblance and dissimulation, of reproduction, duplication and trickery of effect. It engendered a wholesale theft of images, an appropriation still utterly novel, but already dextrous, amused and unscrupulous. Photographers made pseudo-paintings, painters used photographs as sketches. There emerged a vast field of play where technicians and amateurs, artists and illusionists, unworried about identity, took pleasure in disporting themselves. Perhaps they were less in love with paintings or photographic plates than with the images themselves, with their migration and perversion, their transvestism, their disguised difference. Images – whether drawings, engravings, photographs or paintings – were no doubt admired for their power to make one think of other things; but what was particularly enchanting was their ability, in their surreptitious difference, to be mistaken one for another. The emergence of realism cannot be separated from the great surge and flurry of multiple and similar images.
> (Foucault, [1975] 1999: 83–84)

Where others might see a regrettable failure of such hybrids to merit the name 'art', Foucault instead relishes their evasion of such categorical identity. And he does so in such a way that we can detect something of his own project of self-transformation and counter-subjectivation informing his reading of his friend's work. 'In those days', he writes, 'images travelled the world under false identities. To them nothing was more hateful than to remain captive, self-identical, in one painting, one photograph, one engraving, under the aegis of one author' (Foucault, [1975] 1999: 84–85). In the very year in which he wrote these words, Ottinger would premiere *Laokoon & Sons* in Berlin, having decisively moved from Paris to Berlin, and from painting to film. Foucault's invocation of a work with images that is predicated not on medium, not on singularity, nor on authorship as ownership, but rather on a playful relaying of forms seems to me entirely apposite for Ottinger. Indeed, in her turn to film and photography after leaving Paris, she has exceeded Fromanger's paintings in what Foucault sees as their vital relationship to images: 'they do not fix them, they pass them on' ([1975] 1999: 95).

The remarks above, and this detour through Foucault's 'Photogenic painting', offer suggestions as to why multiplicity and mobility are so profoundly the modes by which Ottinger's work lives. From the implications of her first approach to remaking photographic sources into paintings and painting-objects, to her subsequent archiving and cinematic restaging of found images, and her production of photographs which allow her to remix her oeuvre in exhibitions, these qualities are continually fostered by the techniques she uses. Her use of such techniques is motivated by a commitment to the mobile image that Foucault gives us a means to grasp more clearly in his account of a resistance to modernist purity, fixity and self-identity, and which Ottinger herself contextualizes through her concept of a bivalent 'station cinema' that faces, Janus-like, both the past and the present.

In the final section of my essay, I would like to offer at least one possible answer to another question posed but not yet fully addressed: why Ottinger's images are so intensely, memorably compelling. For brevity's sake, I will take a single work as my key example here, that which lent its name to the 2018 exhibition in Glasgow: *Still Moving*. This film was made for a celebration of the work of American queer cinema pioneer Jack Smith, and uses music, dance and a collage of disparate material to meditate on how objects are brought to life. In its first section it assembles and reanimates sculptural objects Ottinger inherited from her father's Africanist collection, juxtaposing them with items of her own, including photographs from the 1970s (Figure 11.1). The sculptures are quite obviously manipulated by hand

FIGURE 11.1: *Still Moving*. Photograph by Ulrike Ottinger, Berlin, 2009. © Ulrike Ottinger.

and an atmosphere of ludic informality attends proceedings. It ends with a cut to a rediscovered fragment of Super-8 film taken at the flamboyant seventy-fifth birthday party of Lil Picard. Lil was Fritz Picard's former wife, a performance artist and critic, a friend of the Dadaists and a frequenter of Warhol's Factory. Of this heterogenous assembly of people, pictures and things in *Still Moving*, Ulrike Ottinger has stated:

> My archive of objects is equal to the no less real archive of my memory. They animate each other and bring forth ever new and unexpected images and ideas. It is as if one were watching, as it takes shape, the play of thinking with its infinite interconnections.
> (ulrike ottinger [website], 2023, n.pag.)

Interconnectedness, however, is by no means understood in Ottinger's cosmos as only a subjective artefact. The interconnected world forged by imperial violence looms large in her work too. Colonial projects of mastery and their reliance on fantasized forms of 'otherness' are figured and contested in it. One key strategy for this contestation is Ottinger's characteristic merging or melding of documentary modes with mythic or fantastical ones (as in *Still Moving*'s synthesis of African objects with Ottinger's domestic scene, her artistic archive and the Picard fragment). Here western projections are pushed to a point of excess, and the documentary image's capacity to narrate or represent its subjects in absentia is undone. 'Ulrike Ottinger sympathizes with all things foreign', Eva Meyer has written, 'because they take her beyond the boundaries of recognition – this makes her films the medium of a cognition that involves imagination and registration, critique and concern' (2007: 39). In its interest in what lies 'beyond the boundaries of recognition', Ottinger's work might be seen as transgressing what Gilles Deleuze posited as a fundamental lesson of Foucault's work: 'the indignity of speaking for others' (Deleuze and Foucault, 1996: 76). There is no doubt that Ottinger's avant-gardiste practices of representation differ from those more painstaking and cautious modes that predominate today and which treat showing otherness in most guises as tantamount to the imposture implied in 'speaking for others'. It is not uncommon to find in recent writing about the artist a certain discomfort around these matters. To my mind, however, the value of the Ottinger cosmos is in many ways inseparable from its willingness to work new hybrid forms from the image repertoire of world history, including its most violent and appropriative episodes. In working with the reality of that imaginary, the artist allows the wildness of cultural encounter to produce new discomforting effects. We could align her oeuvre in this regard with the 'queer vibrancy' and wildness theorized

by Jack Halberstam (Halberstam, 2020). Borrowing from the late José Esteban Muñoz, Halberstam writes that 'wildness is this "spirit of the unknown and the disorderly," and it is not a spirit that "belongs" to Indigenous contexts and gets stolen by others for other purposes; rather ... it describes the space and the modes of knowing and unknowing that emerge in the encounter between capital and chaos, privilege and struggle, myth and countermyth' (Halberstam, 2020: 49). Such are the encounters Ottinger's work begins with and which it communicates or passes on.

To recapitulate: *Still Moving* takes up a problematic inheritance, a collection no doubt exemplary of the pervading colonial lifeworld, and treats it wildly. It brings the disorder of the domestic collection, the chaos of personal memories and what cannot be fully known, decisively into the foreground. It cuts Africa and Berlin together with another scene of displacement and animation (Lil Picard's remarkable, exilic avant-garde life) to show how such worlds may coexist. It poses the question of relation and interconnectedness at each moment. In conclusion, then, I would like to cast this hybrid, relation-making work in the terms of Édouard Glissant's thinking of the 'Poetics of Relation', with which it has several important parallels. First, in its grasping and shaking of an archive of objects and images, *Still Moving* performs an act of Glissantian 'trembling with the world', with others and with otherness. As Glissant explains:

> What I call *tremblement* is neither incertitude nor fear. It is not what paralyses us. Trembling thinking is the instinctual feeling that we must refuse all categories of fixed and imperial thought. *Tremblement* is thinking in which we can lose time, lose time searching, in which we can wander and in which we can counter all the systems of terror, domination, and imperialism with the poetics of trembling – it allows us to be in real contact with the world and with the peoples of the world.
> (Glissant and Obrist, 2021: 140–41)

Trembling is an embodied registration of worldliness and relatedness beyond western thought's rooted identities and universalizing impulses. 'Wandering', Glissant says elsewhere, 'is the capacity to maintain oneself in living suspension, far from foundational and systematic certainties' (Glissant, 1999: 117). And again: 'wandering is not exploration, whether colonial or not' (Glissant, 2020a: 21). The worldly poem, literary text or artwork wander, in Glissant's thinking. In so doing, they also undo themselves:

> Whatever attitude he adopts in his rapport with the Other and whatever global vision of the Other he has formed, the writer has no choice but to disturb this

vision through his work, even after expressing it in the work. Because finally he must denounce indivisibility and terrifying unicity'.

(Glissant, 1999: 5)

Poetic or artistic wandering and trembling make contact and reveal relation, Glissant contends; works that engage relation become productively unworked or unworkable. It is thus restrictive to call them back to particular subject positions, or to ask by what right one individual figures another culture. Such restrictions, he argues, 'evade the heart of the matter: the Relation of literature [or art] to its highest object, the world-totality' (Glissant, 1999: 16).

Glissant's vision of what he variously terms the 'Chaos-Monde' and the 'Tout-Monde' – an interconnected 'world-totality' wrought through, but not limited to or controlled by, colonialism and globalization – resonates deeply with Ottinger's capaciously world-spanning oeuvre, and her drive to make contact through wandering. For Glissant, as for Ottinger, the whole world can be registered and felt from any locale, and it is the interactions between places and peoples thrust into new kinds of contact that compels them both. It is no coincidence that a drawing Ottinger made for the exhibition celebrating her receipt of the Hannah Höch Prize included the handwritten phrase: 'Paris–Berlin et le monde entier'. Crucially, within the recently forged 'Tout-Monde', hybrid identities emerge – figured by Glissant above all in Caribbean processes of 'creolization'. This constitutes, he says, 'a new and original dimension allowing each person to be there and elsewhere, rooted and open, lost in the mountains and free beneath the sea …' (Glissant, 2010: 34). The affinity with Ottinger's reflection on the sedentary and the nomadic in 'Stations of Cinema' is, I hope, clear.

Much political and cultural weight is placed on these processes by Glissant. He writes of

> the thought of hybridity, of the trembling value not only of hybrid cultures but, going further, of cultures of hybridity, which perhaps save us from the limitations of intolerances that lay in wait for us, and will open up for us new spaces of relation.
>
> (Glissant, 2020b: 7)

Within these spaces, relational rather than rooted and immobile identities can form. This evocation by Glissant of a mode of being predicated on contact and contradiction, on chaotic relatedness over inherited norms of domination and on circulation over legitimacy strikes me as a fine description of how Ottinger's work takes place in the world. It models one possibility for a visual technics of relation, one that would let contacts play out within and among images, without denying their subjects what Glissant terms their 'right to opacity' – to being as singularly hybrid as any other subject,

including she who puts them in circulation. For Glissant, 'real diversity is found today only in different conduits of the imagination: the manner of conceptualising oneself in the world, of organising the principles of organisation and of choosing one's native land' (Glissant and Chamboiseau, 2022: 28). In all these regards, Ottinger's work offers us an exemplar of imagining a still moving world, diverse in its entirety.

Coda

By pure happenstance, when Ulrike Ottinger's *Still Moving* was installed at The Hunterian in 2018, it coincided with another exhibition entitled *The Philosophy Chamber*, which presented material from Harvard University's eighteenth-century collections. Among these was a photographic image of a small wax doll modelled after 'Magdeleine of Martinique', a young girl, the daughter of an African slave and a St. Lucian woman, who was purchased and exhibited in Europe as a curiosity on account of a genetic skin condition. Paintings of the girl can be found in the French National Museum of Natural History. Ottinger recognized this image at once as among her sources for the piebald herald in *Freak Orlando*. Her most seemingly outlandish visions, I realized then, hold a mirror up to the culture we have inherited. They are a recollection of the forces of order and disorder that made our world. They compel us and lodge in our minds not because they are images of strangeness or otherness, but because they are part of who we are and how we see. It is because we still need the orientation they give us that her images lodge themselves so deeply in our imaginations.

REFERENCES

Benjamin, Walter ([1931] 1999), 'Unpacking my library: A talk about book collecting', in H. Arendt (ed.), *Illuminations*, London: Pimlico, pp. 61–69.

Benjamin, Walter ([1936] 1999), 'The storyteller: Reflections on the work of Nikolai Leskov', in H. Arendt (ed.), *Illuminations*, London: Pimlico, pp. 83–106.

Bergius, Hanne (2011), 'Ulrike Ottinger's *Peinture Nouvelle*: Decoding the myths of everyday life', in M. Babias (ed.), *Ulrike Ottinger: Paris Pop*, Berlin: Neuer Berliner Kunstverein, pp. 110–19.

Deleuze, Gilles and Foucault, Michel ([1972] 1996), 'Intellectuals and power', in S. Lotringer (ed.), *Foucault Live: Collected Interviews 1961–1984*, New York: Semiotext(e), pp. 74–82.

Didi-Huberman, Georges (2015), 'Knowing when to cut', in F. Caillat (ed.), *Foucault Against Himself*, Vancouver: Arsenal Pulp Press, pp. 77–109.

Foucault, Michel ([1984] 1998), 'Different spaces', in J. Faubion (ed.), *Aesthetics, Method and Epistemology: The Essential Works of Foucault 1954–1984, Volume 2*, London: Allen Lane, pp. 180–83.

Foucault, Michel ([1975] 1999), 'Photogenic painting', in S. Wilson (ed.), *Gilles Deleuze, Michel Foucault, Gérard Fromanger*, London: Black Dog, pp. 81–104.

Glissant, Édouard (1999), *Faulkner, Mississippi*, Chicago: University of Chicago Press.

Glissant, Édouard (2010), *Poetics of Relation*, Ann Arbor: University of Michigan Press.

Glissant, Édouard (2020a), *The Baton Rouge Interviews with Alaexndre Leupin* (trans. Kate M. Cooper), Liverpool: Liverpool University Press.

Glissant, Édouard (2020b), *Treatise on the Whole-World*, Liverpool: Liverpool University Press.

Glissant, Édouard and Chamboiseau, Patrick (2022), 'When the walls fall: National dentity beyond the law', in *Manifestos*, London: Goldsmiths Press.

Glissant, Édouard and Obrist, Hans Ulrich (2021), *Archipelago*, New York: Common Era Inc.

Halberstam, Jack (2020), *Wild Things: The Disorder of Desire*, Durham, NC and London: Duke University Press.

Hansen, Miriam Bratu (2004), 'Room-for-play: Benjamin's gamble with cinema', *October*, 109, pp. 3–45.

Meyer, Eve (2007), 'Ulrike Ottinger's *Chronicle of Time*', *Afterall*, 16, pp. 38–45.

Ottinger, Ulrike, (2001), 'Stations of cinema: A short tale on storytelling in free images', *KW Magazine*, 1:1, pp. 53–56.

Searle, Adrian (2018), 'Interstellar sexual adventures and underground erotica – Glasgow International review', *The Guardian*, 20 April, https://www.theguardian.com/artanddesign/2018/apr/20/glasgow-international-review-festival-tai-shani-mark-leckey-sam-keogh. Accessed 15 December 2022.

Sykora, Katharina (2005), 'A photographic hoard', in U. Blickle, C. David and G. Matt (eds), *Ulrike Ottinger Image Archive: Photographs 1970-2005*, Nürnberg: Verlag für moderne Kunst Nürnberg, pp. 288–99.

ulrike ottinger (website) (2023), '*Still Moving*', http://www.ulrikeottinger.com/en/film-details/still-moving-2. Accessed 5 June 2023.

12

Shadow Plays: Charting Ulrike Ottinger's Recent Navigations

Nora M. Alter

It is a beautiful crisp clear cold day in a bay of the Chukotka Peninsula close to Chaplino, a small Russian Eskimo village of the Yupik people, in the easternmost part of Asia. Across the water, a telltale waterspout and black fluke signal a whale as it cavorts in the sea. The camera tracks its movements as it plunges into the depths only to surface again. However, the camera is not the only one tracking the whale and soon it is surrounded by three small speeding motorboats manned by eight men with harpoons who circle the beast poised to strike. And strike they do, over and over as the water turns red with their carnage. All the while the film rolls as the wounded creature tries to escape, diving down but coming up for air only to be assailed repeatedly, until finally it is still, dead, as the jubilant cries of the hunters affirm. The Yupik Sea mammal hunters secure the whale with ropes and prepare to tow it to shore; however, their knots are not secure, and the corpse slips and sinks to the bottom of the bay. The entire endeavour has failed, a waste of a life, an unnecessary slaughter. The segment lasts almost fifteen minutes; for a quarter of an hour the viewer witnesses this agonizing, slow death. Another sequence follows; this time the prey is a seal. The hunters are more successful in manoeuvring their bounty onto the beach where they proceed to expertly skin, disembowel and strip it of every piece of flesh until only the skeleton remains. Again, cinematically it is a long take and the butchering lasts 25 minutes. A third scene of death is filmed, now it is a reindeer who is targeted from a herd of more than 2000. High in the tundra, three men chase it down, lasso its antlers and wrestle it to the ground. The camera in a close-up captures the animal's frightened eyes the moment before a blade is plunged into its heart severing the spinal cord. At least this time its death is delivered quickly. Like the seal, it is expertly

flayed and dismembered. Why are these deaths filmed in real time and in such detail? There is a violence in these prolonged sequences that when strung together would be close to an hour. A discomfort is produced by the knowledge that this is 'real' and not 'staged' as in a feature film; there is no disclaimer in the end credits that reassures the viewer that no animals were harmed during the film. The transition from life to death is captured by the camera as the film documents the transformation of a living, breathing, integral being into a corpse partitioned into various pieces that bear no resemblance to its former totality (except perhaps for the pelt). Cinema records and preserves both life and death and these sequences shot against an Arctic landscape recall those taken over a century ago by Robert Flaherty in *Nanook of the North* (1922). Also evoked are the opening credits of *Nanook* that inform the viewer that a year after filming Nanook the hunter and his Inuit family died of starvation in the tundra. What is this cinematic process referred to by Chris Marker as a 'botany of death', or by André Bazin as a process of mummification?

The contemporary sequences were filmed in 2014 by Ulrike Ottinger and comprise only a small portion of her epic twelve-hour *Chamisso's Shadow* (2016). The film details Ottinger's three and a half-month voyage in the Arctic as she follows the route of the nineteenth-century German botanist Adelbert von Chamisso's exploration of the Bering Sea and Northwest Passage. Chamisso, a French-born Berlin-based writer and naturalist, served as a botanist aboard the Russian ship Rurik, which successfully conducted a scientific journey around the world. Chamisso embarked on his voyage in 1815 and returned approximately three years later in 1818. In contrast, Ottinger's trip took three and a half months (July–October 2014). Chamisso travelled on a sailing vessel, and Ottinger used ferries, boats and crossed the Bering Strait between the two continents with a small plane. Chamisso's adventure resulted in the publication of three volumes: the first was his detailed travel journal (*Tagebuch*, 1821) with precise descriptions of the places, people, flora and fauna that he encountered. It was accompanied by his illustrations of what he saw and recorded the everyday chronology of the trip. The second two complementary volumes: *Views and Remarks on a Voyage of Discovery* and *Description of a Voyage Around the World* were published in 1827 and constitute a processed, edited and organization of material accumulated in the *Tagebuch*. The *Tagebuch* is permeated with a sense of immediacy, awe and wonderment, whereas the latter two volumes are products of reflection, research and curation. The outcome of Ottinger's odyssey is twofold: both a three-part, four-chapter film and three volumes of *Notizbücher* that comprise Ottinger's research and archival materials, the back text or scaffolding to what we see and hear in *Chamisso's Shadow*. Included are copies of old maps, writings of Chamisso and other explorers, photos of masks, travel schedules,

itineraries, receipts, handwritten notes and drawings by Ottinger, phone numbers, travel brochures, encyclopaedia entries, various contact information, in short everything is saved that was part of the process. All the details and fragments are re-assembled; the working parts are exposed and displayed, nothing is insignificant and all contribute to the final cinematic text of *Chamisso's Shadow*. It is important to note that although some of the scanned narratives will form the voice-over commentaries, these *Notizbücher* are not screenplays; rather they resemble a hybrid between a logbook and a scrapbook. The production and exhibition of the *Notizbücher* as part of her film is a practice that Ottinger has adopted from the onset, and they gesture to her training as an artist.

Over the past decades, filmmaker artist Ottinger has engaged in myriad cinematic explorations that have ranged from the steppes of Mongolia to the snow-covered northernmost islands of Japan, across former 'Eastern Europe', to China. These journeys are often marked by their experience of travel, be it extended sequences in trains traversing seemingly endless landscapes or cars covering miles and miles of territory. Along the way, Ottinger, with an ethnographer's keen sensibility, films people engaged in ceremonial rituals, performances, customs and always food preparations. As such Ottinger participates in a long tradition that links cinema to exploration (Cahill and Caminati, 2021). As Germaine Dulac noted in 1925, 'with cinema, [there are] no more unexplored countries' (1994: 65). And Bazin for his part pronounced, not unproblematically, that with cinema the 'authentic dream of making each one of us a Christopher Columbus' had been realized (2018: 564). But Ottinger's films are not motivated by an imperialistic drive; they are not financed by colonial enterprises or commercial ventures.[1] Rather they tap into modernity's desire to know, to observe (Gaycken, 2010), continuing, as Bazin formulates, a practice of 'documentary authenticity', and not in exoticism (Bazin, 2004: 155). An authenticity that can only be achieved through a process of duration.

Although a significant portion of Chamisso's journey took place in the southern hemisphere, Ottinger decided to retrace the passage to the northernmost part of the globe. Why the Arctic? I argue that it extends Ottinger's earlier cinematic investigations in a part of the world to which she journeyed during times of significant socio-political change. In the 1980s and 1990s, she made multiple trips to Asia covering many parts of the former Soviet Union. The resulting films include the documentaries: *China: The Arts – The People* (1985), *Taiga* (1992), *Exile Shanghai* (1997), and *Southeast Passage* (2002) and the features: *Johanna d'Arc of Mongolia* (1989) – set on the trans-Siberian express train – and *Twelve Chairs* (2004), a comedy that unfolds in the transitional space of Post-Communist Ukraine.[2] Amongst these explorations, it is the eight-hour *Taiga* that most resonates with *Chamisso's Shadow*. In *Taiga*, she travelled to Northern Mongolia

and recorded the everyday lives of the Darkhad and Sojon Urinjanghai nomadic herdsmen who tend yaks and reindeer. Like *Chamisso's Shadow*, the film takes its time as Ottinger documents rituals and performances that reveal the porous relationship between animals, humans and spiritual life.

But whereas these expeditions have entailed land crossings, *Chamisso's Shadow* is markedly different for it traverses bodies of water both fluid and frozen. As such it taps into Ottinger's earliest films from the 1970s: *The Enchantment of the Blue Sailors* (1975) and *Madame X: An Absolute Ruler* (1977), both of which allude to the lure of the sea, sailing, and life on a boat. As once noted by Katharina Sykora, an early photograph taken by a 9-year-old Ottinger was of two turbaned men on a boat. In 2011, her exhibition *Floating Flood* centred on the importance of waterways, channels, rivers and lakes as related to all aspects of life. And in *Chamisso's Shadow*, the ocean beckons promising discovery and adventure. In her decision to retrace Chamisso's Arctic journey, Ottinger insists that as much as possible she, too, will travel by boat. And this mode of transport alters profoundly how time and space are configured returning to a different way of measuring distance (Kern, 2003). Ottinger reminds us of her lengthy passage and crossings by punctuating *Chamisso's Shadow* with prolonged shots of the sea. At times the image bobs up and down to the rhythm of the waves. An early shot sequence is taken from the perspective of Ottinger's cabin through the porthole that hovers just above the water's surface. The round window delivers a limited focus bound by a circle like that of a telescope or an iris shot in early cinema. Parallels have been drawn between train travel and film both in terms of vehicles of travel and the visual similarity between the experience of images passing outside of a train window and the frames of a celluloid print (Schivelbusch, 1986). The porthole, however, references a different mode of primitive cinema: that of science, discovery and the close-up as it zooms in on its subject. The cabin is equipped with a desk, on top of which are notebooks, maps and a pair of reading glasses.

Long takes of the water allow the viewer to observe the variegated characteristics of the sea whose appearance changes depending on the light, salinity, depth, movement and height of the waves, the effect of the wind, the disruption caused by the wake of boats across the smooth surface and the emergence of marine life. The ocean is a living entity, like in Tarkovsky's *Solaris* (1972) it is 'a dynamic force, and an unfathomable more-than-human world' (Deloughrey and Flores, 2020: 132). Early on, Ottinger hears strange sounds emitted across the water. Their source is clarified and she learns that they are produced by a bell attached to a buoy that makes different sounds based on the height of the waves and the weather conditions. In the fog and dark, people navigate sonically according to the range of acoustical tones produced by the movement of the water. The weather buoy's sounds are generated naturally as the ocean

becomes an instrument. However, just as vibrant and teaming with life as the ocean is, it is also dying due to multifarious causes ranging from global warming to pollution islands and oil spills. And the changes in its composition endanger life forms dependent on it. As Elizabeth Deloughrey and Tatiana Flores note, today's conversations about the ocean are coupled with those of the 'Anthropocene crisis', and 'interwoven with narratives of extinction, apocalypse, alterity, and precarity' (Deloughrey and Flores, 2020: 132). Discussions concerning extinction are never far from the surface in *Chamisso's Shadow* whether it be related to now-disappeared animal species or human cultures and languages. These examples are metonymic tips of the (melting) iceberg of a much larger looming threat. Replete throughout *Chamisso's Shadow* are images of centuries-old, abandoned settlements, graveyards, skeletal remains of whales and other crustaceans, as well as more recent vacant modern housing complexes and factories that have been depopulated due to shifts in commercial enterprises and global politics. Like the animals filmed in their transition from life to death, so too do these sequences foretell a shift and portend an uncertain future. Ottinger's film has multiple temporal registers: it shows the remnants of what no longer exists, it records a contemporary phenomenon of erasure and with its recurrent magnificent cinematography it suggests an upcoming as of yet unknown loss and extinction. *Chamisso's Shadow* is an archive of a future disappearance, a document for the future (Groo 2010).

Like an extended train trip such as that depicted in *Johanna d'Arc of Mongolia*, a ship's voyage takes place over a long period. It is a self-contained capsule that traverses distances at a different pace and speed than air travel. Travelling by watercraft is one of the oldest modes of transportation and movement of people across the globe. Millenia before coaches, trains, cars and planes, populations moved, following waterways and currents. And because of the duration spent aboard the vessel, it is a heterotopic space where different systems and understandings outside of conventional space and time are operative. As Michel Foucault (1987: 27) insists, 'the ship is the heterotopia *par excellence*'. For it is

> a floating piece of space, a place without a place, that exists by itself, that is closed in on itself and at the same time is given over to the infinity of the sea and that, from port to port, from tack to tack, [...] it goes as far as the colonies in search of the most precious treasures they conceal in their gardens, you will understand why the boat has not only been for our civilization, from the sixteenth century until the present, the great instrument of economic development, [...] but has simultaneously the greatest reserve of the imagination [...] In civilizations without boats, dreams dry up, espionage takes place of adventure, and police take the place of pirates.
>
> (Foucault, 1986: 27)

Concomitant with her lengthy travels in contemporary time and space, Ottinger moves fluidly between centuries. The commentary of *Chamisso's Shadow* comprises multiple voices that are placed in dialogue with one another across different historical periods. Foremost is Ottinger's overarching narrative that guides us along her journey. Not only is she the voice of the present, but her voice signals her auteurist presence. We never see her except for a few shots of her hands identified by her large ring. We are aware of her presence through the acknowledgement of the film crew by many of her interviewees. Ottinger's voice is acousmatic, an invisible storyteller who sonically sutures the points of navigation and charts a course that is at once geographic, historical, social and cultural. In addition, in her commentary, Ottinger reanimates from silent written text to spoken word the reflections and observations of earlier explorers like Bering or Captain Cook. She wrests these observations and studies from the archives, bringing them up to the surface like sunken treasure. Chamisso, read by actor Hans Zischler, plays a predominant role as extracts from the naturalist's writings are matched to Ottinger's present-day observations. After all, it is his journey that she retraces and his footsteps, which she follows.

But there are other equally important precursors to Chamisso. Nearly 100 years earlier, Vitus Bering, for whom the Bering Strait is named, explored the region in a series of three voyages: the First Kamchatka Expedition (1724), the Second Kamchatka Expedition (1733) and the Great Northern Expedition (1741) that discovered the Aleutian and Kodiak Islands. Accompanying Bering on his final expedition was the naturalist Georg Wilhelm Steller. Steller was part of the crew who went to Kamchatka and spent a winter in Bolsherechye and explored the region. In the spring he crossed the Kamchatka Peninsula by dog sled to rejoin Bering and to continue their explorations of the Northwest Passage. They briefly made landfall at Kayak Island and Steller is attributed as being the first European to step foot in Alaska. Steller was an avid scientist and not only collected specimens but also was especially fascinated by the marine life. He described, graphically rendered and named six new species including Steller's Sea Cow (extinct), Steller's Sea Lion, Steller's Jay and the Spectacled Cormorant (extinct). Steller kept meticulous journals that were posthumously edited and published in several volumes including *The Beasts of the Sea* (1751), *Reise von Kamatschka nach Amerika mit dem Commandeur Capitän Bering: Ein Pendant zu dessen Beschreibung von Kamatschka* and *Journal of a Voyage with Bering* (1741–41). Extracts from these writings find their way into *Chamisso's Shadow*. In addition to his vivid descriptions of marine life, Ottinger includes Steller's description of the different indigenous groups of the Kamchatka Peninsula and their brutalization and enslavement by the Cossacks. Steller's critical account of the marauding and colonizing Cossacks led to his persecution upon

his return to Russia. Steller's ventriloquized voice alongside Chamisso's enters into a conversation with Ottinger's.

These are not the only voices and quotations that are included, but also James Cook who was in the Arctic from 1776 to 1780 seeking to find a Northwest Passage as well as Otto von Kotzebue the commander and navigator of the Rurik. His *Entdeckungsreise* (*A Voyage into the South Sea and Bering's Straits for the Purpose of Exploring a Northeast Passage, Undertaken in the Years 1815–1818* (1821) is rich with descriptions from the voyage. Ottinger is steered through her expedition by these texts that serve as buoys to chart a course providing information about phenomena along the way. The past as signified by an acoustic text and old drawings is brought together with the contemporary moment as represented by Ottinger's stunning film. These extracts produce a rich audial palimpsest and acoustic mystic writing pad of the past and bring to life the wonderment of what was seen and experienced by Western Europeans often for the first time. Foucault stressed that

> Heterotopias are most often linked to slices in time – which is to say that they open onto what might be termed, for the sake of symmetry, heterochronies. The heterotopia begins to function at full capacity when men arrive at a sort of absolute break with their traditional time. [...] Museums and libraries have become heterotopias in which time never stops building up and topping its own summit.
>
> (Foucault, 1986: 26)

Voices from the past are not the only ones with whom Ottinger dialogues. Whenever possible she finds museums in the places she visits and interviews their directors. These small local collections and their custodians produce an additional layer of knowledge from that provided by the explorers. Instead of being informed by a drive for discovery and the desire to collect and take, their mission is one of preservation, exhibition and the codification and production of a history that has risked erasure. Replete throughout *Chamisso's Shadow* are shots of Shaman masks, carved objects, ritual totems, ceremonial clothing, instruments, tools, weapons and old photographs. And here we are reminded of Ottinger's short, *Still Moving* (2009), composed primarily of still images of statues, masks and other ethnographic ephemera from her vast personal collection. In *Still Moving*, inanimate objects are brought to life by Ottinger's camera, choreographed to music. In *Chamisso's Shadow*, they speak to a different production of knowledge and epistemology from that of the West informed by its distinct categories of animal, human and vegetable, one instead informed by animism in which the boundaries between forms are fluid, in flux and constantly shifting. Thus, Ottinger includes details of transformational sculptures that, like

picture puzzles, appear either as a man or animal depending on the angle from which it is perceived.

Finally, *Chamisso's Shadow* is replete with lengthy interviews with locals who live on either side (Russian and US) of the Bering Straits and Northwest Passage. We meet fishermen, herdsmen, hunters and others who make their living off what the region supplies. They are representing various tribes. However, twentieth-century politics has made them Russian or American ignoring their nomadic roots that observe no formal boundaries and territories other than those imposed by nature and the change of seasons. For example, while in Provideniya, Ottinger films the arrival of a group of Yupik men from the Saint Laurence Island (who share the same language as the Chupiks) who have made their annual pilgrimage across the waters and international borders to get supplies. Initially, this trek that has taken place over the centuries was known as the 'blood to freshen up' pilgrimage or in modern parlance to diversify the gene pool. It continues today although the goods exchanged are different. Weather patterns instead of national borders still dictate migratory patterns. Ottinger takes her time with the interviews and through the slow reveal there are interesting surprises. For example, in the final chapter, she films an elderly woman in Kamchatka who sits fishing by the banks of a stream. The fisherwoman's method is quite simple as she finds a small stone to use as a weight and carefully uses pieces of caviar as bait. The sequence stands in sharp contrast to the professional sports fishermen filmed in the first chapter who come outfitted with high-tech gear and equipment as they reel in one impressive salmon after the next. The woman laughs good-naturedly as she manages to catch one very small fish. For approximately ten minutes she talks about her technique; then the interview takes a turn as she recollects that she was adopted out of an orphanage at the age of nine. Her adoptive father was a soviet functionary who oversaw trade and commerce in the local municipality. We then learn that she trained as a physician and was the chief paediatrician in the region. Her duties included annual professional visits to settlements in the tundra where she would examine, treat and vaccinate children. Photographs attest to her prominent position, and she seems far removed from the relaxed, casual and humble elderly woman sitting by the river. The full effect of this extraordinary reveal could not have been achieved without Ottinger taking the time – in this instance almost twenty minutes – to include as much of the encounter as possible. The woman, like most of Ottinger's subjects, acknowledges the camera and the filmmaker's presence.

In *Chamisso's Shadow*, a community is a built of individuals from the past and present who produce a heterogenous dialogue that transcends temporal and spacial boundaries. And yet a question emerges as to why Ottinger references Chamisso in her title and not Steller, Bering or Kotzebue. The answer I argue lies in Chamisso's other identity. At the same time as being an accomplished

botanist, Chamisso was a writer and part of the German Romantic tradition. Shortly before he began his journey, he completed one of his most enduring stories, *Peter Schlemihl's Miraculous Story* (1814). The novella follows the adventures of the titular character who sells his shadow to the devil in return for a bottomless wallet (purse of Fortunata). However, because he doesn't have a shadow Peter is shunned by society. He goes into exile and travels around the world aided by seven-league boots that enable him to leap effortlessly across vast expanses – he springs from Europe to Asia to Africa and back again. In the end, lonely and in a state of permanent exile, he seeks solace in studying nature. In the first few minutes of *Chamisso's Shadow*, Ottinger cites directly from *Peter Schlemihl* as her camera pans 360 degrees revealing a horizon of seemingly endless snow-capped volcanic mountains. She reads the following description from the novella, her recitation is timed perfectly to match the full circle of the camera:

> Wonderfully diverse lands, rivers, meadows, mountain chains, steppes, and deserts of sand unrolled before my astonished eyes. There was no doubt about it, I had seven-league boots on my feet. I stood on the heights of Tibet, and the sun, which had risen upon me only a few hours before, now already stooped to the evening sky. I wandered Asia from east to west, overtaking the sun. I tarried awhile 'til it was day in eastern Asia and after some repose continued my wandering. I traced through both Americas the mountain chain which comprises the most uneven surfaces on our globe. I stalked slowly and cautiously from summit to summit, now over flaming volcanoes, now snow-covered peaks, often breathing with difficulty. I reached Mount Elias and leapt across the Bering Strait to Asia. I followed the western shores in their manifest windings and examined with special care which of the islands there were accessible to me. I roamed about the earth, now determining altitudes; now the temperature of its springs and air; now contemplating animals, now investigating plants. I hastened from the equator to the pole; from one world to the other, comparing experiences with experiences.

There is a cut to the frontispiece of a third edition of *Schlemihl's wundersame Geschichte* printed in 1835 in Nurnberg. What is remarkable is that this fictional story preceded Chamisso's voyage and sprang from the author's imagination, his descriptions bearing an uncanny resemblance to the reality he would soon encounter. It is precisely this combination of the literary author melded to that of the naturalist scientist that draws Ottinger to Chamisso. For, as has been duly noted by many of her critics, Ottinger's signature characteristic is precisely her hybrid style of film production and the intentional blurring of fact and fiction (Alter, 1998; Bergstrom, 1988; Longfellow, 1993; Trumpener, 1993). Recall, at the beginning of *Johanna d'Arc of Mongolia*, Lady Windermere (Delphine Seyrig)

poses the question: 'Was it a confrontation with reality or with the imagination. [...] Must imagination shun the encounter with reality? Or are they enamored with each other? Can they form an alliance?' At the beginning of *Chamisso's Shadow*, Ottinger explains she 'set out in pursuit of their ideas as well as their itineraries. I planned to transform whatever should occur on my journey into an assemblage of the ethnological and the *artistic* (emphasis mine) the past and the present'. The inclusion of different modes of knowledge production including the aesthetic or fictional makes it difficult to categorize a film that is more than just a documentary or an audio-visual ship's log. It is an essay film that at once has multiple threads and narratives and constitutes an investigation into myriad subjects, including self-reflexively the cinema of exploration (Alter, 2012; Corrigan, 2011). In his definition of an essay, Max Bense proposes that it is an investigation, an experimentation with form and that the 'essayist is a combiner, a tireless creator of configurations' (Bense, 2017: 57). He distinguishes the essay from a mere description or 'simple report', because of its aesthetic component. As an example, he chooses the subject of the Green Woodpecker comparing a description by a renowned scientist, Brehm, to that of a writer who has 'an idea while looking at the Green Woodpecker, let's say concerning the concept of rhythm and reflects this idea in the Green Woodpecker. [...] The experimental enters the report that elevates it' (Bense, 2017: 57). In *Chamisso's Shadow*, multiple discourses ranging from scientific reports, myths, oral histories and fairytales are included. I would like to pause with the following example which takes about 45 minutes in the film. The length of the passage and my recounting of the narratives are important for it allows multiple and at times antagonistic meanings to emerge slowly.

Shortly into the first part of her voyage on July 5, Ottinger visits Kodiak Island. Over the natural verdant and lush scenery, the voice of Steller from 1741 describes the dense forests, paths and a clearing in which large cellars had been dug filled with smoked salmon, sweet grass, and bundles of bark (which he acknowledges to be an important food source for the Inuits during a time of starvation), seaweed, arrows and other objects. Steller continues that despite being afraid of an attack he took the salmon and various tools, including those to make fire, back to the captain. He suggested to replace the stone tools with axes and metal blades. But the captain refused this transaction. What Steller considered his duty as a scientist to bring back objects from the expedition to his home country for twenty-first-century sensibilities is nothing short of a raid on a valuable storage site that has been stocked for the long winter ahead.

A cut to a scene of fly fishermen in a rapidly rushing creek casting their lines unrolls as Ottinger's voice announces 'The Sea Otter Maiden', a fairy tale that she narrates over shots of dying fish as well as of children cavorting along the shore of the bay. The story is of an encounter between an otter and a hunter both

of which are the last of their kind. They each explain the historical circumstances that have led them to their solitary existence. The otter recounts how she was one among many before hunters began their relentless slaughter. For his part, the hunter recalls how one day an enormous vessel with white wings appeared on the horizon, he and his fellows greeted the foreigners, brought them to shore, fed them and covered them at night with otter pelts so they wouldn't freeze to death. In an aside, noting the expression of horror on her face, the hunter explained that the fur of the otter keeps humans alive during winter for without it they would freeze to death. He indicates his respect by recounting that each time his tribe killed a sea otter they would perform a prayer and honour the departed spirit. The hunter continued to narrate that the foreigners left and came back with guns demanding more and more otter pelts. If the villagers didn't make their quota, they committed cruel acts of violence first against the women and children, resulting in death, and then against the men. Finally, because there were no more otters, they killed them all except for he who managed to escape. The otter maiden proposed that as they were the last of their kind that they become a couple. Ottinger opines that is why otters are cleverer than ever before but, she concludes, 'as to the progress of the human race we are still waiting for news'. All the while she narrates, the filmed images are taken from a boat as it travels up a river populated by rafts of otters playing in the seaweed.

The second narrative begins as the camera remains trained on the raft of otters getting closer and closer. The voice of Steller recounts:

> The sea otter which because of the nature of his fur, has erroneously been regarded as a beaver, is a real otter, and differs from the river otter only in this; that the former lives in the sea and is only half as big again, and in the beauty of its fur is more beaver-like than otter. The skin which lies as loose on the flesh as seals and shakes all over when running, so far surpasses in length, beauty, blackness, and gloss of the hair all river beavers that the latter cannot be compared with it. The best pelts bring in Kamatchka 20 rubles, in Yakutsk 30, in Irkutsk 40 to 50, and at the Chinese frontier, in exchange for their wares, 80 to 100 rubles. The meat is fairly good to eat and palatable; the females are, however, much tenderer, and, against the course of nature, are most fat and delicious shortly before, during, and after parturition. The suckling otters can, because of their daintiness, be both roasted and boiled, and can compete with suckling lambs. Altogether it is a beautiful and pleasing animal, amusing in its habits, and at the same time ingratiating and amorous. When they run the gloss of their fur surpasses the blackest velvet. They prefer to lie together in families, the male with his mate, the half-grown young with the sucklings. The male caresses the female by stroking her using the forefeet as hands; she, however, often pushes him away for fun and, in simulated coyness, as it were, and plays with the offspring as the fondest

> mother. Their love for their offspring is so intense that they expose themselves to the most manifest danger of death when their young are taken away from them, they cry bitterly like a small child and grieve so much that, we observed in several cases, after ten to fourteen days they grow as lean as a skeleton, become sick and feeble and will not leave the shore. When they flee, they take their infants in their mouth, but the grown ones they drive before them. If they have the luck to escape, they begin, as soon, as they are in the water, to mock their pursuers in such a manner that one cannot look on without a particular pleasure. They stand upright in the water like a man and bob with the waves, sometimes holding a forefoot over their eyes as if they wanted to scrutinize you closely in the sun. Then they throw the young ones into the water and catch them again, etc. If a sea otter is overtaken and sees no escape it blows and hisses like an angry cat. When struck it prepares itself for death by turning on the side and drawing up its hind feet and covering its eyes with its forefeet. When dead it lies like a dead person with the front feet crossed over the breast. The food of the sea otter consists of marine crustaceans, mollusks, small fish, a little seaweed, also meat. These animals deserve the greatest reverence from us as for more than six months they were almost our sole food, and at the same time, medicine for the scurvy stricken.

Steller's account is chilling; through it, one can read a history of the violence of colonialism and imperial expansion. First, the otters are viewed as commodities – valued for the price of their pelts, then as meat, subsequently from a zoologist's perspective, which anthropomorphizes their behaviour. All the while over this long narrative Ottinger's camera tracks closer to the otters as we observe them frolicking in the water. At the end of Steller's account, it lingers on one animal that appears particularly curious and seems to look directly at the camera standing up with its forefeet brought together in front of its chest. Ottinger's voice cuts in and a third narrative begins as she explains the strict rituals observed during an otter hunt.

> On a sea otter hunt, special rites had to be observed because the Aleutians regarded the otters as metamorphosed human beings. According to the myth, an animal is only willing to surrender if the hunter sticks to precisely defined rules and rituals and if he uses self-made weapons decorated with his personal symbols and small objects of walrus ivory. The 'kameleikas' made by the women were also elaborately decorated and fabricated with the utmost care. The beauty of the hunting outfits was a sign of respect for the animals.

The three narratives provide radically different views and they are combined like shards in a kaleidoscope whose image changes with the twist of a hand. As Bense notes, the method of the essay is dialectical and Socratic, 'what is intended to be

said is not uttered right away by a finite verdict as a law; it is rather, produced before the reader's mind's eye in an act of untiring variation' (2017: 58).

This idea of respect and full use of an animal foreshadows the later hunting scenes of the sea lion and reindeer where nothing goes to waste versus that of the whale in which human ineptitude allows a life to be squandered. Throughout the film, one species predominates: the canine. There are dogs everywhere – from those that hang out at the harbour greeting visitors and begging from fishermen to those who wander the villages, to the working sled dogs kept on tethers. In one instance we watch in real time for about 30 minutes the meticulous feeding of fourteen dogs, each of which is given a separate bowl of gruel with whale meat thrown in for extra nutrition. Scenes such as these tilt Ottinger's film into the process documentary genre (Skvirsky, 2020). The omnipresence of dogs renders Ottinger's later revelation that because they are the most revered of the animals when a hunter died, his favourite dog would be killed and buried along with him so he would not be alone, shocking. The Aleutian belief in metamorphoses and animism forms a central nodal point in *Chamisso's Shadow*. Still, on Kodiak Island, Ottinger is taken into a primeval forest, the likes of which she had never experienced. She recounts:

> Here the myths of origin come to life in the imagination. The raven is the creator of the world. From his solid excrements depending on the consistency, land, rock, gravel, or tundra came into being. His fluid excrements turned into lakes, oceans, puddles, streams, or bogs.

She continues,

> The first woman on Earth rose from her soft bed of moss where she had been sleeping and dreaming of a whale. An irresistible desire made her rush to the beach. A whale was frolicking in the bay spewing fountains of water into the air. Coming ashore he metamorphosed into a fine young man.

They spent the Summer together but when it came time for the whales to migrate, he turned back into one and swam away but soon returned to be with the woman. They stayed together and had children, first whale babies then human babies. The myth concludes: 'This is why whales were not hunted in ancient times.' In an amazing shot (1:00.05), Ottinger photographs a moss-covered tree that bears an uncanny resemblance to a bear while she relates the Aleutian belief that a bear is a human wearing bear fur. She continues, 'in animism, the belief in metamorphoses and the animation of objects are closely linked. The soul of a human being is considered equal to the soul of an object, the soul of an animal, or the soul of a plant.' Filmmaking as a photographic process renders every object in front of the

FIGURE 12.1: *Chamisso's Shadow*. Photograph by Ulrike Ottinger, Berlin, 2014. © Ulrike Ottinger.

camera equivalent – prioritization is achieved through editing, movement and sound. To film objects, humans, animals and plants are easy but to film their soul to render the invisible visible is the challenge (Figure 12.1).

To come back to the title, why Chamisso's 'Shadow?' and not his voyage? And here we must return to Schlemihl's miraculous adventures and the significance of the shadow. The film opens with an aerial shot of the sea with shadows on its rippling surface as Ottinger's voice recites from *Peter Schlemihl*:

> But in the sunny sand there glided past me a human shadow, not unlike my own, which, wandering there alone seems to have got away from its owner. There awoke in me a mighty yearning. 'Shadow', said I, 'Dost thou seek a master? I will be he'.

This audial visual sequence will be used to open each of the four chapters. What is the significance of a shadow? In ancient lore, it is believed to be the soul of a person, which is why the dead cast no shadows. Shadows have a long history linking them to early cinema. The connection is made through the allegory of Plato's cave whereby the prisoners in a cave mistake the illusory shadows of reality outside

the cave for reality. Film, because of its indexical nature, is taken to be reality. Just as film shadows are produced by an object blocking a light source so too is celluloid film technology made and projected by light. Famously, in 1896 Maxim Gorky described his first experience of cinema as having entered 'the kingdom of the shadows'. Through her repetition of this passage from Schlemihl, Ottinger suggests that her film will be a cinematic shadow of Chamisso's voyage.

As was the custom, Chamisso gathered species of flora and fauna and other artefacts and relics to bring back to Berlin, including human skulls for the ethnographic collection of the Berlin Museum. He, like Steller, kept a detailed journal with precise accounts of the places and people he encountered as well as precise drawings of what he found. In an era preceding photography, scientists had to rely on their memory as well as meticulously written descriptions, realistic drawings and sketches to illustrate and represent what they experienced. All of this changed in the late nineteenth century when ship photographers accompanied expeditions, and cinematographers became part of the crew in the twentieth century. Ottinger creates out of the archives the film that Chamisso could not make.

Chamisso's Shadow alludes not only to the severed shadow of the literary character of Schlemihl but also to the historical figure of Chamisso. The only access one has to the personage of Chamisso is through his writings, which Ottinger reanimates and restores to the author. His voice as ventriloquized by Zischler serves as an 'audible shadow' against the backdrop of contemporary shots. Chamisso lived during a time when one form of popular entertainment was shadow plays. Shadow plays originated in Asia and Southeast Asia and the tradition continues in Indonesia. Shadow plays were brought to Western Europe by seafarers and explorers where it was popular in France, Britain, Germany and Italy in the seventeenth and especially the eighteenth century. These magic lantern shows have been theorized as precursors to modern cinema (Herbert, 2000). Ottinger's film performs as a shadow play that mobilizes light, colour, and texts, to produce a voyage of discovery. Her text is constructed like a palimpsest or a mystic writing pad that reveals multiple layers and uncovers paths of earlier explorations and expeditions. It pays tribute to earlier forms of recording and shows how history is constantly in flux and being rewritten. It is a history that includes not just people and governments but also animals, plants and natural resources.

And this history contains voices, perspectives and systems that only reveal themselves slowly. They follow a different relationship to time and knowledge that emerges outside of western epistemologies. The myths, the objects, the stories, the animals and careful observations of everyday life rituals in Ottinger's film all point to the faint presence, the shadow of another way of being with nature. Cook, Kotzebue, Columbus and others were active participants in the brutal systems of western colonial expansion and capitalism. They desecrated burial sites, pillaged communities, stole what they could

and opened the door to the future mass slaughter of animals, extraction of minerals and enslavement of peoples. Chamisso and Steller were the unwitting chroniclers of these processes. Ottinger for her part seeks to restore and remember what has nearly been erased; she is a close reader of their texts and through her camera and contemporary interviews traces, albeit faintly, evidence of an alternative system of knowing to that structured by Cartesian thought. As such, *Chamisso's Shadow* represents a weak 'decolonized option' 'a practice of rethinking and unravelling of dominant world views' (Mignolo, 2013; Wynter, 2003). For her part, Ottinger refuses categories and genres of cinematic time as dictated by the norms and institutions of cinema. *Chamisso's Shadow* is a durational film, its twelve-hour length defies conventions and challenges the contemporary viewer to think outside of temporal frameworks and to commit to a different type of seeing and knowing. At the end of *Peter Schlemihl*, the adventurer prepares to die. He is never united with his shadow, but he has completed a manuscript of his discoveries that he intends to send to the university in Berlin and he selects Chamisso to be the 'keeper of my marvellous history, which, when I shall have vanished from the earth, may tend to the improvement of its many inhabitants'.

NOTES

1. *Nanook* was financed by the Revillon Frères fur company and Basil Wright's *Song of Ceylon* (1934) by the East India Tea Company.
2. Immediately preceding, *Chamisso's Shadow*, Ottinger made *Under Snow* (2011) filmed in Echigo, the northernmost island of Japan that receives average accumulations of twenty feet of snow. Ottinger was fascinated as to how people adapt to this radical climate and included sequences of a performance staged in a theatre carved out of snow and ice.

REFERENCES

Alter, Nora M. (1998), 'Triangulating performance: Looking after genre after feature', in I. M. O'Sickey and I. von Zadow (eds), *Triangulated Visions: Women in Recent German Cinema*, Albany: SUNY Press, pp. 11–27.

Alter, Nora M. (2012), 'Still filming: Ottinger's cabinet of curiosities', in J. Kapczynski and M. Richardson (eds), *A New History of German Cinema*, Rochester: Camden House, pp. 622–27.

Bazin, André (2004) 'Cinema and exploration', *What is Cinema* (trans. Hugh Gray), vol. 1, Berkeley: University of California Press, pp. 154–63.

Bazin, André (2018), 'Le paysage au cinema', in Hervé Joubert-Laurencin (ed.), *Écrits Complets*, vol. 1, Paris: Éditions Macula.

Bense, Max (2017), 'On the essay and its prose', in Nora M. Alter and Timothy Corrigan (eds), *Essays on the Essay Film*, New York, Columbia University Press, pp. 49–59.

Bergstrom, Janet (1988), 'The theater of everyday life: Ulrike Ottinger's China: The Arts, everyday life', *Camera Obscura*, 6:3, pp. 42–51.

Cahill, James and Caminati, Luca (eds) (2021), *Cinema of Exploration: Essays on an Adventurous Film Practice*, New York: Routledge.

Corrigan, Timothy (2011), *The Essay Film: From Montaigne, After Marker*, Oxford: Oxford University Press.

Deloughrey, Elizabeth and Flores, Tatiana (2020), 'Submerged bodies: The tidalectics of representability and the sea in Caribbean art', *Environmental Humanities*, 12:1, pp. 132–66.

Dulac, Germaine ([1925] 1994), 'The essence of cinema: Visual and anti-visual films', in Prosper Hillairet (ed.), *Écrits sur Cinéma (1919–1937)*, Paris: Paris Experimental.

Floating Flood (2011), *Exhibition*, Berlin: Haus der Kulturen der Welt, 8 September–30 October.

Foucault, Michel (1986), 'Of other spaces', *Diacritics* (trans. Jay Miskowiec), 16:1 (Spring), pp. 22–27.

Gaycken, Oliver (2010), 'Through the body with a laser gun and camera: Fantastic voyage and the cinema of exploration', in J. L. Cahill and L. Caminati, *Cinema of Exploration*, Abingdon: Routledge, pp. 4–56.

Groo, Katherine (2010), 'Weird loops: Climate change, drone cinema, and the work of mourning', in J. L. Cahill and L. Caminati, *Cinema of Exploration*, Abingdon: Routledge, pp. 73–88.

Herbert, Stephen (2000), *A History of Pre-Cinema*, London: Taylor and Francis.

Kern, Stephen (2003), *The Culture of Time and Space, 1880–1918*, Cambridge: Harvard University Press.

Longfellow, Brenda (1993), 'Lesbian phantasy and the other woman in Ottinger's *Johanna d'Arc of Mongolia*', *Screen*, 34:2, pp. 124–36.

Mignolo, Walter D. (2013) 'Sylvia Winter: What does it mean to be human?' in K. McKittrick (ed.), *Sylvia Wynter: On Being Human as Praxis* Durham, NC: Duke University Press, pp. 106–23.

Ottinger, Ulrike (dir.) (1989), *Johanna d'Arc of Mongilia*, Germany: La Sept Cinéma, Popolar-Film and Zweites Deutsches Fernsehen (ZDF).

Ottinger, Ulrike (dir.) (2016), *Chamisso's Shadow*, Germany: Ulrike Oettinger Filmproduktion, ZDF / 3sat and Rundfunk Berlin-Brandenburg (RBB).

Schivelbusch, Walter (1986), *The Railway Journey: The Industrialization of Time and Space in the Nineteenth Century*, Berkeley: University of California Press.

Skvirsky, Salomé Aguilera (2020), *The Process Genre: Cinema and the Aesthetic of Labor*, Durham, NC: Duke University Press.

Trumpener, Katie (1993), '*Johanna d'Arc of Mongolia* in the mirror of Dorian Gray: Ethnographic recordings and the aesthetics of the market in recent films by Ulrike Ottinger', *New German Critique*, Autumn, pp. 77–99.

Wynter, Sylvia (2003), 'Unsettling the coloniality of being/power/truth/freedom: Towards the human, after man, its overrepresentation – an argument', *The New Centennial Review*, 3:3, Fall, pp. 257–337.

13

Anachronism and Anti-Conquest: On *Chamisso's Shadow*

Thomas Love

Introduction

Ulrike Ottinger's 2016 film *Chamissos Schatten* (*Chamisso's Shadow*) begins with stark shots of a rolling landscape of black volcanic soil and distant snow-capped peaks. A few minutes in, the filmmaker's voice relates: 'wonderfully changing lands, meadows, mountains, steppes, sandy deserts, unfold themselves before my astonished gaze'. Although she seems to be describing the visions recorded by her camera and reproduced for her viewers, the words are an echo from long ago, originating in Adelbert von Chamisso's fantastical 1813 novella *Peter Schlemihl's Wondrous Story* (Chamisso, 1814). In the book, Peter Schlemihl sells his shadow to the devil in exchange for a bottomless money purse, an exchange which he grows to regret since a shadowless man – no matter his means – is destined to be a social outcast. After a good deal of stress and romantic ill luck, he eventually throws the damnable purse into a chasm and redeems himself with one final purchase: a pair of *Siebenmeilenstiefel* ('seven-league boots') that enable him to circumnavigate the globe in a few quick steps. So equipped, he devotes his life to the study of the natural world, eventually publishing several useful volumes on flora and fauna. While the lost shadow remains a matter of interpretation – even, as Leif Weatherby puts it, 'a non-referential and unresolvable allegory' (2017: 190) – its resolution in the occupation of natural history suggests the shadow has been sacrificed to the cause of objectivity. The shadowless naturalist is a roving eye, more passive viewer than active traveller, while the technology of the seven-league boots brings the remotest regions together almost like a montage sequence. It is therefore fitting that these proto-cinematic words should reappear 200 years later as the voice-over of Ottinger's film.

In narrating her own footage with Schlemihl's words, Ottinger creates a curious conflation not only across time but also across fiction and documentary, fantasy

and reality. This turns out to be apropos: Chamisso himself departed on a journey around the world to study its various plants and animals several years after writing *Peter Schlemihl*, as if the author were a mere shadow of his creation (Oksiloff, 2004). Ottinger's title amplifies this obscurity, preserving these meanings while adding to them the possibility that her own voyage is a shadow of Chamisso's, or perhaps aims to uncover whatever shadows he left behind. In the original German, it is not even clear whether *Schatten* is singular or plural, suggesting a shadow that could proliferate in unexpected ways.

Chamisso's Shadow is an epic, twelve-hour-long travelogue documenting Ottinger's trip through the region commonly known as Beringia, where the Eurasian and North American continents face off across the mere 50 mile gap of the Bering Strait.[1] Ottinger explains right away that her voyage retraces paths laid more than 200 years ago by the German naturalists Georg Wilhelm Steller and Adelbert von Chamisso, as well as, to a lesser extent, the British captain James Cook. Steller took part in the second Kamchatka expedition of Captain Vitus Bering from 1740 to 1741; James Cook visited the Bering Strait on his third and final Pacific voyage commissioned by the British government from 1776 to 1780; and Chamisso joined the company of the *Rurik*, helmed by Otto von Kotzebue, from 1815 to 1818.[2] Each voyage aimed to uncover a navigable 'Northwest Passage' between the Pacific and Atlantic Oceans via the Arctic.[3] Although all were stymied by the treacherous ice, the trips nevertheless proved highly informative, especially thanks to the work of the naturalists on board. Steller, Cook and Chamisso each published an account of their voyage, texts that vary from dramatic tales of the high seas to ethnographic descriptions of indigenous inhabitants and detailed observations of local plants and animals, sometimes all within a single book.[4] The voice-over for *Chamisso's Shadow* consists of actors reading excerpts from these historical publications as well as Ottinger herself reading from her own travel journal. By combining these various perspectives, the film seems less a document of contemporary Beringia than a reflection on the continuities and discontinuities between the contemporary and its (pre)colonial past. But the relationship between Ottinger's voyage and those of her predecessors is far from evident: is Ottinger bound to repeat the distortions of her countrymen, or is her film a response and corrective to these earlier accounts?

The answer to these questions lies in articulating how the voice-over relates to the diverse imagery of the film. *Chamisso's Shadow* slowly and continuously cycles between footage of the landscape devoid of people, to indigenous inhabitants or their descendants, and (post)colonial settlements and (post)industrial sites. Scattered interviews primarily address the history and preservation of indigenous culture, whether in the form of museum collections, traditional crafts and occupations such as the construction of walrus-skin boats and dogsleds, or in daily

activities such as hunting, herding, foraging and preserving or preparing food. In addition, the film is punctuated by countless historical images, including illustrations and photographs from travellers, family photographs from interview subjects and even dioramas and objects from ethnological museums. Ottinger challenges us to sit long enough with the film that we encounter all these 'genres', so to speak, a task made extraordinarily difficult by the twelve-hour runtime. The film is typically screened in four discreet three-hour segments, and while each gives a good sense of the film's themes and overall approach, they are still clearly marked as fragments of a larger whole.[5] It is as if the runtime is meant to force the viewer to confront the limits of their attentiveness, and the inevitability that information will escape their grasp.

To hazard a synthesis, I would say that Ottinger's film alternates between two different perspectives. On the one hand, by interweaving a myriad of anachronistic texts and images together, including centuries-old travelogues, historical illustrations and ethnographic photos, footage of present-day Beringia and the filmmaker's own commentary, *Chamisso's Shadow* resorts to what Johannes Fabian has called the 'ethnographic present' (1983: 80–87), a trope that tends to suggest that indigenous culture is without history. This is so even when the imagery clearly contradicts the anachronistic description, for the viewer still strives to find a meaningful connection between the two (*plus ça change …*). On the other hand, Ottinger actively acknowledges the changes inflicted on the region by foreigners, including Russian Orthodox conversions, forced relocations enacted as part of Soviet consolidation (*ukreplenie*), the commandeering of indigenous herds for collective farms (*sovkhozy*), as well as more recent corruption and extortion, such as the iniquities resulting from the Russian state's control of fishing licenses in Kamchatka.[6] This perspective comes across in several interviews as well as in passages from Ottinger's journal used as voice-over. The addition of a voice-over providing historical and cultural background sets *Chamisso's Shadow* apart from Ottinger's other documentaries, which tend to provide little commentary besides title cards designating each section, or 'station', as she calls them, in reference to medieval station dramas (Lenssen 2016).

Both perspectives involve a degree of anachronism: the former layers different times within a single frame, while the latter moves between historical frames over time. In bringing both perspectives together, Ottinger seems to be conveying what Ernst Bloch once called 'the synchronicity of the nonsynchronous', that is, the idea that history is not a single, unified track, but a multitude of overlapping temporalities.[7] Indeed, Ottinger has explicitly stated that she is drawn to the station drama because of its anachronic qualities: '[i]t's a model that allows for the most complex retrospection and foresight and that allows pictures to be both ordered and anarchic' (Matt, 2006: 1367). This aspect of *Chamisso's*

Shadow is not unique; elsewhere I have argued that Ottinger's entire oeuvre can be understood as a reflection on the synchronicity of the nonsynchronous (Love, 2022). What is particular about *Chamisso's Shadow* is the dialogue with natural history.

In this essay, I will discuss how European naturalists such as Georg Wilhelm Steller and Adelbert von Chamisso fit within the project of European colonialism and analyse how Ottinger's film conveys this history. I interpret *Chamisso's Shadow* in the tradition of what Mary Louise Pratt (1992) has called the 'anti-conquest', a genre of European travel writing characterized by passive observation rather than domination or subjugation. Pratt's framework is particularly relevant to *Chamisso's Shadow* because of Ottinger's unusual reliance on the genre of travel writing in the film's conception and structure. I argue that Ottinger mobilizes anachronism in order to hold colonial fantasies in a state of suspension, revealing them to be fantasies without deferring to a countervailing truth. While reproducing the perspective of the anti-conquest, she is able to bracket it out as one of many historical perspectives on this contested region.

German colonialism and the anti-conquest

Germany's period of manifest colonialism arose late and dissolved early in comparison with other European imperial powers (Conrad, 2011: 1). In 1871, when Otto von Bismarck solidified the bonds between the various German states that had joined the North German Confederation during the Franco-Prussian War by declaring a unified German Empire, Germany had no colonies. But with the so-called 'Scramble for Africa' of 1884–85, Bismarck sought to amass a colonial empire that would rival France and Britain, appropriating territories in Southwest Africa, East Africa, Polynesia and China. Though this endeavour made Germany the fourth-largest colonial empire for a time, the outbreak of the First World War saw most German colonies quickly overtaken by the Allied forces, and in 1919, the Treaty of Versailles officially converted each former German colony into a League of Nations mandate.

For a long time, studies of European colonialism treated Germany as a bit player. For example, Edward Said's *Orientalism* (1978: 18–19) brushed aside Germany in its opening section, citing a lack of 'national' interest in the Orient, despite evident academic interest (see Kontje 2004: 2–3). But since then, and especially in recent years, publications, conferences and exhibitions on German colonialism have proliferated, along with public debate around issues such as the repatriation of art and artefacts stolen through colonial intervention.[8] Closer study of German colonialism has challenged the idea that it was a belated mimicry of

British or French colonialism. For example, Russell Berman argues that Germans had fewer anxieties about cultural mixing on the colonial frontier because the Germanophone world itself was so culturally and politically hybrid before 1871 (Berman, 1998: 15). Adelbert von Chamisso himself is a good example of this: born in France but living in Prussia and writing in German, he kept a certain distance from national identity. He explains that when he composed *Peter Schlemihl* in the summer of 1813, he 'no longer had a fatherland, or had not yet had a fatherland', due to the German campaign against Napoleon (von Chamisso, [1836] n.d.: n.pag.).[9] Since the texts cited in *Chamisso's Shadow* stem from this ostensibly precolonial period of German history, I am particularly concerned with how colonial thinking can exist in a latent form even absent manifest colonial rule. Susanne Zantop's (1997) study *Colonial Fantasies* was groundbreaking in this regard. Zantop looks at a broad array of texts from the period leading up to German unification to argue that fantasies of colonial exploration and possession were widespread within German culture, shaping the emergent nation in significant ways. By focusing on texts about the Americas, where Germany never had colonial holdings, Zantop demonstrates how colonial fantasies could function as a sort of substitute, or *Handlungsersatz*, for actual colonial rule (Zantop 1997: 6–7).

Such fantasies were often smuggled in under the cover of scientific objectivity. Mary Louise Pratt describes how naturalists failed to acknowledge that their incursion into foreign lands was part of a political, economic and/or military encounter with indigenous inhabitants, instead narrating their travels as a series of specific and differentiated descriptions of the landscape. When they did discuss indigenous societies, naturalists often portrayed them as extensions of the natural world, drawing on Romantic philosophies of the state of nature and the influence of climate such as those of Jean-Jacques Rousseau and Johann Gottfried von Herder (Weinstein, 1999: 383, 390). Thus, Alexander von Humboldt begins his *Aspects of Nature* with the observation: '[t]hroughout the entire work I have sought to indicate the unfailing influence of external nature on the feelings, the moral dispositions, and the destinies of man' (Humboldt, 1849: ix). This perspective robs indigenous peoples of their history and culture, detailing their bodies and habits in the same manner as endemic plants and animals, or idealizing them as 'noble savages', even as it makes their lands and environment available to the prying eyes of the European reading public. The peculiarity of this approach becomes clear only in relation to explicit tales of imperial conquest and expansionism. Pratt explains,

> the system of nature as a descriptive paradigm was an utterly benign and abstract appropriation of the planet. Claiming no transformative potential whatsoever, it differed sharply from overtly imperial articulations of conquest, conversion,

territorial appropriation, and enslavement. The system created ... a Utopian, innocent vision of European global authority, which I refer to as an *anti-conquest*.

(1992: 38–39)

Although Pratt emphasizes the apparently benign and innocent character of the anti-conquest in this quotation, her book uncovers ways in which this innocence obscured and even facilitated colonial conquest.

Pratt describes two main ways by which the anti-conquest surreptitiously aided European colonialism. First, the Enlightenment task of organizing and categorizing the world created a sense of intellectual mastery even when material acts of conquest remained undisclosed. Pratt identifies Carl von Linné's *Systema Naturae* (1735) as a pivotal moment in the development of a European 'planetary consciousness' that used the apparently simple method of botanical classification to apprehend the globe in a general science of order (Pratt, 1992: 28). While descriptions of the natural world had long been a part of European travel writing, they were usually marginal or supplemental. But after the mid-eighteenth century, they attained a new prominence, even amounting to a sort of storyline. In these texts, the landscape becomes an actor, capable, as in the quotation that opens this essay, of 'unfolding itself' to the viewer. Valerie Weinstein identifies this tendency in Chamisso's writing as well, pointing out how the natural world often seems to act of its own accord, obscuring the impact of humans, whether foreign or native (Weinstein, 1999: 384). This leads to the second way in which the anti-conquest abetted colonial conquest. By displacing the traveller from the centre of the narrative in favour of the non-human world, the anti-conquest promulgated the trope of the empty landscape. Once 'naturalized', the colonies appeared 'uninhabited, unpossessed, unhistoricized, unoccupied even by the travellers themselves' (Pratt, 1992: 51).

The ideological purpose of absenting the indigenous inhabitants is clear: the empty land appears to await settlement or resource extraction, implicitly justifying the colonial project. The absence of the travellers themselves is more complicated. It posits the existence of what Pratt calls the 'seeing eye/I man' or simply the 'seeing-man'. Although the landscape has the agency to 'show itself', 'open up' or 'present a picture', it does so *for* the European traveller who looks on (Pratt, 1992: 60). The seeing-man is thereby granted uncontested authority, even if he has no power to impact or change the landscape. This captures the strange combination of passivity and dominance characteristic of the anti-conquest. The historical and material conditions that enable the seeing-man to gaze upon the landscape are occluded, and their very absence gives the seeing-man his air of objectivity. The seeing-man seems to beg comparison to a camera, an analogy with important implications for ethnographic film in general, and *Chamisso's Shadow* in particular. For example, in analysing the writings of German naturalist and explorer Alexander von Humboldt, Pratt writes,

[o]ne thinks of a camera that is continually both moving and shifting focus – except that the visual actually plays almost no role in the description. Humboldt invokes here not a system of nature anchored in the visible, but an endless expansion and contraction of invisible forces.

(1992: 123)

Chamisso's *Peter Schlemihl* was intended as a satirical homage to Alexander von Humboldt, and so it is fitting that the story mobilizes the seven-league boots to produce a similar spectacle at the limits of the visible. Furthermore, Assenka Oksiloff likens the panoramic perspective of Chamisso's more scholarly writings to proto-cinematic and phantasmagoric forms of representation (Oksiloff, 2004: 106). Therefore, with *Chamisso's Shadow*, Ottinger seems to bring the cinematic potential of her source material to fruition.

While Pratt's book has proven highly influential, it has of course received its fair share of critiques. Among the most cutting is the claim that she relies on a Manichean dualism of colonizer and colonized that resolves into a too-simple dynamic of domination and subordination.[10] From this point of view, the concept of the anti-conquest seems to epitomize a 'paranoid reading' in which even apparently anti-colonial literature is revealed to be actually, at a more fundamental level, colonial.[11] Pratt's peer Russell Berman (1998) provides a more optimistic interpretation of travel writing though his commitment to an Enlightenment project of learning from cultural difference, which he argues can lead to a critique of imperialism. The binary of 'enlightenment or empire' that structures his book could be too simplistic in its own right, and Pratt's analysis of the anti-conquest goes a long way to challenging the positive spin Berman puts on the 'sensuous' encounter with the colonial subject, as if embodied experience were necessarily less ideological than scientific abstraction.[12] Nevertheless, Berman's argument should not be thrown out entirely. For example, James Clifford's proposal for a polyphonic or dialogic form of ethnography goes a long way towards concretizing what Berman puts in more general terms (Clifford, 1988: 21–54). Without mentioning Clifford directly, Chunjie Zhang's analysis of Chamisso's writing as 'transcultural' seems to correspond with this notion of dialogic ethnography, emphasizing as it does Chamisso's Polynesian guide and interpreter, Kadu, whom Chamisso upheld as an authority and peer (Zhang, 2017: 43–67). Zhang's goal of 'enhancing the visibility of non-Europeans' impact on the German discourse' is admirable, but not particularly relevant to *Chamisso's Shadow*, which focuses more on anachronic dialogue within German discourse (Zhang, 2017: 7). While still arguably a form of polyphonic or dialogic ethnography, it is a dialogue with an inherited body of writings and ways of thinking, rather than with the ethnographic subject. This anachronic dialogue corresponds neither with a colonizer/colonized binary nor with a notion of transculturality.

In the next section, I will show that in *Chamisso's Shadow*, the ethnographic subject is neither entirely subjugated to Pratt's 'imperial eyes' nor recognized as co-author. Instead, it is maintained as a locus of fantasy. There is an inherent ambivalence to Ottinger's emphasis on fantasy in *Chamisso's Shadow*: it allows for the persistence of those colonial fantasies inherent to the anti-conquest while also disallowing those fantasies to be mystified as truth. Despite the effect of reality that attends Ottinger's use of documentary aesthetics and invocation of ethnological authority, the film ultimately maintains a certain sur- or irreality. Ottinger thereby acknowledges the structuring role of fantasy within ethnography, even if she still fails to meet the other on their own terms.

Ottinger's eye

The majority of *Chamisso's Shadow* consists of long takes of the landscape framed to emphasize the region's natural beauty. A static shot might position a lone house surrounded by racks of drying fish before a forbidding mountain vista or linger upon a herd of walrus lounging near the crashing ocean tide; a slow pan might reveal a coastal outpost nestled within a bay's embracing crescent or scan the picturesque dilapidation of a row of impoverished homes. There are also extended sequences depicting native practices, such as the slaughter of a seal, documented with clinical detachment from beginning to end in real time, or a performance of traditional dances, elapsing without commentary or didactic framing. This footage evokes the sense of passive observation typical of the anti-conquest (Figure 13.1). The film also displays a partiality towards emptiness, even in the segments shot in towns and villages. Scenes where people gather – to greet an incoming ferry, to labour in a supermarket or factory or to observe a dance performance, for example – only emphasize further the quiet and desolate quality of the countless panoramic views of landscapes and settlements. Furthermore, Ottinger and her crew never appear before the camera, even if the filmmaker's narration discloses their presence. The film primarily counteracts this sense of emptiness with the occasional interview. These moments also serve to provide historical background and include the voices of the subjects of the film, rather than relying exclusively on historical travel writing and the filmmaker's own journal.

Because of these interviews and the additional information provided by Ottinger's voice-over, she cannot be accused of obscuring the region's colonial history. Nevertheless, the film suggests colonization and exploitation was mainly a Russian phenomenon. European explorers in the region are portrayed as passive viewers who had little impact – excepting, perhaps, Ottinger's fleeting discussion of the extinction through overhunting of Steller's sea cow. This fits with Pratt's

FIGURE 13.1: *Chamisso's Shadow*. Photograph by Ulrike Ottinger, Berlin, 2014. © Ulrike Ottinger.

description of the anti-conquest: 'the conspicuous innocence of the naturalist … acquires meaning in relation to an assumed guilt of conquest, a guilt the naturalist figure eternally tries to escape, and eternally invokes, if only to distance himself from it once again' (Pratt, 1992: 57). Beyond simply reproducing the naturalists' supposition of innocence, Ottinger's voice-over seems to place herself within their lineage, distancing herself from the guilt of conquest as well. Furthermore, since Ottinger's trajectory was established by historical sailing voyages, the film remains relatively unconcerned with inland resource extraction, such as gold or tin mining, even though these industries have profoundly impacted and reshaped the environment on either side of the Bering Strait since the turn of the century. Instead, when travelling inland, she attends to the more pastoral industries of reindeer herding and river fishing. For example, after a series of shots of Nome, Alaska, a city built to serve the gold rush, and a brief mention of contemporary gold mining, the film cuts to a solitary dirt road meandering through an empty hillscape and a shot of buffalo grazing in the mist. Sequences like this give the impression that the landscape is raw and unspoiled; the scattered buildings, industrial relics and occasional settlements that appear in the film are dwarfed by the surrounding landscape, which seems impervious to human intervention. This, again, fits with the model of the anti-conquest.

Ottinger is probably familiar with the criticism that her films fail to fully acknowledge colonial history. The complaint emerged most conspicuously in response to her 1989 film *Johanna d'Arc of Mongolia*, which traces the adventures of a group of European women stranded amongst matriarchal Mongolian nomads during their traditional summer festival. Critics complained that the film ignored the political realities of the region in favour of an escapist fantasy mobilized around stereotypes of the noble savage (Rao, 1997; Trumpener, 1993; Whissell, 1996). There are distinct reasons why this debate took off in the 1990s following the fall of the Berlin Wall, the dissolution of the USSR and the spread of postcolonial studies in the academy. Nevertheless, it reflects concerns relevant to Ottinger's oeuvre both before and since. Katie Trumpener, in one of the most unsparing critiques of *Johanna d'Arc*, asserts that '[p]robably the most characteristic feature of all of Ottinger's films is their insistence on framing political questions and historical phenomena in aesthetic terms' (1993: 80). For her early feminist critics, the issue was that Ottinger's aestheticism objectified or fetishized women; later, and sometimes by the very same writers, this criticism was adapted to address Ottinger's representation of the ethnic other. For example, twenty years after having lambasted the aestheticism of Ottinger's *Bildnis einer Trinkerin: Aller Jamais Retour* (1979) in the feminist journal *frauen und film* in 1979 (Lenssen, 1979: 23–24),[13] Claudia Lenssen asserted in *Die Tageszeitung* in 2005 that Ottinger had persisted in her flaws even as she shifted to ethnographic filmmaking: '[p]eople always remain images for her, fascinating camera objects with whom she can rarely establish more personal relationships, as she remains true to her method of autocratic image control behind the camera' (Lenssen, 2005: 16).[14]

In the complaint that Ottinger 'frames historical and political phenomena in aesthetic terms' through 'her method of autocratic image control', I hear a desire to suspend disbelief, to access some truth beyond representation. The issue is not so much whether Ottinger establishes a personal relationship with the subjects of her film as whether she conveys that relationship to the viewer. This is the way ethnography typically communicates authority to its reader, as if the ethnographer were saying 'you are there ... because I was there' (Clifford, 1988: 22). As James Clifford has argued, this analogy depends on ignoring the way ethnographic experience is mediated through writing (or film, as the case may be). Mary Louise Pratt's work is very much in dialogue with Clifford's insofar as both bring literary studies to bear on anthropological or ethnographic texts in order to challenge the construction of ethnographic authority.[15] Her account of the anti-conquest makes clear that travel writing has long framed political and historical questions in aesthetic terms, deploying a form of autocratic image control even without the use of a camera. Ottinger's persistent invocation of centuries-old texts, her inclusion of historical illustrations and photographs and the insistent materiality of her

long takes emphasize not only how mediated the viewer's perspective on Beringia is but also how mediated Ottinger's own perspective is.

As much as critics might complain about Ottinger's aestheticism, it seems actually to be demystifying such autocratic image control by drawing attention to it. Whereas the innocence of the seeing-man comes from his dedication to the task of description, *Chamisso's Shadow* surprisingly falls short of that task despite its wealth of visual information. Pratt explains the anti-conquest as, among other things, a literary innovation that allows the natural world to be narrativized (Pratt, 1992: 51). Ottinger's penchant for the long take, amplified here by the long runtime, resists being contained by a narrative framework. Like many of Ottinger's epic travelogues, *Chamisso's Shadow* seems to be on the cusp of transforming into a structural film, rather than following the conventions of narrative or documentary film. The imagery seems designed less to convey information, let alone emotion or plot, and more to demonstrate the results of a compositional brief – in this case, to film the route travelled by a German naturalist 200 years ago. This proximity to structural film distinguishes the politics of representation in *Chamisso's Shadow* from its eighteenth- and nineteenth-century source material. In the words of film theorist Catherine Russell, '[b]ecause the temporality of structural film tended to refer back to itself, as form, it eliminated any sense of narrative space and frequently entailed a temporality determined by the profilmic. In its durational aesthetic, 'nothing happens' in the film because "nothing happens" in the quotidian realm of the referent' (Russell, 1999: 162). This contradicts the anti-conquest, in which, one could say, *everything* happens in the realm of the referent in order for the seeing-man to practically disappear as protagonist.

In this sense, the film conforms to Steven Tyler's definition of 'postmodern ethnography', which is characterized by, in his words, 'a failure of the whole visualist ideology of referential discourse with its rhetoric of "describing", "comparing", "classifying", and "generalizing", and its presumption of representational signification' (1987: 203). Without this ideology of referential discourse, the anti-conquest becomes unmoored, appearing in the film less as an ideological backbone and more as a genre among others. This polyvocality does not result in relativism, as if all ways of describing the world are equal because equally flawed. Instead, it demonstrates how descriptions of the world always involve a degree of fantasy. As Tyler writes,

> An ethnography is a fantasy, but it is not ... a fiction, for the idea of fiction entails a locus of judgment outside the fiction, whereas an ethnography weaves a locus of judgment within itself, and that locus, that evocation of reality is also a fantasy.
> (1987: 216)

Rather than a cynical argument about the disappearance of reality into fantasy, Tyler insists that there is a reality to fantasy, one based not on the transcendental

individual, but on shared world-making. The role of fantasy in this scenario amounts to a sort of re-enchantment of the world, which Tyler argues has a therapeutic effect. Ottinger seems aware of this element of her filmmaking; indeed, she describes it as part of her process: 'I prepare myself meticulously, read a lot, study maps, and in the process develop fantasies. And then later I stand in front of a herd of reindeer or a grassy landscape and compare my fantasies with what I find' (Peitz and Thomma, 2016). Such a comparison does not amount to 'representational signification' because Ottinger acknowledges that her observations are shaped by fantasy, rather than being objective descriptions of reality or history.

The function of fantasy in *Chamisso's Shadow* is most evident in a framing device that bookends the film: a fairy tale called 'The Sea Otter Maiden', inspired by indigenous folklore, but written and narrated by Ottinger herself. It is told in two parts: the first part occurs 38 minutes into the film, while the second part follows unexpectedly eight and a half hours later. As I was viewing the film, the recurrence of 'The Sea Otter Maiden' was a complete surprise, disrupting the continuous flow of the journey with a different temporality. The story effectively turns the tables with respect to the film's perspective. Rather than being narrated from the point of view of the European traveller, whether Romantic or contemporary, it assumes the perspective of an indigenous hunter who befriends a lonely sea otter maiden. Each is the last of their kind, having suffered due to the increasing demand for sea otter pelts exerted by foreign traders. In commiserating over their shared fate, the sea otter maiden overcomes her fear of the hunter and proposes that they marry. The hunter's account of the foreigners' arrival is emblematic of first contact narratives: their sailing ship is described as having 'white wings, like a giant bird' and their rifles are mistaken for harmless sticks. This puts the story at odds with the contemporary footage of salmon fishers in hip waders and sunglasses and children setting off fireworks. However, when the story recurs many hours later, it seems to have caught up to the present day. The sea otter population has made a recovery, carrying news to the sea otter maiden of 'big ships that had no sails but made a lot of noise and stench, and of huge birds that did not move their wings and drew long white stripes in the sky'. One day, the sea otter maiden encounters visitors in colourful garments constructed without seams who have travelled on just such a ship. This part of the story accompanies footage of actual travellers – three scientists in bright red and yellow rainwear – who have crossed Ottinger's path. When they introduce themselves to the camera, their gaze is returned by an unconventional reverse shot: an ethnographic illustration from 1822 of an Aleutian woman (Choris, 1822). Standing in for the sea otter maiden, this image looks across 200 years of history to confront the European scientists. The story continues: the sea otter maiden runs to tell her husband of the marvellous sight and to bring him to the curious strangers, but they have disappeared by the time

the couple returns. The hunter laughs it off, thinking his wife has been telling an amusing fairy tale. Thus, in a moment of uncanny doubling, the fairy tale character perceives the irruption of reality as itself nothing but a fairy tale. Perhaps no better allegory could be written about how ethnography weaves a locus of judgement within itself, a locus that is also a fantasy.

Like *Peter Schlemihl*, the story of the sea otter maiden revolves around seeing and not seeing, but instead of being an individualized tale of a disembodied eye, a 'good' versus 'bad' gaze, it is a relational story about multiple perspectives that fail to cohere around the same phenomenon. We are no longer in the realm of the 'seeing-man', for the look has been both temporalized and historicized. Whether it is a gendered gaze is up for debate; ultimately, the feminized character is the one whose observations are not believed and dismissed as mere fantasy. But for the sake of my argument, the key aspect of the fairy tale is how it introduces both polyvocality and anachronism. Ottinger hints at these ideas in an interview with Roy Grundmann and Judith Shulevitz when she invokes the notion of a 'wandering fairy tale'. As she explains, its wandering is not only spatial but also temporal: '[t]hese may be old and classical forms but you can show a lot of new things in them. You can make a fairy tale for our times, a modern fairy tale, and it's something that I think works very well for the spectator, and it certainly works well for me. I can put in this structure all the things I like, and it also offers me the possibility of making rich associations' (Grundmann and Shulevitz, 1991: 16). The wandering fairy tale is able to convey Ottinger's fascination with the subject of her film in terms of a convergence of old and new. Such an approach is admirable for refusing to combine fascination with romanticization. Although there is an insistent sense that some meaning is to be found in these desolate landscapes, there is no indication that that meaning has been lost due to the onslaught of modernity. While Ottinger addresses indigenous culture with respect and interest, it is not upheld as somehow more authentic than the soviet, orthodox Christian, or capitalist cultures introduced by settlers and foreigners, but rather as part of a palimpsest that includes them all.

The peculiarity of this perspective comes into relief when comparing quotations from Ottinger's voice-over and Bathsheba Demuth's book on Beringia. Demuth opens her chapter 'The waking ice' with these lines: 'Sea ice speaks to itself, and to any being near, in groans and cracks; in rumbles that grind on for hours, percussive bangs and shrieks and silences, and then a snow-muffled roar. Sailors who overwintered their ships in the ice called it the devil's symphony' (Demuth, 2019: 102). Demuth accuses foreigners in Beringia of treating nature as static, as nothing more than resources awaiting exploitation by enterprising humans, contrasting this perspective with animistic indigenous nature-cultures. She suggests that foreigners are deaf to the language of the world around them, or treat its murmurs with suspicion or even fear. Ottinger, on the other hand, portrays indigenous and

foreign, natural and man-made, as part of the same flux. She ends her film with a similar reflection on the hidden language of the world around her, but oriented towards power pylons rather than ice: '[t]he electrical wires hum, talking to each other in their own language. When the connection is interrupted, the wind and waves transport their message. Listening closely, we may be able to understand what they are saying'. For Ottinger, whatever message the landscape has to tell will inhere as much in the power pylons as in the wind and the waves. From this perspective, the opening shots of the empty landscape are not as empty as they might have seemed; they are populated, in a sense, by Adelbert von Chamisso's words, which bespeak a legacy of colonization both material and immaterial. The message whispered by the landscape is not the landscape's own, but an echo of the voice of history.

NOTES

1. Naming is a political act, and it must be noted that 'Beringia', derived from the name of Danish explorer Vitus Bering (1681–1741), overrides indigenous names for the region and imposes cartographic unity across diverse populations and erstwhile sovereign nations. Nevertheless, important ecological and cultural commonalities have long united the region, despite national divisions between the United States and Russia or the Soviet Union.
2. Georg Forster (1754–94) is a similar figure who receives mention in the film. He and his father were naturalists aboard James Cook's second voyage from 1772 to 1775, which did not include Beringia. Forster's account of the voyage, *Reise um die Welt* (1777) proved hugely influential in the rise of travel literature, echoing within and beyond the writings of Alexander von Humboldt and Adelbert von Chamisso.
3. In the film, Ottinger describes the attempts to navigate the Northwest Passage as endeavours to 'fill in the blank spots on the map', sidelining the economic and political motives for plotting a trade route across the Arctic Ocean.
4. See Steller (1793), Cook et al. (1784), and Chamisso (1821 and 1836). Chamisso's *Reise um die Welt* consists of two volumes, a 'Tagebuch' ('journal') detailing the experience of the voyage in subjective, personal terms and an edited version of the earlier 'Bemerkungen und Ansichten', which was written in a more objective, scientific style.
5. The footage was first screened in 2015–16 as a sixteen-hour, four-channel installation inside a yurt, alongside historical travel documents, ethnographic objects, and botanical specimens in the exhibition *Weltreise: Forster – Humboldt – Chamisso – Ottinger* at the Staatsbibliothek zu Berlin. In February 2016, the twelve-hour film premiered at the Berlinale film festival, screened in four segments. In 2017, the film was included in documenta 14 as part of the series 'Hallucinations', curated by Ben Russell at the Greek Film Archive (Tainiothiki). The first section of the film was also screened on Greek public television (ERT2) in a program called *Keimena* ('germs').

6. For more on Soviet consolidation and collectivization in Beringia, see Demuth (2019), especially chapter four, 'The waking ice'.
7. The synchronicity of the non-synchronous (*Gleichzeitigkeit des Nichtgleichzeitigen*) is a key term in Bloch's 1935 book *Erbschaft dieser Zeit*. For a helpful summary of the concept, see Schwartz (2001).
8. Notable publications include Zantop (1997); Steinmetz (2007); Conrad (2008); Naranch and Eley (2014); Zhang (2017); Fitzpatrick (2022). In 2016, the Deutsches Historisches Museum organized an exhibition on 'German Colonialism: Fragments Past and Present'. In 2020–21, the Federal Foreign Office (AA) and German Academic Exchange Service (DAAD) established programmes to fund research on German colonial rule. The AA also concluded a historic agreement with Namibia for 1.1 billion euros as reconciliation for colonial violence. The year 2021 also saw the opening of a new ethnological museum in Berlin, the Humboldt Forum, which has been a lightning rod for public debate around colonial inheritance. The museum agreed in July 2022 to repatriate its collection of 'Benin Bronzes' to Nigeria.
9. This background explains why Chamisso was chosen as the namesake of a literary prize awarded annually between 1985 and 2017 to a German-language book whose author's mother tongue is not German.
10. For an overview of critiques of *Imperial Eyes*, see Lindsay (2010: 17–35).
11. On the concept of 'paranoid reading', see Sedgwick (2003: 123–51).
12. Weinstein (1999: 379) argues that Berman fails to live up to his expressed appeal to a *dialectic* of enlightenment inspired by Theodor Adorno and Max Horkheimer, resorting instead to a *binary* of 'instrumental rationality' versus 'emancipatory reason'.
13. This was part of a trio of negative reviews in the same issue, including Lenz (1979) and Reschke (1979).
14. Here Lenssen (2005: 16) appends the complaint of salvage ethnography: Ottinger is said to ban from her films any material that contradicts her 'distanced search for traces of beauty that have been handed down and are to be set aside for the future'.
15. Indeed, an early version of a chapter from Pratt's *Imperial Eyes* was included in James Clifford and George Marcus's influential edited volume *Writing Culture: The Poetics and Politics of Ethnography* (1986).

REFERENCES

Berman, Russell (1998), *Enlightenment or Empire: Colonial Discourse in German Culture*, Lincoln: University of Nebraska Press.

Bloch, Ernst (1935), *Erbschaft dieser Zeit*, Zürich: Oprecht & Helbling.

Chamisso, Adelbert von (1814), *Peter Schlemihls wundersame Geschichte* (ed. Baron de la Motte Fouqué), Nuremberg: Schrag.

Chamisso, Adelbert von (1821), 'Bemerkungen und Ansichten des Naturforschers', in *Otto von Kotzebue, Entdeckungs-Reise in die Süd-See*, vol. 3, Weimar: Gebrüder Hoffmann, pp. 1–179.

Chamisso, Adelbert von (1836), *Reise um die Welt mit der Romanzoffischen Entdeckungs-Expedition in den Jahren 1815 bis 1818 auf der Brigg Rurik, Kapitän Otto von Kotzebue*, Leipzig: Wiedmann'sche Buchhandlung.

Chamisso, Adelbert von ([1836] n.d.]), 'Einleitend', in *Reise um die Welt*, https://www.projekt-gutenberg.org/chamisso/weltreis/weltr002.html. Accessed 6 September 2023.

Choris, Ludovik (1822), *A Portrait of a Man and a Woman from the Aleutian Islands*, ethnographic illustration, Anchorage Museum, 81.68.4.

Clifford, James (1988), 'On ethnographic authority', in *The Predicament of Culture: Twentieth-Century Ethnography, Literature, and Art*, Cambridge, MA: Harvard University Press, pp. 21–54.

Clifford, James and George Marcus (1986), *Writing Culture: The Poetics and Politics of Ethnography*, Berkeley: University of California Press.

Conrad, Sebastian (2008), *Deutsche Kolonialgeschichte*, Munich: C.H. Beck.

Conrad, Sebastian (2011), *German Colonialism: A Short Introduction* (trans. Sorcha O'Hagan), Cambridge: Cambridge University Press.

Cook, James et al. (1784), *A Voyage to the Pacific Ocean*, London: G. Nicol & T. Cadel.

Demuth, Bathsheba (2019), *Floating Coast: An Environmental History of the Bering Strait*, New York: W. W. Norton and Company.

Fabian, Johannes (1983), *Time and the Other: How Anthropology Makes Its Object*, New York: Columbia University Press.

Fitzpatrick, Matthew (2022), *The Kaiser and the Colonies: Monarchy in the Age of Empire*, Oxford: Oxford University Press.

Grundmann, Roy and Judith Shulevitz (1991), 'Minorities and the majority: An interview with Ulrike Ottinger', *Cinéaste*, 18: 3, pp. 40–41.

Humboldt, Alexander von (1849), *Aspects of Nature in Different Lands and Different Climates* (trans. Mrs. Sabine), vol. 1, London: Longman, Brown, Green, and Longmans. [Originally published as Ansichten der Natur, 1808, Tübingen: Cotta'sche Verlagsbuchhandlung.]

Kontje, Todd (2004), *German Orientalisms*, Minneapolis: University of Minnesota Press.

Lenssen, Claudia (1979), 'Mit glasigem blick: zu *bildnis einer trinkerin*', *frauen und film*, 22, pp. 23–25.

Lenssen, Claudia (2005), 'Menschen bleiben Bilder', *taz. die tageszeitung*, 20 January, https://taz.de/Menschen-bleiben-Bilder/!651169/. Accessed 6 September 2023.

Lenssen, Claudia (2016), 'Die schöne Stille', *Der Tagesspiegel*, 18 February, https://www.tagesspiegel.de/kultur/chamissos-schatten-bei-der-berlinale-die-schoene-stille/12977868.html. Accessed 6 September 2023.

Lenz, Ilse (1979), 'Die öde wildnis einer schminkerin', *frauen und film*, 22, pp. 28–29.

Lindsay, Claire (2010), 'Beyond imperial eyes', in J. D. Edwards and R. Graulund (eds), *Postcolonial Travel Writing: Critical Explorations*, Houndmills: Palgrave MacMillan, pp. 17–35.

Love, Thomas (2022), 'Temporal displacement in Ulrike Ottinger's films', *The Germanic Review: Literature, Culture, Theory*, 97:4, pp. 310–23.

Matt, Gerald (2006), 'Gerald Matt in conversation with Ulrike Ottinger', in *Ulrike Ottinger: Bildarchive: Fotografien 1970–2005*, Nuremberg: Verlag für moderne Kunst, pp, 134–41.

Naranch, Bradley and Geoff Eley (eds) (2014), *German Colonialism in a Global Age*, Durham, NC: Duke University Press.

Oksiloff, Assenka (2004), 'The eye of the ethnographer: Adelbert von Chamisso's Voyage around the world', in B. Tautz (ed.), *Colors 1800/1900/2000: Signs of Ethnic Difference*, Amsterdam: Rodopi, pp. 101–21.

Ottinger, Ulrike (dir.) (2016), *Chamisso's Shadow*, Germany: Ulrike Ottinger Filmproduktion, ZDF / 3sat and Rundfunk Berlin-Brandenburg (RBB).

Peitz, Christiane and Norbert Thomma (2016), '"Gekochten Seehund fand ich delikat": Filmemacherin Ulrike Ottinger im Interview', *Tagesspiegel*, 9 May, https://www.tagesspiegel.de/gesellschaft/filmemacherin-ulrike-ottinger-im-interview-gekochten-seehund-fand-ich-delikat/13561782.html. Accessed 6 September 2023.

Pratt, Mary Louise (1992), *Imperial Eyes: Travel Writing and Transculturation*, London: Routledge.

Rao, Shanta (1997), 'Ethno-documentary discourse and cultural otherness in Ulrike Ottinger's *Johanna d'Arc of Mongolia*', in K. H. Jankowsky and C. Love (eds), *Other Germanies: Questioning Identity in Women's Literature and Art*, Albany: SUNY Press, pp. 147–64.

Reschke, Karin (1979), 'Frau Ottingers (kunst)gewerbe', *frauen und film*, 22, pp. 28–29.

Russell, Catherine (1999), *Experimental Ethnography: The Work of Film in the Age of Video*, Durham, NC: Duke University Press.

Said, Edward (1978), *Orientalism*, New York: Vintage Books.

Schwartz, Frederic (2001), 'Ernst Bloch and Wilhelm Pinder: Out of sync', *Grey Room*, 3, pp. 54–89.

Sedgwick, Eve Kosofsky (2003), 'Paranoid reading or reparative reading, or, you're so paranoid, you probably think this essay is about you', in *Touching Feeling: Affect, Pedagogy, Performativity*, Durham, NC: Duke University Press, pp. 123–51.

Steinmetz, George (2007), *The Devil's Handwriting: Precoloniality and the German Colonial State in Qingdao, Samoa, and Southwest Africa*, Chicago: University of Chicago Press.

Steller, Georg Wilhelm (1793), *Reise von Kamtschatka nach Amerika mit dem Commandeur-Capitän Bering*, St. Petersburg: Johann Zacharias Logan.

Susanne Zantop, Susanne (1997), *Colonial Fantasies: Conquest, Family, and Nation in Precolonial Germany, 1770–1870*, Durham, NC: Duke University Press.

Trumpener, Katie (1993), '*Johanna d'Arc of Mongolia* in the mirror of Dorian Gray: Ethnographic recordings and the aesthetics of the market in the recent films of Ulrike Ottinger', *New German Critique*, 60, pp. 77–99.

Tyler, Steven (1987), 'Postmodern ethnography: From document of the occult to occult document', in *The Unspeakable: Discourse, Dialogue, and Rhetoric in the Postmodern World*, Madison: University of Wisconsin Press.

Weatherby, Leif (2017), 'On the conservation of cultural force: *Naturphilosophie*, romantic nationalism, and prose narrative in Joseph Görres and Adelbert von Chamisso', *The Germanic Review*, 92:2, pp. 189–208.

Weinstein, Valerie (1999), 'Reise um die Welt: The complexities and complicities of Adelbert von Chamisso's anti-conquest narratives', *The German Quarterly*, 72:4 (Autumn), pp. 377–95.

Whissel, Kristen (1996), 'Racialized spectacle, exchange relations and the western in *Johanna d'Arc of Mongolia*', *Screen*, 37:1, pp. 41–67.

Zhang Chunjie (2017), *Transculturality and German Discourse in the Age of European Colonialism*, Evanston: Northwestern University Press.

PART FIVE

COMMENT AND INTERVIEWS

14

Ulrike Ottinger, or the Strange Death of Metaphor

Adrian Rifkin

My substantive engagement with the work of Ulrike Ottinger came surprisingly late in my life – the mid-1990s – after much had been said of her and written, but before her exhibition at David Zwirner in LA in 2000 that was to put her better before an international public. Odd enough, not only given this already substantial recognition dating back two decades or more and my position in the study of gay work. Or maybe, even, in the specialized world of gay subjectivations, gay men and women could pass one another by all too easily? Then one of the MA students in the cultural studies programme at the University of Leeds told me that she wished to write a dissertation on Ottinger's 1979 film *Bildnis einer Trinkerin*. As things were, the only way to watch it was to go to the BFI film archive in London and to play a copy on a Steenbeck editor.

I was requested to attend with the student in question, which was fine as I had, as my generation did, plenty of experience in using these machines. After all they were in one sense the parent of shot-by-shot analysis, of 'Screen-theory', and it was as natural to review a movie in this way as it was to see it in projection. This form of watching also enabled Laura Mulvey's notion of 'death 24 times a second', and it has some consequences for my attention in the face of Ottinger's work, and to film in general, that is to say my pleasure in film as a form of parataxis rather than as montage. And, in Ottinger, her abundant accumulation of materials that are an excess to, and despite of, apparently quite powerful narrative structures. Ottinger's work does not look like the ongoing generation of 'third meanings' – as in the classic post-Barthesian understanding of montage, but rather a succession of 'and' after 'and', with the occasional, 'then' … which enables the illusion of the primacy of a story. But no one thing is necessarily anything else, nor becomes any diegetic third, in its combination with another thing. So, in a sense, this frees the work from normative theoretical writing about film. Usually in writing on art,

critics and scholars tend to use the word 'is' a great deal: this image or that part of an image or a work 'is' some aspect of their inferential framework, or 'is' the vector of a feeling of some kind. Nothing is less certain than this commonplace usage and in Ottinger's work where, for me, the succession or precession of her takes on the 'seen' or the 'seeable' pile up. In her characteristic prosody this is to say, is, ironically is ever overwhelmed by 'and': the et puis … of a prosodics of listening or overhearing.

Anyway, the afternoon that we were to spend with the film was an epiphany, to find ourselves in the presence of such – how can I put it – a monstrous capacity to make images, to invent and destroy forms of narrative in a rapid series of gestures, to impose, involve, charm and repel. The repeated presence of sheets of glass, of windows of different sizes from vast airport doors to those of cars, is monstrous, dividing the screen in its depth, staging the distance of intense proximity, and so too the motion of vehicles is monstrous, and Tegel Airport, a lost unhomely home base, a place that I recognize and once loved. Yes, the word 'monstrous' is fitting – but a monstrousness of unremitting refinement, of judgement and decision at their most complex, overflow and preciseness in an improbable oxymoron … hyperbole as a minimum, the fleeting detail as a powerful upsetting of the viewer's sense of proportion. This is to say queer, epistemically, cognitively, ontologically. Glory be! Yet, hyperbole is also a closet of kinds, one set as a trap for the viewer while leaving the artist in peace to think about their next move.

In his complex and productive book, Rickels (2008) comes up with two slight but major suggestions that enable me, as I take her up again through the *Bildarchive* book, bought after seeing her great exhibition at Witte de With, Rotterdam, in 2006 and having the book of *Calligrammes* beside me to, to reposition her world in my scopic field. On its cover *Bildarchive* figures a glass screen from *Trinkerin*, clothes and lips, a white glove, spots of snow and eye liner on its cover. *Bildarchive* here becomes the gaze of the drunk, drunk on departure, arrival, alcohol and vision and with an insistent and relentless *anomie*: made of these fragments and their sub-fragments. Can a feeling be the form of a narrative? It looks very much like it. As we leaf through this gigantic archive of possibilities and constructions and journeys and stories and sets for shooting, and as we teeter on the borderlines of the categories of documentary and fiction, eroding before our gaze, *anomie* becomes a homeland. Why should we know where or who we are? Ontologically, queer. (And how can I not, already, be distracted by the figure of Allen Ginsberg in *Calligrammes*? Slipping into just these two images halts me in my writing about her at all.)

So, the feeling, this anomie, does it regard what Rickels writes of as the boringness of the art film? I hope so, as for me, when I first sat, a whole night, through *Empire State*, or suffered the repeated footstep after footstep on the soundtrack of

Chantal Akerman's *Jeanne Dielmann*, or the sliding ones of her *East*, or the slow burn of any number of videos or slow musical performances, of Cardew's *Treatise* or Cage's *Indeterminacy*, boringness was even a form of devotion. Being bored into and by, to the depths of my inattention, devoted, somewhere on the way to the experience of the mystic, to an infinitely differed finale or one that passes me by, unnoticed, so that I mourn my missing it.

In sexual practices, there is something known as edging, the prolonging of pre-orgasmic states until jouissance itself is defeated by its de-narrativizing into process, and this is the challenge of art film as boring. Narrative is frustrated and surpassed by boredom, another queer enough bodily and mental state, regardless of sexuality. And this too sits at a tangent to Ottinger's excess of image or geographic space or location of she, the artist, and dislocation of me, the viewer. Excess edges our attention into the boredom of frustrated expectations, whatever the story or its retelling might do, a Dorian Gray who returns me to the book as hopelessly lost, of the 1945 film as timid try-out, even though Ottinger might have done very well with Angela Lansbury as well as Seyrig or Veruschka.

This is to say that before a work by Ottinger, I make an iconography of my viewing which has little to do with her trajectory nor with the history of art film, nor with queer and gay theory practices, but as I watch them I am forced to hail myself as a viewer in my history: and while something tells me to locate the work within a field, German cinema of her time, for example, and while there is a scene from Fassbinder's *In a Year of 13 Moons* (1978) that does enable me to see her, my lifeline is silent Lubitsch. The astonishing crafting of the sets in *Sumurum* (1920), another envisioning of excess's excess, exceeded only by the crazed 'story' that is so hard to see through the paratactical organization of substances in the set; or the excessive gestures and actions of the *Oyster Princess* (1919), rage, fury, skipping, hopping, touching, dancing and the happy ending that is overdetermined by their exhausted rage. Or in this seeing, I behold a double of some figures of my own founding experiences, Veruschka as Dorian/Teleny, for example: the sublimation of the Easter funfair in a local childhood park in the Prater, folded into a black and white archive that I believe I have also lived. I become the unfortunate hero of E. T. A. Hoffmann's great *Die Doppelgänger*, of Deodatus, who is taken for a painter called Haberland. I become Ottinger's version of what I might have wanted.

In Lubitsch's *Puppet* (1919) film, there is a scene that foretells the Olympia passages from Powell and Pressburger's *Tales of Hoffman*, which itself maps out the visual possibility of Ottinger. As the doll smiles while being wound, I can see that Seyrig, or what Seyrig does with the face, the smile, is already and always waiting to be born anew in the microscope of the uncanny that haunts grander gestures, across the visible of our times.

One last location, Mongolia: one last suggestion. Ottinger risks adopting the gaze of the outsider, but the outrageous quality of her story boards, her picture novels, that have, like so much of her work, been through the fire of the incomplete must then belong to that gigantic narrative, of which the ending is just a bracket, that has haunted and formed the 'western' imaginary for centuries, the *1001* or *Arabian Nights*. That is to say that Ottinger, in finding her own mode of excessive times and places, has done as much as any writer could to dismantle gazes of colonial domination just as her queerness abjects the simplicities of gender. And in this, her radical accomplishment is to have made destitute the axis of metaphor in the endless edging of metonymy as an aesthetic and a political effect.

REFERENCE

Rickels, Laurence A. (2008), *Ulrike Ottinger: The Autobiography of Art Cinema*, Minneapolis: University of Minnesota Press.

15

'Most Young Women ... Are *Bihonists*': Interview with Yeran Kim

Angela McRobbie

10 April 2022

Yeran Kim is professor in the School of Communications, Kwangwoon University, Seoul, South Korea. She has published papers and books, including 'Idol republic: The global emergence of girl industries and commercialization of girl bodies' (*Journal of Gender Studies*, 2011), 'Eating as a transgression, multisensorial performativity in the carnal videos of *mukbang* (eating shows)' (*Sage Journals*, 2020) and *Visages of Words* (Muk Hak Gua Ji Sung Sa, 2014). Her current research focuses on the cultural intersection of affect, communication and society in the contemporary social media ecology.

> ANGELA MCROBBIE (AMCR): Yeran, I invited you to be part of this Ottinger book project, because as a leading Korean feminist media studies scholar it was my feeling that you might be able to respond in an interesting way to the work she was invited to make during the time of her visit.
>
> YERAN KIM (YK): Ulrike Ottinger's visit to Korea was in 2008, as part of the celebration of the 10th anniversary of the Seoul International Women's Film Festival (SIWFF). She was invited to produce and present some work about Korea. According to her, the exact subject of the films had not yet been decided. As a well-known feminist and avant-garde film director crucially positioned in the tradition of the New German Cinema movement, this was a good opportunity for audiences in Seoul to see something by Ottinger for the first time. SIWFF has distinguished itself with the objective of progressive gender politics. Byun Jaeran, head of the SIWFF committee, commented on the main theme of the 10th SIWFF, saying, 'What are the stories that SIWFF has wanted to speak about over the past ten years since the start of

the presentation and curating of films, and what sort of hope does it want to find?' She continued, 'This is a journey and trajectory where we attempt to search for women's views about what has been visible and invisible in the history of SIWFF, and what has been erased and is also non-erasable in the lives that we as women live in Seoul' [Byun Jaeran, 2008: n.pag.]. What remained to be answered was the question of what the Ottinger films would be about? What would she make visible, that had been invisible, what would she make invisible in terms of what had been too visible? She has often been called a 'nomad filmmaker' because she has made films focusing on what we might call the geo-society of the landscape and often in collaboration with local filmmakers, where she happened to be staying during each film-making period. There was the idea then, that this would be an interesting project. In the event the result of the time in Korea was two works, one *The Korean Wedding Chest* and the other short of just 16 minutes was *Women Seoul Happiness*.

AMCR: So how does a Korean feminist scholar like yourself read the work made by Ottinger during her stay in Seoul?

YK: It is all the more interesting to consider the cultural shifts between then and now. Ottinger's film *The Korean Wedding Chest* is a mixture of myth and document, as well as a mingling of old and new. All the actors and the mise-en-scène of the film are normal people in Seoul's everyday life space. However, the story itself is based on the genesis of Korea and its people, which is believed to have occurred about five thousand years ago. This myth is referred to by simply mentioning that the Ginseng man and Ginseng woman lived in the 'time when Bear and Tiger created the first men' in the introductory narration at the beginning. According to that myth, it is said that the Bear and Tiger spent one hundred days together confined in a cave, eating only mugwort and garlic in hopes of becoming human beings. After a difficult 100 days of confinement, the bear became a woman, and the tiger became a man. A son born between them, named Dangun, later established the first country of Korea, called *Gochosun* (meaning the old Chosun dynasty), and became its first king.

In the film an explanation of the Ginseng man and Ginseng woman is narrated in a standard male English voice. The camera follows the journey around Seoul across the old town to high-rise buildings in the present time. These images focus on various sights happening around a wedding, from the preparation of gifts that the two families will exchange prior to the wedding in traditional style, to a wedding ceremony in modern style. The

couple wear a tuxedo and a white wedding dress, declaring 'I do' in front of several hundreds of guests in a commercial wedding palace. The film documents the reality of the wedding industry in Korea. Korean weddings are not only a simple promise between two lovers, but an entirely commercialised event as part of the invention of patriarchal capitalism, filled with expensive commodities, heavily decorated programs, all orchestrated to create an illusion of harmony and happiness.

But there are tensions. We can feel a splitting sensation in the pacing and temporality of *The Korean Wedding Chest*. There is a clash between the nuanced camera views and actual scenes of people and events. The camera reveals a certain absurdity, failure, and meaninglessness inherent in the event. For instance, the guests at the wedding party seem to be interested not in the wedding, but rather in eating the food served at the party. The groom looks stiff, and the bride is forced to keep smiling, all the time being politely sociable. All the family members keep having their makeup retouched and their clothes are constantly tidied by the staff hired for the wedding. The bride and groom are instructed to situate themselves in many provocative poses to take memorable photographs, such as eating a small piece of fruit mouth to mouth, the groom carrying the bride on his back, as well as cutting a large piece of wedding cake with a huge knife. The wedding palace also has its own conventions such that young female staff in light blue uniforms form an elaborate ceremonial arch for the new couple to walk through together and a song of congratulations echoes through the palace until the couple moves to another event in a white Mercedes Benz limousine.

AMCR: What is achieved with this interlacing of the mythical and the modern?

YK: In the original sense of the journey, the Ginseng man and Ginseng woman are expected to become human beings and 'prove that they belong together' as the saying goes through the wedding. However, this expectation seems to have failed in the here and now because the grand illusion of the wedding, staged with such spectacular effects and with so many photographs taken, falls apart and the people just return to normal as if nothing has happened. In the final scenes the chef at the wedding party takes food for himself after working so hard. Likewise, the other people there are busy packing up souvenirs and leaving the party, while workers clean up the empty palace after all the guests leave. There is another split between the narration of the male voice and the role of the woman. The bride never says anything but 'Yes' to the numerous instructions on how to

handle the precious gifts for the new family, how to perform the wedding ceremony, and that she must respect her parents-in-law after the wedding, all the while keeping herself impeccably beautiful. And yet in the myth she has a more active role. It is the Ginseng woman who leads the Ginseng man throughout the entire journey from the mountain of human society to another new world. Indeed, the film concludes with her proclamation: 'Let's go again and roam the world and see what's new in the old and old in the new.'

Through her stubborn gaze, Ottinger even gently queers the whole structure of the wedding. The bride's obedient attitude is shown to be ambivalent. There is a suggestion that, as with the Ginseng woman's powerful voice, she is very much alive in the midst of her silence. Young Korean women can start their own journey to change, much like the Ginseng woman in the end. Her final words resonate with what contemporary young Korean women think about and request nowadays. What is crucial in their lives is not the hypocritical harmony of the old and the new, but the experimental 'discontent' [Rancière, 2009] between the two.

AMCR: Is this then the feminist and queer effect?

YK: The film creates an affect of intimacy on the basis of the camera close ups of the rituals. *Ham* in general means a box in which one keeps precious things such as jewelry, refined clothes, or metaphorically virtual elements such as dreams and thoughts. A wedding *Ham* is specifically referred to as a large wooden box given by a would-be bridegroom's family to a future bride's a few days before their wedding. The *Ham* is regarded as an expression of gratitude of the bridegroom's family toward the bride's family, gratitude for bringing up a wonderful girl and *gifting* her to his family. In addition, *Ham* can also be used as a powerful instrument to reveal the bridegroom's economic power by conspicuously including precious and expensive items (called *Yedan* in Korean) that are stuffed inside. In other words, *Ham* is one of the most symbolic objects revealing the patriarchal system associated with Korean weddings, marriages, and intra- and inter- family relations, expressing the man's power over women and confirming that the wife's duty is to obey her husband and his family for good. Yet, what is significant is less about the folk history of *Ham* itself than the contemporary meanings that *Ham* has for young people, especially young women, in contemporary Seoul. This is what Ottinger said on the opening day of SIWFF [Seoul International Women's Film Festival, 2008: n.pag.]:

Until Autumn 2007, when I opened one email from Korea, I had never even imagined that I would come to open a box soon, which is filled with miracles, or Korean wedding *Ham*. The *Ham* was full of contents inspiring me to create the film Korean Wedding Chest. The *Ham*, well stuffed and decorated, is filled following the honorable traditional norms of Korea. For that very reason, the wedding *Ham* provides a precious opportunity and insight with which one can explore contemporary Korean society. A thought occurred to me that in order to examine what is new inside oldness and what is old inside newness, I want to approach old and new rituals more closely. A modern fairytale holds the balance there, between new mega cities and the societies that contradict them. I hope this film leads to an enjoyable journey to the present.

AMCR: Can you say more about how the Ottinger film touched upon new sensitivities, things that were perhaps bubbling under?

YK: Gender conflict has become widespread and important in Korean society in recent years, to the extent that almost every political debate is inevitably directed back to these topics, and to the terrain of gender and generational conflict. A range of feminist spirits and values have dramatically grown and become popular, particularly among young women, who claim that they do not want to follow patriarchal traditions anymore.

AMCR: So, with Ottinger indicating her film is also about the now, she is with some subtlety also interrogating this terrain of sex and gender?

YK: Yes but with a superb politeness, curiosity and with her artist's eye and with the gaze of her camera she maybe unwittingly opened the Pandora's Box. In fact she said this herself about the making of the film. Now that it is really opened some years later it takes the form of the *bihon-juui* or the manifesto of anti-marriage (and certainly, the refusal of the wedding chest) as a serious aspect of young Korean women's struggle against patriarchal traditions. So there has been a lot of change in marriage culture since Ottinger's film. The past five years have seen a radical transformation of gender and generational politics. Most young women in their 20s–30s enjoy (or at least feel free) to announce that they are *bihonists*. It is not simply in daily life, it also affects real politics in every instance of elections, policy decisions, laws, cultures, and markets: 'We do not want to live like our mums!' they shout in anger against the male dominant history and anticipate a gender-equal future. As requests to change the patriarchal order and norms (that have dominated Korean societies

for several centuries) have grown stronger on the part of young women, legal and social punishments for such deep-rooted problems as sexual violence, sexual segregation, gender inequality, and misogynistic misconduct have become more and more enforceable. At the same time, feminism has become more popular and has been a huge influence on the whole society, particularly through young women's proactive deployment of political activity, literature publications, artworks, popular cultural fandom, and everyday resistance.

Bihon, or anti-marriage. *Bihon-juui*, which means anti-marriage-ism, has been largely shared among young women in Korea. Numerous young feminists have been quite active in deploying their belief in *bihon* in various channels and unique styles, from books, YouTube broadcasts, social media contents, and cultural events. They enjoy introducing themselves as 'wild, strong, fabulous' in their cultural sensibility or 'alternative, collective, and resistant' in their political position. In one study, a positive view of non-marriage and single life among people in their 20s is about 53% and that of non-marriage partnership and marriage life without children reached 46% and 52%, respectively. In the traditional perspective, and in contrast to the western societies, in which single parents or other various forms of partnerships are liberated, recognised, and legalised, any familial relationships outside the institutionalised form of marriage are regarded as non-ethical in Korea. Cohabitation or having a baby outside marriage is not legally acceptable.

AMCR: So, contemporary feminism in Korea finds a focus symbolically around the wedding chest?

YK: It is hardly surprising that the hostility against the normative model of marriage has led young women to declare *bihon* themselves. Both rates of marriage and birth have kept declining. Meanwhile, the number of marriages in 2020 was the lowest since 1971 when the national research started. Korea's birth rate is 0.84 (2021), which is the lowest record in the world; for example, Korea is the only single country whose birth rate is below 1.00 in OECD countries.

To Korean young women (including myself), the seemingly beautiful and mystic images of Korean traditional weddings may be nothing but a fantasy with disastrous results that have suffocated their grandmothers' and mothers' lives long enough and continue to repress their own lives too, unless they make radical changes for themselves. The anachronism

generated in the clash between a stranger's view of harmony and the lived experiences of actual people has been frequently criticized in the tradition of postcolonial studies. The critique of orientalism is familiar to us, as Oriental societies (disguised with feminine beauty) are commonly conceptualised as weak, docile, and passive in the eyes of powerful western visitors. Some might argue that Ottinger revives this Orientalist fantasy and repeats the male-dominant view of marriage and family. But this is not a satisfactory conclusion to draw because of the combination of the seriousness and intensity of her project and the queer kitsch element. This requests of us all that we look more deeply across the divide of cultural difference. Somehow from this movement there arises a scene of ambivalence. This marks a 'space' of newness. It occurs between the western artist, the project from SIWFF that she is invited to create, and what her documentary-anthropological gaze envisages and realizes. The *Korean Wedding Chest* is important, not because it preserves history unchallenged, but because it both conceals and reveals a certain possibility for change that should be led by the women to come. There is the potentiality to make the future unknown, undeterminable, and changeable.

REFERENCES

Jaeran, Byun (2008), 'Preface to the opening act', Seoul International Women's Film Festival, 3 November, https://siwff.tistory.com/35. Accessed 21 March 2022.

Rancière, Jacques (2009), *Aesthetics and Its Discontents*, Cambridge: Polity Press.

Seoul International Women's Film Festival (2008), 'Special screening – *The Korean Wedding Chest*', https://siwff.or.kr/kor/addon/00000002/history_film_view.asp?m_idx=101933&QueryYear=2009. Accessed 21 March 2022.

16

'We Were Pioneers for Fashion Spectacles That Didn't Exist Before': Interview with Claudia Skoda

Julia Meyer-Brehm

10 March 2022

Claudia Skoda emerged as a preeminent independent fashion designer in West Berlin in the 1970s. With a specialism in dazzling punk-inspired knitwear the androgynous collections included body-clinging items for club culture as well as for the street. Her studio space, the Fabrikneu in Kreuzberg, was also a meeting place for David Bowie, Iggy Pop and the artist Martin Kippenberger. Claudia Skoda formed lasting friendships with both Tabea Blumenschein and Ulrike Ottinger. She took part in Ottinger's 'Night Sessions' photographs, and she collaborated with Ottinger on a number of the film projects. Skoda's work over the decades was the subject of an exhibition in 2021 at the Kulturforum Berlin.

JULIA MEYER-BREHM (JMB): Claudia, you were born in Berlin in 1943. With your avant-garde knitwear designs and revolutionary fashion shows, you were an important part of the West Berlin subculture in the 1970s and 1980s. How would you describe the atmosphere of the city at that time in your own words?

CLAUDIA SKODA (CS): Above all, it was very free. You didn't have to have a lot of money, everything was cheap in Berlin. You could find alternative housing, you could go out. Of course you couldn't travel as much as others, but we went out a lot at night. You met everyone you had dealings with, either for dinner in the evening or at the club at night. You worked during the day. Unlike today, money didn't play a major role. Not only because of

the subsidies, but also because we were more or less undemanding. Everyone found their niche. I found the time very great and exciting.

JMB: Do you remember how you met Ulrike Ottinger for the first time?

CS: That was together with Tabea Blumenschein in the Werner Kunze gallery. We felt attracted right away. Tabea was a bit more reserved back then, but we quickly struck up a conversation and then we made an appointment. Ulrike then invited me to dinner – she was really, really good at cooking. Ulrike always invited a lot of people, artists and people she liked. It was always a nice get-together with her.

JMB: Does that mean you hit it off straight away?

CS: I became friends with Tabea straight away. She was very involved with fashion, she designed fashion herself. I immediately thought she was well-dressed and vice versa. We both did a lot together. Tabea had a small studio with Ulrike, and I often visited them there. The environment of the two was very creative and you just felt comfortable there. The people I was with at the factory were often there too. And when David Bowie was in Berlin, we also went to Ulrike's with him and Iggy Pop. It was always a big social round-table.

JMB: Ulrike Ottinger said about you: 'There were women who needed this encouragement and support in order to have the courage to follow their wishes, and there were also women, as there have always been, who just did it. For me, one of them is Claudia Skoda.' Was Ulrike Ottinger herself one of those women who didn't need to be encouraged?

CS: Yes, absolutely. Unlike today, she didn't have any producers for the films she shot back then. She just did it because she felt the need. That's how it was with me too. When we had ideas, we didn't ask too many questions, but implemented them. You talked to friends and included them too. There was simply this desire to create and experience something.

JMB: You organized the first fashion shows in the 'Fabrikneu', a living and working community on a factory floor in Kreuzberg on Zossener Strasse. You were working with materials, colors and cuts before they became mainstream. And even though it was the 70s, there was something special about working and living so unconventionally and freely. Did you also perceive it that way at the time?

CS: The way I lived or worked was always based on the pure pleasure principle. I wanted to experience something – so I created this experience for myself.

JMB: Do you think this way of living is still possible today?

CS: Today everything is much more controlled. Certain conditions must always be met. At that time, this celebrity thinking was not so pronounced. The question of whether you know him or her. It sort of spilled over from America. Back then it didn't matter – the main thing was that the person was interesting. You didn't always ask for the name right away, you concentrated more on the person.

JMB: Together with Tabea Blumenschein and Jenny Capitain you have been photographed by Ulrike Ottinger many times over. In the so-called 'Night Sessions' you can be seen in a wide variety of roles: sometimes as a vamp, sometimes as a femme fatale, androgynous and strict, then again extravagant or incredibly sexy. Were the photos spontaneous? [see Chapter 19]

CS: As far as I remember, we agreed to do that. We thought about it beforehand, Ulrike also made a lot of suggestions. Then we dressed and made up accordingly. And then we met and implemented our plans.

JMB: You all play with identities and ambivalent role models in these photos. You can observe looks and gestures that are now considered the epitome of queerness. How did that happen?

CS: When Ulrike was new to Berlin and didn't know many people, at that point she and Tabea did the sessions alone. At some point she included us in these activities, which of course we found exciting. Back then, people tended to take snapshots at parties. But Ulrike's plan was always to stage the photo sessions.

JMB: The images feel incredibly intimate, almost like watching your girlfriends standing together in front of the mirror getting ready to go out.

CS: Ulrike is the master of light. She prepared and illuminated everything – as she has always done with her film images. No flash photos were taken at all. You can tell immediately that she worked a lot with light and shadow, she was extremely good at it [Figure 16.1].

JMB: How did you feel in front of the camera?

FIGURE 16.1: Claudia Skoda, *Night Sessions*. Photograph by Ulrike Ottinger, Berlin, 1976. © Ulrike Ottinger.

CS: I had a lot of fun! With Ulrike it didn't go 'clack-clack-clack' as it is done today, but every shot was prepared. It always dragged on for a long time. She didn't take thousands of photos but worked very carefully. In between, she captured moments that she found exciting.

JMB: In 1977 you then took on a film role in Ulrike Ottinger's film *Madame X: An Absolute Ruler*. What interested you about becoming an actor?

CS: The role that Ulrike gave me corresponded exactly to my personality. I wasn't an intellectual 'Frankfurter Allgemeine' reader with a dachshund, I was exactly the opposite. That was the exciting thing, that Ulrike always liked to have all these eccentric people that matched with what she was up to.

JMB: Both men in evening dresses and women in androgynous looks have featured in your fashion shows. Was it your general aim not to take traditional gender roles so seriously or even to break them?

CS: It was completely normal for us back then. We had a lot of contact with gays and lesbians. For example, when we went out, Ulrike would go to the women's night bar 'Pour Elle' and I would go to 'KC' or a gay or punk club with Tabea. At some point we met again and went home. We also spent a lot of time with gay men in the factory – they loved us eccentric women and were all very fashion-conscious. That was our favorite scene – and that's how it turned out that looks like this came about.

JMB: Do you still get the feeling of being surprised when you watch fashion shows today?

CS: Yes, yes. Today there are crazy shows, huge formats with a lot of money. For example, the last Balenciaga show: there are so many people involved in the spectacle and who are specialized in this type of show. It's not like the designer does everything alone. We, on the other hand, organized everything on our own back then. Without a lot of money.

JMB: For example, highly expressive fashion shows like 'Laufsteg: Berlin – Mode – Elektronik – Show 78' (1978), your first major public show in the Egyptian Museum, now the Scharf-Gerstenberg Collection. Or 'Drum Fire' (1982) in the Martin-Gropius-Bau. This combination of fashion and art was completely new at the time?

CS: I was always looking for special locations, so museums came first, of course. Somehow it always worked. And I never had to pay anything for the locations either, they were always made available to me. The only thing we had to pay for was the night in the convention hall.

JMB: You're talking about your show 'Big Birds' (1979), which took place in what is now the House of World Cultures. Instead of a catwalk, the hall

was divided by armored lattices and illuminated only by single, powerful cones of spotlights. The performers Salomé and Luciano Castelli were almost naked, made up all over their bodies and hovered on a high trapeze above the models, who moved like birds. A happening!

CS: Tabea contributed her own collection and we developed the choreography together. Everyone took part, we infected each other. We had never seen or copied the visions we had. Ultimately, we were pioneers for fashion spectacles that didn't exist before.

JMB: So you wanted to create a unique fashion spectacle experience?

CS: Yes, and that's it. And we always had spectators and audiences. They didn't just come from Berlin, they came from everywhere. From London, Paris, Zurich, New York. That was great! This connection between Berlin and New York was very strong at the time. Ulrike also had strong connections to certain female artists from New York.

JMB: In 1981 you went to New York yourself and opened your first store in SoHo. Did you keep in touch with Ulrike Ottinger during this time?

CS: I was in New York with Tabea at the time. Ulrike had more or less told me to take care of Tabea a bit. It really was a really exciting time. We stayed with Lutze, a mutual friend (Christine Lutze). She acted in Ulrike's film *Portrait of a Drinker*.

JMB: Coming back to your events, which have been incredibly closely linked to the art scene. To date, these two areas are often treated separately and are clearly hierarchically separated from each other. Did you consciously try to build a bridge?

CS: That was the scene! At that time it was manageable in Berlin. You need the right environment to be able to do things like this. There were various scenes where like-minded people met. And I just knew the people who made art. This also included the filmmaker Robert van Ackeren, in whose films I also acted. Or Werner Schroeter. This art scene met mainly in the club called 'The Jungle'.

JMB: So you had the right contacts.

CS: I wouldn't call it 'contacts'. Rather the right friendships. That's the difference from today. It was always friendships.

JMB: Have you always clearly seen yourself as a designer? Or would you also describe yourself as an artist?

CS: No, I never wanted to be an artist. I've always said, 'I'm a fashion designer!'

JMB: Was Ulrike a frequent guest at the fashion shows?

CS: Of course she was often a spectator! But Ulrike is still one of my customers to this day. She often comes to my studio and chooses something beautiful. Ulrike loves my things and still wears them to this day.

JMB: Which places in Berlin do you particularly associate with Ulrike Ottinger?

CS: The Werner Kunze Gallery, because that's where we met. But we also often went out to eat together, for example in *Exil*. Those were always very turbulent evenings. Or we went to the 'AxBax', a Greek restaurant, or to the 'Paris Bar'. Our typical axis was: Hermannstraße, Ulrike's apartment, the Fabrikneu, the Jungle, the KC, AxBax, Exile – that was the scene in which all the artists moved.

JMB: It sounds like you've been out on the town a lot.

CS: At that time yes, I couldn't do that anymore either. We always went out to eat first, and it was quite late. Only at 10 or 11 o'clock. At 2 you went to the clubs and at 4 or 5 you came home. And that during the week! We lived in the factory, where some people came to work as early as 6 a.m. We just got home then.

JMB: Is there an experience with Ulrike Ottinger that you remember well to this day?

CS: Certainly! There is the footage for *Madame X: An Absolute Ruler*. My role, Flora Tannenbaum, ends in the story as a drowned corpse. So I had to lie in a small pond at night, covered only with a thin dress. When Ulrike is working, she is very dominant. You can't complain about that, you have to

endure it. I remember that scene very well! I lay in the cold water for hours. When it comes to realizing her cinematic ideas, Ulrike knows no mercy. She is very persistent and knows exactly what she wants to show. Really great. Great woman! (laughs)

17

'Back Then We Often Went to the "Lipstick"': Interview with Heidi von Plato

Julia Meyer-Brehm

15 May 2022

Heidi von Plato (born in Altenburg Thuringia in 1944) is a novelist and dramatist who has lived for many years in Berlin. Her recently best-known works include *The Concrete Express* (1997), *Hampel and Trampel* (1999) and *The Hairy Girl* (2005).

JULIA MEYER-BREHM (JMB): Hallo Heidi, it would be good to get a sense of the kind of art and cultural scene which you were involved in professionally before your close friendship (and for some years partnership) with Ulrike Ottinger. You founded the women's theater group ANNA KONDA in Berlin in 1980. Out of what motivation?

HEIDI von PLATO (HvP): My approach was that something had to be done for women in the theatre sector. It all started with a holiday course at the UdK (University of the Arts, Berlin) [formally HdK (Hochschule der Künste Berlin)]. As a playwright, I had worked there with women on my own texts during the summer holidays. From there the theatre group developed. I wrote and directed the plays, designed the costumes and sets. I just wanted to see my own texts implemented and visualized. It was wonderful work and I really enjoyed it.

JMB: You also worked as a dramaturge in Oberhausen and at the Westfälisches Landestheater in Castrop-Rauxel. That must have been a completely different scene than the one you knew from Berlin?

HvP: Completely different! These were smaller cities in the middle of the Ruhr area with site-specific problems. At that time there were other

structures there – all the more exciting for me to work there as a dramaturge. We have worked with migrants and developed migration projects together. And I belonged to a generation that was very political. But the theatre was too patriarchal for me and so I soon returned to Berlin.

JMB: With the ANNA KONDA theatre group your work was performed for example in the theatre of the University of the Arts, at festivals and in a ballroom in Kreuzberg. Your work was seen by many audiences. Did you also want to provoke with it?

HvP: Absolutely! My texts were very much about the role of women, which was questioned in absurd texts and actions. They were also about the role of patriarchy and its relationship to National Socialism. I was very much influenced by image theatre, which was more about specific images than plot. In the late '70s I watched Death, Destruction & Detroit by Bob Wilson at the Schaubühne, that was a revelation for me: strong, impressive images. In my plays, too, I didn't orientate myself towards realistic theatre.

JMB: Marina Auder, Brigitte Classen and Branka Wehowski were the editors of the magazine *Die Schwarze Botin* (1976–87), which was considered radically feminist at the time. You too started writing for the magazine in the 1980s. What did that mean to you?

HvP: I published an essay and some poems there. *Die Schwarze Botin* was an important intellectual forum for the women's movement and a great initiative. A critical journal that analyzed taboos in our society with irony and sarcasm. At that time I met Elfriede Jelinek and Heidi Pataki, who wrote regularly for the magazine.

JMB: What were you working against?

HvP: There was an impression in the women's movement that women were only seen as victims. We strongly criticized that. For example, Unica Zürn was received in this way. It was important to us to see women not only as oppressed, but as self-confident, intellectual beings who can defend themselves against the inflictions of patriarchy and late capitalism.

JMB: You are talking about the writer Unica Zürn (1916–70), who wrote prose all her life, but also worked as a dramaturge and illustrator.

HvP: At that time, the women's bookshop Lilith published Unica Zürn's books. They were beautifully designed, real works of art. 'The white with the red dot' was published by Inge Morgenroth, for example. We dealt with that a lot back then. I wrote a play about Unica Zürn and made a small film starring Eva Meyer and Gertrud Goroncy.

JMB: The motivation to take a different perspective runs through your entire work. That is definitely one thing that connects you with Ulrike Ottinger: portraying women in different roles.

HvP: Yes, that's what Ulrike's artistic work is all about. For example, in *Madame X: An Absolute Ruler* (1977): The woman as a figurehead, as a beautifully made-up, expressive person, by no means in the victim role. Likewise in *Bildnis einer Trinkerin* (1979) and in many other films. The special costumes of the actors represented an important means of aesthetic expression. That connected our work.

JMB: Do you still remember the first meeting with Ulrike? Had you heard of her before or knew her films?

HvP: Ulrike's films were already very well known. I had seen her film *Bildnis einer Trinkerin* at the Delphi. I also watched *Madame X* in the Arsenal. Likewise her short films and documentaries, for example *Berlinfieber,* a film about Wolf Vostell. At the time I was obsessed with cinema and also an avid Berlinale goer. In 1984 I met Ulrike in person for the first time at a women's festival.

I was fascinated by her unusual world of images, the play with different female roles, the questioning of role clichés and her love of extravagant costumes. There is also the role of fairy tales and myths that find their way into Ulrike's films. We were both interested in archaic worlds that reach into and determine the present. In the lectures by the famous religious scholar Klaus Heinrich, which I attended during my studies, modernity is understood as a narrative in which suppressed mythologies continue to have an impact.

JMB: You were close with Ulrike for some years.. How did it all develop after you first met?

HvP: After we met at the women's festival, we became partners.

JMB: Which places do you associate with Ulrike and your time together?

HvP: Back then we often went to the Lipstick. It was a big women's disco on Richard-Wagner-Platz. Unfortunately it no longer exists. There was a big dance floor and all the appropriate songs were played and sung, Patti Smith or Marianne Faithfull. I associate this place very strongly with Ulrike. But we also went out to eat a lot and to the Arsenal of course.

There was a Viennese restaurant in Kreuzberg called Exil, which we went to very often.

Ulrike liked to invite a lot of people to her place. Ulrike loves company, she cooks wonderfully and is always happy to invite people of all kinds. Then she would talk about her work and the adventures she had in all the foreign countries. She is a great storyteller and can entertain entire societies. Just like my Mongolian aunt!

JMB: You and Ulrike also worked together on some projects. How did that come about?

HvP: When she wrote scripts, we went through the scenes together and discussed them. I've sat with her at the editing table on some of her documentaries and made suggestions. My role was more in the dramaturgical area. I've been with her filming, for example with *Countdown* in 1990 where I was a production assistant. I also had been writing a novel that was based on my aunt. She was my father's sister and lived in China and Mongolia for a long time. She was married to a marmot hunter. She lived with us for a while. I was maybe 10 or 11 years old then. A very unusual woman who has always told endless stories. Of course I shared all these stories from Mongolia with Ulrike. Ulrike later made a feature film set in Mongolia. The interest in the foreign connects us. I got to know Eliade's book about shamanism through Professor Klaus Heinrich. I talked a lot about that with Ulrike. We also always have shared a common interest in outsiders. This is certainly determined by my youth when I felt like an outsider. My novel *The Hairy Girl* (2005), for example, deals with the life of Antonietta Gonzales, a 16th-century woman with hair all over her body.

JMB: In Ulrike's short film *The Specimen* you take on two roles: that of the museum visitor and that of a newspaper boy. How did that come about?

HvP: Ulrike knew my passion for acting and she knew how much I loved the theatre. So she asked me if I wanted to do the roles. Of course I thought it was great and I enjoyed doing it.

She gives clear instructions and she is very much a perfectionist, she has high standards and of course wants her ideas to be implemented. I had to repeat my scenes five or six times. You know that from film: the endless repetition and the endless waiting for the next action.

JMB: Is there a collaboration situation that you particularly remember?

HvP: Once Ulrike turned up at minus 20 degrees. That was for one of the seven deadly sins in her film *Superbia: The Pride* (1986). The poor actors and actresses were shaking and freezing. I provided them with blankets and of course they got a hot drink. But that was tough, a real challenge. In such situations, Ulrike is fully involved and implements her ideas. Siberian cold, sleeping in a tent that almost blows away in a storm – Ulrike can take a lot, otherwise she would never have been able to make her films.

JMB: In 2013 you and other authors of *Die Schwarze Botin* sat down with representatives of the current women's movement as part of the Wiener Festwochen and went through your texts. What was the result?

HvP: There were many who worked for the magazine. Ginka Steinwachs, Mona Winter and Marina Auder. The younger people from the university spoke a language that was foreign to me at the time: I heard for the first time what a cis man was. Those were really difficult discussions and we also clashed. At that time the question was asked whether one could still speak of a patriarchy. The young people said: 'What nonsense'. And of course we as 'old feminists' said 'patriarchy is not over yet. Not for a long time!'

18

'The Magic of Costume and Masquerade': Interview with Gisela Storch-Pestalozza

Thomas Love

29 August 2022

Gisela Storch-Pestalozza (b. 1940) is a costume designer widely acclaimed for her work in theatre and cinema. After a degree in haute couture and a practicum at the Staatsoper Hamburg, Storch-Pestalozza worked for the Schauspielhaus Hamburg between 1962 and 1974. She then moved to Berlin, where she has worked for the Schaubühne, Schiller-Theater, and more. In the mid-1970s, she began to work more extensively in film, especially with Werner Herzog and Ulrike Ottinger. Her work on Herzog's *Nosferatu* (1979) was nominated for a German Film Prize and a Saturn Award from the Academy of Science Fiction and Horror Films, USA. Her costumes are held in the archives of the Deutsche Kinemathek.

> THOMAS LOVE (TL): Could you first tell us a little bit about your education and how you became a costume designer?
>
> GISELA STORCH-PESTALOZZA (GSP): My education began with an apprenticeship as a ladies' tailor and then I went to Munich – to a fashion salon on Maximilianstrasse – and I did my master's degree in haute couture. However, fashion alone didn't interest me. I wanted to get to know this other world of art and theatre. So I went to Hamburg, to Rolf Liebermann at the Staatsoper, where I made wonderful ballet costumes. Balanchine was still a choreographer there. All the workshops were still in house at the time. The props, the hats, the jewellery and tutus and all the decorations, everything was still made by hand. That was quite wonderful. Then I went to the Hamburg Schauspielhaus as an assistant to a costume designer.

Then I got married and went back to Munich and had two children. I realized that just sitting around in the sandbox wasn't my world. This was during the women's movement at the end of '68. Through the women I was involved with, I got to know about alternative day care centres and later we set up a shared apartment in an old villa with theatre people and architects. That's how I had the opportunity to be away from home and how I was able to work for so long. In 1974, I was invited to join the Schaubühne in Berlin as a wardrobe supervisor. My first project was Gorky's *The Summer Guests*, where I made costumes out of old flea market linens, blankets, and towels. I was always thrifting and making things through recycling. We did intensive research for the shows at the Schaubühne – I could always go to libraries and study the costumes. And during the season breaks, I went back to Munich and worked in film. I had previously met Werner Herzog in Munich and worked on his film *Kaspar Hauser* (1974). That was such a beautiful collaboration: we all lived and cooked together and it worked wonderfully. Then came *Heart of Glass* (1976) and *Nosferatu* (1979). For *Fitzcarraldo* (1982), he said 'now I need you for longer'. So I left my nice job at the Schaubühne and we went to Peru together and prepared the film there. It took quite a long time to finish it. I was always interested in all that ethnological history. I also lived near the ethnological museum in Dahlem. I always went there and looked in the archives, a huge cellar full of original costumes.

TL: That also connected you to Ulrike?

GSP: Yes, this interest and curiosity in ethnological research. That's how I got started working with these historical costumes, which I continued to use later in *Johanna d'Arc of Mongolia* (1989) to some extent.

TL: Were the historical costumes mostly made for these particular projects or did you work with archival materials, with real historical pieces?

GSP: I prefer historical pieces, actually. Because I haven't seen costume houses that are able to recreate historical pieces accurately, in the proper proportions with the underpinnings and the materiality and the ingredients that go with it.

TL: How did you first meet Ulrike and begin working with her?

GSP: The film *Ticket of No Return* (1979) was shown here in Berlin at the Akademie der Künste, and that's when I noticed her. I found the costumes and the film – and also her personality – very special.

TL: And your first work with Ulrike was *Dorian Gray [in the Mirror of the Yellow Press]* (1984) ...

GSP: Yes. For that film, I had the opportunity to work with completely different materials, with plastic and other strange and unusual materials. And I found that very exciting, because it was a different approach to the costumes. It was much more artificial.

TL: What was the research process for a more fantasy-like film such as *Dorian Gray*?

GSP: Well, there was a description of all the characters, so I researched all that and put it together. The monk and the *infante*, for example, were made according to Spanish models, but also from unconventional materials. And there were tin soldiers whose costumes were made out of saucepans and sieves! That was great fun for me, of course.

TL: It's very fun to watch, too! Were you working with an idea of what the set was going to look like?

GSP: Yes, that's where I work very closely with Ulrike. She's very good at describing her vision and explaining it and also making it look so fascinating. Ulrike works very visually. The main motif is very strongly coordinated, also with the colours of the costumes. The collaboration is very intimate and requires intensive preparatory work together. That's different from Herzog. I would also work closely together with Herzog, but I would have time on my own to explore the epoch and the characters. I would have to rely more on myself and make the best of it.

TL: Did this collaborative way of working with Ottinger have an influence on your costume design?

GSP: Yes, of course it was greatly enriching. It was a wonderful experience to work on something that was almost a total work of art.

TL: And then came this turn to documentary with *China. The Arts – The Everyday* (1986) and *Johanna d'Arc of Mongolia* (1989). Did you have a certain image of China and Mongolia at that time that perhaps changed once you finally travelled there?

GSP: No, it wasn't necessarily China that interested me, it was the cut of the clothing. To simply make a dress from a straight piece of fabric and then put an angle in there just so ... that kind of pattern construction fascinated me. I've always studied and experimented with different clothing patterns, including Japanese and other Asian cuts and old Turkish robes, I found all of that just great.

TL: When you decided on those particular cuts and historical clothing, did you work with Chinese tailors?

GSP: I prepared very well in advance here in Berlin. You need a big work table to cut, say, a huge caftan with all the layers on top of each other and the laces and the braids and the embroidery and everything that goes with it. And the extras who performed in China had some of their own clothes, too. In China, it would have been impossible to put together the kind of studio I had here in Berlin, because we were staying in a yurt, or we were in the grasslands. I didn't have the option of working on a large scale.

TL: And what would come after a film? Did you take heed of Ottinger's reception?

GSP: Back then, one really always lived from hand to mouth, as they say. When a shoot was finished, Ulrike would retreat to the editing room for months until the product appeared for the premiere. But in the meantime, I would already have moved on to something else, on to other material, plays, or films.

TL: Do you try to bring these new experiences into every project?

GSP: Yes, it's always new. Every project is set in a particular era or time. Whether I'm doing rococo or medieval or working with Japanese kimonos or the Kabuki theatre or traditional Styrian costumes. All of that always fascinates me: the magic of costume and masquerade. I think it's unfortunate that people don't utilise that anymore today.

TL: What do you mean by that? What do you think theatre is like today?

GSP: Well, they bring everything into the present moment, even historical plays. I find that researching traditional or historical clothing enriches me.

To go to museums and archives and costume libraries and to look at these wonderful works. It's complicated. How can you present and show their beauty to the whole world? To dress up like that, to slip into other roles, into other lands?

19

'As a Viewer You Have a Lot of Freedom': Interview with Wieland Speck

Thomas Love

8 August 2022

Wieland Speck (b. 1951) is a German filmmaker, author, curator and, occasionally, actor. He served as programmer for the Berlin International Film Festival from 1981 to 2019 and as director of the Panorama Section from 1992 to 2017. In 1987 he founded the TEDDY AWARD – The Queer Film Award at the Berlinale. His films include *Westler – East of the Wall*, from 1985, and *Escape to Life – The Erika and Klaus Mann Story*, co-directed with Andrea Weiss in 2000.

THOMAS LOVE (TL): Could you describe when you first met Ulrike Ottinger and how you got to know her films?

WIELAND SPECK (WS): It was when I saw *The Enchantment of the Blue Sailors* (1975) at the Arsenal cinema in the mid-seventies that I first glimpsed Ottinger, even if I didn't speak to her. I saw Tabea Blumenschein more often, of course, since she went out more. During that time, I was always out and about in West Berlin. I was doing shows, theatre performances, and publishing men's literature [*Männerliteratur*]. At some point, our paths crossed.

TL: What was your first impression of her work?

WS: It fitted perfectly into the subcultural landscape at the time. There weren't that many filmmakers who brought the underground – the German underground, but more specifically the West Berlin underground – to light. You knew about everyone who was doing something like that. The films of Werner Schroeter, Rosa von Praunheim, and Lothar Lambert were already somehow in the air.

TL: Were you already a film programmer at that time?

WS: Not yet at the Berlinale. My story as a programmer started in the mid-seventies, when I was involved in the Tali-Kino in Kreuzberg, which is now called Moviemento. It's one of the oldest cinemas in Berlin, from 1907. And of course we already had a conceptual program there, including films we wanted to engage with and, of course, our favourite films. It wasn't about careers or development or any specific plan; we were just doing what we were doing. Not surprisingly, that was a more creative time. The professionalization – which hit hard from the mid-eighties and really defined the nineties – hindered creativity in a lot of ways. And I've always said that when it comes to art, 'professional' is a dirty word.

TL: Do you think Ottinger's work was also changed by this tendency towards professionalization over the years? Or did she find her own way?

WS: Ottinger was really extremely idiosyncratic. She creates a paraworld that nevertheless has a lot to do with ours. Though she has moved away from her more obviously libidinous films, her work has always been sensual. Even when it slowly became detached from Tabea Blumenschein, who, in her aloofness, functioned as an object of desire for all of us. Blumenschein was always a mirror for this alternative audience. Of course, every star is a mirror, otherwise they wouldn't be a star, but Blumenschein was a star for very unusual people. Ottinger only brought on people who were interesting enough for her. And those were usually people who were interesting for me, too.

TL: And then at some point it also happened that she found you interesting enough to bring into a film – *Freak Orlando* (1981), that is [Figure 19.1].

WS: I don't remember how that happened. It all seemed so natural. She was looking for unconventional people who could express something for her. Rosa von Praunheim was always looking for crazy characters to portray themselves. Ottinger didn't do that. She was more looking for people who could bring a crazy element into a particular situation. She was creating tableaus for the camera. So the viewer is not absorbed into the craziness; they can look at what is happening and have their own thoughts. As a viewer, you have a lot of freedom, because Ottinger's images transcend real life.

TL: You also have a lot of time. In many of Ottinger's films, the duration allows a different kind of observation.

FIGURE 19.1: *Freak Orlando*. Photograph by Ulrike Ottinger, Berlin, 1981. © Ulrike Ottinger.

WS: Yes, absolutely, that's a good point. It's not the usual stress that the filmmaker puts on the viewer to pay attention constantly because what you're seeing could be gone in a moment and never come back.

TL: Do you find that Ottinger's films have had a consistent audience?

WS: Definitely. And that helps to avoid getting lost. That happens to many filmmakers, after all, that they just peak a few times. Ottinger has been able to have a certain consistency and at the same time she has also developed an audience that has its own consistency. The alternative never stopped being alternative because the mainstream just didn't come closer to what she was doing.

TL: But there have also been critical perspectives on Ottinger, first in the context of feminist film or 'women's film' [*Frauenfilm*] and then this postcolonial moment and then this queer moment.

WS: With Ottinger, the absence of violence always plays a role. It's a particular worldview that you have to understand from the get-go. Of course, she

includes traditional portrayals of how people live in yurts or whatever, and there is always violence in the background of that, as in every society. It's not that she denies that. What she films serves to capture a transcendent moment, so to speak, and not a documentary moment. When watching a film, I always ask myself where the violence is that you don't see. But that was never Ottinger's approach.

TL: Yes, and that annoyed some film scholars a lot, because they wanted colonial violence, for example, to be more present in the films.

WS: You mean in recent criticism?

TL: Already in the nineties.

WS: If you were to attack Ottinger from this perspective now, then you would also destroy a lot that might be valuable in her work. You need a very reflective person to write about it, because if you bring up appropriation, then of course Ottinger's work is full of it. But there would be no culture – zero – without appropriation. The confrontation with the other is already a sort of appropriation. In Ottinger's films, you can also feel how the world has opened up to her, and therein lies, for me, a valuable model of communication. This respect that she is obviously capable of showing towards life, towards culture, towards other beings, that is the foundation upon which she works. It has the potential to create a non-violent situation.

TL: How would you characterize Ulrike's contribution to queer cinema?

WS: I understood her as part of the movement, without her ever emerging as a figurehead. Many people only understood later what anarchistic potential there is in people standing up for themselves. The gender roles, the class barriers, the cultural differences, Ottinger transformed all these things into an image of humanity in which one can miraculously find oneself everywhere and nowhere. The androgyny that always played a big role in her work was also very attractive for me, because that was exactly the emancipatory, non-binary, revolutionary approach in the late sixties – and then especially in the seventies – that we wanted to show the world. There were so few of us freaks that we opened the doors wide and said that if anyone felt included, they were welcome. Liberation cannot be solely individual. If I liberate myself, then that is of course totally necessary, but it is of no use at all if I don't bring the whole joint with me in some way.

TL: But even in the seventies, if someone were to say, for example, 'that doesn't count as women's film', that's a kind of exclusion. And Ottinger showed a resistance to that very early on.

WS: Absolutely, because it speaks to one of our great character traits, which is self-righteousness [*Rechthaberei*]. And the Germans are particularly good at that.

TL: You have to have a different logic. You can't have a discussion with that kind of language.

WS: I came to Berlin in 1972 and I immediately joined the HAW (Homosexuelle Aktion Westberlin). They were only two years old – maybe not even that – and already completely at odds with each other. On one side were the strict leftists and on the other side were the anarchists, more *Spontis*. I was always on the *Sponti* side because it was more open. With the others, you had to have categories and dogmas and all that. That was the opposite of what we wanted to be, or what I wanted to be. At that time, people said 'we' a lot. I also only lived in men's emancipation communes – up until five years ago, actually. It's amazing when you get as old as I am and you haven't died of AIDS. That's something special in my world, to be able to learn what it's like to grow old. When I was young, I didn't have any examples to show me how to live because I always felt that I don't belong. And I must say, it is the same today. There are so few examples left that I can relate to. There are of course other older gays, but there are really very few of my sort. But Ulrike is just one of those figures, someone who is engaged and acts and creates and has energy. As is quite often the case, it's just serendipity. I think that's a nice word to end on.

Contributors

NORA M. ALTER is a scholar of comparative film and media arts. She has published numerous essays on cultural and visual studies, contemporary art and sound studies. She is author of *Vietnam Protest Theatre: The Television War on Stage* (Indiana University Press, 1996), *Sound Matters* (Berghahn Books, 2004), *Chris Marker* (University of Illinois Press, 2006) and *The Essay Film after Fact and Fiction* (Columbia University Press, 2018). Her most recent monograph is *Harun Farocki: Forms of Intelligence* (Columbia University Press, 2024).

TIM BERGFELDER is professor of film at the University of Southampton. He is one of the editors of the journal *Screen*, and co-curates Berghahn's Film-Europa book series and Palgrave's European Film and Media Studies book series. He has published on multiple aspects of German and European cinema, and is currently researching the history of German film studios.

ERICA CARTER is professor of German and film at King's College London. Her publications include *Mapping the Sensible: Distribution, Inscription, Cinematic Thinking* (with Bettina Malcomess and Eileen Rositzka: De Gruyter, 2022), the co-edited *German Cinema Book* (BFI, 2020); *Béla Balázs: Early Film Theory* (Berghahn, 2010) and *Dietrich's Ghosts: The Sublime and the Beautiful in Third Reich Film* (BFI, 2004). Her current research centres on whiteness and colonial cinema in the post-World War II moment of decolonisation and Cold War.

CASSANDRA XIN GUAN is an assistant professor in cinema and media studies at the University of Chicago. She is currently completing her first book project, *Maladaptive*

Media: The Plasticity of Life in the Era of Its Technical Reproducibility (forthcoming), and beginning to work on a new book, *Imagine There's No Human: China in Animation*. Her writings have appeared in *October*, *Screen* and *Critical Inquiry*.

* * * * *

GERTRUD KOCH is emerita of cinema studies at the Free University in Berlin. She is co-editor and board member of numerous German and international journals like *Babylon, Frauen und Film, October, Constellations, Philosophy & Social Criticism*. Her latest books are *Die Wiederkehr der Illusion: Film und die Künste der Gegenwart* (Suhrkamp, 2016), *Zwischen Raubtier und Chamäleon: Essays* (Fink, 2016) and *Breaking Bad, Breaking Out, Breaking Even* (Diaphanes, 2017).

* * * * *

ESTHER LESLIE has an interest in Walter Benjamin and has written about animation, synthetic dyes, liquid crystals and clouds. A recent book is with Sam Dolbear and it is called *Dissonant Waves: Ernst Schoen and Experimental Sound in the 20th Century* (Goldsmiths Press, 2023).

* * * * *

THOMAS LOVE received his Ph.D. in art history from Northwestern University and is a Preparing Future Faculty for Inclusive Excellence postdoctoral fellow at the University of Missouri. His current book project, titled *Queer Exoticism: Strategies of Self-Othering in West Germany, 1969–1994*, analyzes queer art in post-1960s West Germany to show how representations of racial and ethnic difference became essential to the definition of contemporary queer identity. His writing has been published in *Art in America*, *The Germanic Review*, *Texte zur Kunst* and in the Art Institute of Chicago's 'Perspectives' series.

* * * * *

ANGELA MCROBBIE is fellow of the British Academy and professor emeritus at Goldsmiths University of London. Her most recent books are *Feminism and the Politics of Resilience* (Polity, 2020) and *Fashion as Creative Economy* with Daniel Strutt and Carolina Bandinelli (Polity, 2022). *Feminism, Young Women and Cultural Studies: Birmingham Essays from 1975* will be published in summer 2024 (Goldsmiths Press).

* * * * *

CONTRIBUTORS

MANDY MERCK is professor emerita of media arts at Royal Holloway, University of London, and currently an Honorary Research Fellow at Birkbeck, University of London. Her latest book is *Cinema's Melodramatic Celebrity: Film, Fame and Personal Worth* (BFI Bloomsbury, 2020). Her next is *Downsizing: Film and the Miniature* (forthcoming).

DOMINIC PATERSON is senior lecturer in history of art and curator of contemporary art at the University of Glasgow. He has written widely on contemporary art, including recent essays on Neil Clements, Ilana Halperin and Rachel Maclean. Recent curated exhibitions include *Jimmy Robert: Tobacco Flower* (2021), *Flesh Arranges Itself Differently* (2022), *Elizabeth Price: UNDERFOOT* (2022) and *The Trembling Museum* (2023, co-curated with Manthia Diawara and Terri Geis).

LAURENCE A. RICKELS is the author of many books on mourning and melancholia, B-culture and the history of psychoanalysis. His most recent publication, *Critique of Fantasy* (Punctum Books, 2021–22), will be followed soon by *Opportunists and Impostors: The Berlin Analysts on the Unconscious and in the Language of the Third Reich*. He has held professorships at the University of California, Santa Barbara and the Academy of Fine Arts Karlsruhe. Beginning January 2023, he is part of a group inaugurating a new programme in pedagogy at the California Institute of the Arts. The graduates will instruct at-risk youth nation-wide in the collective effort of filmmaking, aiming for a social revolution within and through the culture industry.

ADRIAN RIFKIN is a visiting professor at Central Saint Martins, London. His recent essays on artists include 'The once and future archive', in *Elizabeth Price: Slow Dans* (Artangel, Film and Video Umbrella, Whitworth Art Gallery, 2019) and *Anne Tallentire: There Is Nothing New, Under the Sun* (Hollybush Gardens, 2022). His most recent book is *Future Imperfect, Time Between My Fingers* (Ma Bibliothèque, 2021).

KATHARINA SYKORA is professor emerita of art history at Braunschweig University of Arts and a specialist in constructions of gender and authorship in visual

culture and on intertextualities between photography, painting and film. The most recent books are *Zwischen Welten: Ulrike Ottingers Filme im Spiegel der transatlantischen Kritik* (Wallstein Verlag, 2022) and *Überfliegen: Figuren erratischer Wahrnehmung* (Wallstein Verlag, 2021).

✳ ✳ ✳ ✳ ✳

PATRICIA WHITE is centennial professor of film and media studies at Swarthmore College and an editor of *Camera Obscura*. Her books include *Rebecca* (British Film Institute, 2021); *Women's Cinema/World Cinema: Projecting Contemporary Feminisms* (Duke University Press Books, 2015) and *Uninvited: Classical Hollywood Cinema and Lesbian Representability* (Indiana University Press, 1999).

✳ ✳ ✳ ✳ ✳

HYOJIN YOON is a Ph.D. candidate in film studies at King's College London. She is currently working on her doctoral thesis on women's moral subjectivity in contemporary German cinema. Her project studies the cinematic images of a solitary woman from a cultural, historical and philosophical perspective.

Index

Page numbers in *italics* indicate figures. Page numbers followed by n indicate endnotes

A
anthropomorphism 161
anti-conquest 204–18
art 2, 3, 6, 10, 12, 15, 22, 24, 33, 36, 39–42, 51, 63, 66, 67, 69, 79, 106, 113, 127, 165–68, 174, 176, 184, 207, 225, 227, 240, 241, 244, 246, 249, 251, 261
artefacts 3, 5, 7, 33–35, 37–43, 123, 124, 126, 135, 168, 201, 207

B
Barbarella 87, 93
Bazin, André 188, 189
Benjamin, Walter 4, 10, 21, 25, 68, 72, 77, 82, 167, 175, 178, 260
Bergius, Hanne 178
Bering Straits 16, 194
Beringia 10, 205, 206, 214, 216–18
Berlin School of the Ready-Made 78, 79
Berlinische Galerie 61, 65
Blumenschein, Tabea 6, 18, 42, 58, 60, 63–66, 71, 72, 73, 173, 236–38, 254, 255
Butler, Judith 61, 71

C
China 7–9, 49, 101–08, 110, 111, 112, 114, 115, *117*, 143–45, 150, 154, 156, 174, 189, 207, 247, 251, 252, 260
Chukotka Peninsula 187
colonial mimicry 91

costume 6, 12, 20, 42, 50–52, 61, 63, 64, 66, 76, 90, 116, 244, 246, 249–53
cultural revolution 107, 109, 155
cultural studies 3, 6, 59, 225

D
Dada 4, 20, 22, 29, 66
documentary 2, 8, 9, 16, 17, 21, 23, 34, 49, 50, 76, 87, 102–07, 111, 113, 114, 117, 133, 142, 145, 161, 166, 168, 182, 196, 204, 214, 226, 251, 257
Dorian Gray 2, 5, 18, 35–37, 63, 69, 104, 173, 227, 251

E
Echigo 9, 39, 40, 166
Eschenbach, Margit xi, 67, 108
ethnography 17, 102, 103, 106–09, 112, 113, 115, 117, 210, 213, 214, 216, 218

F
fables 2, 4, 9, 11, 124, 167
fairy tale 4, 11, 39, 41, 161, 169, 196, 215, 216, 246
fashion 6, 11, 57–73, 87, 124, 148, 237, 240, 242, 249, 260
feminism 61, 132, 234, 260
feminist theory 61, 73
figurative painting 4
figures colon 43

film studies 1, 16, 58, 262
Foster, Hal 3
Freud, Sigmund 161, 164, 165
Friedlaender, Johnny 32

G
Ginseng 161, 162, 230–32
Glissant, Edouard 178, 183–85

H
Hagen, Nina 59, 70, 71, 80, 157n3
Hebrew 44, 149, 168
Hoch, Hannah 67, 121, 184
Hongkou ghetto 144, 147, 149

I
imperialism 24, 145, 183, 210

J
Japan 7–9, 17, 39, 52, 143, 166, 174, 189, 202n2
Jelinek, Elfriede 94, 245
Jewish, exile, diaspora 4, 9, 16, 44, 45, 126, 142, 144, 150, 154, 155, 168

K
Kalinka Sisters 122, 123, 126, 131, 135
Kim, Yeran 11, 229–35
King Kong 88, 89, 93, 97
Kippenberger, Martin 79, 80, 236
Klein, Melanie 9, 164
Kodiak Island 192, 196, 199
Korea 7–9, 17, 229–31, 233, 234
Kreuzberg 77, 79, 236, 237, 245, 247, 255

L
Lady Windermere 17, 20, 36, 122–28, 131, 132, 135, 136, 195
legends 11, 161, 165, 167

M
Marker, Chris 107, 188, 259
Marx Brothers 22
masquerade 6, 50, 58, 61, 62, 92, 249–53
Mulvey, Laura 61, 225
Mongolia 7–9, 12, 16, 17, 36, 50, 85, 91, 103–05, 107, 120–39, 175, 176, 189, 191, 195, 213, 228, 247, 250, 251
Montezuma, Magdalena 173
Murnau, Friedrich Wilhelm 23, 26, 27, 29

N
narrative figuration 21
New German Critique 73, 118, 119, 159, 160, 203, 220
Newton, Esther 27, 28
Night Sessions, The 61, 236, 238, 239
Northwest Passage 188, 192–94, 205, 217n3

O
objects 2, 3, 5, 7–9, 22, 24, 25, 29, 32–54, 58, 61, 64, 78, 91, 102–04, 113, 135, 139n3, 164, 169, 181–84, 196, 198, 199, 201, 206, 255
Obrist, Hans Ulrich 183
orientalism 4, 17, 25, 128, 133–38, 235
Orlando 2, 18, 20, 28
Ottinger, Ulrike 1, 4, 8, 10, 11, 12, 15–17, 19–25, 23, 27–29, 28, 32–45, 49, 52, 53, 57–73, 75, 78, 83, 85, 88, 101–18, 117n1, 120, 125, 131, 142, 144, 152, 161, 169, 173–85, 188, 200, 204, 212, 225–29, 236–39, 241, 242, 249, 256, 262

P
Picard, Franz 21
Picard, Lil 25, 182, 183
pop art 4, 21, 46, 51, 66
popular song 4, 154
Prater 7, 85–97, 169, 227

Pratt, Mary Louise 4, 11, 207, 208, 209, 212, 214
postcolonial theory 105

Q
queer theory 5

R
refugees 43, 44, 143, 147, 148, 177
Riesenrad 2, 85, 86, 88, 92
rituals 9, 11, 25, 38, 42, 52, 53, 135, 136, 164, 169, 193, 198, 201, 232, 233

S
Sea Otter Maiden, The 196, 215, 216
Seoul 3, 9, 37, 38, 161, 165, 169, 229, 230, 232
seven-league boots 41, 42, 195, 204, 210
Seyrig, Delphine 8, 20, 36, 63, 122, 126, 195, 227
Schlemihl, Peter 41, 42, 168, 195, 200, 202, 204, 205, 208, 210, 216
Shanghai 8, 9, 17, 43, 44, 142–56
Skoda, Claudia 11, 59, 66, 236–43, 239
Smith, Jack 23, 25, 42, 181
Speck, Wieland 4, 12, 254–58

Spies, Walter 27
Sternberg, Josef von 89, 90, 92, 124
Storch Pestalozzi, Gisele 12, 249–53
subculture 6, 66, 67, 73, 236

T
Tegel Airport 59, 69, 70, 226
totems 193
travel ethnography 115

V
von Lehndorff, Veruschka 87, *88*, 173
von Plato, Heidi 11, 244–48
Vostell, Wolf 65, 79, 80, 246
Vienna 2, 7, 85, 87, 89, 92, 95, 96n1, 145, 146, 174

W
West Berlin 6, 57, 79, 236, 254
Wilde, Oscar 15
Woolf, Virginia 20, 77

Y
Yiddish 4, 9, 24, 122–24, 152, 168
Yupik people 187
Yupik Sea 187